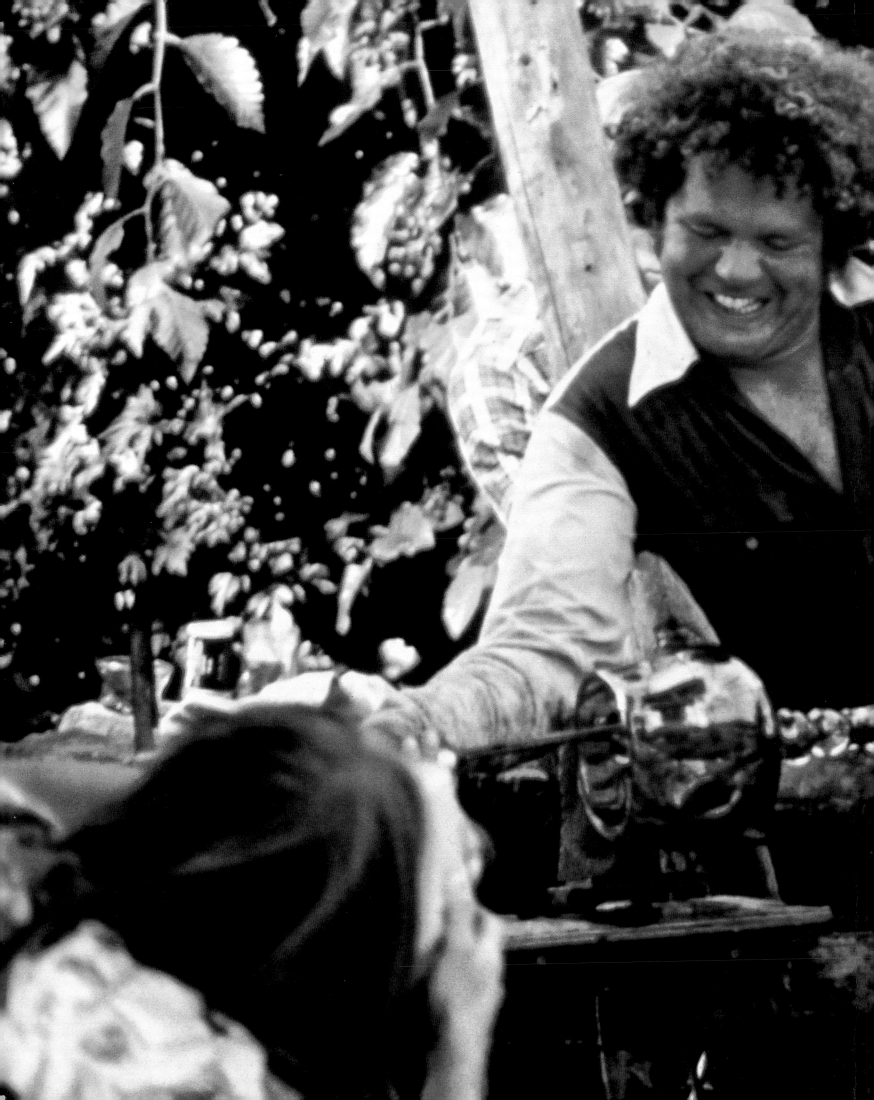

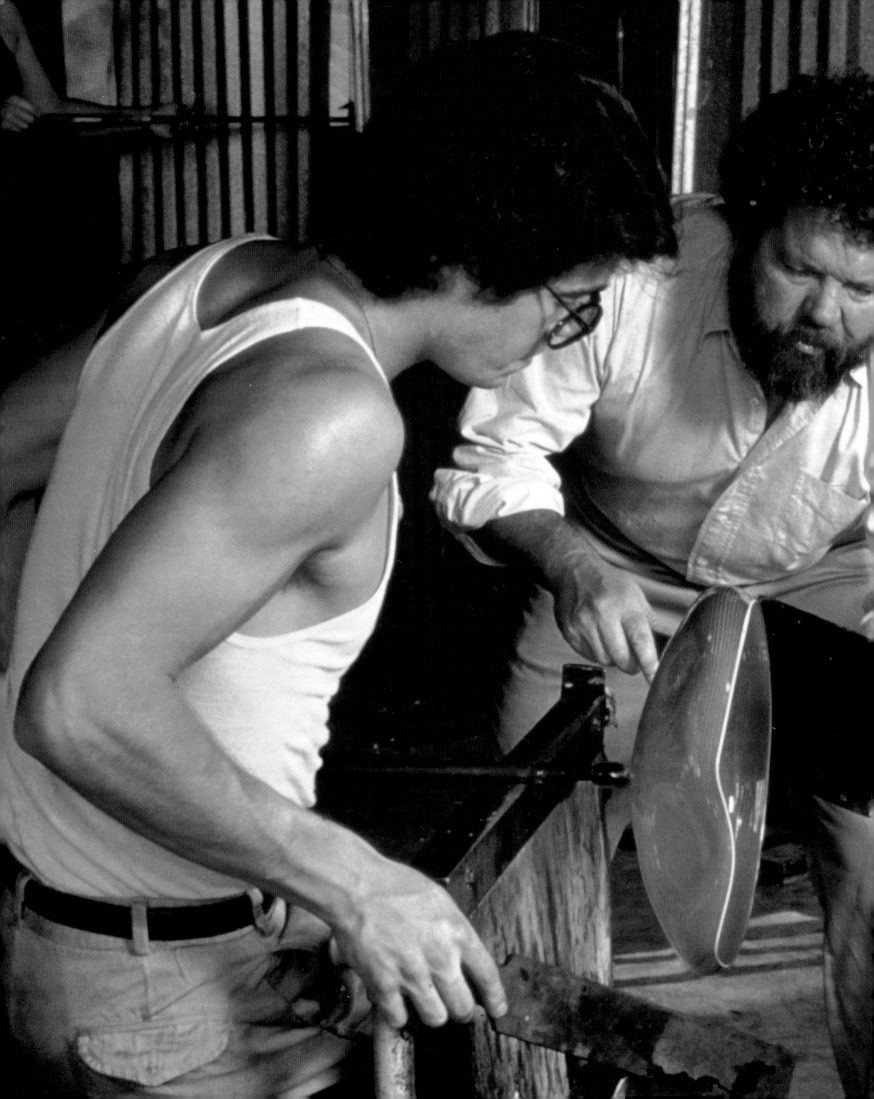

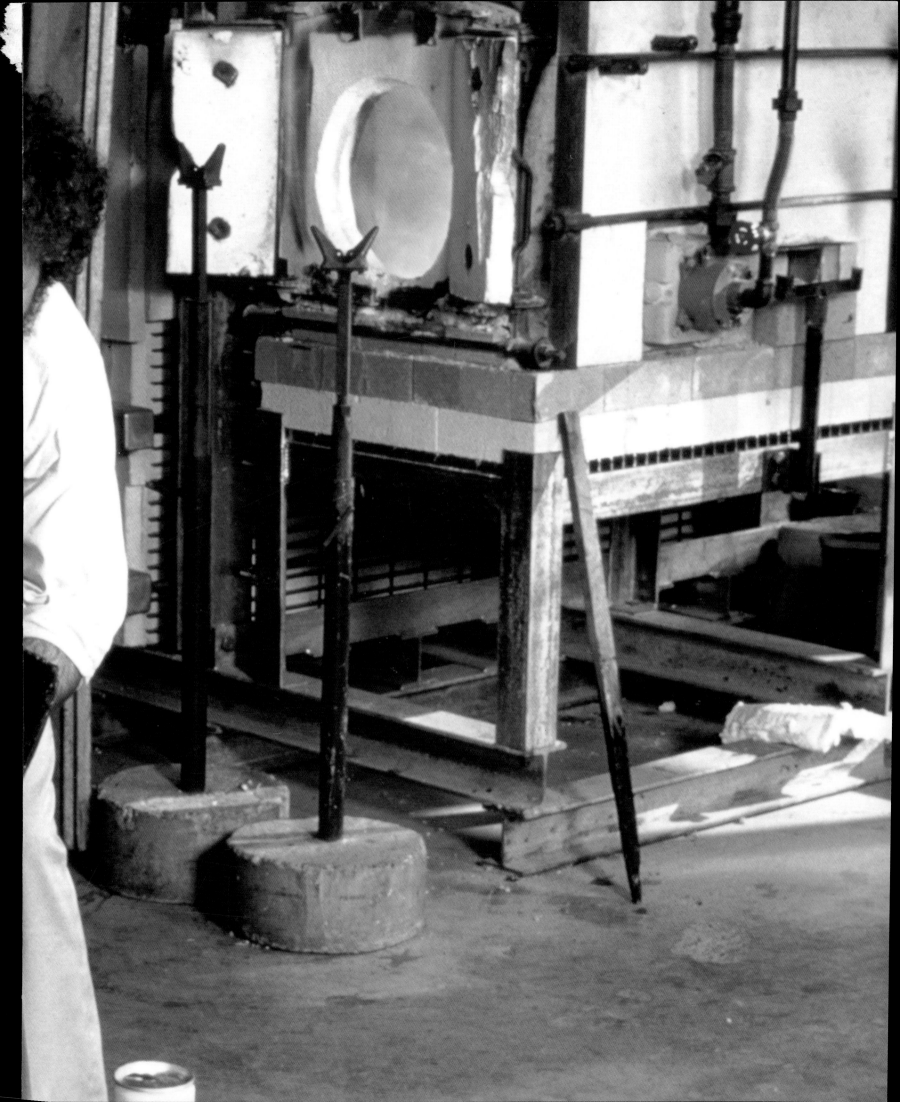

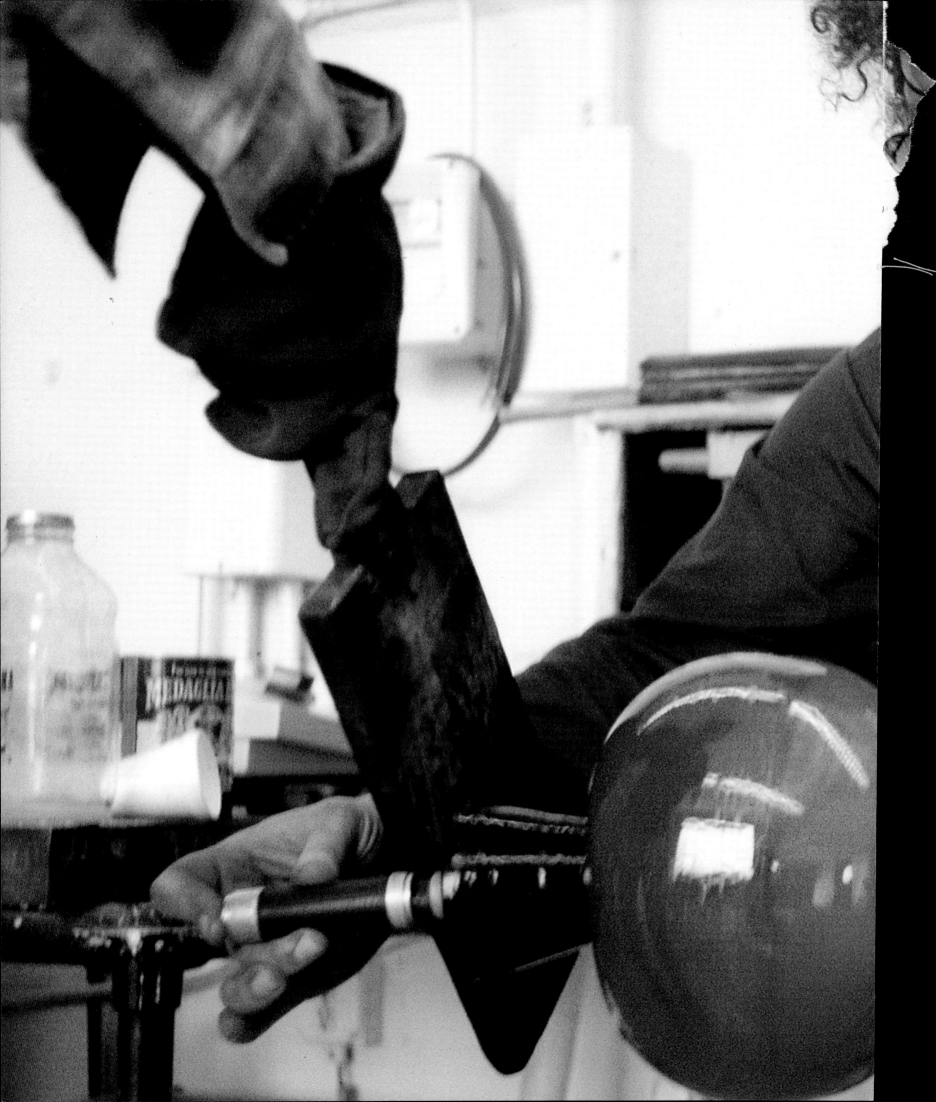

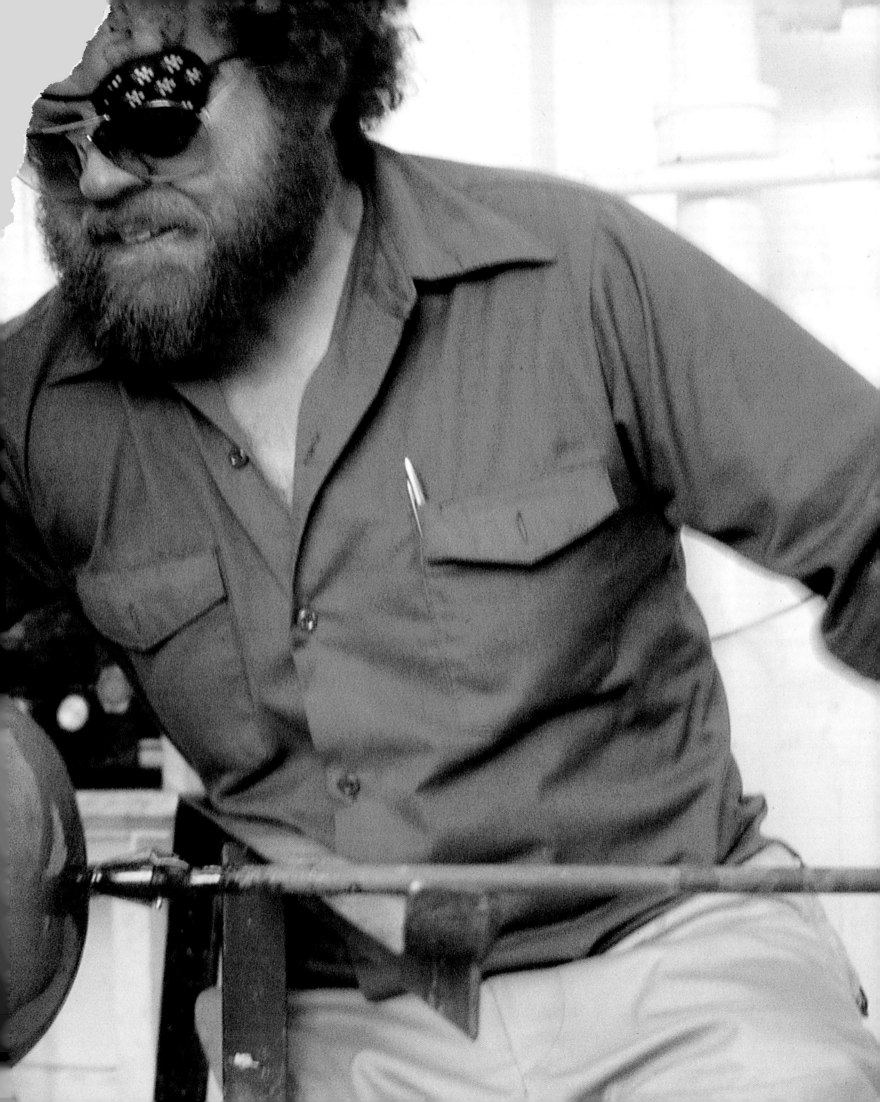

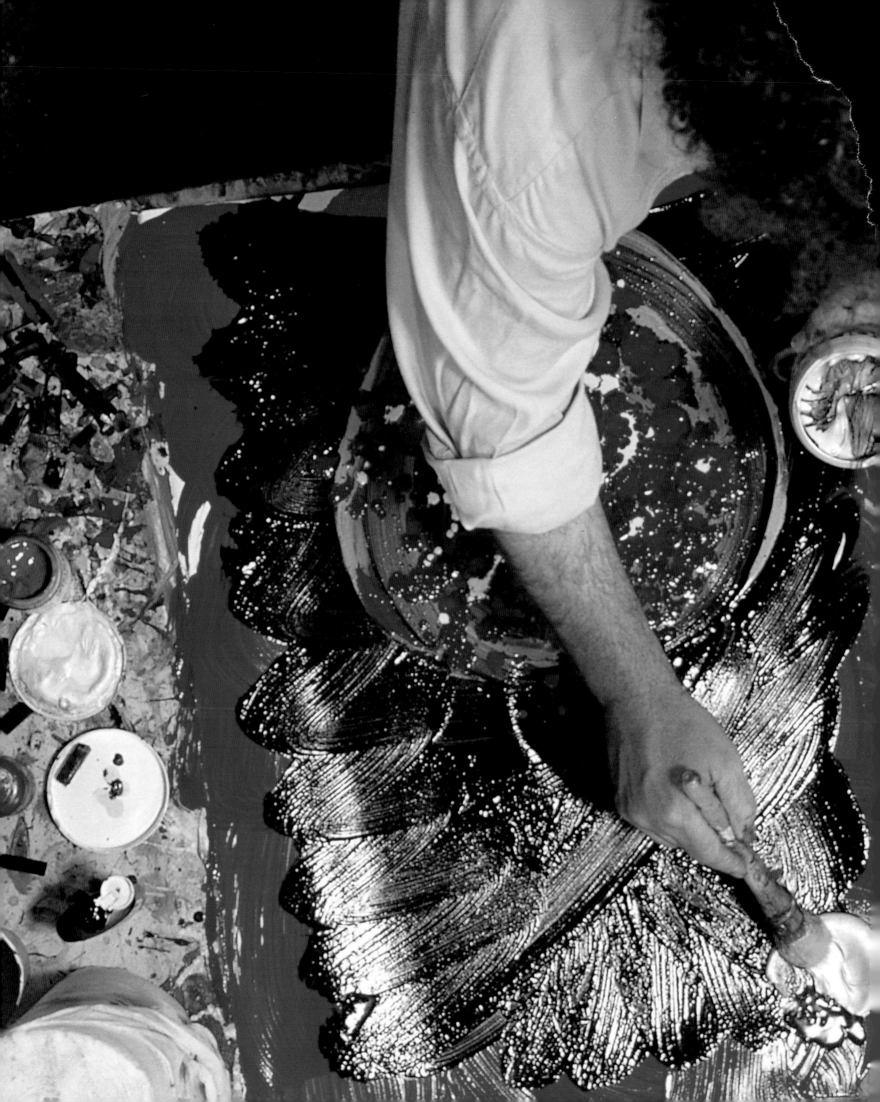

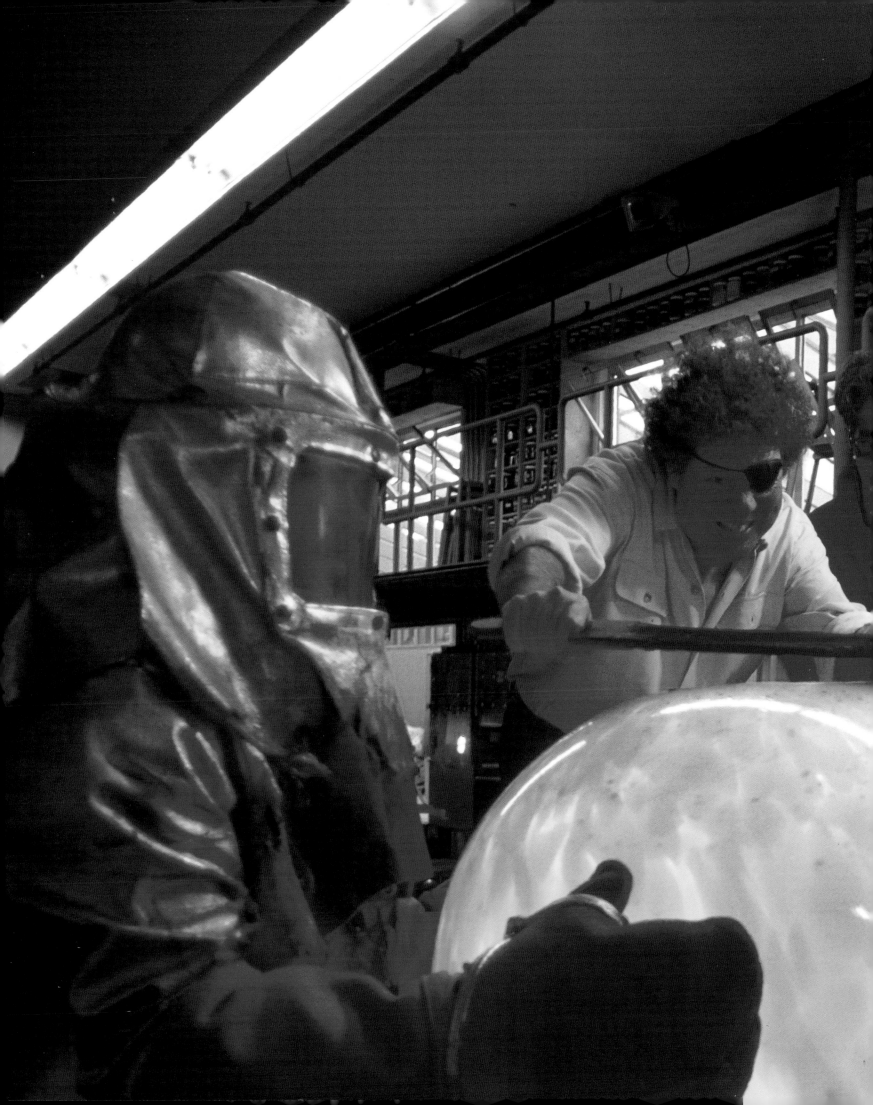

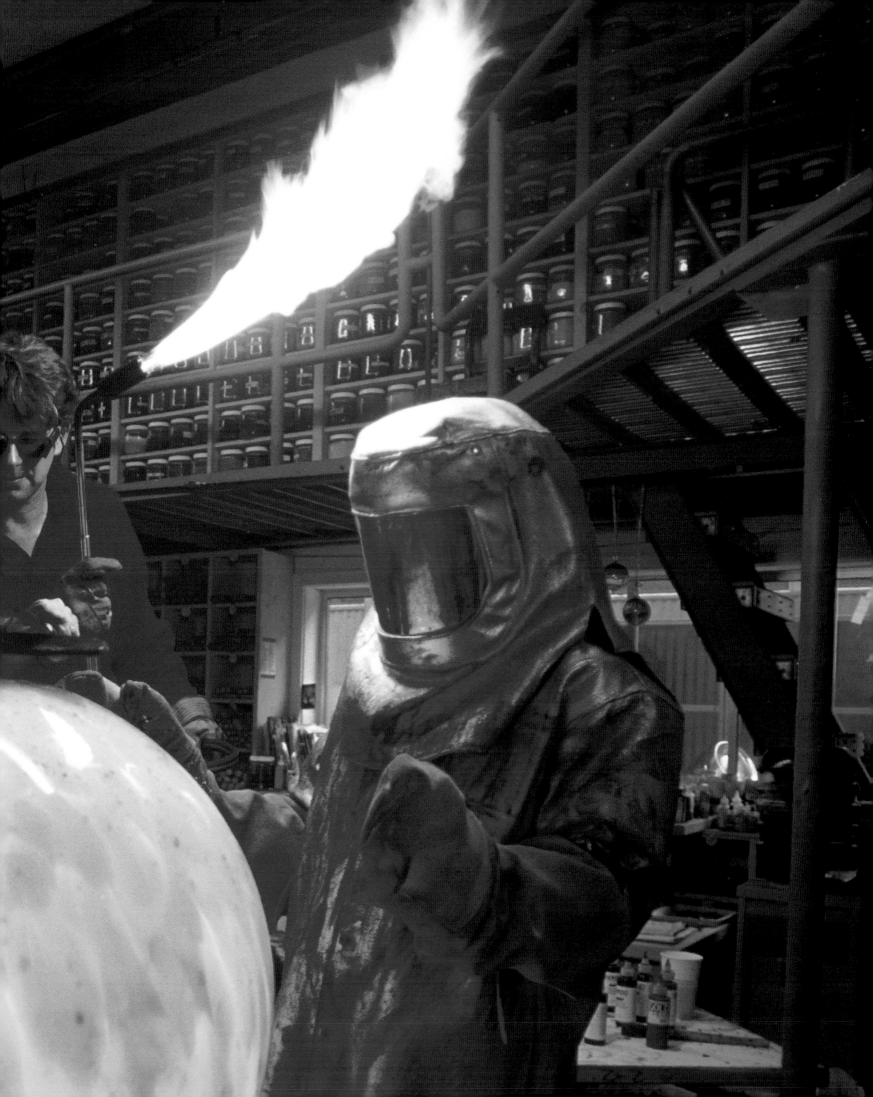

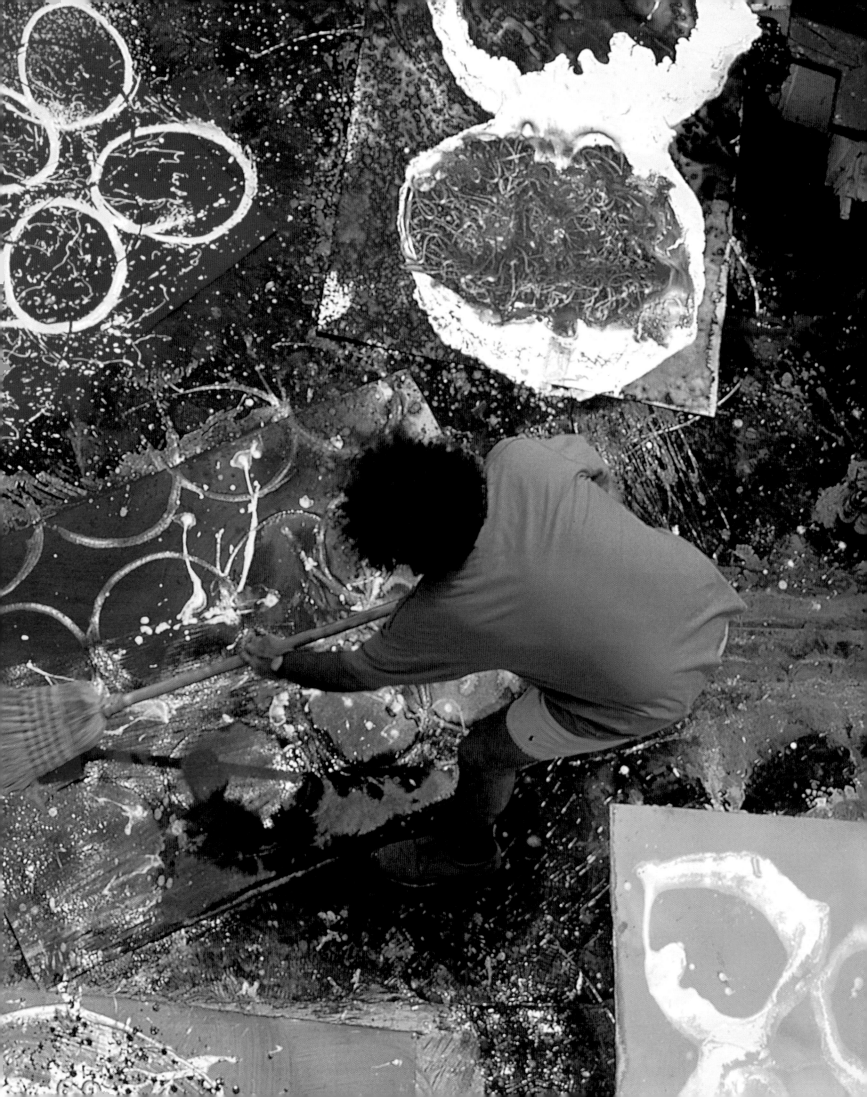

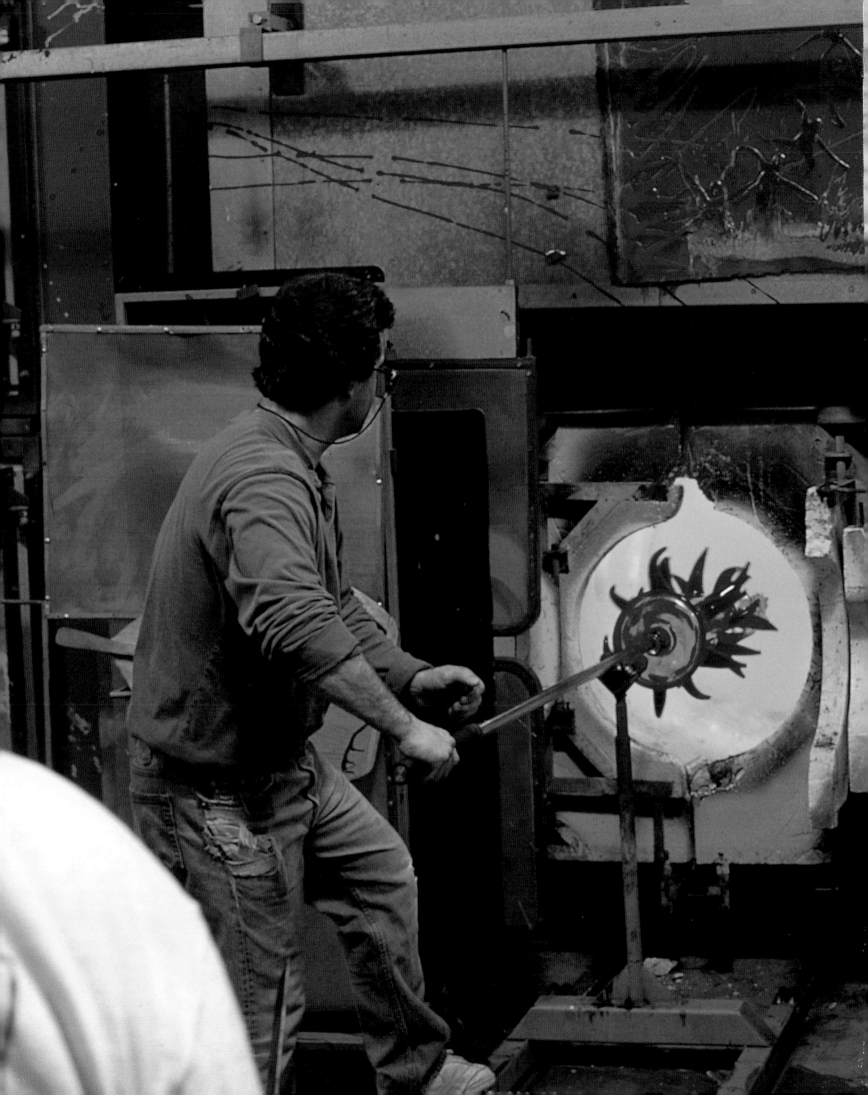

Second edition, revised and expanded
Essay by Donald Kuspit
with an Introduction by Jack Cowart
Book design by Massimo Vignelli

Harry N. Abrams, Inc., Publishers

Copyright © 1997, 1998 Dale Chihuly
First Edition, 1997, 10,000 copies.
Second Edition, 1998, 10,000 copies.
 Second Printing, 1998, 5,000 copies.
 Third Printing, 1999, 10,000 copies.
 Fourth Printing, 2001, 5,000 copies.
 Fifth Printing, 2002, 4,000 copies.

Library of Congress Cataloging-in-Publication Data

Kuspit, Donald B. (Donald Burton), 1935-
Chihuly / Donald Kuspit with an introduction by Jack Cowart.
 p. cm.
Includes bibliographical references.
ISBN 0-8109-6336-1
1. Chihuly, Dale, 1941- —Criticism and interpretation.
2. Art glass—United States—History—20th century.
I. Title.
NK5198.C43K87 1997
730'.92 – dc21 96-50018

Published in 1998 by Portland Press, Seattle
Second edition, revised and expanded
Second edition ISBN 0-8109-6373-6

Distributed by Harry N. Abrams, Incorporated, New York

Contents

This book is in memory of my father, George S. Chihuly, and my brother, George W. Chihuly

Introduction: Ecstasies of the Mind and Senses
Jack Cowart

*Nature is a temple, in which living pillars
sometimes utter a babel of words;
man traverses it through forests of symbols,
that watch him with knowing eyes.*

*Like prolonged echoes which merge far away
in an opaque, deep oneness,
as vast as darkness, as vast as light,
perfumes, colors, and sounds answer each to each.*

*There are perfumes fresh and cool as the bodies of children,
mellow as oboes, green as fields;
—and others that are perverse, rich and triumphant,*

*That have the infinite expansion of infinite things,
such as amber, musk, benjamin, and incense,
which chant the ecstasies of the mind and senses.*

Charles Baudelaire, "Correspondances,"
Les Fleurs du mal, 1857

In the vast bulk of literature on Dale Chihuly, almost every known active and interactive verb and evocative poetic adjective has been used. Further, a great deal of analytical energy has been spent trying to reconcile his effervescent behavior with our more sober need for adult comprehension. I have contributed my own share of these verbs, adjectives, exhibitions, and images over the last fifteen years, since my first visit to his seductive Pilchuck commune in the early 1980s. Yet this artist seems always to be upping the ante, continually making things more difficult, both physically and intellectually, in the studio glass movement. I am now not so sure we will be able to encompass fully maestro Chihuly as he and his high-performance teams blow, spin, shape, and daringly reinvent glass art, pushing out into ever-larger spaces with a heavy rock music backbeat. Perhaps this is the way it should be, in the perverse spirit of life's incompatibilities and things unresolvable. We have been counseled about this existential truism long ago in Baudelaire's "Correspondances" ("Correlatives"), in which he wrote, "There are perfumes fresh and cool /. . . / That have the infinite expansion of infinite things /. . . / which chant the ecstasies of the mind and senses."

This monograph offers the most complete visual outline of Chihuly's lifelong fascination with glass and his use of it to produce a wide range of dramatic visual and emotional effects. It also documents a profound acceptance of Chihuly by the general public and the artist's energetic and unabashed pushing of glass into that public domain. Supported through numerous gallery and museum exhibitions, videos, large public commissions, and art magazine and news media pieces, Chihuly emerges as a phenomenon, an extravagant artist who aggressively enhances our daily lives and surroundings. His work seems part of our modern hyperactive and vanguard extension of the beauties found in Louis Comfort Tiffany's turn-of-the-century iridescent Favrile glass for stained-glass windows, vases, and art nouveau lamps.

We may supply the adulation, attention, and communal love needed by the artist. For his part of the bargain, Chihuly meets our needs to connect with an ecumenical, gregarious, yet vulnerable creator, one who is open and risk-taking, avoiding the intricate, esoteric strategies pursued by so many contemporary artists. Chihuly's manifest joy and enthusiasm for life and the world around him offer more accessible and attractive alternatives.

Chihuly, the driven and willful American, absorbs the two-thousand-year history of blown glass and transforms it. He exploits technologies and sensitivities and upsets purists by his excess of gesture, mannerist/baroque form, enormous scale, and simultaneously industrious, combative, friendly, and promotional behavior. Even working with others in his glass factory setting has not hindered the evolution of the personal Chihuly signature "style." It is at all times gestural, expressive, overloaded, engaging, and cherished. It should also be noted that his acceptance by critics and connoisseurs is not yet unanimous. There may indeed be jealousy and resistance to his bold crossover to grandiose installations, endless variations of his impossibly lush and organic objects, public relations sense, and his eloquent and touching recombinant raiding of world cultures.

How should we approach Chihuly's phenomenal rise in the art scene? His early installations are prescient but essentially parallel to contemporary, reactionary experiments with new materials and expansive siting. His subsequent small and tidy early works don't declare the revolution. What does he give us that others haven't, can't, or won't? Donald Kuspit's essay in this book provides an engaging array of proposals. But to begin, I suggest a return to Baudelaire's poem about Nature's "correlatives" that, like Chihuly, proceed from a "forest of symbols" to "prolonged echoes" merging in "an opaque, deep oneness, as vast as darkness, as vast as light, perfumes, colors, and sounds answer each to each." Chihuly's *Glass Environments* (1967–68), *Pilchuck Pond* (1971), and, notably, his *Glass Forest* (1971) exude just such vast light, perfumes, and colors. Now, in

his more current work, profound beauties are mixed with intonations of the sinister. One cannot enjoy his opulent *Seaform* shells of color, bulbous *Chandeliers*, or exquisite extrusions and tendrils without a subliminal recollection of a floating world of stinging nettles, poisonous Portuguese men-of-war, and otherworldly underwater dangers. We know that nature's most seductive and mesmerizing colors are reserved to attract prey to its most dangerous and deadly species. Glass, especially enormous disks and stacks of nested shapes, signals fearful caution of wounding and breakage. Regardless, we are irresistibly drawn in by the effects of Chihuly's works. We are held captive by the spell of this new contradictory world where hot colors are frozen in impossibly thin fused silica reanimated by strong light and shimmering reflection. Therefore, it may be that Chihuly is simply the best at plugging into our needs, being an extravagantly extroverted introvert who brilliantly subverts glass to enter the public psyche.

Chihuly is a luminist. He uses glass as a literal and metaphorical prism through which he projects both ambient and intense theatrical light to produce sublime, luminous effects. This connects him to the long history of art in which light is cherished, "otherworldly," and implies divine presence. It is the transporting element for spirits, grace, godly presence, and ineffable mystery. From the beginning of human time we see all cultures worshiping light, a critical by-product of the life-giving sun. Later, the shimmering gold ground of medieval illuminated manuscripts and iconostases and the great Gothic rose windows fracture light into myriad animate sparkles to dazzle the eye and mind. Later still, the luminous wonder captured by J. M. W. Turner and Caspar David Friedrich, American Hudson River painters, French impressionists, and fauves have set the stage for the art of our time.

Henri Matisse may be a modern prism for viewing Chihuly's contemporary pursuit of luminous effects and beautiful organic form. Matisse found an attraction to the hot colors, sensuality, and transcendent light of the Mediterranean. He would spend

more than half of his artistic life in Nice sanctifying his art, in both secular and nonsecular ways, through infusions of spirit-giving light. His thirty-five years on the Côte d'Azur were fundamental to this path. Yet it was the artist's brief trip to Tahiti in 1930 that provided the critical shock when Matisse personally experienced the effects of nature viewed through water. There, looking first down into the clear lagoons and then up through levels of water toward the sky, Matisse discovered the spectral shimmer of new underwater worlds. He saw marine creatures with strange colors and fanciful shapes. This exoticism and newly structured crystalline world would never leave Matisse's art. Chihuly's transparent sculptural organisms recall just such an Oceania.

In both artists, theatrical commissions provided defining moments: Matisse's remarkable sets and costumes for the Ballets Russes de Monte Carlo's *Rouge et Noir* (1938) and Chihuly's for *Pelléas et Mélisande* (1993). For each artist these works enforced a unique synthesis of collaboration and the interplay between total visual effect and the role of physical form and action. Then, in the 1940s and 1950s, Matisse, severely hindered by physical ailments, developed his system of *gouaches découpées*, highly inventive color-cuttings which could be put in place by his assistants. These, like Chihuly's environments of today, were additive, endlessly expansive decorative suites of cut and colored forms, floating in worlds of light. For example, Matisse's grandest room-size cutout, the *Parakeet and the Mermaid* (1952), is ablaze with flat colored leaf, coral, fruit, and animal shapes upon a vast white ground. Chihuly's carving and shaping of light and color in his *Seaforms, Macchia, Persians, Venetians,* and *Floats* make them all seem clear sculptural offspring. Further, Matisse's famous Chapel of the Rosary in Vence is a rich artistic and spiritual jewel, where the blues, greens, and yellows of his great stained-glass windows flicker with even more colors created by their visual blending in the air and upon all the chapel's exquisite tile surfaces. As our contemporary approximations, Chihuly's environmental gestalt of sexy, colored glass and hot light propel these qualities into our

own lives and real space, whether we are in Seattle, Washington, D.C., or Venice, where visitors were most recently enthralled by his *Chandeliers*.

Finally, not unlike Matisse's severe medical problems after 1940, Chihuly's loss of the sight in his left eye in 1976 obliged him to find new ways of working, since his vision was "flattened." Chihuly moved to intermediary processes of drawing and a kind of orchestral choreography. This would allow him to objectify his art and to direct others. These others transform his two-dimensional schemes into a full visualization of the three-dimensional surround of space. The artist and workers also engage in the fourth dimension: duration. There is a literal passage of creative time and dynamic interrelationship. Chihuly's large, broadly gestural, high-color painted drawings start the process. These energetic renderings are his way of showing the glass teams, succinctly and provocatively, what he has in mind. Not mechanical blueprints, they are rough, two-dimensional versions of hoped-for three-dimensional creations. They communicate at most a need that the finished glass objects should actively diffuse, "paint," and flood areas with expansive veils of evanescent colored light.

Chihuly uses his sense of light to create abstracted expressions. He has a distinct, painterly approach. His light carves out the object and its reflection to create new kinds of space: physical, psychic, and visual. Chihuly has always been a sculptor of environmental spaces. He has made complex site-specific constructions from his earliest days, including experiments with neon and ice. He hit upon glass as a newly curious medium to carry on his interests. Chihuly perfected ways to build accumulative environments of any dimension. He broke the bounds of the conventional hand-blown glass object by creating installations in which hundreds of glass parts are spread over all the available space. Such additive, scaleless work is a characteristic of vanguard modern art, and Chihuly's aggressive use of unconventional materials has added yet another dimension and potential to its continued development.

His works seem made to delight our eyes, to dazzle with their visual effects and their evident tenuous hold on permanence. Glass inherently displays much of its creative history, recording both the improvised and calculated energies of its makers. We know that every one of these objects has been shaped by split-second decisions, with little room for error. The molten materials are quickly pulled from the furnace, inflated, spun, shaped, trimmed, manipulated, and fused onto other glass elements—and even if a work makes it through this birthing, it still might not live through the artist's selection process.

Chihuly and his workers are virtuosos. Aside from the usual meanings of virtuoso, in which great skill, bravura, ingenuity, and talent are manifest, other attributes pertain. For example, the root of virtuoso is *virtue* or *vertu*: goodness, power, and right action. By these right actions we have been freed from our inhibitions just as Chihuly has helped other artists break their own conventions to enter his world, one that runs on a parallel kinetic synesthesia reminiscent of *Fantasia*.

A keen observer, employing an unencumbered enthusiasm for the world around him, Chihuly easily converts others to his cause. His colleagues (visiting artists and resident gaffers, assistants, archivists, administrators, packers, and installers) passionately engage in the artistic mission to create a profusion of things unexpected. They all challenge their conductor-choreographer Chihuly to do his best by doing their best. Mutually inspired, the collaborative troupe engages in a remarkable and surreal display of daring skill and beauty. By pushing the limits of glass, these powerful artists embody the passion and anxiety of their medium. They are a locus of joy and wonder, in which More is More. I've never seen anyone look at a Chihuly who didn't respond, smile, and appear buoyed by the experience. Viewers and collectors alike appear to have found a place of sincere personal refuge from our sometimes joyless and threatened lives. Chihuly has reflexively seized and directed these qualities into surprisingly new and persuasive dimensions.

Delirious Glass: Dale Chihuly's Sculpture
Donald Kuspit

The act of creation at depth has to do with an unconscious memory of a harmonious internal world and the experience of its destruction; that is, the depressive position. The impulse is to recover and recreate this lost world. The means to achieve it has to do with the balance of 'ugly' elements with beautiful elements in such a way as to evoke an identification with this process in the recipient. Aesthetic experience in the recipient involves psychic work. This is what distinguishes it from pure entertainment or sensuous pleasure.

—Hanna Segal, *Dream, Phantasy and Art*, 1991

Craft and Art

It is an old bugaboo: the difference between craft and art, art's assumed superiority to craft, the craftsperson's secondary position compared to the artist's primacy. For all the craftsperson's efforts to make objects indisputable as art, whether good or bad, he or she supposedly never quite succeeds: by definition, craft is not art. The craftsperson's hands-on approach and subservience to the making of the object—indeed, obsession with the object's perfection—seem to miss art's point. By avant-garde definition, art is never unmistakably, unilaterally art; it is always divided against itself. The avant-garde revolution has taught us that "art" is as much—perhaps even more—an idea as an entity: it is never beholden to its objects, however much it exists in and through them. And the craftsperson isn't meant to have any ideas, isn't meant to understand art's insidious dialectic between object and idea, to know that neither is art by itself.

But is the craftsperson really limited by the emphasis on the object at the expense of the idea, by the naive belief (according to avant-garde standards) that a work of art is an object before it is an idea, or that it is always more object than idea—indeed, that whatever ideas went into its making disappear in its "objectivity"? Are craftspeople really incapable of ideas, and do they really believe ideas are unnecessary in the making of objects? If ideas are unnecessary to the craftsperson—if techniques rather than ideas are necessary—then the craftsperson is caught in a double bind, wanting his or her objects to be respected as art but failing to understand that art is more than its objects. Unless the objects signal that ideas are invested in them, they cannot be evaluated as art, however perfect their "objectness." Indeed, their perfection as objects may interfere with our perception of them as art—with our ability to recognize the ideas in them, unless the idea they want to communicate is simply that of perfection itself. This is why people say that craftspeople don't understand what art is about, however much the objects they make at first glance look like art.

Dale Chihuly is credited with obliterating the difference between craft and art. He "confidently bestrides" that distinction, in Henry Geldzahler's words,[1] doing for glass what Peter Voulkos has done for ceramics and Wendell Castel for wood. Chihuly himself senses this: "I don't feel like I fit into any category very well," he says, "whether it be artist, designer, or craftsman."[2] The question is what this means—what the ideas are that would make Chihuly's objects art.

I will argue that Chihuly effects an ironic reprise of the problematic relationship between craft and art—ultimately the relationship between the decorative and the expressive—in the very act of reconciling them. This makes his objects postmodern. At the same time, the sensuous surfaces of these objects have a magical ineffability, an uncanny expressivity—they realize, with special perfection, a classical avant-garde idea (and ideal) of surface. This perfection is possible only through the medium of glass. For the ineffability of, say, Chihuly's *Venetians* (begun in 1988)—which seem simultaneously refined and raw, paradoxically signaling both alpha and beta elements, to use W. R. Bion's concepts[3]—is that their surfaces are, in psychic fact, hallucinations of depth, with the implicit sensation of being underwater—Sigmund Freud's oceanic feeling. At least since Symbolism, it has been an ideal of avant-garde art to mediate such "nonobjective" sensation and feeling, to use Kasimir Malevich's characterization—or the "unnamed . . . subtler emotions" that Wassily Kandinsky discussed,[4] the less articulate, deeper emotions than those we have in everyday life—through surface and shape alone, insofar as they are immanent in the medium. Chihuly has shown that exquisitely perfected glass craft can facilitate this task to the extent of making it seem spontaneous. The result is an almost overwhelming revelation on the order of the Lacanian real, that is, a sensation-full expression of feeling that seems to transcend, even almost shatter, the language of the craft that has been used to express it.

Indeed, Chihuly's most exquisite glass gains its eloquence in no small part because it always seems about to shatter. Chihuly can stretch glass until it seems on the verge of breaking; the "ugly" crowning touch on the beauty of his objects is our heightened sensation of their fragility. The best beauty always brings with it the awareness of frailty. The price of beauty is always potential disaster, a sense of impending doom: we cannot help but recognize, however subliminally, that Chihuly's objects seem too fine to survive. It is as though a glance would destroy them, for every glance is too hard for their softness. A glance slows their motion, fast-freezes their swift fluidity.

Chihuly's best sculptures are avant-garde successes not only because their complexity bespeaks the complicated process of their making but because they remind us how fraught with the possibility of failure that process was. They are a success because of the subtle tension they maintain between the reality principle and the pleasure principle, the latter obvious, the former intimated. Chihuly's objects remind us that there is always something strange in beauty, something harsh, or, as Rainer Maria Rilke suggests, something destructive and terrorizing. (Without this quality, beauty would merely be prettiness.) They force us to awareness of the inherent strangeness or uncanniness of glass itself, of its radically contradictory properties: this is a material that seems to invite us to ignore it, to be unconscious of it—to see right through it—yet that at the same time makes us self-conscious. For the flaw of fragility, the imperfection built into the medium of glass, makes us feel as vulnerable as it is in actuality.

The consummate beauty of Chihuly's sculptures comes partly from their exploitation of this feeling. Perfection without a serious hint of perishability would be trivial. And if Chihuly's glass lacked a subliminal emphasis on the medium's capacity to self-destruct, the pleasure it afforded would be less poignant and urgent than it is. Unless a sense of the potentially imminent but perpetually postponed death of the glass object spiced the pleasure it offered, that pleasure would be sentimental rather than intense.

Part of the conceptual coup of Chihuly's glass sculptures, which seem so breakable, is that many of them already appear as fragments fused into eccentric wholes. The effect is reinforced by the variety of their colors, which makes them into chemical composites as well as material ones. Thus they are already acts of reparation, even though they would seem irreparable should they break. This combined sense of the fragmentary and the repaired makes them all the more anxious as objects. I allude to Harold Rosenberg's notion of the "anxious object," that is, "the art object [that] persists without a secure identity ('Am I a masterpiece,' it must ask itself, 'or an assemblage of junk?')."[5] (Or, one might add, am I merely decorative, nothing but an adornment intended to make the hollow space of modernity seem full and resonant?) It is the very ambiguity of Chihuly's objects that makes them art, even as it makes us uncertain as to whether they *are* art. It is not only his anxiety to make objects art that makes them art, however, but also the anxiety inherent in them—in their irregular surfaces, their generally strange shapes, and their tendency to be assemblages of fragments forming a bizarre body. Because we experience these objects as saved in the very moment that we experience them as endangered, they seem all the more ineffable and uncanny. Because they are made of the broken, they seem all the more unbreakable in spirit.

This tension restages the dialectic of permanence and perishability that haunts avant-garde art, the uncertainty as to whether the material objects of art are simply the dispensable, perishable means of conveying enduring ideas or whether it is the ideas that die and the objects that are immortal. Chihuly brings this crisis to an excruciating climax of irresolution. The absurdity of glass as a medium—its fragility—makes it well suited to the task. At the same time, glass is also peculiarly suited to expressing a sense of the ineffable. Indeed, it seems inherently ineffable—its subtlety as a medium has to do with the fact that it conveys the sense of effortless seeing-through, while also implying that what we see through it is essentialized, even while continuing to exist in an ordinary way. What is seen through glass seems to be phenomenologically reduced, as it were. We are simultaneously unconscious of glass and conscious that we see through it, and that "seeing through" seems mysteriously to change what is seen.

Glass has the power to alter consciousness. It is the original alchemic material in that the production of this seemingly mystical substance—mystical in part, no doubt, because it is "open" to light—recalls the alchemist's effort to transform *prima materia* into *ultima materia*, that is, to purify or "perfect" matter. The alchemist aimed to make the fundamental properties of matter—its "golden" qualities—self-evident, to "spiritualize" matter, as well as our consciousness of it. The glass studio may be the last place where an attitude approaching the alchemic,

with all its rituals and superstitions, survives unquestioned.[6] Here is one distinction between the glass artist and the glass craftsperson: for the artist, glass has psychic as well as material primordiality. For the craftsperson, it has only material primordiality.

If part of the conceptual brilliance of Chihuly's objects is that they put us in the position of being unable to decide whether they are craft or art, creating a Gordian knot of aesthetic consciousness, then part of their physical brilliance is that they seem to reify sensuous immediacy even as they make it ecstatically intense. The ultimate point of Chihuly's glass sculptures is to embody and convey ecstasy. At their best they are metaphors of orgasmic experience, as though they were precipitated by it. No doubt they represent nature abstractly, in an American tradition that stretches from the New England of Milton Avery to the Northwest of Morris Graves, but for Chihuly, nature is more ecstatic expression than empirical substance. One might say that in affording an abstract epiphany of nature's luminous color and unsettling tactility, Chihuly's objects signal the contradictory quality of ecstasy itself. For ecstasy, when it occurs, seems simultaneously timely and timeless, overdetermined and indeterminate, the way nature exists for all visionaries.

In its ecstatic duality, Chihuly's glass sculpture bespeaks the ultimate dialectic of art as simultaneously an abstract articulation and evocation of experience and a transcendent fixing and reification of it. His objects suggest art's sophisticated mix of inarticulateness and articulateness—its power to mediate and aestheticize inarticulate experience without rationalizing it. Chihuly not only lifts the taboo on inarticulate sensuousness—a dangerous seduction into mindless pleasure—but suggests that without the magic lamp of art to be rubbed, there would be no sensuousness of any significance, no in-depth sensuous experience. All along, perhaps, the "idea" that craft missed was the inherent sensuousness of its objects. For craft is peculiarly puritan: it prefers perfect construction to sensuous realization, perhaps naively believing that the latter will automatically follow from the former. In fact, expressive sensuousness— sensuous power—does seem like a by-product of construction, or rather of all-too-strange construction; it seems the result of a failure of perfection. Technique can no doubt tease it out, as Chihuly's objects show, but only if perfection is no longer technique's goal.

Chihuly abandons traditional craft perfection, with its ideal of the solid, well-made, well-balanced object, in favor of eccentric objects that are so much sensuous, ephemeral surface that they deny the purpose of solidity.[7] His objects are so refined that they seem completely unique sense experiences, indeed seem to reoriginate sense experience at its psychosomatic root. Yet they appear to depend heavily upon craft. This is not craft as an end in itself, however; it is not the kind of craft that embodies the clarity and precision of its methods in a carefully constructed object. (Chihuly's objects have been called "cavalier," suggesting their ironical relation to craft.[8]) Rather, this is craft as a means of evoking feelings, indeed of trying to ferment *new* feelings. This is craft as Susanne Langer writes of it: the crafts, she says, not only "furnish the materials and techniques of artistic creation"

but "have actually been the school of feeling . . . as they were the incentives to articulation and the first formulators of abstract vision."[9] In a sense, it is through sensitivity to craft—which goes beyond mastery of accepted techniques—that one becomes enough of an artist to make "the emotive symbol," to symbolize "ideas of subjective reality," to express what would otherwise be known in too unstable and "brief an intuition."[10] When Chihuly successfully stretches technique beyond what seems possible, he is looking for—trying to generate—"impossible," unnameable feelings. It is in pursuit of feeling that he pushes technique to hitherto unthought-of limits.

Without this testing of the limits of traditional craft, Chihuly would be unable to make objects that seem organic embodiments of ecstasy, that very rare feeling that seems to stretch feeling as such to the limit. Without this testing of the boundaries of traditional craft, he would not have arrived at a new aesthetic of feeling—a feeling that for all its intensity seems too elusive to symbolize.[11] Feeling is crucial for Chihuly, as the descriptions of him as a fantasist implicitly acknowledge.[12] This is, I think, most explicit in the *Venetians* (begun 1988; p. 152). Here his aesthetics are conspicuous and aggressive: the *Venetians* bristle with aesthetic uncanniness and "shudder," to use Theodor Adorno's word for the art object that affords "a kind of premonition of subjectivity, a sense of being touched by the other."[13] These works reflect less than ever the reification of making that craft embodies. Indeed, that they have been experienced as sinister, "threatening," dangerous objects moves them altogether beyond craft's expressive innocence.[14] In psychoanalytic parlance, they have become subjective objects, as Chihuly himself implicitly recognizes when he calls them "bizarre."[15]

The *Venetians* are decisive in our recognition of Chihuly as a fine artist. They have more expressive complexity than his previous works; those have a consistent feeling and tone while the *Venetians* disclose an inherent ambivalence of feeling—a tension between libido and aggression, creative love and destructive hatred, and, finally, the life wish and the death wish. This is why they are more dramatic than the earlier works. Their acceptance of ambivalence seems to suggest a greater emotional maturity; the way they stretch glass to the breaking point and incorporate that breaking point into the work—indicating an awareness of the possibility of destruction within the act of creation—shows that Chihuly has understood the emotional depth of his craft.

The Rehabilitation of the Decorative
Chihuly's most important "conceptual" contribution to contemporary art may be the rehabilitation of the decorative that he effects through his "bizarrification" and "expressifying" of decorative objects. His technical efforts and aesthetic effects lift decorative objects out of the limbo of superficiality to which avant-garde art consigned them (however much the radical art of the original avant-gardes had to do with a turn to the decorative as a release from the traditional narrative burden of painting and from traditional painting's illusion of a natural space in which narrative can unfold[16]). Most particularly, Chihuly restores the dignity of the decorative through his creation of environments— his use of glass not simply to ornament space but to transfigure it, in a total, abstract installation. The decorative, in fact, has

everything to do with environment; it is an attempt to arrive at environment's essence.

In his installations Chihuly existentializes the decorative, giving it a life of its own. It becomes active and enveloping, indeed all-encompassing, rather than the passive, take-it-or-leave-it accompaniment to life it usually is. No longer a form of decorum, the decorative in Chihuly's environments is full of Sturm-und-Drang feeling. His work's exuberance, its opulence, and its relentless love of luxury have been much commented upon, but his environments are scarcely transposed "luxury painting."[17] His sets for the Claude Debussy opera *Pelléas et Mélisande* (1993; p. 238), for example, one of his important environmental works (also realized as an installation at the Seattle Art Museum in 1992; pp. 218–19), are overt in their technical novelty, theatricality, heroic scale, and seemingly sensationalist pyrotechnics; but they are also fraught with anxious passion. (The set is all the more sensational because it uses not only glass but also multicolored translucent cloths—rolled into a forest of loose, luminous columns, for example—and other materials in a way that makes them seem as risky and inherently brilliant as glass.)

In creating what he calls "clusters" of objects, polyphonic fields of objects that move painterly all-overness, the so-called "musical" painting,[18] into three dimensions, Chihuly restores avant-garde art to its decorative roots. His sculpture can be regarded as a climactic revelation of decorative abstraction as unfettered color-music. However dynamic, even violent, this music is always subliminally serene, explicitly so when Chihuly allows the "envelope," as he calls it, to retain its integrity, as in the vase-and-bowl-like *Cylinders* (begun 1975; p. 69) and *Baskets* (begun 1977; p. 74). In a sense, the *Macchia* (begun 1981; p. 100) are unfolded envelopes, and the *Ikebana* (begun 1989; p. 179), with their fantasy flower forms, are refolded envelopes. They are the ultimate arabesques—consummate articulations of the decorative at its most authentic and dynamic. Yet Chihuly creates them without compromising the power of avant-garde art to articulate the sense of being a subject, a power that is the source of its radical expressivity.

The keys to Chihuly's work are his installations, particularly *Glass Forest* (p. 61), an installation he made with James Carpenter in 1971, and *20,000 Pounds of Ice and Neon* (pp. 58–59), another installation done with Carpenter in the same year and re-created on the occasion of his *Installations 1964–1992* exhibition at the Seattle Art Museum in 1992. Chihuly's installations, his series of objects, tell us more about his intentions than any individual work he has made; each object in them is a rootless, highly individualized "personality," but the total effect is of sublime cooperation. Chihuly creates an ideal community of uneasy individuals in easy balance with each other, as different as they are similar, but converging in common expressive cause. Brought together in a bizarre panorama, Chihuly's objects have more expressive depth than they have individually.

Not incidentally, Chihuly's "collaborations" of objects, in which the emphasis is as much on grouping and interaction as on the discrete object, bespeak the peculiarly harmonious yet dynamic collaboration of persons working together to create a piece of studio glass. It is a synergistic collaboration, fraught with the excitement of team interdependence, of which Chihuly is acutely conscious.[19] But most important, Chihuly's collaborating, clustering objects form a tainted harmony of internal objects—they recapitulate a sense of primitive, vital harmony, and its impending destruction. The ice blocks will melt; the enchanted glass forest is as morbid as it is erotic. In Chihuly's installations, the decorative is the facade of primitive expression, which it makes socially palatable.

Avant-garde art has been said to realize subjectivity as no other art before. The decorative, by contrast, seems inherently unsubjective—it seems to play on the surface of subjectivity, attending to the sensuousness of the skin, not the body's depth of feeling. All the more objective because usually anonymous, it is a matter of the enhancement of surface rather than of the depth of recognition of subjective reality, which explodes surface. In fact, decorative art is often regarded as anonymous and unoriginal—it seems a product rather than a creative expression, to allude to Phyllis Greenacre's distinction between productivity and creativity.[20] Indeed, the craftsperson is conventionally regarded as less "individual," less unique, than the artist—especially the avant-garde artist. For if decorative art is an anonymous product designed to make space more comfortable, avant-garde art is intended as a personal production that makes us uncomfortable in our subjective space, for it forces us into awareness of our own identity by confronting us with the artist's unconventional one. In a sense, avant-garde art explodes conventions of self, as well as of art. Decorative art, supposedly, confirms them.

The triumph of Chihuly's environments is that they successfully fuse the avant-garde and the decorative outlooks. They function as autonomous expressive spaces that unsettle the self, provoking self-recognition, but they also become "facilitative" in the process, in the deepest sense of that concept of D. W. Winnicott's.[21] Chihuly began his career imbuing individual pieces of decorative glass with unique expressive power, but his most important achievement is to arrange these pieces in total expressive environments that engulf and alter consciousness. Insofar as these environments relate to the healing effect of stained glass,[22] it is as though Chihuly wished—and a fantasy derives from a wish—to return to the prelapsarian time before what T. S. Eliot called the "dissociation of sensibility": the time when feeling and its ideational representation were one.[23] But stained glass was sustained by a myth of transcendence—it is a kind of transcendental environment, meant to transform and deepen consciousness. Chihuly, on the other hand, must find transcendence in the medium itself. He must make a myth of the medium itself, must mythologize glass into the ideal medium of expression. The problem haunts all avant-garde art.

Yet Chihuly convincingly manages this mythologization, through the sheer quantity of the objects in his environmental installations and through their seemingly infinite reiteration. His obsession with mythical engulfment is already evident in his first collaborations with Carpenter, where he attempts—already with the flamboyance, the sense of grand gesture, later seen as typical

of him—to reconcile the decorative and the expressive, the environmental and the authentically individual, the anonymous, standardized ornament and the unique, spontaneous gesture. (These are the symbols of the social and the creative selves, in Greenacre's language, or of the false compliant and the true bodily selves, in Winnicott's.) Decorative art is thought to lack expressive center (which is why it is described as nonhierarchical, diffuse, unfocused[24]), avant-garde art to turn the work as a whole into an expressive center (the allover painting is equally expressive everywhere; every one of its details has the same expressive density, the same concentration of expressive purpose). Yet in Chihuly's and Carpenter's installations of the early 1970s, the convergence of these two positions is already a fait accompli. In them, technique already induces a vision of feeling.

The History of the Works

As I have argued, the installations *20,000 Pounds of Ice and Neon* and *Glass Forest* are the touchstone works of Chihuly's oeuvre. The former originally consisted, in Patterson Sims's words, of an "array of U-shaped neon tubes in about sixty standing molds filled with water, with the electrodes above the tops of the molds. The strength and slight flexibility of the glass tubing kept it from breaking as the water expanded and froze into 300-pound blocks."[25] In its re-creation for Chihuly's 1992 exhibition of installations at the Seattle Art Museum, the piece comprised forty three-foot-high slabs of ice with neon tubes inside. Both the 1971 and the 1992 pieces took about ten days to melt.

In *20,000 Pounds of Ice and Neon*, Chihuly and Carpenter brought together primal elements—fire and ice—in a high-tech way, in effect raising the question of Robert Frost's poem: How will the world end? Will it freeze in ice or sizzle like neon? At a time when many artists were working in neon, eager to assimilate technology into art, Chihuly and Carpenter used it to make a brilliant conceptual poem, ironically self-contradictory. The transience of the ice obliquely alluded to the fragility of glass, indicating that Chihuly was aware of the entropic aspect of existence from the very start of his career. And the lurid, ghostly look of neon light seen through ice prefigured the moody, "smoldering" effects of Chihuly's later glass objects, which show his fascination with the effect of the passage of light through glass made partially opaque by color.

Glass Forest consisted of about a hundred stalks of opaque white milk-glass, ranging from six to nine feet tall, which rested upon the flattened residue of the molten glass balls from which they were made. (This residue was the result of pooling, since the pieces were poured from above.) Each stalk was like some weird growth of nature; the forest as a whole suggested a fantasy of ecstatic immersion in a self-expressive environment. *Glass Forest*, too, prefigured Chihuly's later environmental installations. The method of construction, for example, resembled that of the 1991 installation *Niijima Floats* (pp. 214–15), a group of twenty-four opaque balls, half black, half white, ranging from a foot to a yard or more in diameter (apparently among the largest blown-glass bubbles ever made),[26] as shown in the American Craft Museum, New York City.

20,000 Pounds of Ice and Neon is a perverse example of the conceptual dematerialization of the art object;[27] *Glass Forest* is a fully realized statement of Chihuly's sense of the contradictory character of glass as both morbid residue and libidinously expressive line. Chihuly can draw with glass—all his sculptures are expressionistic three-dimensional drawings, as his later work process makes clear[28]—or use it as blunt, implicitly aggressive material. He can maintain the lyric, organic, even flighty line of the drawing or make the glass epic, peculiarly weighty, and stable. His skill with expressive line suggests the infinite malleability of glass in the molten state, bespeaking the protean forms libido can take, indicating its inherent creativity; his sense of glass as residue suggests the "suicidal" character of the medium—it begins to "die," as it were, as soon as it leaves the fire. To truly understand Chihuly's art one must take his drawings and sculptures together, for they belong in the same frame of reference, material opposites that constitute a single conceptual environment.

As the ice blocks in *20,000 Pounds of Ice and Neon* began to melt, the previously minimalistic arrangement took on a random look. Geometry became inadvertently expressive; construction became perversely "expressionistic." This sense of metamorphosis is important, partly because it bespeaks—in reverse—glass's own change of state from molten to solid, but also because it is inseparable from, it is, natural process itself. *Glass Forest*, on the other hand, can be understood as natural metamorphosis abstractly reified (perhaps the basic motivation of virtually all Chihuly's later works). The theatricality of both installations makes clear the cosmic scale of natural metamorphosis and presents metamorphosis as an abstract truth about concrete life. Theatricality for Chihuly is not arbitrary enlargement but confirmation of universality. A vitalist, he is obsessed with energy and the forms that express it. Glass, transparently metamorphic in character and appearance, is tailor-made for him. *Glass Forest* was first installed in a black Plexiglas-and-vinyl-covered space at the Museum of Contemporary Crafts (later the American Craft Museum) in New York. It was subsequently installed in an all-white environment in the Rhode Island School of Design's Museum of Art. On opening night of this second installation, Chihuly positioned a young woman (Eva Kwong) clad entirely in white within the installation, turning it into a performance.[29] A later performance involved several women dressed in white: "From beneath the stage, the glass stalks were charged with high frequency energy which caused color modulations when the women touched them."[30]

It is not simply that Chihuly's environmental installations are literally theatrical performances—the women in *Glass Forest* were, in effect, wood nymphs, spirits of the forest—but that they have a specifically feminine connotation. Glass in its molten state is feminine, yielding; in its hardened state it is masculine, phallic. But its feminine state is primary, its masculine state derivative. In working with glass, Chihuly is struggling with his female side, which remains vividly evident in the fluid shapes his hard glass takes. The young women were projections of his femininity. I also think it no accident that the first of these performers was Asian, not only presaging his later exploration of Oriental ideas (in his *Persians*, and *Ikebana* series) but also suggesting his own sense—

half-defensive, half-celebratory—of the exotic character of the feminine from a masculine perspective. Indeed, I venture to say that his various glass spheres—"biomorphic bulbs of glass"[31]—are emblematic of female containment, and as such unconsciously show a man's profound appreciation of the redemptive powers of woman.[32]

Chihuly's preoccupation with femininity is inseparable from his preoccupation with the forest, a concern clearly related to the Northwest environment in which he grew up. The experience of being surrounded by trees in a forest, in effect lost in a forest, is "feminine"—that is, oceanic. One may consciously experience an individual tree as masculine, but a field of trees is unconsciously experienced as feminine. As early as 1971, in the *Pilchuck Pond* (p. 60) installation, Chihuly was making feminine bulbs of glass, as curved as a woman's body, harmoniously floating on water— another feminine element. These were as personal in import as the appearance of an Asian woman in the *Glass Forest* performance, for they were Chihuly's way of remembering his fascination, as a child, with Japanese blue-green floats for fishing nets. As has been remarked, the *Pilchuck Pond* globes were the precursors of the later *Floats* series (begun in 1991), but the important point is that they were feminine. The sensation of floating freely is inseparable from the oceanic experience. It also occurs when one is deep in the forest, cut off from civilization. Chihuly's installations re-create the sensation of floating on a sea, as when the globes in his *Niijima Floats* installation float on a sea of glass whose brokenness "onomatopoetically" emulates little waves, as does the residual glass on which float the stalks of *Glass Forest*. In *20,000 Pounds of Ice and Neon*, masculine ice changes into water, which floats away, leaving the phallic neon line stranded.

Whatever else his art may be about, Chihuly has clearly given a new twist to the traditional relationship of the Northwest to the Orient, and to Japan in particular. He seems to experience the East as exotic rather than alien—strange but alluring—because he understands it to possess secret wisdom about life. His glass sculptures have been described as exotic, suggesting that they distill a kind of wisdom: presumably the wisdom that comes with sensitive submission or, rather, with subtle attunement to the flow of a deceptively soft, "feminine" material. Chihuly's abandonment of the particular shape of the self in deference to the "cosmic" flow of the material, which takes whatever shape it will according to its own inner laws, *suggests* the selflessness or self-effacement that Americans tend to associate with the Orient. But his objects clearly contradict such "passivity" in the very act of exemplifying it; they are informed by the Faustian/Mephistophelean will to mastery—the stubborn determination to stamp material with the shape of the self—that is typical of the West. Thus his glass art extends the Eastern attempt to harmonize with nature, applying the accommodation of opposites with one another, even their convertibility *into* each other, to the relationship between Oriental and Western attitudes to life. The two seem incommensurate but can be artistically— "transcendentally"—reconciled.

Throughout this essay I have tried to identify the various conflicts—East and West, forest and sea, masculine and feminine,

expressive and decorative, provincial and cosmopolitan, youthful Seattle and decadent Venice,[33] the expressively unique object and the decorative field of objects—that inform Chihuly's art, making it something more than the production of precious objects. Whether the oceanic experience in which such conflicts seem to resolve in this work is simulated by a sense of immersion in the forest or the sea, or generated by the process of shaping glass artistically, or through the expressively decorative character of the calligraphic arabesque, the important point is that Chihuly's somewhat overdetermined art aims at a peculiarly indeterminate psychic effect. Personal value is rooted in the oceanic experience generated by the oceanic environment. This oceanic experience is at once a regression to and a sublimation of narcissism.[34]

Oceanic experience is necessary for psychosomatic health; to maintain him- or herself, the individual must, however irregularly, recover a sense of elementary narcissistic integrity—a sense that society is always undermining.[35] Society suppresses our sense of our own intrinsic value, telling us that we are worthwhile only insofar as we are instrumental to society—that our only consequence is our use to it. The informal structure of Chihuly's paradisiacal environments, and especially the melting look of their sensual surfaces (emblematic of the integrative fluidity of the healthy psyche), is a response to the unyieldingness of society, the totalitarianism with which it defends against pleasure and subjectivity. The narcissistic expressivity of these environments rejuvenates us by returning us to the psychophysiological state in which the reality of society, with its rules and conformities, does not matter. One of the tasks of art (a secondary task in much art, but a primary one in the best art) is to express and restore the individual's primordial sense of intrinsic value. It does this by facilitating, mediating, catalyzing, and inducing an in-depth oceanic experience, that is, a return, in spirit, to the seemingly hermetic containment of the womb (experienced as self-containment), to childlike innocence, and to an unself-conscious feeling of well-being. Such innocence and well-being, with their implication of psychosomatic health and their sense of responsive delight, radiate from Chihuly's forest-and-sea environmental installations. Morbidity is implicated in these works as well, for morbidity—unconscious awareness of the potential for destruction—is inseparable from the glassmaking process, which cannot be sophisticated without an awareness of the limits at which glass may self-destruct. Still, there is no question about the elated tone of these works, about the way they stretch the language of objects into poetry.

Chihuly's environmental installations reflect the myth of Seattle as a healthy environment, good for mind and body. Indeed Seattle, a crossroads of forest and sea, is their point of departure; they are an apotheosis of the place. What Venetian art did for Venice, elevating the city's atmosphere until it seemed sublimely concrete and ineffable, Chihuly's art does for Seattle; the painterliness and colorfulness of his sculptures are in fact closely related to those of Venetian painting, which may be a more important resource for him than American abstract expressionist painting (often a reflection of the New York tendency to "tragic" grimness[36]). Seattle is the literal as well as the expressive basis on which Chihuly articulates unconscious universals. This makes his art a highly creative compromise formation of universal

conflict, for it unconsciously takes as its model an art and an environment full of the *promesse du bonheur*, however much awareness of the vicissitudes of life they also reveal.

With *20,000 Pounds of Ice and Neon* and *Glass Forest*, Chihuly's conceptual turn to performance and environmental art became decisive and irreversible. Virtually all his subsequent works are theatrical environments, in which there is as much of what Winnicott calls "acting-in" as acting out. But Chihuly had obviously worked with glass before 1971. In 1963, he took a weaving class at the University of Washington. (It is significant that weaving is conventionally thought of as an archetypal female activity, suggesting that he was already in touch with the feminine in himself.[37]) The assignment was to loom weave with a nonfiber material; Chihuly chose glass "because it was the material most foreign to fiber."[38] From the start, then, he was interested in opposites and contradictions. And from the start he was interested in creating a field of glass, as well as in using bits of glass: "Chihuly cut flat planes of colored glass into rectangles and incorporated small, often slumped, or fused, bits into panels of open weaving and created several shimmering tapestries."[39]

While this woven-glass piece taught Chihuly "more about the fluid possibilities" of glass—as he said, weaving is a kind of elementary shaping—and about how to combine glass with other materials, the important point is that he made a kind of minimalist "painting." The weave, of course, is a universal grid. At the same time, the bright colors of the piece, its general intricacy, and its "duplicity"—its suggestion that glass be read as cloth, yet at the same time its letting us know it as unmistakably made of glass—give it a postminimalist dimension.[40] It is as though Chihuly had condensed the development from minimalism to postminimalism—which was, in fact, a rapid development—in one object. In fact, his woven glass seems to me an early, even prescient example of what I have elsewhere called expressive minimalism—postmodernist minimalism at its best. From the start, he was aware of aesthetic (dialectical) issues as well as of craft (technical) issues. He could not help but turn craft into art.

Chihuly taught himself the basics of glassblowing in Seattle in the fall of 1965, and then took up the skill seriously in the fall of 1966 when he went to the University of Wisconsin at Madison to take a graduate program in glassblowing at Harvey Littleton's seminal, innovative studio, the first of its kind in the United States.[41] It was in Wisconsin that he made his first art glass and became aware that glass could be art—that it could be a personal expression, not simply an industrial product. Chihuly's untitled early works of 1967 and 1968 already showed all the traits of his later works: they were organically referential and were arranged in installations so that their individuality served a larger, group purpose. They were also abstract from the beginning—to speak of any of Chihuly's works as glass vessels or vases is absurd—and colorful. These early works are tentative but self-consciously "art," even a little "arty." The determination to be an artist, not simply a craftsperson, is evident in Chihuly's experimentation with the medium: he blew glass around steel, used commercial neon, and set blown glass in both clear and tinted Plexiglas boxes à la Larry Bell, as has been noted. At the time, minimalism was the hot new abstract innovation; Chihuly was clearly aware of it.

In the fall of 1967 Chihuly became a teaching assistant at the Rhode Island School of Design, where he made "blown glass loaves of bread" and arranged glass in installations like "sides of meat from a butcher."[42] His father had been a butcher, which, like his later evocations of the blue-green fishnet floats he saw as a child on the beach at Tacoma, suggests the profound influence of his childhood environment on his creativity. His works seem to refer to, even function as a metaphor for, particular childhood experiences. It is significant that he first attempted the magic trick of alchemically transforming the inorganic material of glass into organic, life-symbolizing—indeed, literally life-giving—materials, here bread and meat—under the sway of unconscious identifications.

Chihuly's work with neon, as Linda Norden writes, was undertaken in order "to animate . . . glass, to move from solid, sculptural statements to more energized environments that invited human participation and response."[43] His later attempts to reconcile sculptural solidity and energized environment would use the energy of color to create an effect of quasi-solid objects. But neon was also glass-as-color, and Chihuly first achieved color by filling glass with neon. These "drawings" with neon seem to show his awareness of Keith Sonnier, another postminimalist artist who was as taken with the flexibility, the feminine softness, of neon as with its colorfulness. A further indication of Chihuly's postminimalist orientation is his use of foam rubber; indeed, his works at this time have a certain *arte povera* look.

Perhaps the most important aspect of Chihuly's determination to keep up with avant-garde innovations, however, was his precedent-setting use of the hanging environment, which he explored before Eva Hesse did. Chihuly's glass was the equivalent of Hesse's fiberglass, if less austere—in part a temperamental difference. *Glass Environment #3* and *Glass Environment #4* (both 1968; p. 56) make clear that Chihuly's concern with chance was derived not only from the problems of working with molten glass but also from the postminimalist ambition to resuscitate a "global" abstract expressivity. These works were at once seemingly arbitrary accumulations of objects and autonomous, vaguely intimidating spaces with a nonobjective expressivity of their own. In such "chance" expressivity the connotations of the material, and its use to construct a purely aesthetic space, overwhelm its denotation, indeed the very possibility of denotation: like Hesse, Chihuly seems to arrange objects narratively, or in such a way as to create the environment for a narrative, but in fact his installations, like hers, undo narrative's very possibility. They "deconstruct" narrative, through the expressive uncertainty—the effect of unnameable expressive intensity—generated by both the eccentricity of the glass shapes and the seeming randomness of the relationships established between them.

The nonobjective expressivity of postminimalism broke through the stylization of the abstract expressionism of the late 1950s and early 1960s by exploring and exploiting the expressive potential of "alternative" materials, such as molten lead, cloth— and glass. The point was to find a substance that seemed as fluid as paint but was in fact as solid as it was fluid—like glass. Where paint was indefinite, the new material had to be indefinite yet

definite as well. In embodying these contradictory states, it differentiated itself radically from paint, which looked and literally was flat by comparison. Through the use of such materials, postminimalism—and Chihuly—found a way to undo late abstract expressionism's conventionalization and reification of what Winnicott calls "spontaneous gesture and personal idea."[44] Used expressively, the materials of postminimalism became suggestive of true bodily selfness.

It can be argued that a material like glass cannot help but seem expressively urgent, even excessively so, because of its inherent perversity.[45] Because it seems always to be in process, and as such to emblematize primordial "creative flux,"[46] it appears to subvert, even to undo, the art object made of it. The object seems always to be on the verge of dissolving back into the process out of which it seems spontaneously to have precipitated. This automatically makes it expressively poignant. One is never clear what process this "process substance" is involved in—whether it is liquefying or solidifying, whether its process is regressive or progressive, as it were. Furthermore, whatever process it is in seems instantly reversible. Glass seems inherently transitional, incapable of being used "decisively." I think this incompleteness or insufficiency is what is conveyed by the general eccentricity of the artistic products that are made of it and by the particular eccentricity of their surfaces (which seems overly irritable, because of their surfeit of texture).

Eccentric abstraction is in fact perverse viscerality. But after abstract expressionist painterliness had become conformist to the point of inauthenticity, only perversity could liberate it and restore to it a sense of authentic expression. The postminimalists had to use perverse materials such as glass, neon, fiberglass, and cloth, or normally hard materials in the molten state, like lead, to regenerate expressivity. These materials, and the aesthetic use to which they were put, made the point that paint had come to an expressive dead end—that it was no longer an aesthetic frontier, was no longer good enough to convey in-depth experiences. Expressivity could be revitalized only through materials whose fluidity seemed fresher than paint's because of their different density and tactility. The quality of fluidity had to change to effect an expressivity that seemed inherent to existence and capable of mediating a deep experience of existence's sensory and affective fundament. The postminimalists' perverse new expressivity conveyed a new excitement about subjectivity, seeming freshly resonant with it.

Of all the postminimalist materials, glass—in effect, Chihuly's signature material—seems the most "perverse," because it is the most whimsically self-contradictory. Initially, Chihuly used its capriciousness—its "susceptibility" to light and color and above all the apparent unpredictability or touchiness of its behavior—to counteract minimalist and conceptualist antiexpressivity, even inexpressivity; eventually it became the source of an alternative abstract expressivity, seemingly beyond reification.

It should be noted that the perversity of glass had to do in part with the medium's implications of bisexuality. I have suggested that glass, when it is soft, can be identified as female, and when it is hard, as male. At the same time, when it is hard it is static, a trait often traditionally considered female, and when it is soft it is dynamic, supposedly a male trait. Glass also escapes conventional associations of male or female character by being emblematic, in the fluid state, of ineffable feeling—"ineffable" because feeling, as Jacques Lacan suggests, is the ultimate unspeakable reality. (However much they are twisted into volatility, words always fail feeling.) And the perversity of studio glass also seems inseparable from the fact that extraordinary technical finesse is necessary to work with it and that it is the product of a group's craft, yet, in Chihuly's case, it becomes identified as a work of art made by an individual artist.

Had Chihuly stopped with postminimalism, had he become fascinated with eccentric abstraction for its own sake, his work would have had a cranky, derivative look. But glass, not any particular style—not some aesthetic that hadn't arisen directly from the properties of glass—was his ultimate concern. To master glass further he went to Italy in 1968 on a Fulbright fellowship, gaining access to the Venini glass factory on the island of Murano in the Venice Lagoon.[47] At Venini, "individual signature styles were shunned in favor of teamwork and intense technical experimentation."[48] Yet individuality and teamwork end up as two more of the opposites Chihuly reconciles; it has been said that these were the great lessons he learned there. Chihuly never actually blew glass at Venini, though he watched the process. Instead he was assigned a design project (an equally important lesson): the Venini entry for an architectural competition in Ferrara. The plaza installation of plastic, glass, and steel was never executed, apart from one spherical element made full scale (36 inches). "Outlined with opalescent neon, the sphere was turned into a prototype lighting fixture," the only material result of Chihuly's stay on Murano.[49]

The Ferrara mock-up is Chihuly's only unequivocally geometric installation—a high-tech, purely constructivist work. Never before or since have his objects been so "Euclidean." The *Floats*, for example, which are generally circular or elliptical, are always geometrically "off," or "odd"—sometimes indented, generally misshapen. Nor are his installations as symmetrical as the Ferrara piece, however much that project disguises its symmetrical core with peripheral asymmetry. No doubt Chihuly had to submit to an architectural framework, but he had done so before, in his use of Plexiglas boxes (but then he made his own architecture), without compromising his expressivity. Chihuly lost his independence and individuality at Venini—an exercise in discipline.

He put that discipline to good use when he returned to the Rhode Island School of Design in the fall of 1969 to head the new glass program. At the same time, he quickly recovered his expressive freedom. His new sense of architectural structure is explicit in *Homage to Bob Reed* (1971), a construction of neon tubes, reminiscent of Dan Flavin's work and of serial art in general. More interesting for the future are *Neon Experiment #17* and *Uranium Neon Installation* (both 1971), both in collaboration with Carpenter and both using glass, neon, and argon. These works, more images than pure abstractions, reflect Carpenter's interest in flower and seedpod shapes; meant to be a part of an architectural installation, they function as spatial ornaments, if

if not in the strictest sense.[50] They are ostensibly explorations of "the characteristics of luminosity, reflection, and transparency," but they are really linear extravaganzas, wildly expressive exercises in stretching and twisting a line until it becomes indescribable, and so all the more expressive.[51] Their allusions to nature, if not entirely nominal, are not of their essence. Giant abstract expressionist gestures, prolonged, by glass hook or neon crook, as much as possible, they are the first works in which Chihuly shows his capacity to create singular tours de force, to extend glass seemingly ad infinitum without losing a sense of its fluidity—indeed, making it seem to flow more freely than it actually does. These works are Chihuly's first genuinely imaginative glass creations—the first works in which he extends glass "fantastically." They seem like fantasy environments in themselves, as well as uniquely expressive objects.

The momentum of these liberated pieces extends throughout the works Chihuly created with Carpenter at the Haystack Mountain School of Crafts on Deer Isle, Maine, where he spent time during the summer in the early 1970s.[52] In the summer of 1970, for example, they produced a series of red and brown pieces (pp. 54–55), globules and baroque stemlike flourishes of glass, in which the swirl of the earlier installations became more suave and systematic, if that word can be used. Chihuly had gained seemingly complete control of his gesture, refining it at will without destroying his spontaneity. His objects had come to possess inner necessity; they were no longer simply ingenious but were now purposive as well. Chihuly's objects of the early 1970s seem the quintessence of the purposive purposelessness that Immanuel Kant thought was the core of art. They had become serious play. Apparently, he arranged them in a meadow and on Deer Isle's lichen-covered rocks, as if to suggest that they were outgrowths of the natural landscape, if a little more conspicuously picturesque. Here we see Chihuly's tendency to blur the boundary between the artificial and the natural, paralleling his tendency to blur the difference between man-made architecture and natural environment. I think he also wanted to blur the difference between glass and neon, yet another parallel conceptual ambition and an ecstatic one—worthy of the Haystack pieces, which are his first genuinely ecstatic, subjective objects.

The climax of what began at Haystack was the elaborate series of arcs, in glass, neon, and argon, that Chihuly and Carpenter exhibited in Ohio at the third Toledo Glass National in 1970, and the 1971 installation they showed at the 1st National Invitational Hand Blown Glass Exhibition, at the Tacoma Art Museum. The Toledo works were given eloquent Latin plant names (supplied by Carpenter): *Orchis Pubescence, Monotropa Uniflora, Physalia Deluxeus, Medusa Superioris.* The Tacoma piece was more colloquially titled *All the Way Out to East Cupcake.* The two kinds of titles reflect the extremes that Chihuly's objects have come to reflect: on the one hand, they seem desire incarnate; on the other, mischievous showmanship with perhaps a touch of kitsch, somewhere between Rube Goldberg and Barnum and Bailey.[53] The exotic lushness, even the luridness—certainly the deliciousness—of the Toledo pieces contrasts sharply with the technical contrast (perhaps a bit too blatant) between the blown-glass bulb and the neon swirl in *All the Way Out to East Cupcake,* which is all the more perversely exhibitionistic by reason of its

coffinlike case: on the one hand, a delectable sign of life; on the other, the corpse of technique (which is what finished glass can be said to be). Chihuly was inspired by both. Is the latter symbolic of his own puritan response to his own passion—his most basic conflict, and his most ingeniously disguised (repressed) one? In both works, Chihuly is into aesthetically startling effects, but in the one case he is rapturously biophiliac, in the other morbidly necrophiliac. And in both, the aesthetic is supported by an irresistible exhibitionism.

After *20,000 Pounds of Ice and Neon* and *Glass Forest* there was no stopping Chihuly, or, rather, all the stops were out: he worked on every imaginable front, from neon to stained glass, from conceptual environments combining minimalist and ecological concerns (in a way that recalls Robert Smithson) to painterly, gestural environments that are at once vitalistic and glamorous. Glass in all its forms—and phases—became a grand obsession.

Nowhere was this more evident than in *Dry Ice, Bent Glass and Neon* (1972), a collaborative sculpture with Carpenter. The work was at once a homage to the Crystal Palace—built in London for the great exposition of 1851, destroyed by fire in 1936—and a minimalist/postminimalist "deconstruction" of it, revealing its basic form and its history simultaneously. For the structure of the piece followed the elevation of the Crystal Palace—a breakthrough work in glass and arguably the most innovative, most protomodernist architecture (and sculpture) of the nineteenth century—but was built of blocks of dry ice, which, in melting, emulated the palace's "meltdown." The smoke made by the rapidly melting ice reinforced the allusion, making it and the installation's performative character unmistakable. The Crystal Palace was in effect the model for Chihuly's early installation sculpture, which was constructivist in all but name.

Dry Ice, Bent Glass and Neon shows Chihuly's awareness of history, but also his profound sense of form—the kind of original relationship to form that invokes an epiphanic recognition of precisely its ahistoricity, its inevitability. Chihuly sees through the worldly use of a form to its ahistorical primordiality, in effect acknowledging it as a kind of fate or limit that cannot be transcended: a condition that paradoxically gives it all the more historical consequence. History is evident in the melting of the dry ice, both history and ahistory are evident in the "classical" simplicity—the "reduced" character—of the piece as a whole, and a history in all its originality exists in the various planes and curves (basic forms) of the glass, as well in the glass itself, a basic material.

In a sense, a lot of avant-garde art is aimed at "reducing" worldly representations to the abstract forms that are fundamental to them, making the inherent expressivity and autonomy of these forms unequivocally manifest, to the extent of regarding them as aesthetic ends and psychomoral expressions in themselves. Traditional art, by contrast, integrates these seemingly asocial forms in a "representation" that is meant to be more expressively powerful, "organic," and generally communicative than they are by themselves, however much such art makes use, both conscious and unconscious, of their obscure expressive potential. In postmodern art, incommensurate styles, both representational

and fundamentalist (abstract), are forced together to absurd effect. But they converge superficially rather than integrating organically, suggesting that they exist in paradoxical, disintegrative relationship. With nihilistic irony, each confirms the irrelevance of the others, implying the disintegration of all. Each in effect cancels the others out or implies that none had a point to begin with.

Dry Ice, Bent Glass and Neon seems simultaneously avant-garde, traditional, and postmodern—at once analytic, integrative, and a disintegrative theater of the absurd. It heroically articulates basic structure and autonomous form; it combines abstract forms in a representation of a structure that, by deanthropomorphizing architecture, was perhaps the first to make the abstractness of architecture explicit; and it ironically, and ultimately absurdly, joins ice and glass—superficially compatible by reason of their similarity, but fundamentally incommensurate in that ice melts, disappearing, while glass endures, even when it melts. Nihilistically juxtaposed, the two media symbolize the nihilism, the futility, of history, for they represent a building that was once daringly avant-garde but that quickly became a cliché, a model for the future, the start of a tradition. Not even lasting a century, the Crystal Palace shows how rapid the deterioration of meaning is. Chihuly's nihilistically ironic representation of this building as an avant-garde conceptual performance is in expressive fact about the ruin of art—its figurative as well as literal destruction and eventual irrelevance.[54] His attitude, which seems to be rejuvenating but in fact confirms decadence, is quintessentially postmodern: it suggests that art is always destroyed by society, its meaning is always trivialized by time, but also that its hermeticism is ultimately suicidal.

At the same time, it must be emphasized that *Dry Ice, Bent Glass and Neon* is not only a postmodernistic recapitulation of the Crystal Palace's ironic history but a modernist epitomization of the building's critical significance, for society as well as for architecture and art in general. The Crystal Palace was socially as well as structurally and materially revolutionary, for while on the one hand it was a kind of successful delusion of grandeur, testifying to bourgeois success, on the other its means suggested, perversely, that the structure of bourgeois life is less solid than it looks. On the one hand, the glass showed bourgeois success to advantage, displaying its industrial strength and commercial creativity, laid out in the great exposition, in brilliant daylight; on the other hand, if one could see through glass, one could see through bourgeois life, and if people who live in glass houses should not throw stones, the bourgeois class should not imagine it is invulnerable. As a glass house, the Crystal Palace subverted the success it embodied. It was an ambiguous symbol: its materials suggested the precariousness, the flimsiness, of the whole bourgeois enterprise, implying that this was an illusion that could be destroyed by a critical look—thrown like a stone. *Dry Ice, Bent Glass and Neon* was hardly nostalgic, for in calling attention to the ironies of the Crystal Palace's dialectical structure, Chihuly suggested its hidden critical meaning, just as, in articulating its disintegration, he signaled its crucial importance as the first truly modern work of glass art.

In Search of Excess: Saturating Sight

Rondel Door (1972) and *Cast Glass Door* (1972) are the first works in which Chihuly abandons his more explicit suggestions of disintegration to create an effect of unequivocal, inexhaustible sensuality, all the more complex because it integrates contradictory emotions. (The Haystack works and *Glass Forest*, while extraordinarily sensual, are also like the last efflorescence of a flower before death.) The doors, I think, have to be regarded as opposite sides of the same expressive coin, suggesting the extraordinary ease with which Chihuly moves between the extremes of the emotional spectrum and implying that his creativity exists to heal a split fundamental to the psyche. *Rondel Door* is manically bright, each of its four round panels, with their different-colored spiraling pinwheel patterns of glass, like a relentless, blinding sun. *Cast Glass Door*, a door of glass parallelograms arranged in even diagonals, the whole in tonalities of blue, is overcast and subliminally depressive, as though all light were slowly but surely in the process of being extinguished, perhaps forever. In a sense, the former work is a play on the pontil ("bull's-eye") of bull's-eye glass, the latter on the modernist grid. Whether the expressivity is positively or negatively charged, it evokes a primary sensuality.

The doors are a sharp change from the slightly earlier, experimental, pop art–like *Case of Beer* (1971), with its stacked commercial neon signs inside a found crate. They remain experimental—Chihuly is invincibly exploratory, indefatigably curious—but show him moving from the public to the private, intimate realm, although still making works that are highly social. With the doors, Chihuly no longer invents his own nonconformist architecture but accepts and conforms to existing architecture. This was a major change for him—an unusual humbleness—but it gave him the liberty not only to be uncompromisingly decorative but to make an avant-garde, nonconformist decorative art.

To make decorative art at its traditional best means to make a fixed, rigid structure seem more fluid and vital by making it sensually exciting, even voluptuous—to cover bare architectural bones with sensual flesh. It is to bring what seems dead to extravagantly expressive and erotic life. Chihuly certainly accomplished this in the doors, but at the same time he radicalized the decorative so that it seemed no longer a secondary feature of the structure but a primary one. It seemed to take the environment over and transform it—finally to become an environment itself. The doors are avant-garde works: relief sculptures, abstract paintings, and total environments at once. As such, they transcend both their architectural function and the usual definition of the decorative.

Clearly extroverted, if not as blatantly as many of Chihuly's earlier works, the doors also have what can only be called an introspective dimension. This doubleness, I have suggested, is characteristic of Chihuly's later decorative works. They have an unmistakable social presence but are at the same time mysteriously evocative, for their resonant colors and amorphic shapes induce an intricate, unfathomable mood. They also continue Chihuly's mixed-media mode: these are assemblages of blown, cast, and mosaic glass, with elements of text—an overt avant-garde touch—and surface drawing. *Rondel Door* has a

stained-glass look, in that the four blown rondels are set with beveled plate glass in a cloisonnélike lead-came matrix or framework. The work is ostensibly a homage to art nouveau and to the so-called high-impact design of the 1960s, but it is more useful to understand it in abstract, even modernist terms. This is a work that eschews representation in the very act of representing, resulting in an effect of subliminally ironic purity. At the same time, the purely abstract result bespeaks Chihuly's irrepressible joie de vivre.

Thus the vertiginous swirl of the rondel design—implicitly that of a flower in full bloom—reiterates its circular shape ad infinitum. In the way the swirls converge or bunch their centers, or rather their off-centers, the rondels have an op art look; it is as though the intensity and pressure of the spiraling pushed the centers out of place. One has the illusion of descending into a whirlpool, though not in the Edgar Allan Poe sense, in which the whirlpool is a symbol of going mad. The "offness"—the perverse, unexpected asymmetry—of the circles makes them eccentric and dangerously seductive, because it makes them seem erotic, a kind of orgasmic expression. The effect is all the more vivid and exciting given the regularity of the four rondels and the stylized leaves that flank them like wings, making them explicitly emblematic, if not angelic.

Complementing all this are the emphatic edges of the black lead carries, which contrast sharply with the colors' dynamic, almost psychedelic swirl. The thin lead lines within the leaves, which are as white as the pure light they let through—it seems all the purer in contrast to the colored light of the rondels—and the thick black lines of the framework firmly maintain the planar surface of the glass, making the sense of breaking through it created by the rondels seem all the more violent a shock.

For all these devilish dynamics, what is especially important about the doors is the new sense of composure, even decorum, they bring to Chihuly's work. The frameworks impose an order. It is stronger, if no more conspicuous, in *Cast Glass Door*, in which the stark black framework, this time of steel, calls attention to itself by cutting diagonally across the field of glass, dividing it eccentrically. The field is less aggressively divided into thin vertical stripes, their repetitiveness reflecting that of the heavier, more disruptive black diagonals. The two kinds of division are in unresolved, tense relationship with each other.

Rhythmic repetition, a major strategy of musical decorative abstraction at least since Paul Gauguin, is a basic structuring feature of both doors. Chihuly has masterfully integrated—finessed—the seriality of minimalism and the repetitiveness of decoration but without the monotony and one-dimensionality, or the sense of banal redundancy, for which both are infamous. Indeed, the clashing diagonals and verticals of *Cast Glass Door*, as well as the slant-shaped strata in which more weirdly shaped elements seem sedimented—they are somewhere between poetic microorganisms and geometric mutations—throw us off, creating the effect quintessential to Chihuly's decorative radicality.[55]

This effect is inseparable from what I call Chihuly's "vertigo principle," which I find most evident in, and in fact basic to,

his most famous decorative sculptures—the *Pilchuck Baskets* (begun 1977), *Seaforms* (begun 1980; p. 92), *Macchia* (begun 1981), *Persians* (begun 1986; p. 102), *Venetians* (begun 1988), *Ikebana* (begun 1989), *Niijima Floats* (begun 1991), and *Chandeliers* series (begun 1992; p. 227). In all these works he aims at an effect of delirious vertigo. The works create a hallucinatory effect of synesthesia, as though to gratify sight, and through sight all the senses, to a rapturous point of saturation. And Chihuly's installations of these objects orchestrate colors in ingeniously rhythmic arrangements that are as expressively engulfing as music. They are fresh realizations of Kandinsky's notion of improvised musical composition.

The delicious, dreamy dizziness of these works arises from their colored swirls of glass—swirls made of ripples. Many of the sculptures are three-dimensional swirls, embodied swirls, though they also use two-dimensional or surface swirls like those in *Rondel Door*. Indeed, the simultaneity of two-dimensional and three-dimensional swirling is ultimately what makes these works so hypnotically and emotionally absorbing.

The swirl is the secret of Chihuly's expressivity. In *Rondel Door*, it is an exciting, two-dimensional decorative device; the ripples remain concentrated in a circle, for all the absurdity of a circle with an off-center heart. By contrast, in many of the individual pieces in the installation *Rose Madder and Green Persian Shelf* (1988), for example, the swirl's ripples expand until it seems impossible for them to return to any center. They not only cancel the centers of these unevenly shaped and folded disks of luminously colored glass but seem to set the forms themselves in disintegrative process so that they too swirl absurdly. Indeed, the *Persians* don't hold together at their perimeters, which are wavy, frilled, unpredictable. Each object seems infinitely expandable, as though it were a shell that could grow with the organism it once enclosed or a flower that could spread its petals infinitely. Each object entirely loses the unity and self-containment that the rondels signaled by their circularity, in defiance of their disturbing swirling.

The disintegrative potential of the decentering in *Rondel Door* has been realized in the later series: these shell-like forms are shells of life, the residue of growth. What was a paradoxical subversion of formal unity in *Rondel Door* becomes a complete—radical—informality in the shells. There is no longer any pretense to unity here, however ironically unified the objects may seem. What was a perceptual matter in *Rondel Door* has become both perceptual and conceptual in *Rose Madder and Green Persian Shelf.* Individual objects within the installation—which is the real work of art—may have a superficial unity by reason of their repetitive surface ripples (sometimes zigzag in character) or because they look like self-contained vessels, but the effect is seriously undermined not only by their intense colorism, and the light passing through and illuminating them, but by the fact that *they* are simply details in an amorphic whole. This is why Chihuly's decorative masterpieces have been described as flamboyant and enigmatic: they are inherently absurd, not simply irregular, or ironically eccentric, but radically incoherent.

In *Rose Madder and Green Persian Shelf*, as in many other decorative works of the 1980s, Chihuly has created phantom organisms (ghosts of life) and phantom vessels (ghosts of use). The installation is also a colony of creatures analogous to the glassmaking collective that created the individual objects. But the main point is that just as each object is a delirious swirl, the installation as a whole is a swirling delirium of objects that overwhelm vision and, by implication, all the senses.

The site-specific installations *Mitla* (1973), *Glass Pour* (1974), and the various works done at Artpark in Lewiston, New York, in 1975 (p. 62) ostensibly had little if anything in common with the radically decorative objects and installations of the 1980s and 1990s. Yet they had their own kind of decorative intensity. Above all, they continued Chihuly's effort to radicalize the decorative, here by removing it from the domestic interior—from the architectural situation in general—to the landscape. Implicitly homages to Robert Smithson,[56] these works were not only absurd in themselves—as absurdly centerless as the later works, though not through the use of dizzying swirls—but absurdly sited outdoors. And although they were alienated from their environments, they formed no hermetic alternatives to them, as Chihuly's installations usually do. Each ingeniously reflected its setting but remained isolated in it.

The monumental *Mitla* makes this particularly clear: this pyramidlike construction of glued-together sheets of plate glass was inspired by an archaeological site near Oaxaca, Mexico, but was built in a very different site—a glassworks near Philadelphia. *Glass Pour*, in which molten glass was simply poured onto the ground at an improvised glassworks outside Santa Fe, took the amorphous, irregular shape of the earth's surface. The transparent colored-glass panes of the Artpark installations, collaborations with Seaver Leslie, glamorized nature almost as much as any Hollywood color lens (and with more wit). Yet balanced on rock ledges in this park near Niagara Falls, or set in the shadows of the river, or made into windowlike grids positioned in both indoor and outdoor spaces, the panes combined a decorative cleverness—an ironically decorative relationship to nature—with a sense of being abandoned in the wilds. Token gestures of reconciliation with nature, they ultimately suggested the impossibility of reconciliation. The glass became a looking glass that seemed to reflect the world directly, but in fact placed it at an infinite, alien distance. The works made the world seem uncanny, as though it had turned itself inside out yet still looked the same.

Chihuly was working with an environment quite different from that of Seattle, let alone of Venice. Artpark is situated on the Niagara Gorge. Like Chihuly's two adopted cities, it has an inexhaustible abundance of water, but the site is undomesticated—not integrated into a human setting. It is a more alien environment than Seattle; like the glass of *Mitla*, which took off from a pre-Columbian necropolis, glass installed here reflects nature's deadliness. Chihuly had left the apparently benign nature of Seattle and Venice to strike out in the wilderness.

But something more was at stake. The Artpark works seemed existentially alienated beneath what one might call their decorative demonstrativeness, because Chihuly was in creative transition when he made them. They were a last gasp of pure avant-gardism, as opposed to the communally purposive avant-gardism that preceded and followed them. What is important about these mid-1970s installations is that they are chronologically framed by the 1972 *Rondel Door* and the 1980 windows that Chihuly made for the Shaare Emeth Synagogue in St. Louis (p. 86).[57] Compared to these communal works, more conservative in both their sense of the decorative and their relationship to space, the Artpark works reflected an old avant-garde sense of isolation—of working alone in a vacuum, against the social odds. The Artpark grids in particular bespoke Chihuly's dilemma, for they were windows in all but name yet stood absurdly isolated in raw nature. It is as though Chihuly was uncertain whether he wanted to use them in a building or not—to stay outdoors or to come inside. I regard these works, and especially *Mitla*, as symbols of loneliness and abandonment, no doubt in part owing to Chihuly's sense of being out on a creative limb, which might have broken at any moment. He defended against this feeling with a reaction of defensive self-ostracism, as though anticipating failure and rejection. However rare such feelings are in Chihuly's oeuvre, they are not unrelated to his indifference to the fate of his objects, that is, his acceptance of their death by breaking. Are his installations visionary necropolises? They are made of "dead" glass—glass that is no longer molten, that is a kind of skeleton of its former fluidity, and, when he represents shells, that is like a tomb, doubly dead. (In general, his pieces are a kind of sublime waxworks.) In any case, the Artpark works struck an existential note of dread: because of their uncertain footing in the wilderness, they amounted to a creative cry for help in finding a direction out of it.

Since the early 1980s Chihuly's art has become quite surefooted in the world. This is not simply because he has grown economically successful, is celebrated as a pioneer of the studio glass movement—a legend in his lifetime—and has received numerous institutional and corporate commissions as his reward.[58] It has more to do with his aesthetic ability to reconcile his glass mysticism with a worldly view of the decorative as atmospheric background music to life, facilely affording a superficial sense of well-being. In the 1980s and 1990s Chihuly has taught himself to tread the fine line between creating charming, lovely-to-look-at sculptural backgrounds and autonomous avant-garde environments that lure one, irresistibly, into their expressive mystery. *Rainbow Room Frieze* (1988; p. 144) is a major testimony to this, and an important new point of departure.[59] It is a compromise formation, in which Chihuly strikes a judicious balance between the avant-garde and the conservative. The frieze comprises an arrangement of blown-glass sculptures—again, dish- or shell-like, roughly circular folded and molded forms—set in a dining room of the Rainbow Room, a nightclub and restaurant high in New York City's Rockefeller Center. As an autonomous installation, an aesthetically independent expression that exists in its own expressive right and has its own indispensable spirit, it eloquently realizes Chihuly's wish to radicalize decoration by removing it from the realm of applied art. But it also submits to social reality—to the

conventional understanding of decoration as art applied to and dependent on an environment and, thus, that environment's dispensable, superficial expression. Often, the decorative seems to be applied to an environment from the outside, so as to create a faux inside that ironically reflects the decoration's own exteriority and extraneousness. It becomes autonomous when this is no longer true. The decorative must embody irreducible insideness, a sense of itself as hermetically expressive—not simply innate to an environment but an expressive environment in itself. Chihuly achieves this by intensifying abstract decorative surface until it seems no longer like surface but like a spontaneous revelation, a sudden bursting forth of depth—that is, until it dialectically reverses itself. Rather than "sensationalizing" the environment until it seems gratuitously overdetermined, he makes the abstract decorative the epitome of the self-expressive, that is, the fluid expression of a feeling of immanent selfness.

At first glance, the glass objects of the 1980s and 1990s seem conventionally charismatic and histrionic, but they are so intense and rhapsodic that they force us to take a second, more reflective look. In fact, they are radically sensual—they have an uncanny, orgasmic fusion of libido and aggression that seduces us into the emotional depths. Chihuly's objects and installations are not as pleasant, as simply hedonistic, as has sometimes been suggested and as the decorative is supposed to be. If they were naively libidinous—if they were without aggression—they would be easy to relegate to the background. But their uncanny, "duplicitous" shapes, surfaces, and colors are hypnotic.

Because Chihuly's objects are so uncanny, we cannot take or leave them as we ordinarily can decorative objects. We are possessed by them, and they become objective correlatives of what is most subjective in us, indeed, of the fundament of our subjectivity. Chihuly accomplishes the shift from craft to art when his conscious intention to produce a technically perfect object is overtaken by his unconscious intention to create a transference object. It is their radical subjectivity that makes his objects not simply bourgeois artifacts but avant-garde ones—unexpectedly disruptive and disturbing, rather than a kind of bourgeois jewelry that knows its place in the living room.[60] Chihuly's sensually reckless objects always seem to be squirming out of their place. Their sensuality breaks through our defensive crust, forcing us to face the deepest emotional truth about existence—that it is fraught with desire.

It may be true, as Henry Geldzahler writes, that "Chihuly seems to be working with [the] great American traditions of watercolor and Color Field painting,"[61] but Color Field dead-ended in post-painterly abstraction.[62] As always happens when art becomes too pure, it lost almost all its evocative power, trivializing its expressivity into sensation—sensation that hardly sank in. For when sensation becomes too refined, too "sublime," it evaporates at the moment it is experienced. It has no presence, only specious presentness.[63] Perfectly pure art lacks all expressive significance.

This is what occurs in the "veils of Morris Louis, the chevrons and stripes of Kenneth Noland, and the large stained chromatic landscapes of Helen Frankenthaler,"[64] to which Geldzahler links Chihuly. He overstates the link. In those artists' work, desire runs thin; but desire makes Chihuly's art dense, exciting. His objects are vigorously impure, for all their refinement, which is why they remain radically expressive, while the purist work of Louis, Noland, and Frankenthaler remains "sensational."

Chihuly's glass objects are "inconsistent," as their various misshapes and surface mottlings indicate. (The title of one of his series, *Macchia*, is Italian for "spotted.") However "brilliant and fresh [his] color juxtapositions," and however much he "play[s] with the diaphanous clarities of glass,"[65] the visual fact of the matter is that his colors and transparencies are always exquisitely "corrupted." This is what makes them evocative. The work of the Color Field painters, on the other hand, seems more strategic than spontaneous, and is strained in its combinations of color and shape. The artists are attempting to construct a semiosis of form; indeed, their art has a strong didactic dimension, as though they wanted to make a technical point about formal possibilities (like Josef Albers?) rather than use form to full expressive advantage. Their art remains strictly on the level of consciousness. In consequence, it quickly became academic and has something sedate about it. Ironically, Color Field painting lends itself to background atmosphere—becomes trivial decor—more readily than Chihuly's glass objects, which seem restlessly "immanifest" with disruptive desire and are decadent and pure at once.[66] Chihuly's work embodies what Mihaly Csikszentmihalyi calls "flow experience";[67] Color Field painting stops the flow. The resemblance between the two can be sustained only superficially. A more unlikely comparison, perhaps, with the decidedly undecorative works of Joseph Beuys, ends up far more fruitful. Chihuly's full-fledged decorative objects of the 1980s and 1990s are full of desire (it is inhibited or contained only by the shape of the vessel, which reflects the erratic pressure of desire by becoming eccentric, that is, bent out of shape);[68] indeed, desire is so intense here that the works can be said to be shamanistic.[69] No doubt it seems farfetched to put Chihuly's glass objects in the same category as Beuys's fat and felt ones, but they reflect the same healing process and have the same healing use.[70] (Both oeuvres are also performative, in themselves and as the accompaniments and residues of a performance—in Chihuly's case, the performance, with a large supporting cast, of producing the glass object.) The shaping of "disintegrated" molten glass into an ecstatic subjective object, giving integrity to the shattered and shapeless, is clearly a healing process on a psychic level. In fact, the same reparative dialectic of liquid and solid that informs Beuys's objects informs those of Chihuly.[71]

In addition, Chihuly's objects, like Beuys's, are a kind of subjective, quasi-hieroglyphic language, in which a three-dimensional statement seems to express emotion directly, making it a concrete symbol.[72] This is perhaps most self-evident in Chihuly's *Irish* and *Ulysses Cylinders* (both 1975; p. 64), "text sculptures" that are among his most conceptually daring avant-garde uses of glass. (They were collaborations with Flora Mace and Seaver Leslie.) Here Chihuly quotes phrases and sketches scenes from James Joyce's *Ulysses* on the vessels, making them into a "surreal" language. (*Ulysses,* of course, is not only about Dublin but about loneliness and the relationship of Leopold Bloom and Stephen Daedalus, the one a Jew and the other a

poet. Both feel betrayed by society and literally are.) He also begins the glass process with a series of drawings that are a kind of "text book" of expression, in which the work struggles to take symbolic form, as well as a testing ground for form as such.[73] In these drawings he shows himself both the Caliban and the Ariel of the tempestuous process of turning expressive text into concrete symbol.

The distance from the *Pilchuck Baskets* of 1977–78 to the *Seaforms* and *Macchia* of 1983–84, and from those to the *Persians* of 1988, the *Venetians* of 1989, the *Floats* and *Ikebana* of 1991–92, and the *Chandeliers* of 1992–93 (with and without the putti suggestive of a Tiepolo and generally Italian heaven), seems great, but there are in fact certain expressive and technical consistencies within their inconsistency.[74] First, they all convey a sense of exhilarating plenitude, becoming increasingly expansive until, with the *Chandeliers*, plenitude becomes positively explosive. Second, there is an amazing integration of centrifugal and centripetal effects—of convolution and involution. Such integration is typical of arabesque, the decorative at its most sophisticated and modern, as Henri Matisse made clear. Third, there is a consistent use of an emphatic outline or familiar fixed shape suggesting the firm containment of a vessel, for all the objects' "bubbliness." Finally, many of the works are additive or accumulative, if not literally then in effect (with the important exception of the *Floats*). Detail is piled upon detail, each expressively equivalent to the other and expressively supplementing and reinforcing the other, to create an effect of overwhelming allover expressivity.[75] The works' small, seemingly trivial differences add up to a large expressive difference, all the more telling because it seems irreducible, fundamental-radical. It is said that there is a point at which quantity becomes quality; Chihuly seems to reach it quickly. A few parts fused into a singular object, a few objects deftly united in an installation, are all he needs (although he is clearly into quantity with a vengeance, as though quality were indistinguishable from it).

In creating by ritualistic adding (an external process, bespeaking the traditional idea of decoration as a superficial addition to an environment), then organically fusing all the additions to a "stem" or core to create an object with its own integrity and inner necessity (an internal process, bespeaking the avant-garde conception of decoration as autonomous expressivity), Chihuly resolves, on the basic level of making, the ultimate (because conceptual) conflict of decorative art. In the *Chandeliers*, for example, the core is a rectilinear metal construction, from which numerous globular elements are suspended. Each *Chandelier* is a hard, Apollonian construction within a soft, Dionysian one; the latter "postmodernizes" the former, which is intransigently modernist and minimalist. Many of Chihuly's drawings show a geometric core (a closed circle) with streams of gestures spontaneously emanating—indeed, extravagantly erupting—from it. It is a model of the core self in ceaseless expression.

The chandelier is clearly of major formal and emotional consequence for Chihuly, as suggested by his extensive use of it in *Chihuly Over Venice* (1996; p. 307). In this installation a number of huge, weighty *Chandeliers*—each an exotic, lush agglomeration of unique parts resembling imaginary fruit—were suspended, not unlike ancient phallic amulets or good-luck charms, at various sites around that watery city, "the most mysterious and secretive [and feminine] city of all," as Chihuly says. If *Chihuly Over Venice* is the grand, recapitulative climax of his works thus far, both in terms of scope and concept, then Chihuly's installation for a production of Debussy's opera *Pelléas et Mélisande*, performed in Seattle in early 1993, is the overture to it: as self-contained as *Chihuly Over Venice* is uncontainable, as intimate as *Chihuly Over Venice* is global—French foreplay heralding the Venetian orgasm. *Chihuly Over Venice* is in a creative class by itself: in the *Pelléas et Mélisande* installation Chihuly enters into the spirit of another artist's work while remaining himself, but in *Chihuly Over Venice* he is unequivocally—triumphantly—himself. It is a creative self-apotheosis—indeed, the apotheosis of his creativity—and as such requires a section of its own. Nonetheless, Chihuly's stage set for *Pelléas et Mélisande* is, in its own way, a high point in his career. It makes clear the rhetorical and spatial aspects—sublimated grandiosity—of his art as no previous installation does. He returns to the seemingly formless hanging sheets of fluidity—here fabric sheets, functioning as a kind of "figure of speech"—of his postminimalist youth, but now on a heroic scale, giving space instant symbolic significance. Indeed, Chihuly's affiliation with the opera makes clear his Symbolist sensibility.[76] He returns to the forest-sea, that ancient symbol of self-immersion, with its undertone of otherworldliness. (The general color tone of the installation is sea and forest green, with dazzling flashes of complementary red, often tinged with golden yellow, creating an effect of sudden inner illumination, emotional as well as literal.) Seemingly infinite external space becomes symbolic of haunted internal space, a terra incognita of expressive possibilities.

When Chihuly made the stage design for *Pelléas et Mélisande*, he linked himself with two of the most seminal, innovative creators of modern abstract art, suggesting his own consummate modernism and originality. For no less an artist than Kandinsky, Debussy was to be classed with the Impressionist painters (as Chihuly can be); he wrote, "The most modern musicians like Debussy create a spiritual impression, often taken from nature, but embodied in purely musical form."[77] In *Pelléas et Mélisande*, Debussy was working with a poem-play by Maurice Maeterlinck, whom Kandinsky heralded, again, as "perhaps one of the first prophets, one of the first artistic reformers and seers," creating "spiritual atmosphere . . . principally by purely artistic means."[78] Kandinsky also thought that Maeterlinck "dematerialized" the object into an "abstract impression."[79] This is what Chihuly can be said to do with the natural object, spiritualizing it with uncanny color and shape—dematerializing or, rather, using its material for spiritual effect.

Yet Chihuly's installation more than equals Debussy's music; it is the music's visual equivalent, not simply its accompaniment. This, too, generates an effect of introspection and interiority, indeed of narcissistic undertow and radical individuality. Oceanic feeling, conveying a sense of Dionysian merger, and a sense of separateness, conveying a feeling of Apollonian uniqueness, are equally evident in the installation, which shows Chihuly at his most self-contradictory and thus most himself. Yet the *Pelléas et Mélisande* project must have required more team effort and

coordination than any other. It is in fact a collaboration with a composer, indeed an identification with a uniquely individual, avant-garde composer, confirming Chihuly's sense of being one himself.

The set is the decorative background for the opera's action, but it is hardly passive atmosphere and ordinary mood, for it is an environment, and a performance, in itself—a performance in seemingly perpetual motion and as such hermetic, self-sufficient. Chihuly's set, in fact, competes with the human performers in expressive intensity even as it supports them. Similarly, it dwarfs their figures, upstaging and uprooting them with its epic scale, even as that scale adds to their presence by locating them in an infinite expressive space. The set is an extraordinarily imaginative materialization of the elusive mental space into which Symbolist opera—and Debussy's music in general—invites us. Gigantic sheets of color sing lyrically in the space and personify it, like internal objects or representations, and like the human singers, only abstractly. Encompassed by this rhetorical, quixotic space, the figures have as much a surplus of affect as it does. The set carries them, as Chihuly's *Floats* are carried by the sea. Thus the entire installation is rhetorical, in the positive sense of the term.[80]

Pelléas et Mélisande is perhaps Chihuly's most profoundly avant-garde, imaginative, delirious, absurdly theatrical installation, even his most grandly ecological one. It is a dramatic alternative to the expressivity of the mass media, which has a deadening effect—which betrays the very emotions it sensationally expresses and above all betrays the *promesse du bonheur* that art at its most consummate conveys, whatever its theme.[81] Chihuly's "choreography" for *Pelléas et Mélisande* is his consummate work—a climactic articulation of the *promesse du bonheur* that his art has always expressed, even when it has dealt (implicitly or explicitly) with the destruction as well as the re-creation of a harmonious internal world of nurturing objects. (This is true even though he has followed it—and it is clearly a hard act to follow—with the *Chandeliers*, each a kind of Diana of Ephesus, although with many more than forty good, if also phallic, breasts.) The *Pelléas et Mélisande* set articulates—three-dimensionalizes—the feeling of floating more completely than any of his other works (even if the *Chandeliers*, also hanging pieces, seem to levitate) and empathically draws us into itself, more than any other installation. (The *Chandeliers* distance themselves from us and even push us away, however much their parts look like rare—but not clearly edible—fruit.)

Finally, Chihuly's *Pelléas et Mélisande* is a meditation on imagination itself, a reaffirmation that imagination is necessary for psychic survival in an emotionally inhospitable, expressively alien world. At the same time, it is not simply another artistic act of ingeniously deferred gratification, as fantasy—substitute gratification—often is. Chihuly's fantastic objects are the kind of fantasy that is gratifying in itself: the unconscious fantasy of consummate intimacy with internal objects, the fantasy of re-creating the harmonious internal world of the lost paradise of childhood.[82] Chihuly's installations are fantasy clusters of fantasy objects in a fantastic paradise—the ultimate, most grandiose fantasy.

There is, then, no renunciation of gratification in Chihuly's decorative art but something more complex—the creation of inherently gratifying objects. This is something rare in both modern art—which, in retrospect, seems to have made a fetish of presenting ungratifying objects that supposedly reflect the tragedy of the modern world, as well as of art in such a world—and postmodern art, where gratification has become the premature intellectual excitement that accompanies the appropriation of any art that is of passing interest, if only for its appearance rather than for its expressive substance. The easy aesthetic thrill of much postmodern art confirms the hollow grandiosity of its acts of appropriation.

Chihuly has in fact realized the idea of gratification implicit in the decorative abstraction with which modern art began. It is essentially the mystic's gratification at communion with—spontaneous visionary intuition into—internal objects, facilitated by radical withdrawal from the world.[83] In his mystical attitude toward glass, Chihuly has restored a sense of destiny to the decorative, which had become a kind of facile gratification or simpleminded amusement, hardly gratifying even voyeuristically. The astonishingly protean character of his objects, so personal for all their exhibitionism, shows that glass, by reason of its material qualities—which, in a sense, are all that Chihuly's objects and installations express—cannot help but show the lineaments of self-satisfied desire, sufficient unto itself.

Chihuly, as a person, is the epitome of energetic buoyancy. His development, as a glassmaker, has been from grounded to "groundless" objects: from objects that sit stably on the ground, to objects that restlessly climb the walls and seem to change shape in the course of doing so, and finally to objects that hang from the rafters, as it were. He moves from normally to "abnormally" situated objects and from objects that are finished products to objects that explicitly embody the process of their making, and as such seem self-reflexive and unfinished at once. He has moved away from the repetitive minimalism of his fused glass weaving (1963) and *Homage to Bob Reed* and *20,000 Pounds of Ice and Neon* (both 1971), all involving grid construction and acknowledgment of, indeed adherence to, a fixed plane (the wall or floor), to freestanding, free-form postminimalist installations, spreading freely in space—ambiguously abstract and mimetic expressionist environments and ecological manifestos in one, and as such a unique synthesis of modernist and postmodernist ideas.

His forms have become irreducibly individual and more and more buoyant and energetic and uninhibited—inwardly restless and outwardly assertive at once. He has a vision of glass as the primordial buoyancy: this is the "message" of Chihuly's buoyant glass. In search of new ways to articulate primordial buoyancy—to strip glass down to its essential buoyancy so that it becomes a symbol of the human spirit at its most buoyant and undefeated and finally of the buoyancy of pure Being—he has challenged all the "givens" of glassmaking: conventions of placement and containment, the traditional balance between opacity and transparency, the notion that color is additive rather than integral to shape, and that surface and shape are distinct. Bernard Berenson thought that genius was "the capacity for productive reaction against one's training";[84] by that standard Chihuly's

idiosyncratic objects and installations clearly show his genius. Nowhere is it more evident than in the installation of *Chandeliers* that constitute *Chihuly Over Venice*—Chihuly buoyant in Venice, one might say. He thinks of the *Chandeliers* as a "massing of color," as he has said, but the mass of color floats buoyantly. His color, in and of itself, is buoyant: it seems to float on the light that shoots through it. The crucial creative achievement of the color-filled *Chandeliers* is their buoyancy: they do not simply hang suspended and static in space, as ordinary chandeliers do, but seem to float on it. They are thus the ideal symbols of Chihuly's creativity—his buoyant, resilient spirit. To raise them over water—the element in which life was created and which it needs to survive and incorporates in its own being—is to make them all the more buoyant, creatively resonant: to exponentially increase their grandeur.

Chihuly's buoyancy has an inner meaning: his objects have a "self-supporting"—one might say self-righting—capacity.[85] They convey a sensation of autonomy, even as they reflect and embody an environment. They are unequivocally themselves, even as they are dependent on nature. They are his unique creations but also emblems of the creativity of nature. They convey a sense of jubilation—élan de vivre—but also of durability: they have come through the fire of the kiln with flying colors. For all their apparent fragility, they have strength of character. If creativity and buoyancy are correlate—if to be creative means to be buoyant, to demonstrate a "capacity for uplift" without losing inner balance[86]—then Chihuly's objects and installations, and by extension Chihuly himself, are buoyantly creative. It is buoyancy that permits a productive reaction against the constraints of one's training—permits one to break the inhibiting rules with creative impunity. The novel result embodies buoyancy—indeed, at its best, as in Chihuly's case, elevates it into an absolute. Chihuly is, I think, unique among avant-garde artists in that he has made the articulation of buoyancy the goal of his art. Indeed, he has effected a revolution within the avant-garde: for him, buoyancy is the antidote to the poisonous horror and hatred of life that has become de rigueur in avant-garde art—its traditional emotion.[87]

Chihuly Over Venice seemed designed to unsettle the tidy world of professional glassmaking. In Finland Chihuly worked at the famous Hackman factory in Nuutajärvi (June 1995), in Ireland he worked at the prestigious Waterford Crystal factory in Waterford (September 1995), and in the industrial city of Monterrey, Mexico, he worked at Vitro Crisa, a factory within the vast Vitro complex, where functional glassware is made (January 1996). Chihuly brought his own innovative, nonfunctional ideas to bear on the industrial process, shaking up—disturbing the preconceptions of—the professional glassmakers he worked with. Amazingly, his own avant-garde team of glassmakers was able not only to get along with them but to work creatively with them, infusing them with a new spirit. Indeed, the atmosphere in the factories was transformed—vitalized—by the presence of Chihuly and his American team: it became positively buoyant, upbeat, rather than the typical humdrum daily business as usual, with its insidiously demoralizing effect.

I have argued elsewhere that what John Ruskin and William Morris called the "craftsman ideal," so influential in America from circa 1887 to 1915, remains crucial to craft art.[88] Chihuly's attitude to glassmaking is a unique new version of it. The craftsman ideal was an attempt to counteract what Ruskin and Morris felt was the degradation of work in industrial capitalism. Craft was to be a way of restoring "the lost utopia of unalienated work," thus symbolizing the "joy of work," and above all its importance as a means of individualization. Genuine craft is always a labor of love, and as such the core of art. I have always been struck by the unalienated, genuinely cooperative atmosphere in Chihuly's Boathouse, and the same atmosphere of camaraderie prevailed despite the alien circumstances—because of the foreign and factory environment and the language barrier—of *Chihuly Over Venice*. The odds against human beings working cooperatively together are always great, and the odds of their doing so with vigor and pleasure even greater. But it seems that, through the sheer force of his buoyant spirit, Chihuly was able to catalyze a remarkably positive, collaborative, even synergistic work atmosphere. He in effect created, however temporarily, a kind of utopian community in the industrial factory. Ruskin asked: "Was the carver happy while he was about it?" And answered: "It may be the hardest work possible, and harder because so much pleasure was taken in it; but it must be happy too, or it will not be living." Chihuly's glassmakers, American and those in the countries he visited, clearly took pleasure in their hard work of shaping glass; indeed, they were perhaps never happier in their work lives.

Chihuly is an amazing facilitator—catalyst—of freedom and a healthy attitude. Lawrence S. Kubie has argued that "the essence of illness is the freezing of behavior into unalterable and insatiable patterns."[89] "Any Moment of behavior is neurotic," he has written, "if the processes that set it in motion predetermine its automatic repetition, and this irrespective of the situation or the social and personal values or consequences of the act."[90] The work atmosphere in the typical factory, with its repetitive, automatic procedures—its frozen habits—is, by this definition, invariably neurotic, indeed, demoralizing. By forcing the factory glassworkers to change their habits—to break their usual, mundane, tedious pattern and process of work—Chihuly created an exciting atmosphere of freedom and experimentation, thus renewing their health. Changing their methods of work, and its purpose and goal—changing the spirit in which they work—Chihuly changed their attitude to life for the better. Kubie asserts that "the measure of health is flexibility, the freedom to learn through experience, the freedom to change with changing internal and external circumstances."[91] Chihuly's enormous flexibility, so evident in his objects and installations—his ability to work and remain buoyant whatever the circumstances—is a gift of health he freely gives to those who work with him, whoever and wherever they are. He lends them his buoyancy by embracing them with it. His free spirit—his ability to learn from new experience, indeed, apparent inability to be bored by glass despite long experience with it—invariably raises the morale of those he works with, restoring their creativity and sense of freedom. Chihuly continues to learn from the unpredictability of glass, and he gives those he works with an exhilarating appreciation of creative unpredictability through his own unpredictable style of

work—his on-the-spot creativity. In short, his endless fascination with glass and buoyant, creative enthusiasm are contagious: they renewed the factory workers' enthusiasm for their work, making it feel fresh and fascinating. He turned the craftsmen he worked with into creative artists, at least for the duration of his stay with them. For the glassworkers in Finland, Ireland, and Mexico, an unhealthy industrial process became, for an exciting moment, a healthy creative process. Chihuly is not simply an artist working in glass but a social innovator. His work is not simply about objects but a critique of society. Indeed, he has said that "the people became more important—all the glassblowers and artisans from the different countries working hand-in-hand with all the Americans. The hanging of the *Chandeliers* became secondary." His sense of the integrated work community is a reminder that workers who are demoralized and neurotic rather than buoyant and healthy cannot be creative, whether as human beings or artists.

It was in Nuutajärvi that *Chandeliers* first became part of the landscape. Hung between trees in the village and along the river, they were accompanied by smoky black saguaros placed in high grass, cobalt pieces along the canal, and tall reedlike forms (ten to fifteen feet high) in the bogs. Chihuly's installation in Ireland was even more daring. Provocatively, he hung a one-ton crystal *Chandelier* (p. 292) from the high ceiling of the Waterford Crystal factory, as though to shine new light on the workers. And after working two weeks in the factory—where, always ready to learn and cooperate, Chihuly used Waterford's clear crystal and traditional cutting techniques, which were relatively new to him; and, always ready to teach and give, he showed the Waterford glassblowers how to work with colored glass, which they were not accustomed to do—Chihuly moved all his glass pieces to the grounds of Lismore Castle forty miles away. He hung *Chandeliers* in the archways and crumbling rooms and courtyard of the five-hundred-year-old castle and between yew trees. Large amethyst *Gourds* were placed in the lower gardens and crystal pieces in the greenhouse. His glass buoyed up the dead old castle, giving it new life and organic presence. Once again, Chihuly had created a unique, total, luminous environment, integrating glass works, architecture, and nature. In Monterrey Chihuly also hung *Chandeliers* in the factory, and, as though to counteract the industrial environment of the city, used smokestacks, silos, and industrial buildings as a backdrop for other *Chandeliers*. The colors of the Mexican *Chandeliers* were particularly intense, in part by reason of an old Mexican technique Chihuly revived: silver nitrate was used to line many of the parts, adding a festive touch. A bold red *Chandelier*, with mirrored balls and long tendrils, was hung in the Governor's Plaza, in celebration of Monterrey's four hundredth anniversary.

All of this was but a prelude to Venice (September 1996). The *Chandeliers* from the previous venues were shipped there and installed in fourteen sites around the city, some above small canals, others in palaces along the Grand Canal, and several in small courts and grand spaces. Complementing and accenting the city's architecture and water, they were the stars of Venezia Aperto Vetro, an international celebration of contemporary glass. (One Chihuly *Chandelier* was installed in the Doges Palace as an official part of the exhibition.) Chihuly had at last returned to his spiritual home: he worked on the island of Murano, as he had thirty years earlier. Chihuly's pursuit of "new people, new ideas, new places" had led him back to an old, familiar place. *Chihuly Over Venice* was a consummate performance—a remarkable orchestration of people and places and glass. The result was not simply spectacular but uplifting, transformative. It was a revelation of the essence of glass. Chihuly had once again shown how far buoyancy can carry you: it can fly you around the world and safely back home. As Jean-Michel Quinodoz says, buoyancy involves the "feeling of succeeding in 'flying with one's own wings'"[92] and also the capacity to shelter many others under them.

Notes

1 Henry Geldzahler, "Foreword," *Chihuly: Color, Glass and Form* (Tokyo, New York, and San Francisco: Kodansha International, 1986), p. 11.

2 Dale Chihuly, "Interview," *Glasswork* no. 5 (May 1990): p. 9.

3 See Hanna Segal, *Dream, Phantasy and Art* (London and New York: Tavistock/Routledge, 1991), p. 51: "Beta elements are raw, concretely felt experiences which can only be dealt with by expulsion.... When those beta elements are projected into the breast they are modified by the mother's understanding and converted into what Bion calls 'alpha elements.' If the beta elements are felt to be concrete things that can only be ejected, the alpha elements on the contrary lend themselves to storage in memory, understanding, symbolization, and further development. They are the elements which can function in the symbolic way which characterized the depressive position."

4 Wassily Kandinsky, *Concerning the Spiritual in Art* (New York: Dover, 1974), p. 2.

5 Harold Rosenberg, "Toward an Unanxious Profession," *The Anxious Object: Art Today and Its Audience* (New York: Horizon Press, 1964), p. 17. Rosenberg writes, "The anxiety of art is a philosophical quality.... It manifests itself, first of all, in the questioning of art itself.... anxiety is thus the form in which modern art raises itself to the level of human history. It is an objective reflection of the indefiniteness of the function of art in present-day society and the possibility of the displacement of art by newer forms of expression, emotional stimulation and communication. It relates to the awareness that art today survives in the intersections between popular media, handicraft and the applied sciences; and that the term 'art' has become useless as a means of setting apart a certain category of fabrications. Given the speed and sophistication with which the formal characteristics of new art modes are appropriated by the artisans of the commercial media and semi-media (architecture, highway design, etc.), the art object, including masterpieces of the past, exists under constant threat of deformation and loss of identity. Today, there is no agreed-upon way of identifying works as art except by including them in art history. But art history is constantly being expanded to comprise such new species as photography, TV, cinema, comic books. Moreover, the historical qualification of works as art is today threatened by the transformation of the museum and the art book into media of mass communication." I have quoted Rosenberg at length because I think his argument is particularly pertinent to Chihuly's glass works, which exist at the intersection of popular, handicraft, applied-science, and high-abstract-art interests. They expand our sense of "art"—of the complex identity an object must have to be regarded as art—even as they try to lend themselves to appropriation by photographic reproduction, in which Chihuly puts a premium because of its power to disseminate the unique object, which otherwise would be seen only in limited circumstances. (He seems unaware that the photograph may turn the object into a copy of itself.) On the other hand, Chihuly's objects, however much they come in series, never become multiples—duplicates—but remain one-of-a-kind in their radical idiosyncrasy.

6 I am thinking of Mircea Eliade's description of the "Rites and Mysteries of Metallurgy" in *The Forge and the Crucible* (London: Rider, 1962), chapter 5. Furthermore, what Eliade writes of stone in chapter 4, "Terra Mater, Petra Genitrix," can also be said of glass: it is "an archetypal image expressing absolute reality, life and holiness" (p. 43). "The alchemist," Eliade writes (p. 47), "takes up and perfects the work of Nature, while at the same time working to 'make' himself." Above all, the "alchemist contributes to Nature's work by precipitating the rhythm of Time" (p. 51). He is thus "the brotherly savior of Nature. He assists Nature to fulfill her final goal, to attain her 'ideal,' which is the perfection of its progeny—be it mineral, animal or human—to its supreme ripening, which is absolute immortality and liberty (gold being the symbol of sovereignty and autonomy)" (p. 52). Just as art perfects nature, so Chihuly's works perfect glass. Their autonomy and sovereignty symbolize that of the self bringing itself to ripe perfection—one definition of the creative personality, or "artist."

7 One cannot help but think that Chihuly's abstract glass sculptures realize modernist purity with special perfection. For, to use Clement Greenberg's words, they are made of a matter that seems "incorporeal, weightless and exists only optically like a mirage," their "flexibility" suggests a "wide range of expression," and their space is inflected by light to the extent of not seeming to exist in darkness. Greenberg, "The New Sculpture" (1952), *Art and Culture* (Boston: Beacon

Paperback, 1965), pp. 142, 144. At the same time, their muscular incongruities and capricious colorism give them a greater, more vibrant expressivity than the usual "positivist" sculpture.

8 In an anonymous review in a Seattle newspaper.

9 Susanne K. Langer, *Feeling and Form: A Theory of Art* (New York: Charles Scribner's Sons, 1953), p. 388.

10 Ibid., pp. 387–88.

11 It should be noted that there is a compulsive dimension to Chihuly's experiments with technique: it is as if, in his compensatory, daring demonstrations of craft ability, he wanted to show that he is still capable of participating physically in the glassmaking process, even since an automobile accident blinded him in one eye, destroying his depth vision. See Dale Chihuly, "On the Road," *Chihuly: Color, Glass and Form*, p. 19: "Seaver [Leslie] and I were on a lecture tour in England (in 1976) when we had a serious automobile crash.... It took about a year to recover from my injuries." According to Jon Krakauer, "Dale Chihuly Has Turned Art Glass into a Red-Hot Item," *Smithsonian* (February 1992): 92, the "automobile accident robbed him of sight in his left eye. The ensuing loss of depth perception made it all but impossible for him to safely manipulate the five-foot-long blowpipe and other arcane tools of his trade." Recently, however, Chihuly has again begun to blow pieces on his own.

12 Regina Hackett, in "Dale Chihuly Finds Beauty in Excess," *Seattle Post-Intelligencer*, 17 June 1992, declares, "Chihuly is a fantasist," noting that the installation of the *Macchia* series "on tree-like white pillars of various sizes" suggests "a florid, fantastic form of tree life" (p. C1). Similarly, Deloris Tarzan Ament, in "World Glass," *Seattle Times*, 17 June 1992, quotes Chihuly's description of the forest set for *Pelléas et Mélisande* as a "mostly transparent, shimmering, luminous . . . abstract and very simple" fantasy (p. F7). In "Chihuly: Climbing the Wall," *Art in America* (June 1990): 203, David Bourdon describes Chihuly as "a fantasist, improvising essentially bizarre pieces." None of these writers, however, states the content of Chihuly's fantasy—which is, after all, a psychological production—apart from noting that, in Bourdon's words, it is "nature-based," here involving "the spiraling forms and coiled growths sometimes found in marine creatures," there suggesting "bunches of fantastic flowers" (p. 166). Living nature, whether animal or vegetable—and that Chihuly turns both into mineral suggests the cosmic completeness of his vision of nature—is a formal point of departure for Chihuly, not the expressive end of his art.

13 T. W. Adorno, *Aesthetic Theory* (London: Routledge & Kegan Paul, 1984), p. 455.

14 Matthew Kangas, in "Dale Chihuly: A Return to Origins," *Glass* 39 (1990): p. 2, describes the *Venetians* as "ill-behaved, irritating, and threatening," noting that they "alternate between gloomy, aggressive shapes and luxuriously decadent forms." "Regardless of how seductive or repellent the surfaces are, an indeterminately threatening quality pervades all the *Venetians*."

15 Chihuly, quoted in Christa del Sesto, "Artist Dale Chihuly's Venetian Visions," *Washington Post*, 13 April 1989, p. 36: "I took old models [of Venetian glass] and branched out from there.... They got more and more bizarre, and I liked that." Segal, in "The Klein-Bion Model," *Models of the Mind*, ed. Arnold Rothstein (New York: International Universities Press, 1985), p. 37, discusses "'bizarre objects'—those objects being fragments of the object, containing projected fragments of the self and imbued with hostility and anxiety." These objects are associated with "typical schizoid fears of annihilation and disintegration," an "excessive anxiety" that seems unconsciously inseparable from working with glass, particularly when, as Krakauer writes (p. 100), "Chihuly really only cares about pushing the boundaries of glassblowing."

This may be overstating the matter, but Chihuly himself remarks that "glassblowing is a tricky business, especially when you're pushing the edge of the envelope, when you're trying things . . . big and intricate" (ibid., p. 94). Clearly, as Richard Royal, a former student of Chihuly's, says, "A lot can go wrong. Some days, everything you do turns out like magic and you're a hero; other days you lose most of the pieces you attempt" (ibid.). To work in such a situation has to arouse intense anxiety. It may be that Chihuly's particularly bizarre objects obliquely acknowledge this anxiety, reifying the fear that the piece will disintegrate at the very moment

of its realization, an annihilation that would seem to destroy its conception as well. In straining glass to its expressive and physical limits, Chihuly surely has to become anxious, consciously and unconsciously—has to feel that the whole enterprise is bizarre.

16 Modernist art is highly ambivalent about the decorative. On the one hand, it understands the decorative as art's formal and sensual fundament, as in Oscar Wilde's insistence that the "incommunicable artistic essence" of a work is "the arabesque of the design, the splendour of the color," and in Paul Gauguin's conception of "decorative abstraction," with the stained-glass window as its model. On the other hand, the decorative, as Greenberg suggests, can "go slack" aesthetically, and can even "fall flat," that is, lose all aesthetic drama—the tense contrast that is the core of the aesthetic. These quotations come from the survey of modern attitudes to the decorative in Patricia Ann Laughlin's excellent dissertation "Lee Krasner's Collages: The Decorative Impulse in Modern Art" (Department of Art, State University of New York at Stony Brook, 1993). Laughlin points out that the decorative subverts the idea of the painting as a "slice of pictorial life." Thus Maurice Denis famously asserts, "A painting—before it is a battlehorse, a nude woman, or some anecdote—is essentially a flat surface covered with colors assembled in a certain order." See Denis, "A Definition of Neo Traditionalism," in *Impressionism and Post-Impressionism 1874-1904*, ed. Linda Nochlin (Englewood Cliffs, NJ: Prentice-Hall, 1966), p. 187.

17 Luxury painting, as Greenberg calls it, involves emphasizing "the pleasure principle with a new explicitness," as in the School of Paris after World War I. It involves the location of "pictorial pleasure" "mainly in the exhilarating and more physical facts of luscious color, eloquent surfaces and decoratively inflected design." Quoted in Donald B. Kuspit, *Clement Greenberg, Art Critic* (Madison: University of Wisconsin, 1979), pp. 92–93, in which I analyze Greenberg's notion of luxury painting in detail. As he implies, luxury is art's narcissistic defense against pessimism, its attempt to cure itself of cynicism in a society that has come to seem predictably self-defeating, even self-destructive. The question is whether Chihuly's gorgeous, extravagant objects are a defense against pessimism or the sign of a new optimism.

18 Gauguin wrote, "Like music, [painting] acts on the soul through the intermediary of the senses: harmonious colors correspond to the harmonies of sound. But in painting a unity is obtained which is not possible in music, where the accords follow one another, so that the judgment experiences a continuous fatigue if it wants to reunite the end with the beginning." Quoted in Herschel B. Chipp, ed., *Theories of Modern Art* (Berkeley: University of California Press, 1968), p. 61. Similarly, Kandinsky expressed the wish to emulate "the purely musical method" of Richard Wagner, which "creates a spiritual atmosphere by means of a musical phrase" (ibid., p. 16). Such "color-music is no new idea," as Kandinsky's translator, M. T. H. Sadler, writes (p. xix); but Kandinsky added the conception of music as realizing "the greatest freedom of all, the freedom of an unfettered art" (p. 17), which is one of the reasons he wanted painting to be like music. As he wrote, "Music is the best teacher" (p. 19).

Greenberg, in "The Crisis of the Easel Picture," *Art and Culture*, p. 155, speaks similarly of "the all-over, 'decentralized,' 'polyphonic' picture." Apologizing for borrowing "the term 'polyphonic' from music," he nonetheless writes, "Just as Schönberg makes every element, every sound in the composition of equal *importance—different* but *equivalent*—so the 'all-over' painter renders every element and every area of the picture equivalent in accent and emphasis. Like the twelve-tone composer, the 'all-over' painter weaves his work of art into a tight mesh whose scheme of unity is recapitulated at every meshing point" (pp. 156–57). (It is significant that Greenberg, like Kandinsky, p. 17, sees Arnold Schönberg as the consummate composer.) The result is a surface whose "hallucinatory uniformity" (p. 157) shows "the decorative [being used] against itself" ("Milton Avery," p. 200). This "imaginatively completes" it ("The Later Monet," p. 43), indicating that it can convey a "*vision*," that is, transcend itself ("Picasso at Seventy-Five," p. 66).

19 For an account of Chihuly's teamwork see Karen Chambers, "With the Team," *Chihuly: Color, Glass and Form*, pp. 22–31. Krakauer also has a useful step-by-step account of Chihuly at work in the studio (pp. 93–95). Chihuly blew glass for ten years before his accident made it impossible for him to continue. (Many earlier masters of glass, such as Louis Comfort Tiffany, Émile Gallé, and René Lalique, did not themselves know how to blow glass; see Chihuly, "Interview," *Glasswork*, p. 11.)

He has been described as the director of a symphony orchestra (Krakauer, p. 93), and he himself compares the way he works "a little bit to being the director of a film. My gaffer is like a camera man, and my color person is my lighting person. But ultimately it is a project directed by me." Chihuly, "Interview," *Glasswork*, p. 11. This reminds one of Howard S. Becker's argument, in *Art Worlds* (Berkeley: University of California Press, 1982), that the work of art ought to have a list of credits attached to it, like "the typical Hollywood film," acknowledging not simply the collective effort but the "finely divided set of activities" that went into its making (p. 7).

20 Phyllis Greenacre, in "Play in Relation to Creative Imagination" (1959), *Emotional Growth: Psychoanalytic Studies of the Gifted and a Great Variety of Other Individuals* (New York: International Universities Press, 1971), 2:556, states that "creativity" involves "the capacity for or activity of making something new, original or inventive, no matter in what field. It is not merely the making of a product, even a good product, but of one which has the characteristic of originality. No absolute dividing line between creativity and productivity can be made. The different meaning between the two extremes—the copied product and the new invention—is clear enough." In distinguishing between "the creative process" and "the subsidiary executive functions involved in productivity," Greenacre is in effect distinguishing between art and craft.

21 D. W. Winnicott's idea of the facilitating environment is complex. Suffice it to say that in "Contemporary Concepts of Adolescent Development and Their Implications for Higher Education," *Playing and Reality* (London and New York: Methuen/Tavistock, 1982), p. 139, Winnicott writes that "the good-enough facilitating environment . . . at the start of each individual's growth and development is a sine qua non. . . . nothing takes place in emotional growth except in relation to the environmental provision, which must be good enough." (It should be noted that "good enough" has a very particular meaning for Winnicott.) I am arguing that decorative art at its expressive best functions as a surrogate, compensatory facilitating environment. "The imperfections that are characteristic of human adaptation to need are an essential quality in the environment that facilitates," Winnicott writes; I want to suggest, no doubt farfetchedly, that the imperfections that make Chihuly's objects uncanny help make them facilitative, along with their installation in a situation of complex dependence on one another. Chihuly's grouping of objects in an installation signals, in Winnicott's words, that "the individual seen as an autonomous unit is in fact never independent of environment." The installation signals that independence and dependence are "relative."

22 According to Roland Hunt's *Seven Keys to Colour Healing* (London: C. W. Daniel Co., 1971; reprint), Leonardo Da Vinci said, "Our power of meditation can be increased tenfold if we meditate under the rays of the violet light falling softly through the stained-glass windows of a quiet church." Hunt himself regarded violet as "the ideal Purifier"; see John Elderfield, *Matisse's Cutouts* (New York: Museum of Modern Art, 1984), p. 35. For Elderfield, Henri Matisse's use of violet "in the Vence Chapel would have been considered appropriate by Hunt." Matisse, of course, is perhaps the key figure in the twentieth-century redemption of the decorative. According to Jack Flam, ed., in *Matisse on Art* (New York: Dutton, 1978), p. 21, there is a "direct parallel" between the ideas of Henry Havard in *La Décoration* and those of Matisse in the 1908 "Notes of a Painter." Chihuly is perhaps the most recent in a line of artists of different sorts—including Claude Debussy, Claude Monet, Paul Cézanne, and Matisse—who took nature as the point of departure for a form of expressive decorative abstraction. In Chihuly's case it involved a three-dimensionalization of stained glass. Bourdon notes that "Chihuly's colors often have the intensity of medieval stained glass, particularly when he favors . . . cobalt blues and ruby reds," the idealized colors of the Madonna's divinity and suffering (p. 166).

23 See T. S. Eliot, "The Metaphysical Poets," *Selected Essays 1917-1932* (New York: Harcourt, Brace, 1931), p. 247, in which Eliot argues that "in the seventeenth century a dissociation of sensibility set in from which we have never recovered." Sensibility split then into "the sentimental" and "the ratiocinative" (p. 248), that is, into feeling that has lost its precision—Eliot thought that "every precise emotion tends toward intellectual formulation" ("Shakespeare," in ibid., p. 115)—and precision that has lost feeling.

24 Greenberg, in "The Crisis of the Easel Picture," p. 155, describes the decoratively successful allover picture as dispensing "with beginning, middle, end."

This infects it "with a fatal ambiguity," diffusing its "fictive depth" until it loses focus and the integrity afforded by perspective. The notion that decoration can subvert the illusion of "natural" space has been in circulation at least since the French Symbolist critic Albert Aurier. See Laughlin, p. 15. See also Kuspit, chapter 4, for a discussion of Greenberg's conception of the decorative.

25 Patterson Sims, *Dale Chihuly: Installations 1964–1992*, exhibition catalogue (Seattle: Seattle Art Museum, 1992), p. 39.

26 Rita Reif, "Chihuly's Glass Spheres Are Worlds unto Themselves," *New York Times*, 5 July 1992, p. 24.

27 I allude to Lucy R. Lippard, "The Dematerialization of Art," *Changing* (New York: Dutton, 1971), where Lippard argues that "art as idea and art as action" are in fact "two roads to one place" (p. 255). Also pertinent is Lippard's remark, "A series is an appropriate vehicle for an ultra-conceptual art, since thinking is ratiocination, or discovering the fixed relations, ratios, and proportions between things, in time as well as in space" (p. 257). The relationships among the objects in Chihuly's series and installations, of course, are not always "geometrically" clear. Nonetheless, many of his early installations deserve a place in Lippard's compendium of conceptual art projects and experiments, *Six Years: The Dematerialization of the Art Object from 1966 to 1972* (New York and Washington, D.C.: Praeger, 1973).

28 Chihuly generally draws on the floating dock of the Boathouse, the house in which he has lived and worked since 1990. Even more than his glass works, his drawings convey the sensation of color floating on ceaselessly moving clear water. Color ripple overlaps color ripple to convey an intimate sublime—an interior infinity in perpetual play. See Sims, pp. 13–14, for an account of the Boathouse and of Chihuly's use of drawings.

29 Ibid., p. 43.

30 Ibid.

31 Ibid., p. 40.

32 I am thinking of Wolfgang Lederer, who argues, in *The Kiss of the Snow Queen: Hans Christian Andersen and Man's Redemption by Woman* (Berkeley: University of California Press, 1990), that "without the validating love of woman . . . man in himself would be an empty shell, an ephemeral accident unrelated to the grand purposes of God and world, an idle display" (p. 183). Lederer, a psychoanalyst, argues that the relationship between Gerda and Kay in Andersen's *The Snow Queen* "reminds us of how lonely we are or have been; how, if we are men, we need the validation, the confirmation, the redemption by woman; and if we are women, how the redemption of such a lonely man is one of the magic feats, one of the miracles a woman can perform." Is it absurd to say that Chihuly's objects are androgynes, which is why they suggest the richness of the experience of being alone?

33 Sims notes that Chihuly regards Venice as "his favorite city on earth, cherishing its food, exotic architecture, and idiosyncratic urbanity. During his third visit to this fabled city [in 1986], he studied glassblowing at the Venini factory on the neighboring island of Murano, and the city's unabashed love of luxury and the genius of its glass artists continue to draw him to Venice and its lagoon" (p. 9). It was at Venini that Chihuly learned "perhaps the most critical lesson . . . the centrality of the team to successful glassblowing. The sheer physical demands of the process require skilled collaborators" (p. 11). Because of Chihuly, "Seattle is second only to Venice in its concentration of artists and artisans who work with glass" (p. 13).

34 Sigmund Freud, in *Civilization and Its Discontents* (1930)—republished in the *Standard Edition* (London: Hogarth Press and the Institute of Psycho-Analysis, 1961), 21:64—describes "a sensation of 'eternity,' a feeling as of something limitless, unbounded—as it were, 'oceanic.'" Freud interprets this state as one in which "the boundary between ego and object . . . melt[s] away," and traces it back to "the infant at the breast [who] does not as yet distinguish his ego from the external world as the source of the sensations flowing in upon him" (pp. 66–67). It can ultimately be traced back to the feeling of being in the womb, in which the infant is literally one with the mother.

In his essay "Narcissism as a Form of Relationship," in *Freud's "On Narcissism": An Introduction* (New Haven: Yale University Press, 1991), pp. 209–10, Heinz Henseler describes the origin of "the myth of primary narcissism": "Paradise . . . was only later constructed, composed out of memory traces of a psychophysiological state, satisfying experiences with objects, and wishful fantasies of happiness and harmony—which can be understood as reaction formations to frustrating reality. Hence, primary narcissism and the narcissistic constellations that later develop from it are a wonderful human achievement, a subsequent invention, offering us withdrawal from a harsh reality into an 'intermediate area' (Winnicott) in which reality and fantasy can still blend in an agreeable way. Primary narcissism would then be a myth, in the best sense of the word: although never having taken place historically, it yet tells us something true." I am arguing that Chihuly's environments are so many versions of a narcissistic paradise, urgently repeated out of blind desire.

35 Following Winnicott, pp. 139–40, I am thinking of the search for paradise as a healthy response to social deprivation, that is, to the failure of the facilitating environment in the broadest sense—the failure of the social envelope. Such a search involves a sophisticated version of what Bela Grunberger, in *New Essays on Narcissism* (London: Free Association Books, 1989), calls the "monad": "a nonmaterial womb which functions as though it were material; on the one hand, it encloses the child in its narcissistic universe; on the other, it prepares it for the partial dissolution of that universe—or, in other words, for the dissolution of its own essence" (p. 3). Only then can it start to build its self, a necessary—but not always realized—alternative to paradise. I suggest that Chihuly's glass, at its most watery, shows this double process of primitive preservation and dissolution—of paradise and the expulsion from it—although there is a greater tendency to the former. Freud writes, "What we call happiness in the strictest sense comes from the (preferably sudden) satisfaction of needs which have been dammed up to a high degree, and it is from its nature only possible as an episodic phenomenon. When any situation that is desired by the pleasure principle is prolonged, it only produces a feeling of mild contentment" (p. 76). But Chihuly's environments embody happiness, prolonging it. They are about not so much the episodic satisfaction of transient needs as the satisfaction of narcissism, the deepest, most enduring, most pressing need of all. Its satisfaction involves contradictory, equally radical feelings of intimacy to the point of inseparability and omnipotent individuality. Because they surround us so completely, forming an intimate, alternative psychic envelope to society's inadequate envelope, Chihuly's environments suggest that there is no reason to relinquish these feelings and return to the reality of a society that sooner or later lets one down and is invariably narcissistically frustrating.

36 Barbara Rose, *American Art Since 1900* (New York: Praeger, 1975), p. 175.

37 In "Femininity," *New Introductory Lectures on Psycho-Analysis* (1933), *Standard Edition* (London: Hogarth Press and the Institute of Psycho-Analysis, 1964), 22:132, Freud writes that one of the "few contributions to the discoveries and inventions in the history of civilization" is the "technique . . . of plaiting and weaving. . . . nature herself would seem to have given the model which this achievement imitates by causing the growth at maturity of the pubic hair that conceals the genitals. The step that remained to be taken lay in making the threads adhere to one another, while on the body they stick into the skin and are only matted together."

38 Chihuly, quoted in Sims, p. 22.

39 Sims, p. 22.

40 Robert Pincus-Witten, in *Postminimalism* (New York: Out of London Press, 1977), p. 16, writes that "the first phase of Post-Minimalism is marked by an expressionist revival of painterly issues." It also involved "the application of this expressive painterliness, not only to painting itself, but to sculpture," implying "a revival of gestural Abstract-Expressionist attitudes." "This expressive painterliness was accompanied by a refreshed focus on personality and colorism, and on a highly eccentric dematerialized, or open form. . . . Often the eccentricity of the substances . . . used was the means whereby the artist could be identified, a 'signature substance': Serra's lead, Sonnier's neon, Benglis's foam, Le Va's felt," and, one might add, Chihuly's glass. There is an "emphasis on the process of making, a process so emphatic as to be seen as the primary content of the work itself, hence the term 'process art.'" One can argue that Chihuly's sculptures are ultimately about the process of glassmaking, whatever else they may seem to address as well.

41 See Krakauer, pp. 98–99, for an account of Harvey Littleton.

42 Chihuly, quoted in Sims, p. 26.

43 Linda Norden, quoted in ibid.

44 D. W. Winnicott, "Ego Distortions in Terms of True and False Self" (1960), *The Maturational Processes and the Facilitating Environment* (New York: International Universities Press, 1965), p. 148.

45 In her *Creativity and Perversion* (London: Free Association Books, 1985), p. 2, Janine Chasseguet-Smirgel describes perversion as the "erosion of the double difference between the sexes and the generations, of all differences in fact." With a little heat, glass readily "dedifferentiates," losing the difference it has when solidly shaped.

46 Alfred North Whitehead, *Process and Reality* (New York: Humanities Press, 1955), pp. 31–32. Whitehead sees "creative flux" as the "Category of the Ultimate." If glass is effectively in perpetual creative flux—in a perpetual process of concrescence, to use Whitehead's word—perhaps it can be regarded as the ultimate creative material, at once primordial and fraught with experimental consequence.

47 See Sims, pp. 9, 11, for an account of Chihuly's stay at the Venini Fabrica.

48 Ibid., p. 29.

49 Ibid.

50 Wilhelm Worringer, in *Form in Gothic* (New York: Schocken, 1964), pp. 55–56, observes that "Northern ornament lacks the concept of symmetry which from the beginning was so characteristic of all Classical ornament. Symmetry is replaced by repetition. . . . A continually increasing activity without pauses or accents is set up and repetition has only the one aim of giving the particular motive a potential infinity. . . . If . . . we close our eyes, all that remains to us is a lingering impression of a formless, ceaseless activity." The "infinite line" of such ornament is "more than enigmatic: it is labyrinthine. It seems to have neither beginning nor end and above all no center: there is a total absence of any such means of guidance for the organically arrested feeling." I suggest that a good part of the paradox of Chihuly's sculpture is that it has the infinite expressive line of Northern ornament and the infinite expressive color of Mediterranean—Venetian—art. That is, it merges North(west) and South(east).

51 Sims, p. 30.

52 Ibid., p. 33.

53 Chihuly's ironic use of kitsch reaches a climax of sorts in the *Putti* series (begun in 1990), plump glass angels that combine, as Sims writes, "mocking self-portraiture with impish kitsch" (p. 14). One can say that the *Putti* show Chihuly satirizing the narcissistic paradise of his environments without, however, expelling himself from it. Justin Spring, in "Dale Chihuly at Charles Cowles Gallery," *Artforum* 30, no. 10 (Summer 1992): 110, describes Chihuly as "a singular and visionary artist, cleverly disguised as a craftsman of kitsch." It should be noted that in fusing avant-garde and kitsch ideas Chihuly shows his postmodernity. This does not contradict the modernism of his allover environments and color-music, for, as I have argued in *The Cult of the Avant-Garde Artist* (London and New York: Cambridge University Press, 1992), modernist and postmodernist tendencies can coexist in the same artist, and indeed do throughout modernity. The simultaneity of avant-garde and kitsch is a fact of modern existence. But what counts is whether the former is hierarchically elevated over the latter, as occurs in modern art, or whether the relationship between the two is leveled, each infecting and converging with the other (whether as an attitude or a practice), as occurs in postmodern art and in postmodernity as such.

I should remark that I regard kitsch, in all its infinite variety, as an attempt to distract us from the reality of our existence, both as subjects and objects in the world, while the avant-garde is an attempt, with means that necessarily change constantly in a world that appropriates them almost as fast as they are invented (which means that the avant-garde must constantly reinvent itself), to restore that lost (externally suppressed, internally repressed) reality to us, in

however perverse form. Thus the postmodern destruction of the distinction between avant-garde and kitsch means we can no longer determine the character—let alone the meaning—of reality, or even if there is any. This is reflected in the irreality of Chihuly's works.

54 Chihuly's streak of nihilistic fatalism—no doubt it comes with working with glass, which can always shatter in process—is exemplified in his reported indifference to the destruction by fire of his studio in Providence, Rhode Island, in the summer of 1973, while he was teaching at the Pilchuck Glass School (which he founded) in Washington State. See Sims, p. 44.

55 As Marion Milner writes in *On Not Being Able to Paint* (New York: International Universities Press, 1957), p. 99, "To allow a rhythm to develop in one's hand movement . . . did seem to require a temporary throwing to the winds of the dominating will. . . . a kind of plunge which one's ordinary consciousness could dread." More broadly, creativity involves release from socially enforced inhibition of "bodily impulses" or the physical expression of feelings (p. 107). Certainly this is what occurs in the strenuous physicality of the glassmaking process. Throwing caution to the winds in order to stretch the limits of glass technique, Chihuly returns to primordial bodiliness. Only in such abandonment, and in the recovery of elemental bodiliness to which it may lead, can what Milner calls "the communication of primary sensual experience" occur. See her *Suppressed Madness of Sane Men: Forty-four Years of Exploring Psychoanalysis* (London: Tavistock, 1987).

56 *Mitla* echoed Robert Smithson's early minimalist sculptures—the so-called entropic monuments—as well as his various mirror works, perhaps particularly the "mirror displacements" he created in the Yucatán. (Mitla, too, was inspired by the architecture of ancient Mexico.) See Smithson, "Incidents of Mirror-Travel in the Yucatán," *The Writings of Robert Smithson* (New York: New York University Press, 1979), pp. 94–103. *Glass Pour* strongly echoed Smithson's various pour pieces using liquid tar. And the Artpark installations reflected Smithson's attempt to "return sculpture to the landscape" (ibid., p. 5), to rearticulate the timeless by calling attention to geological time. See Sims, pp. 49, 50, and 53, for descriptions of these works by Chihuly.

57 Sims, p. 54.

58 Ibid., p. 57.

59 For a brilliant analysis of Chihuly's Rainbow Room installation, see Linda Norden, "A Rainbow in the Dark," *New Work* (Fall 1980): 20–23.

60 In *Critical Essays* (Evanston, IL: Northwestern University Press, 1972), p. 68, Roland Barthes writes, "The avant-garde author is somewhat like the witch doctor of so-called primitive societies: he concentrates the irregularity, the better to purge it from society as a whole. No doubt the bourgeoisie, in its declining phase, has required these aberrant operations which so noticeably label certain of its temptations. The avant-garde is in fact another cathartic phenomenon, a kind of vaccine intended to inject a little subjectivity, a little freedom under the crust of bourgeois values: we feel better for having taken part—a declared but limited part—in the disease." Chihuly's work is avant-garde to the extent that it tempts the bourgeois with a subjectivity so completely alienated from them that they don't know if it is really real. Pop or kitsch psychology is another attempt to retrieve what seems inalienable but has been objectified into alienation by bourgeois society. This suggests that Chihuly's works, insofar as they are kitsch, can be comprehended only by a psychology as kitschified as subjectivity itself. It may be that in postmodern society the most avant-garde psychology—for example, Lacanian psychoanalysis and cognitive psychology—is necessarily kitsch, that is, it forcefully hides, even undermines, the reality it reveals—conceals it by revealing it, which is to give it an obscurity from which it can never recover.

61 Geldzahler, p. 12.

62 "Post-painterly abstraction," the title of an exhibition, and a movement, that Greenberg organized in 1965, marked the beginning of the decline of Greenberg's influence as a critic.

63 Peter Hartocollis, in *Time and Timelessness or the Varieties of Temporal Experience (A Psychoanalytic Inquiry)* (New York: International Universities Press,

1983), notes that "the term [specious present] was coined by the English psychologist E. R. Clay (1882), who wrote: 'The present to which the datum refers is really a part of the past—a recent past—delusively given as being a time that intervenes between the past and the future'" (p. 3).

64 Geldzahler, p. 12.

65 Ibid.

66 See the account of the ironic relationship between manifest meaning and immanifest desire—a distinction made by Barnaby B. Barratt—in my book *The Dialectic of Decadence* (New York: Stux Press, 1993).

67 See Mihaly Csikszentmihalyi, *Flow: The Psychology of Optimal Experience* (New York: Harper & Row, 1990). Csikszentmihalyi describes "flow experience" or "optimal experience"—the opposite of "psychic entropy"—as occurring "when a person's body or mind is stretched to its limits in a voluntary effort to accomplish something difficult and worthwhile" (p. 3). It brings with it a sense of open system and "leads to ecstasy" (p. 40).

68 The vessel is no more than a form of "envelope," to use a concept important to Chihuly. It is psychically rather than literally functional. The envelope or container becomes its own content in these sculptures. Containment is a basic concept of Bion's theory of the infant-and-mother relationship; Segal, in *Dream, Phantasy and Art,* notes his argument that "the good experience for the infant is that the containing object modifies in some way the part that had been projected into it. He describes how sojourn in the breast seems to ameliorate the projected parts" (p. 50). She also writes, "When the infant introjects the breast as a container that can perform what Bion calls the alpha function of converting the beta elements into alpha ones, it is a container which can bear anxiety sufficiently not to eject the beta elements as an immediate discharge of discomfort. An identification with a good container capable of performing the alpha function is the basis of a healthy mental apparatus" (p. 51). Chihuly's objects, I suggest, are good container-breasts that can bear the anxiety evident in their distorted shapes.

69 Eliade, in *Shamanism: Archaic Techniques of Ecstasy* (Princeton: Princeton University Press, 1964), describes the shaman as "the technician of ecstasy" (p. 4). Andreas Lommel, in *Shamanism: The Beginnings of Art* (New York: McGraw-Hill, 1967), argues that the difference between the shaman and the "modern psychotic" is that the former can "cure himself and progress from . . . a 'negative' psychological state to a 'positive' and productive one" (p. 8). The objects the shaman uses are part of his technique and of the ritual of cure.

70 See my essay "Beuys: Fat, Felt, and Alchemy," *The Critic Is Artist: The Intentionality of Art* (Ann Arbor: UMI Research Press, 1984), pp. 345–58, for an account of the basic role of these materials in Beuys's art and life.

71 Beuys regarded the bee's metamorphosis of honey into honeycomb as the "primary sculptural process," for it involved the transformation of a "chaotic, flowing" material—an embodiment of "spiritual warmth," and an inexhaustible sense of energy—into "crystalline sculptures. . . . regular geometric forms." Warmed, the solid honeycomb melts and becomes fluid, making its own primary warmth available as nurture. See Gotz Adriani, Winfried Konnertz, and Karin Thomas, *Joseph Beuys: Life and Works* (Woodbury, NY: Barron's Educational Series, 1979), pp. 39, 41. There is clearly an analogy here with glassmaking.

72 "Concrete symbolism" or "concrete representation, strictly speaking is not representation at all, since no distinction is made between the object or situation represented." R. Money-Kyrle, quoted in Segal, p. 48.

73 See Michael W. Monroe, "Drawing in the Third Dimension," *Chihuly: Color, Glass and Form*, pp. 32–39. Chihuly's drawings are technically preparatory for his sculptures but, in fact, can stand on their own. The two bodies of work have been exhibited together all too infrequently.

74 The dates of these series are fluid, for Chihuly will return to a particular genre whenever he feels like doing so. He never really closes a series, just as no installation ever takes a fixed form—it can always be rearranged, reinstalled—and no individual work ever seems "closed." This openness is part of his creative fluidity, which can "regress" and "progress" at will.

75 Kangas, discussing the *Venetians*, alone recognizes the additive aspect of Chihuly's sculptures (p. 2). But I would argue that this is not only the case in the *Venetians*, where the "add-ons" are external, but internally, in the coral-like building up of color streams.

76 George Heard Hamilton, in *Painting and Sculpture in Europe 1880 to 1940* (Baltimore: Penguin, 1967), traces Symbolism back to Baudelaire's ideas of a "correspondence" "between experiences of nature and internal state of mind" (p. 41). Gustave Kahn, the "Baudelaire of the Symbolist movement," regarded Symbolism as an attempt to "carry the analysis of the Self to the extreme," with "dream life" being "a fertile source for such subjectivity" (p. 42). Indeed, one can regard Chihuly's glass fantasies as dream objects, which is perhaps the core of their delirium.

77 Kandinsky, quoted in Chipp, p. 16.

78 Ibid., p. 14.

79 Ibid., p. 15.

80 Eliot, in "Rhetoric and Poetic Drama," *The Sacred Wood* (London: Methuen, 1920), distinguishes between a rhetoric of manner and rhetoric of substance (p. 82): it is the difference between a "vicious rhetoric" automatically triggering predictable feelings and a "progressive variation of feeling" bound to real experience. Chihuly's art is clearly a rhetoric of substance. In fact, one of his most amazing feats—a sure sign of creativity—is that he never falls into mannerism, never involuntarily caricatures or reifies himself, which is all the more extraordinary in view of his series' repetitions.

81 Adorno writes, "Art's *promesse du bonheur* . . . has an even more emphatically critical meaning: it not only expresses the idea that current praxis denies happiness, but also carries the connotation that happiness is something beyond praxis" (p. 17). He also states, "Stendhal's dictum about art's *promesse du bonheur* implies that art owes something to empirical life, namely the Utopian content which is foreshadowed by art" (p. 430). But this promise is of the narcissistic paradise, where there is no need for praxis.

82 Of course, childhood only seems a paradise because of the repression of memory through selective amnesia—the self-brainwashing necessary for emotional growth or, more particularly, the repression of the destructive rage induced by childhood frustration. This hardly denies its later sublimation.

83 Winnicott, in "Communicating and Not Communicating Leading to a Study of Certain Opposites," *The Maturational Processes and the Facilitating Environment* (New York: International Universities Press, 1965), speaks of "the mystic's withdrawal into a world of sophisticated introjects," his "retreat to a position in which he can communicate secretly with subjective objects and phenomena, the loss of contact with the world of shared reality being counterbalanced by a gain in terms of feeling real" (pp. 185–86).

84 Quoted in Anthony Storr, *The Dynamics of Creation* (New York: Atheneum, 1985), p. 81.

85 Jean-Michel Quinodoz, *The Taming of Solitude: Separation Anxiety in Psychoanalysis* (London and New York: Routledge, 1993), p. 172. I am using the concept of buoyancy with the full weight of meaning Quinodoz gives it, particularly in chapter 12 on "The Capacity to be Alone, Buoyancy, and the Integration of Psychic Life."

86 Hanna Segal, Foreword to Quinodoz, p. ix.

87 Roger L. Williams, in *The Horror of Life* (Chicago: University of Chicago Press, 1980), a study of the medical history of five prominent nineteenth-century French writers, and its demoralizing effect on them (they all had syphilis and a variety of mental problems, including, as one might expect, hypochondria and paranoia), argues that their negative attitude to life (however compensated by a kind of mental erotomania) motivated their avant-gardism. Negativity, of course, has become a staple of modernism since Marcel Duchamp, who was as anti-life as he was anti-art—a nihilistic mocker of both. A good part of the importance of Chihuly has to do with the fact that his insistence on buoyancy, and its healing power, is a

revolt against 150 years of avant-garde negativity, demoralization, and neuroticism, without forfeiting avant-garde innovation and depth, that is, the search for new ways to articulate what is essential to being and human being. Chihuly, then, has rediscovered and reasserted, with all the robust viscerality implicit in glassmaking, a neglected, indeed, repressed essence and attitude: buoyancy. Avant-garde negativity privileges the abyss over buoyancy—privileges suffering over joie de vivre—in effect dismissing the latter as an illusion and lie. Indeed, avant-garde negativity regards the joyless feeling of being unsupported or "groundless" and thus helplessly sinking away into nothingness as more authentic than the "bourgeois" feeling of being buoyant with life and thus enjoying it— buoyed up by life and buoying it up with one's own being and happiness. Chihuly's new positive, enjoyable avant-garde art asserts the opposite, namely, that the nihilistic sense of falling into the abyss, epitomizing the pathology of demoralization, bespeaks the inauthenticity and failure of existence—the truth that one's being never fully came into its own, and as such is incompletely human. Traditional avant-garde art is not as buoyant with and full of life and humanity as it could be.

88 Donald Kuspit, "Craft in Art, Art as Craft," *New Art Examiner* 23 (April 1996): 14–19, 53.

89 Lawrence S. Kubie, *Neurotic Distortion of the Creative Process* (New York: Farrar, Straus and Giroux/Noonday Press, 1958), p. 21.

90 Ibid., p. 21.

91 Ibid., p. 20.

92 Quinodoz, p. 173.

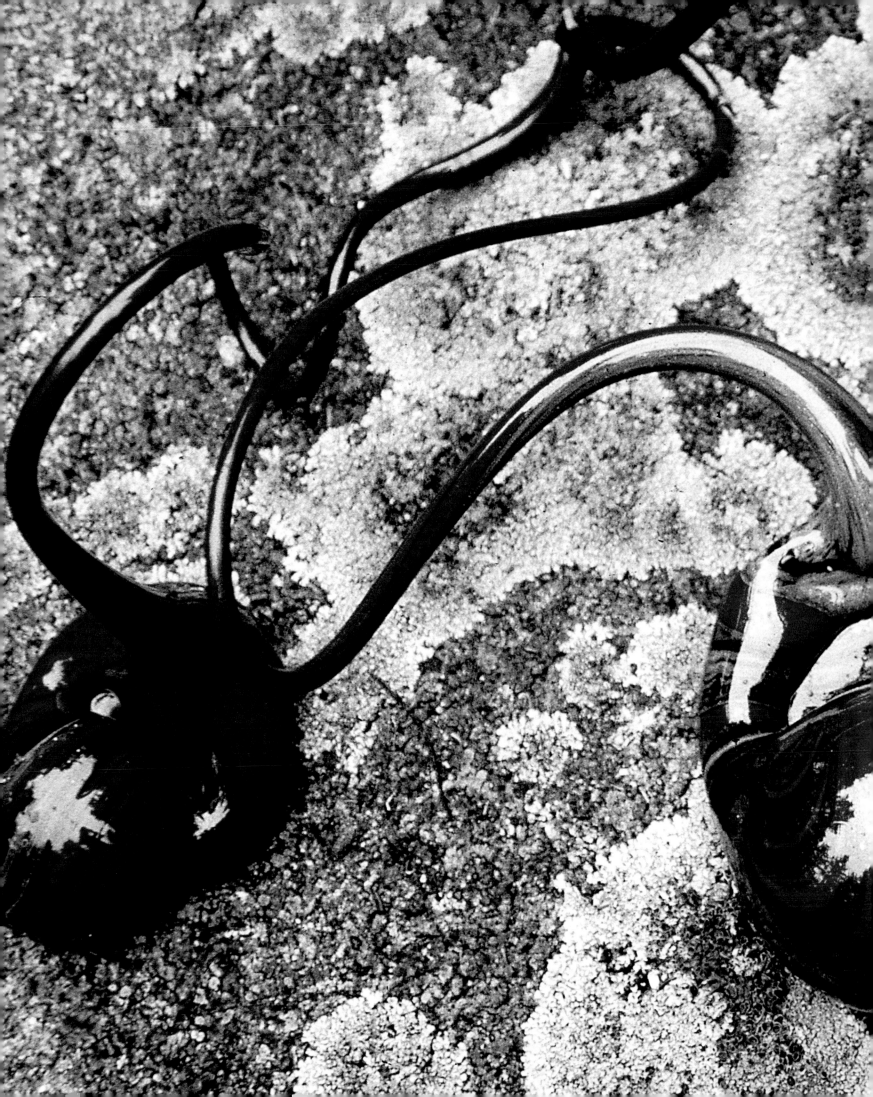

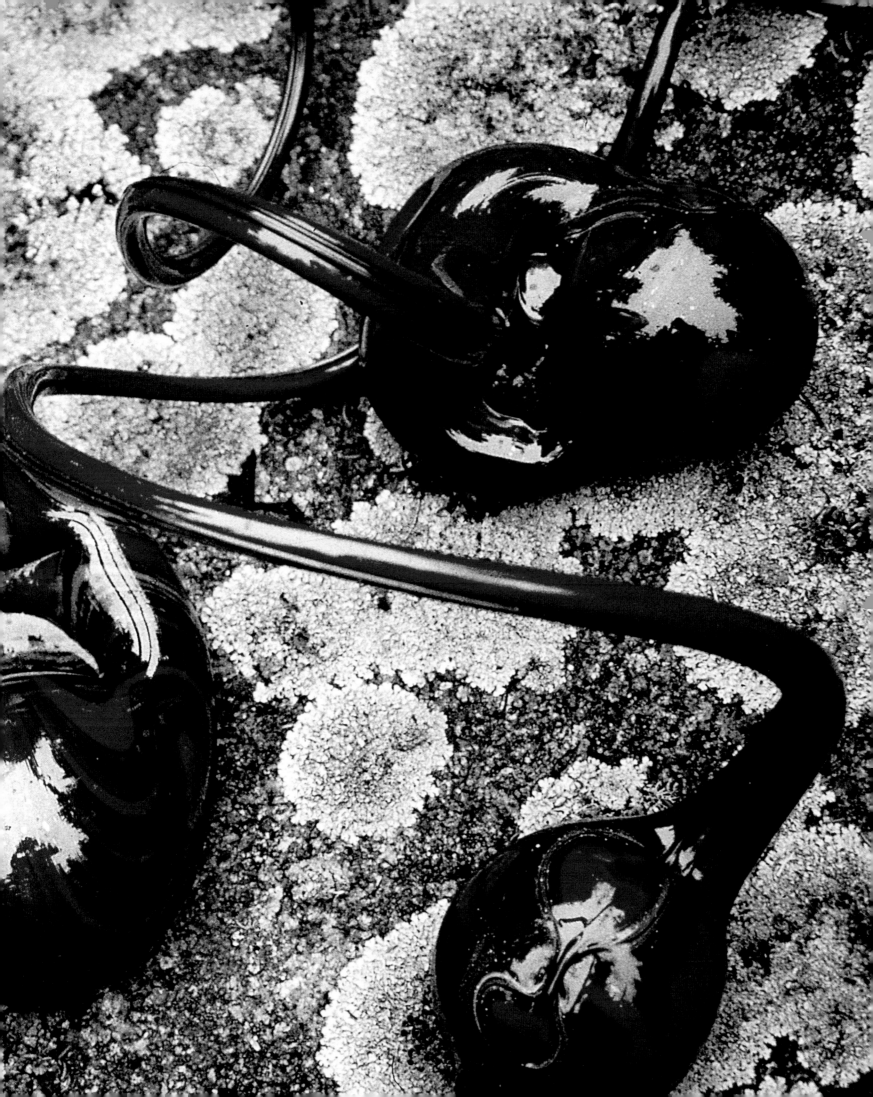

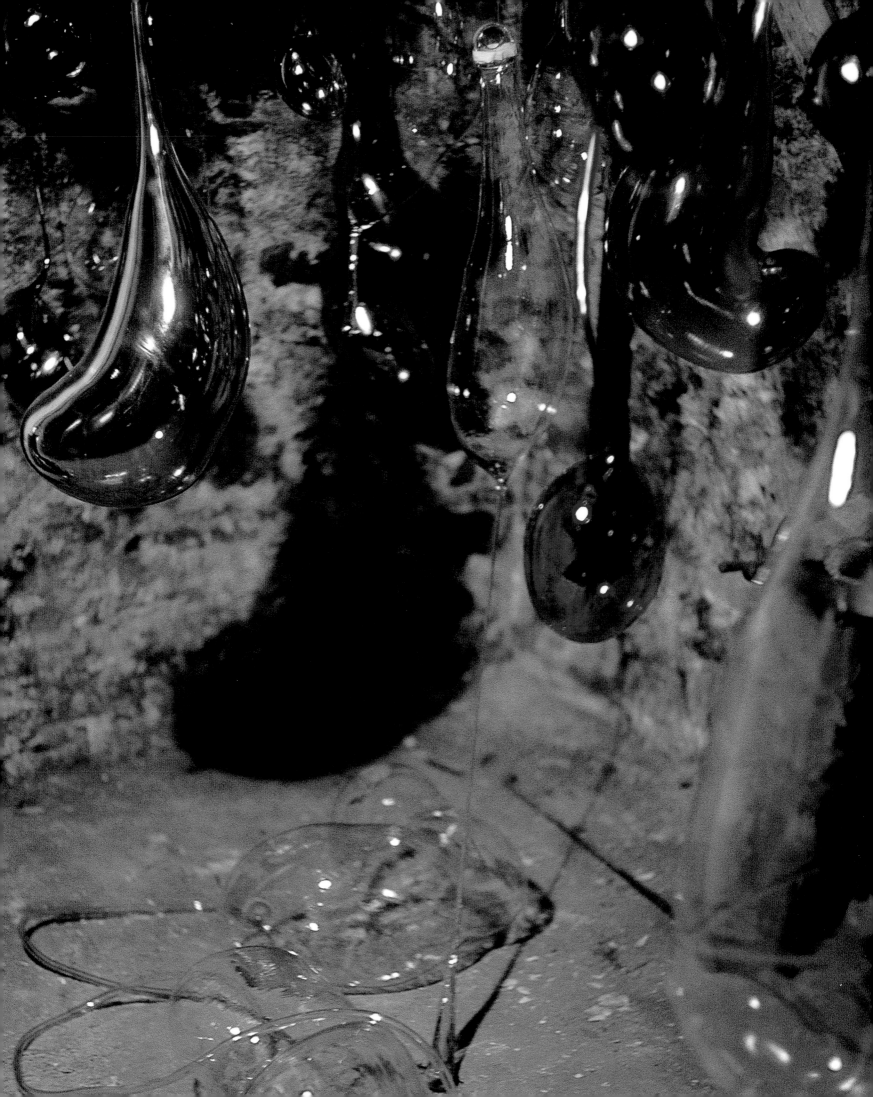

*In the fall of 1967, Chihuly accepted
a teaching assistantship at the
Rhode Island School of Design.
In his basement studio, he created
environments by hanging his
blown glass bubbles "like sides of
meat," sometimes adding other
elements, such as foam rubber,
fluorescent lights, plastic, or neon.
As the curator Patterson Sims has
noted, these temporary, process-based
works had their parallels in the works
of postminimalists of the time—Eva
Hesse, Richard Serra, Lynda Benglis,
and others.*

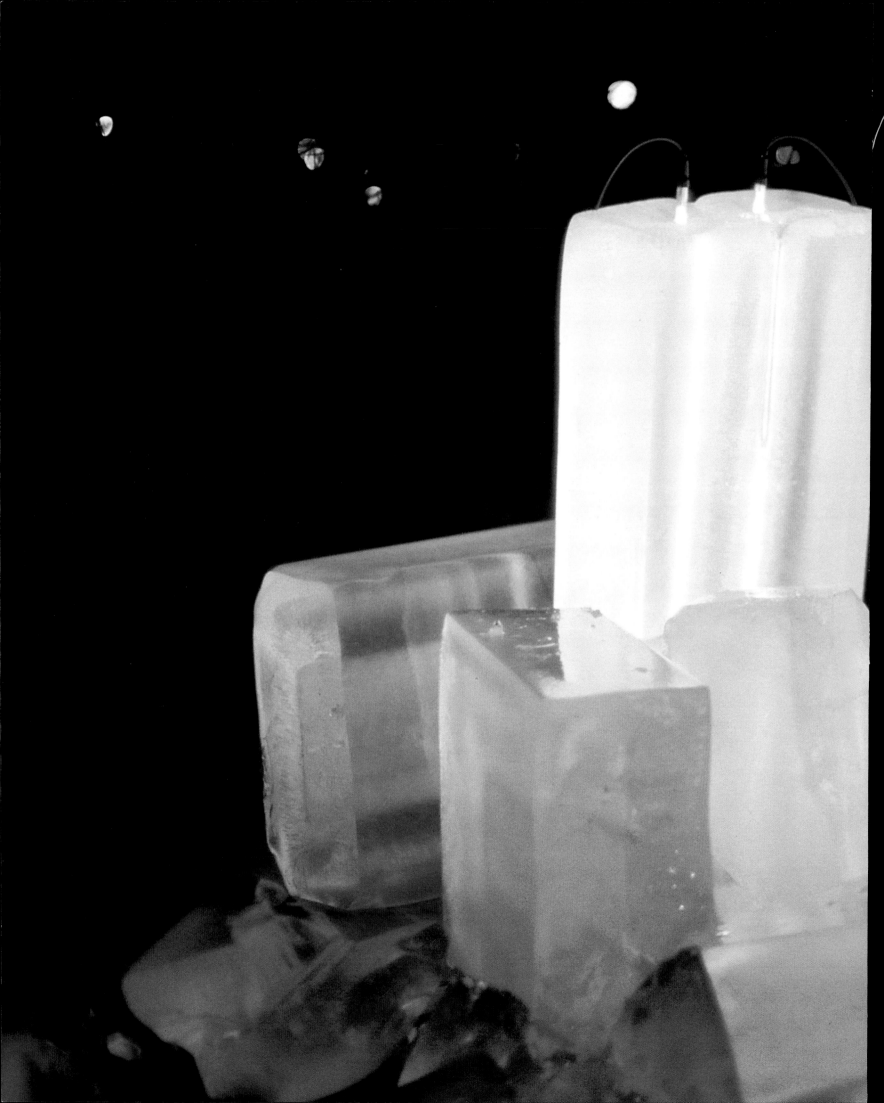

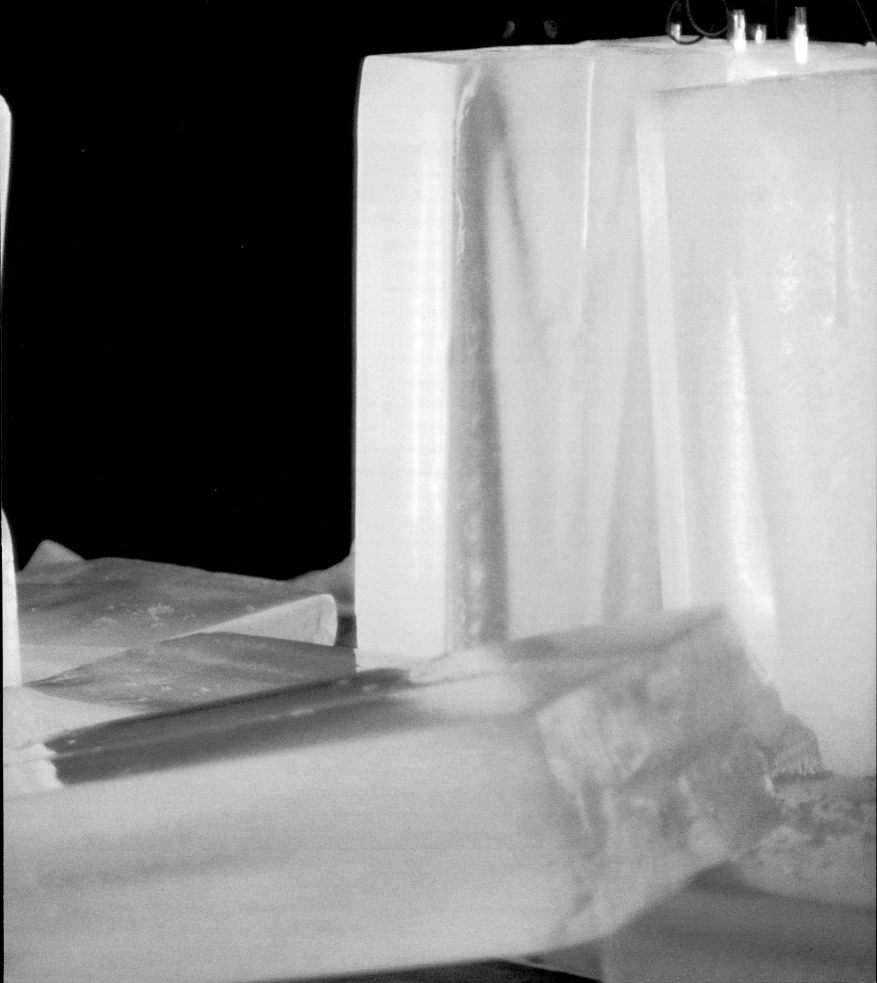

It was a time for experimentation. I wanted to teach in a different way, without the confines of the traditional institution. I thought the Northwest had an ideal climate for a glass blowing school. I went out there with the $2000 and the sixteen students who showed up on the designated day at my mother's home in Tacoma in the beginning of the summer. We started working on the site, which was donated to us for the summer by John Hauberg and Anne Gould Hauberg. We went to work and fourteen days later, we had finished a little facility to blow glass.
—Dale Chihuly, Glasswork, *May 1990*

Above
Pilchuck Pond Installation, 1971, Pilchuck Glass School, Stanwood, Washington

Below
Dale Chihuly (left) and John Hauberg on the grounds of the Pilchuck Glass School, 1982

Opposite
Glass Forest #1, glass, neon, argon, collaboration with James Carpenter, 1971–72, 500 square feet, Museum of Contemporary Crafts, New York, New York

Chihuly experimented, while teaching at the Rhode Island School of Design, with second-year student James Carpenter to see how far the molten glass could be stretched. In an impressive room installation in 1971 at the Museum of Contemporary Crafts (now the American Craft Museum) they utilized pulled strands of molten glass in which they incorporated neon to create an organic, glowing sculptural environment.
—Lloyd E. Herman, Five Visiting Artists, *1984*

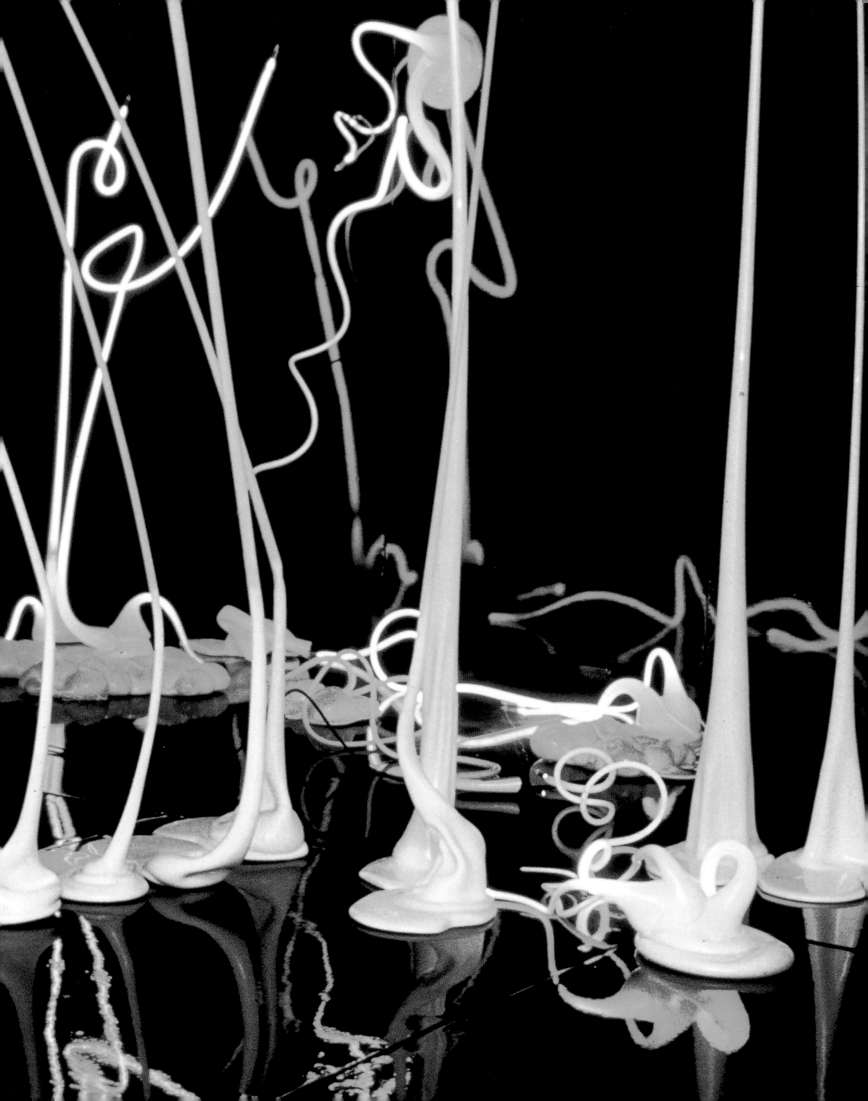

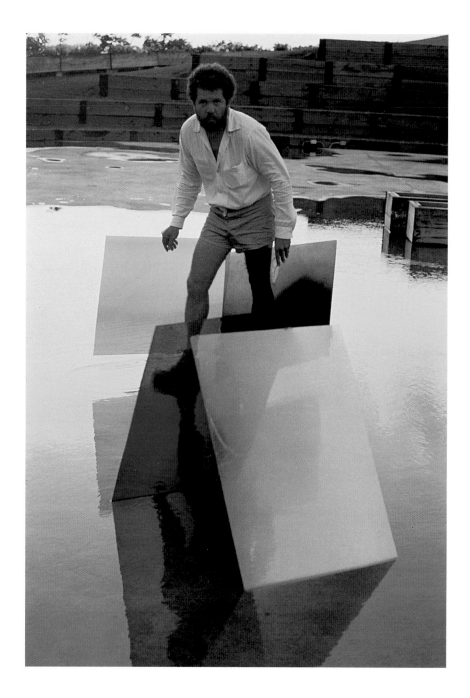

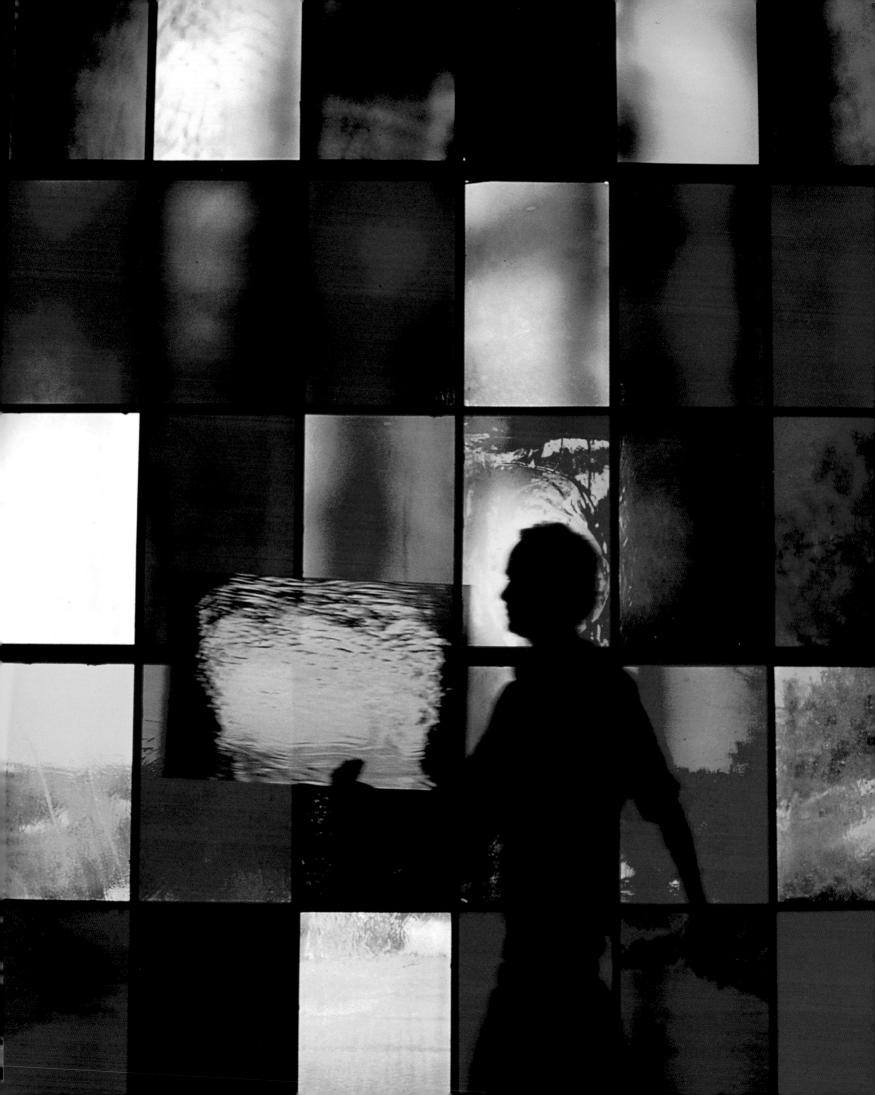

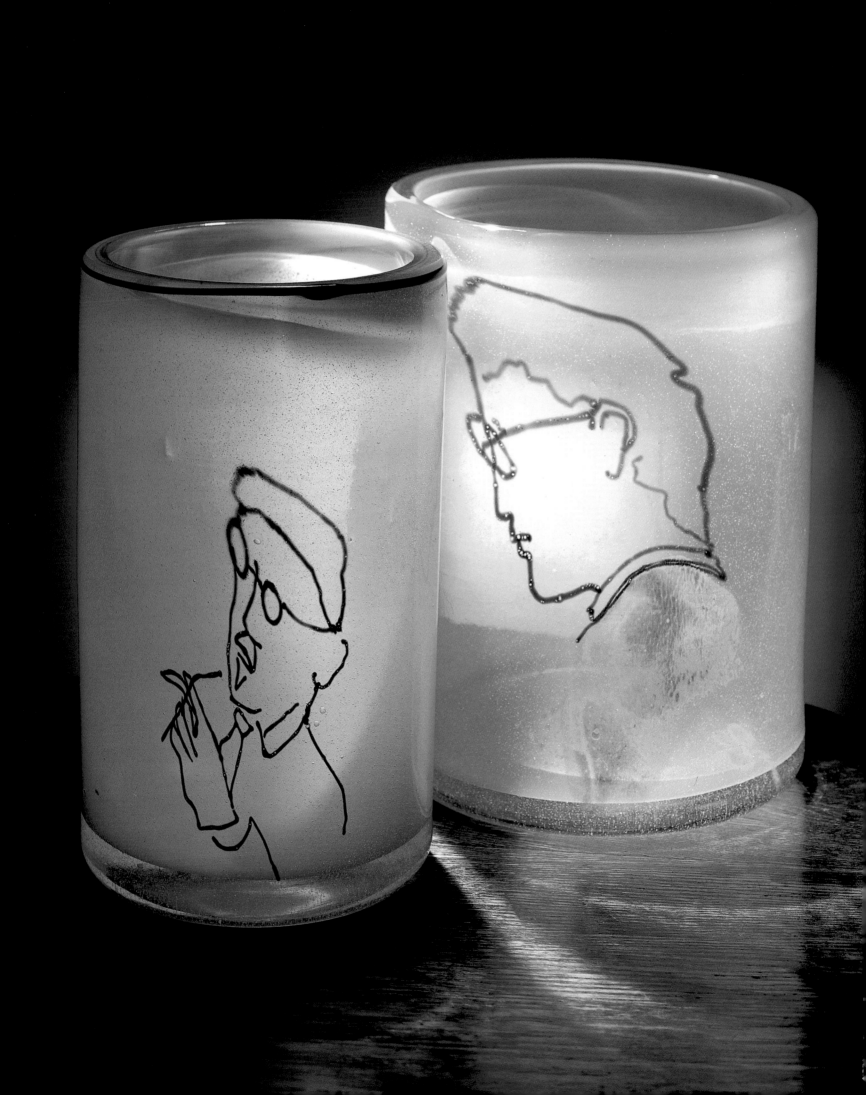

Opposite
Irish Cylinders, James Joyce #1 and
#41, in collaboration with Seaver
Leslie and Flora Mace, 1975, 10" tall

Below
Irish Cylinder #38, "Blazes Boylan," in
collaboration with Seaver Leslie and
Flora Mace, 1975, 10" x 8"

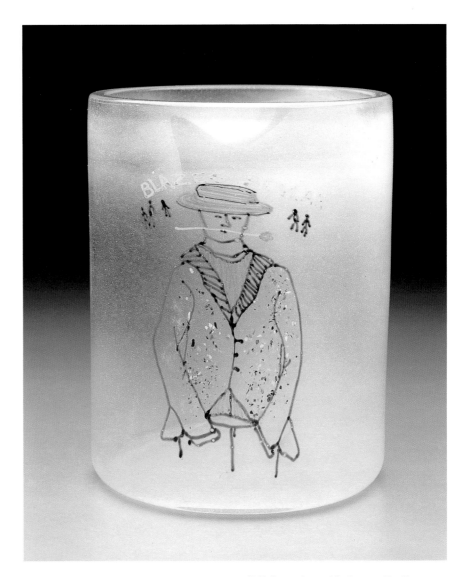

Overleaf
Martells Dandymount, in
collaboration with Seaver Leslie and
Flora Mace, 1975, 9 1/2" x 7 1/2"

Ballynahatty, in collaboration with
Seaver Leslie and Flora Mace, 1975,
11" x 5 1/2"
Lisnacroppan, in collaboration with
Seaver Leslie and Flora Mace, 1975,
10 1/2" x 6"

Collaborating with Seaver Leslie
and Flora Mace in the late fall of
1975, Chihuly created two series of
Cylinders: a "Ulysses" series based on
images from the novel by James Joyce,
and an "Irish" series depicting scenes
from Irish folklore and ancient sites.

Opposite
*Irish Cylinders, in collaboration with
Seaver Leslie and Flora Mace, 1975*

*I had seen a collection of Navajo
blankets at the Museum of Fine Arts
in Boston. And just at the same time,
Italo and Jamie and I had discovered
a technique in glassblowing where
you could make a little drawing in
glass and pick it up on the marvering
table. And we knew right away, this
was kind of a breakthrough technique.
And then I saw the Navajo blankets
and started the Navajo Blanket
Cylinders.*
—Dale Chihuly, Installations, *1992*

*In his cylinders, which he chose for
their simplicity and stability, his
primary concern is the treatment
of the surface. The beauty of the
cylinder series arises from two
sources: skillful manipulation of
the properties unique to glass—clarity
of texture and brilliance of color—and
the painterly qualities of the molten
forming process.*
—Michael W. Monroe, Baskets
and Cylinders: Recent Glass by
Dale Chihuly, *1978*

Above
*Navajo Blanket Cylinder, c. 1975–76,
10" x 6"*

Overleaf
*Navajo Blanket Cylinders, 1974–75,
largest 17" x 6"*

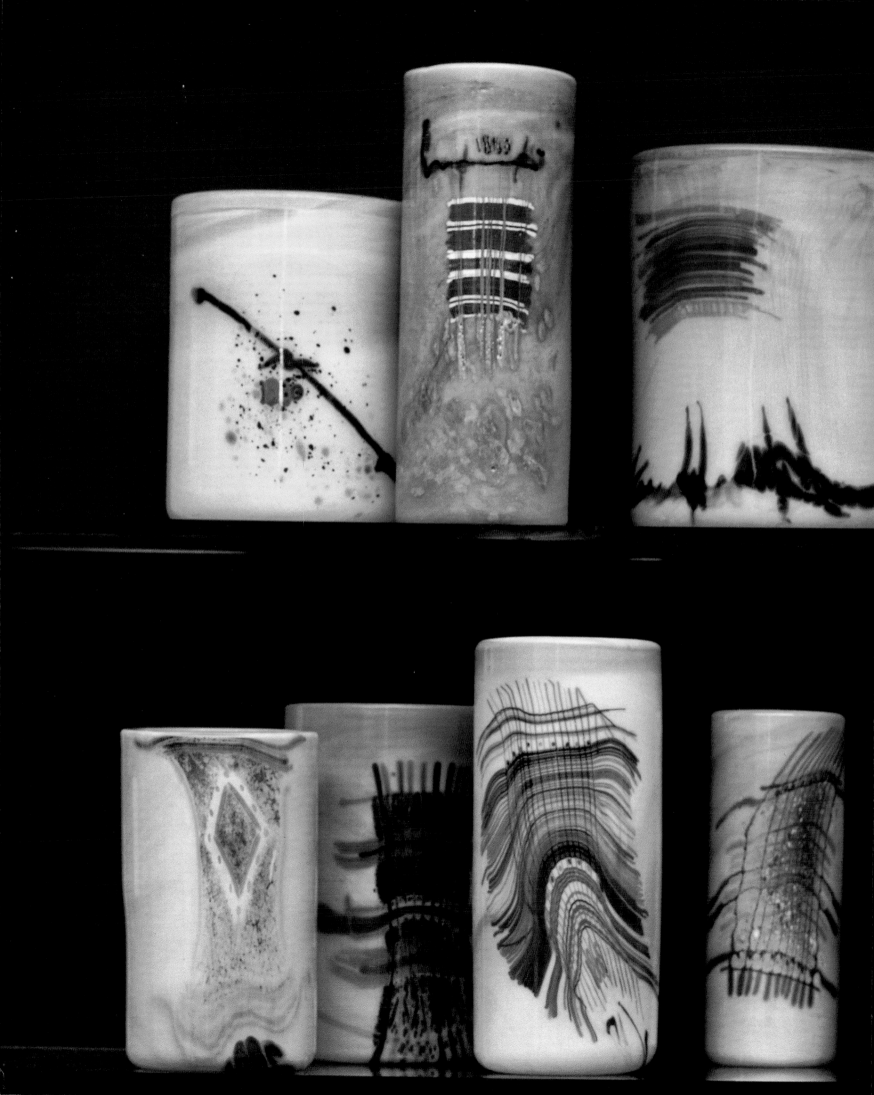

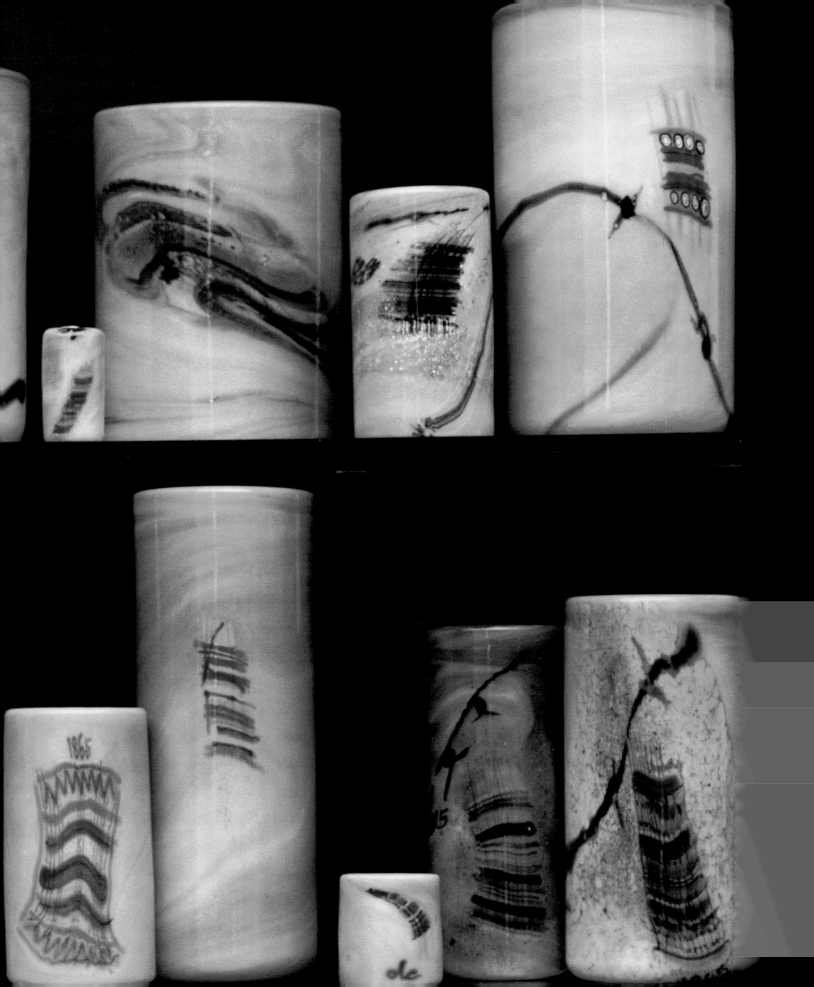

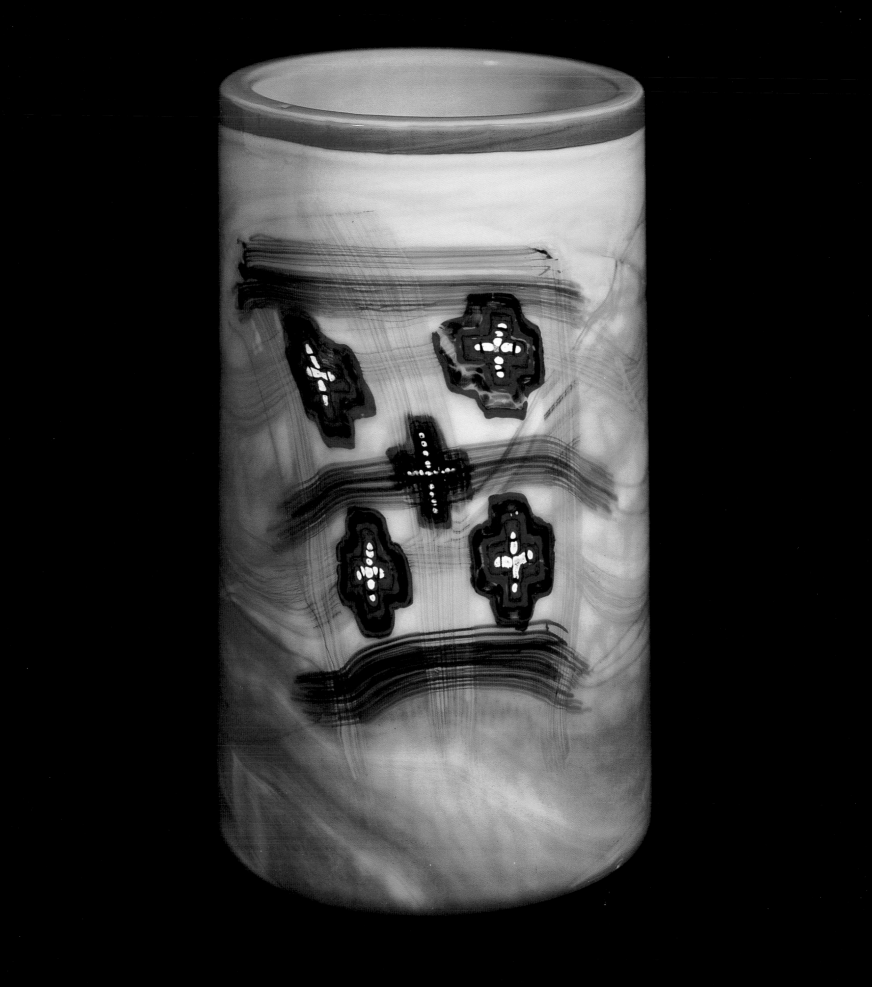

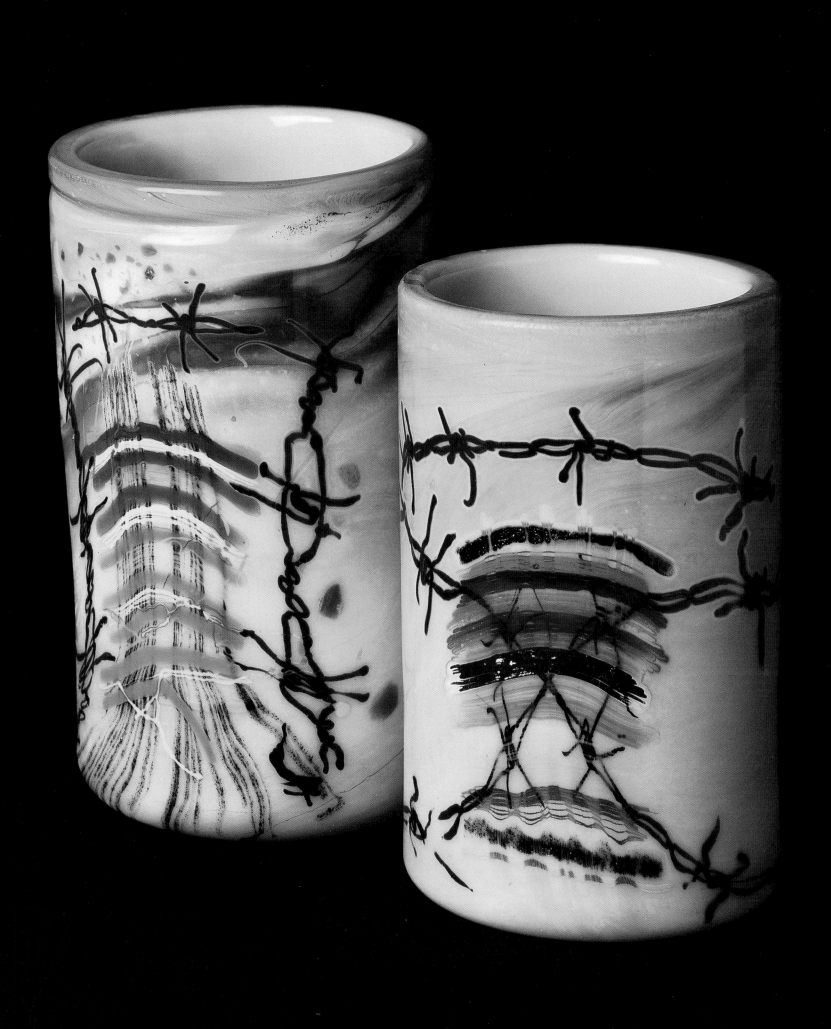

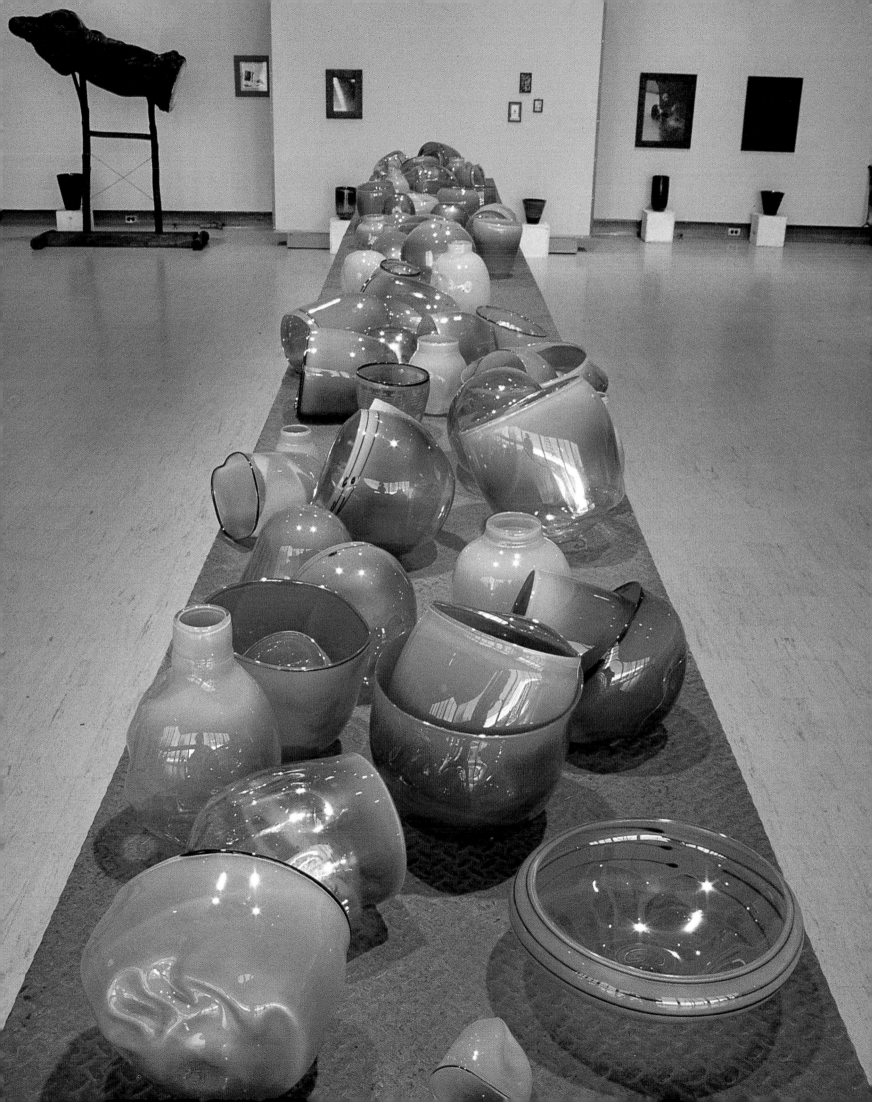

Opposite
An installation of Chihuly's Pilchuck
Baskets in the exhibition Carpenter,
Chihuly, Scanga 1977, curated by
Charles Cowles, at the Seattle Art
Museum, Seattle, Washington

*In the summer of 1977, I was visiting
the Tacoma Historical Society with
Italo Scanga, and I remember being
struck by a pile of Northwest Coast
Indian baskets that were stacked one
inside another. They were dented and
misshapen, wonderful forms. I don't
really know what made me want to
reproduce them in glass but that was
my mission for the summer.*
—Dale Chihuly, Chihuly: Color, Glass
and Form, *1986*

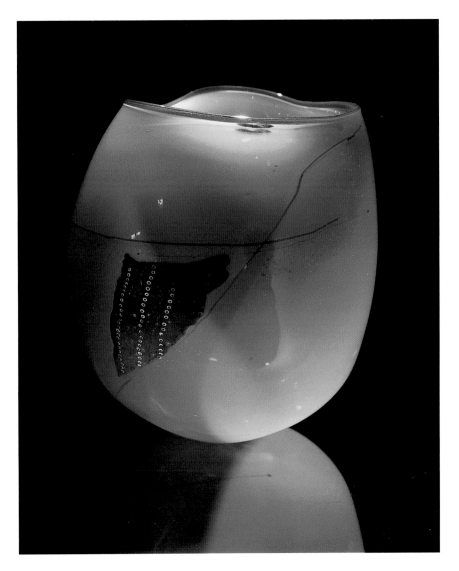

Above
Pilchuck Basket, 1978, 8" x 6"

Overleaf
Tabac Pilchuck Basket Set, c. 1978,
32" wide

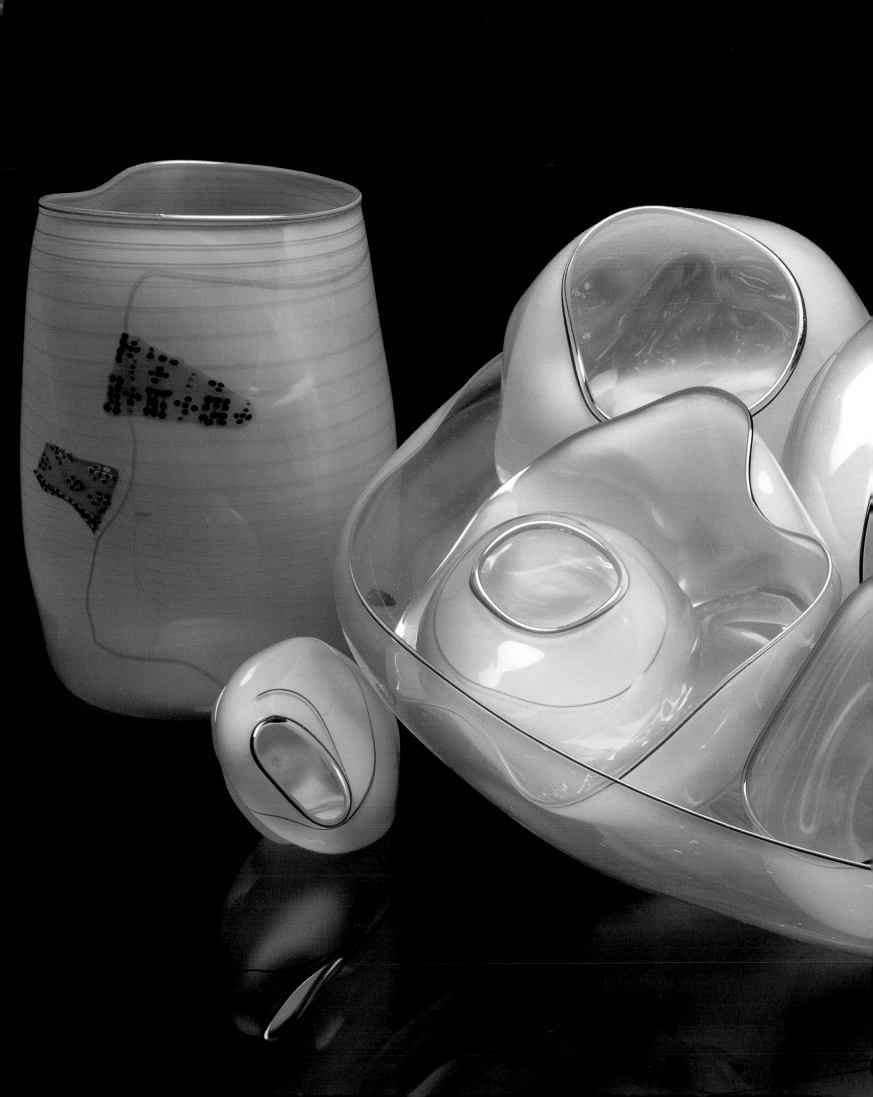

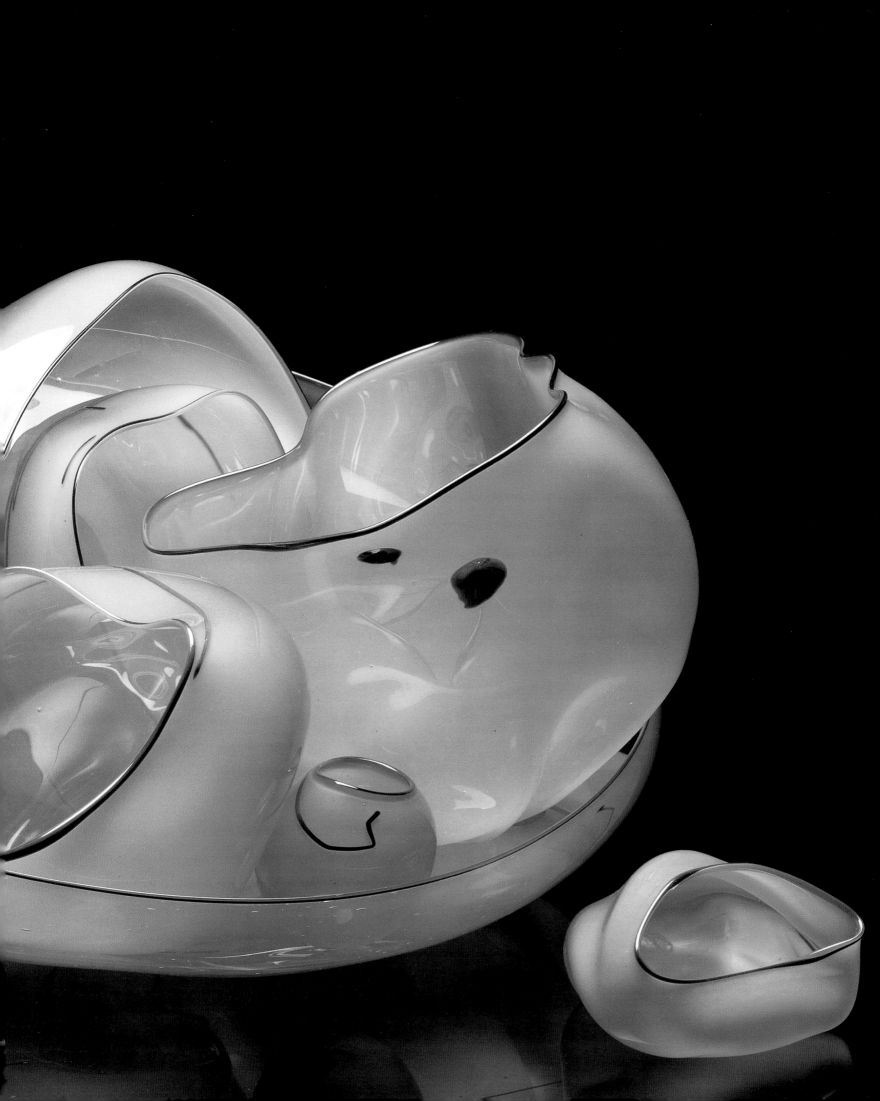

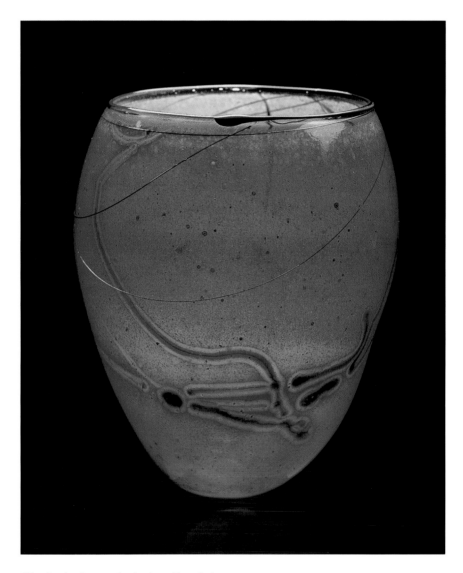

The finely drawn dark glass lines help
accentuate the fragility of these objects
as well as adding a sensitive
decorative element. Indian baskets
stacked on shelves inspired Chihuly's
paper-thin glass forms that tumble
about in spatial arrangements, often
nesting inside each other.
—Alma Eikerman, Contemporary
Glass, *1980*

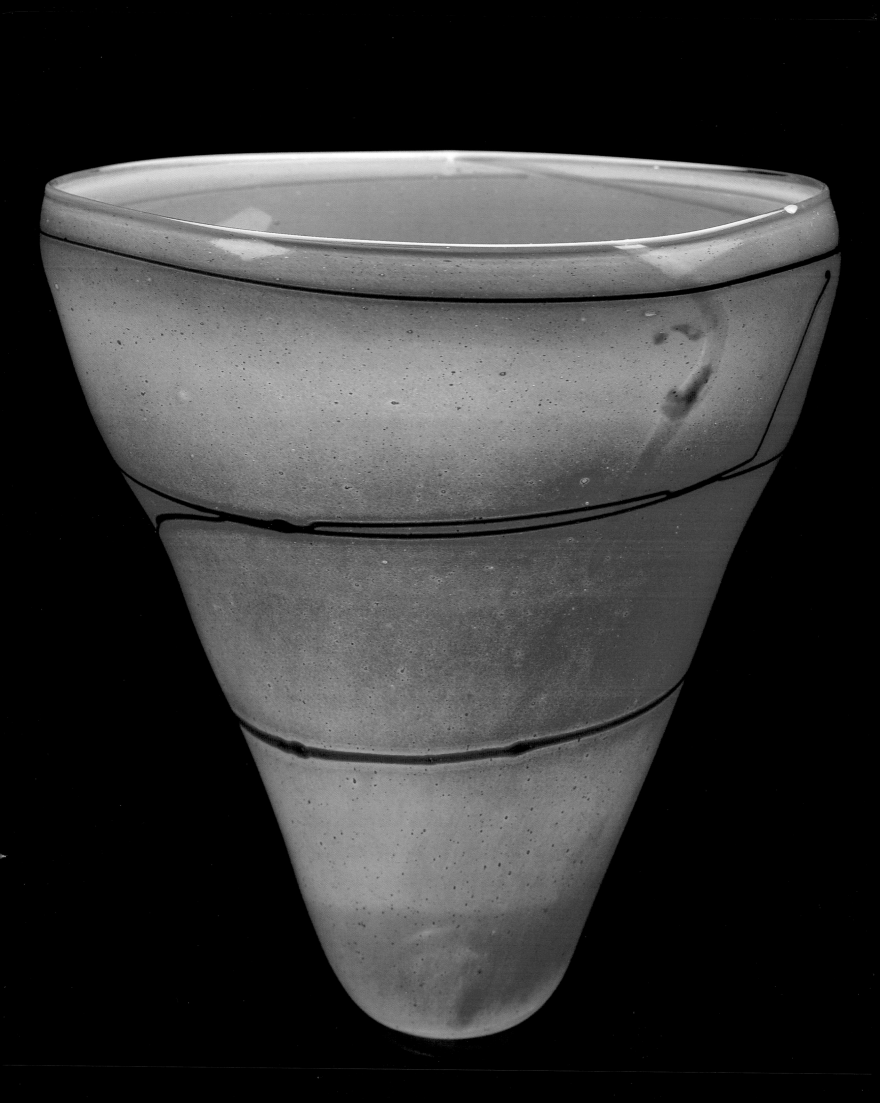

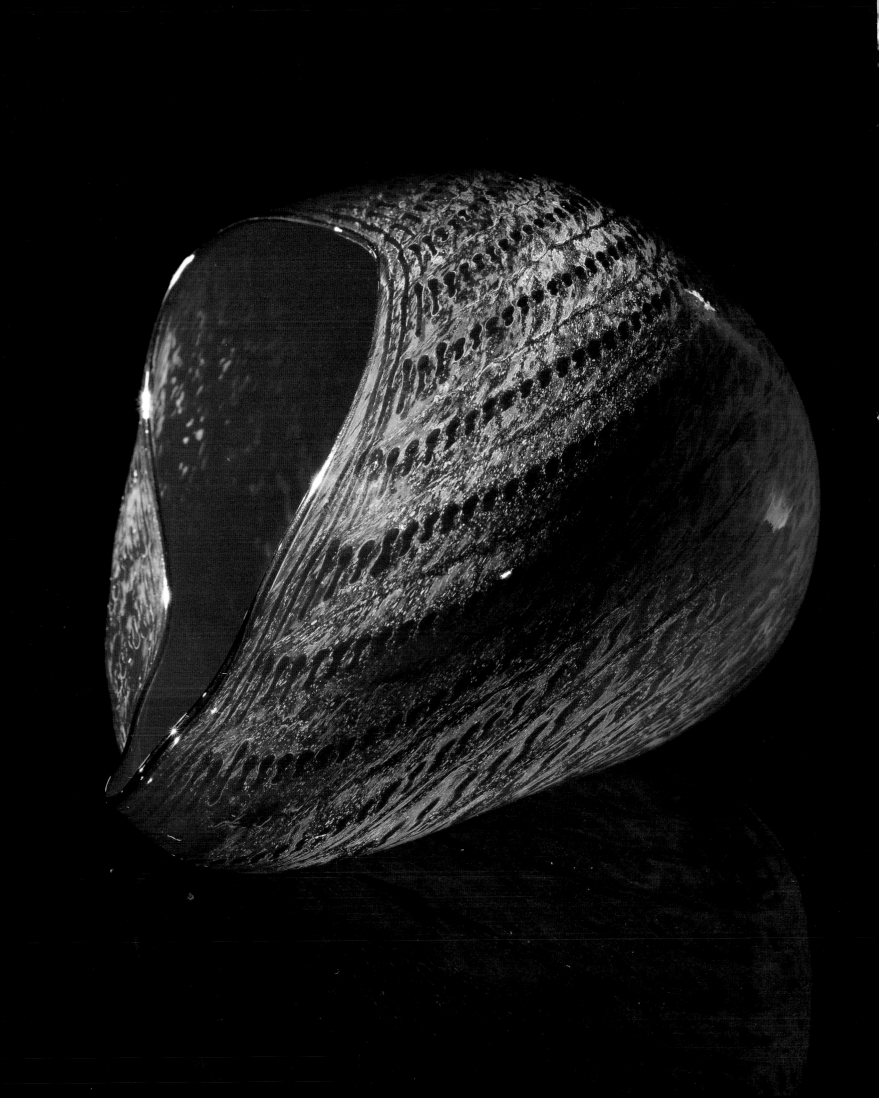

Opposite
Cedar Red Seaform Basket with
Oxblood Wraps, 1981, 4" x 6" x 7"

Below
Basket Set, 1980, 5" x 12" x 12"

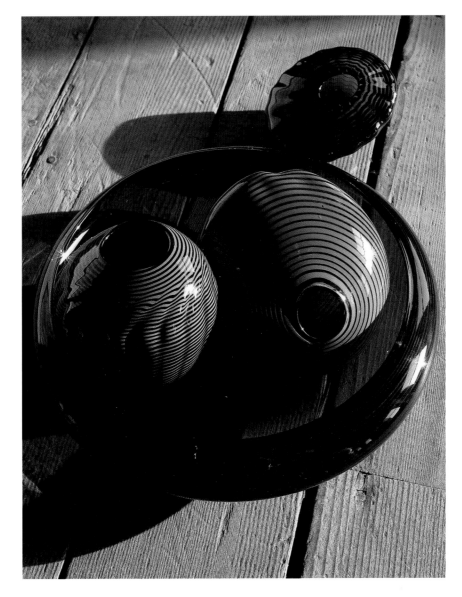

Overleaf
Leopard Basket Group, 1979,
largest 9" x 9" x 9"

Pilchuck Basket Set, 1978,
8" x 16" x 16"

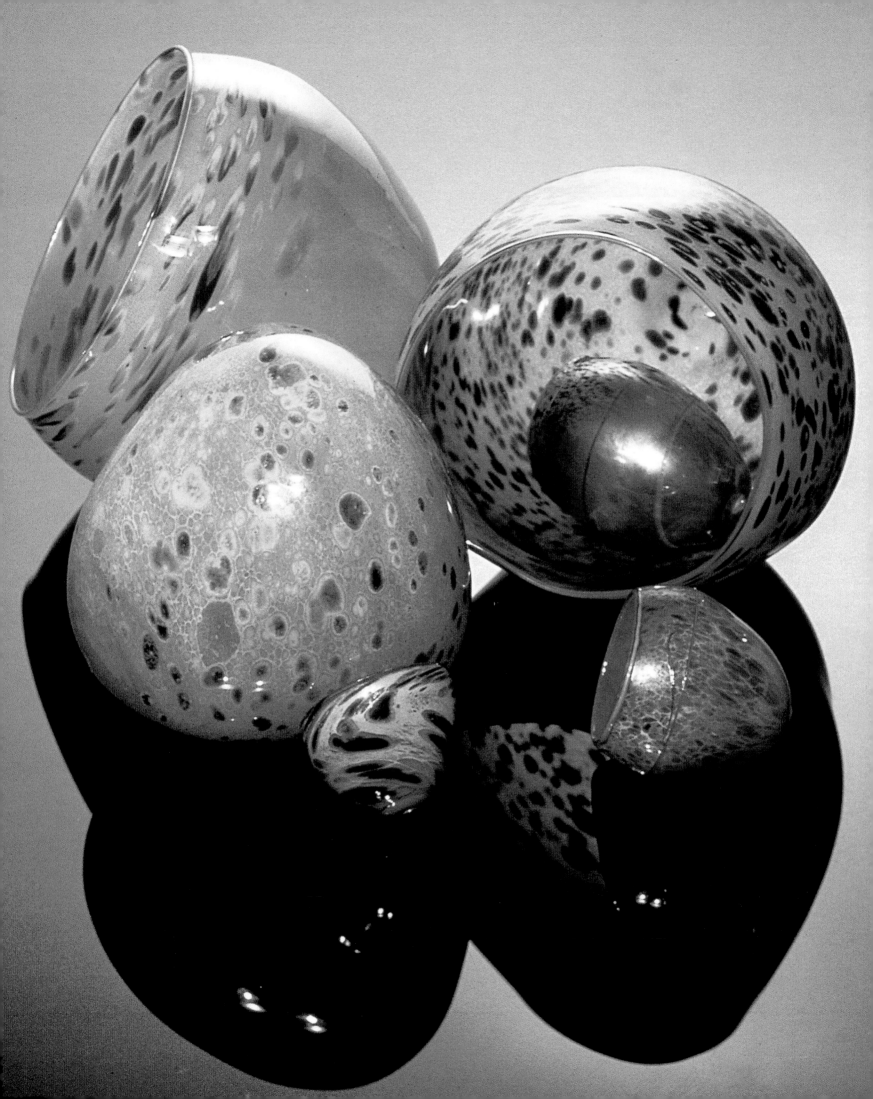

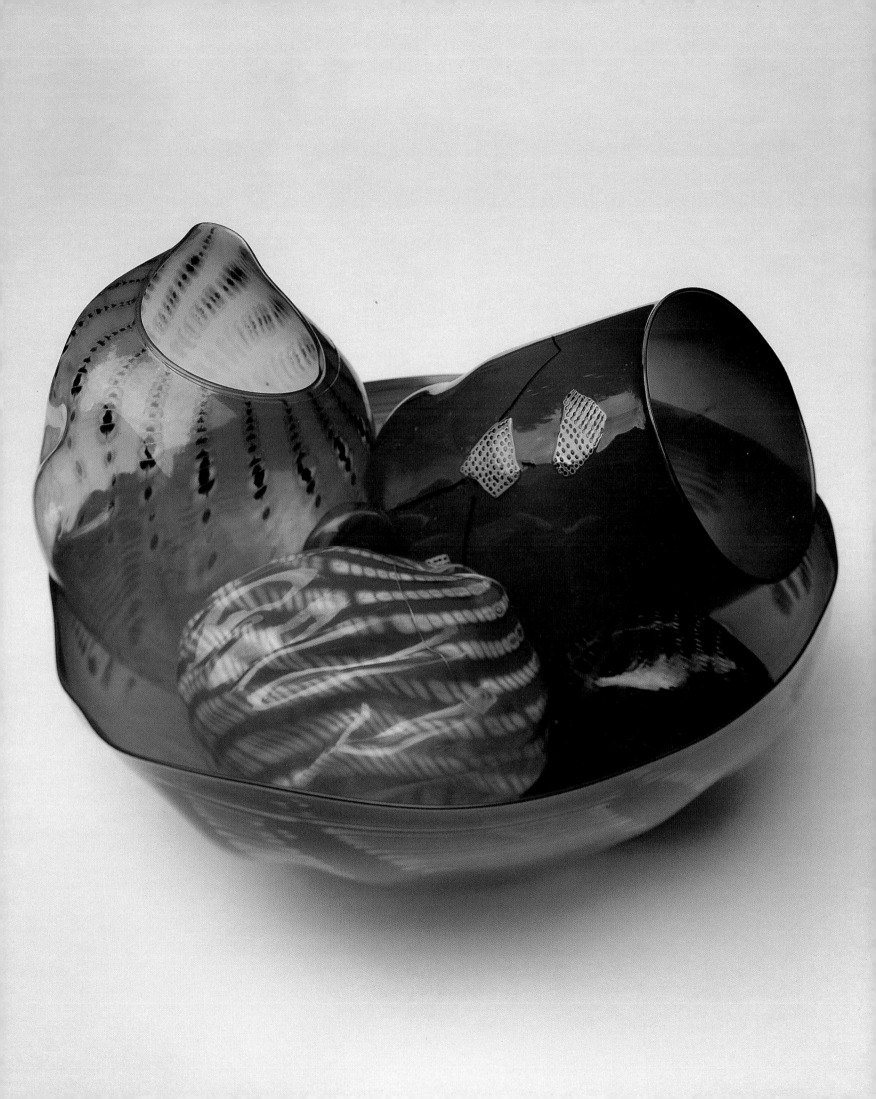

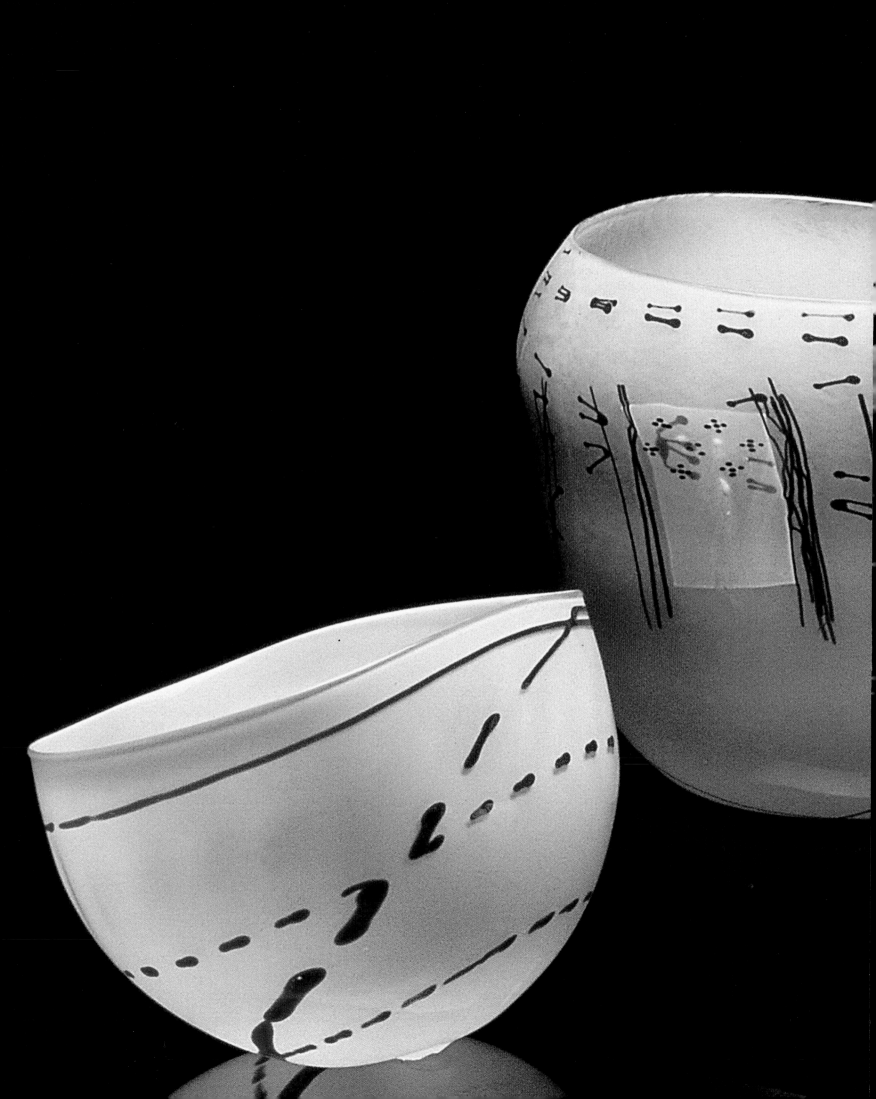

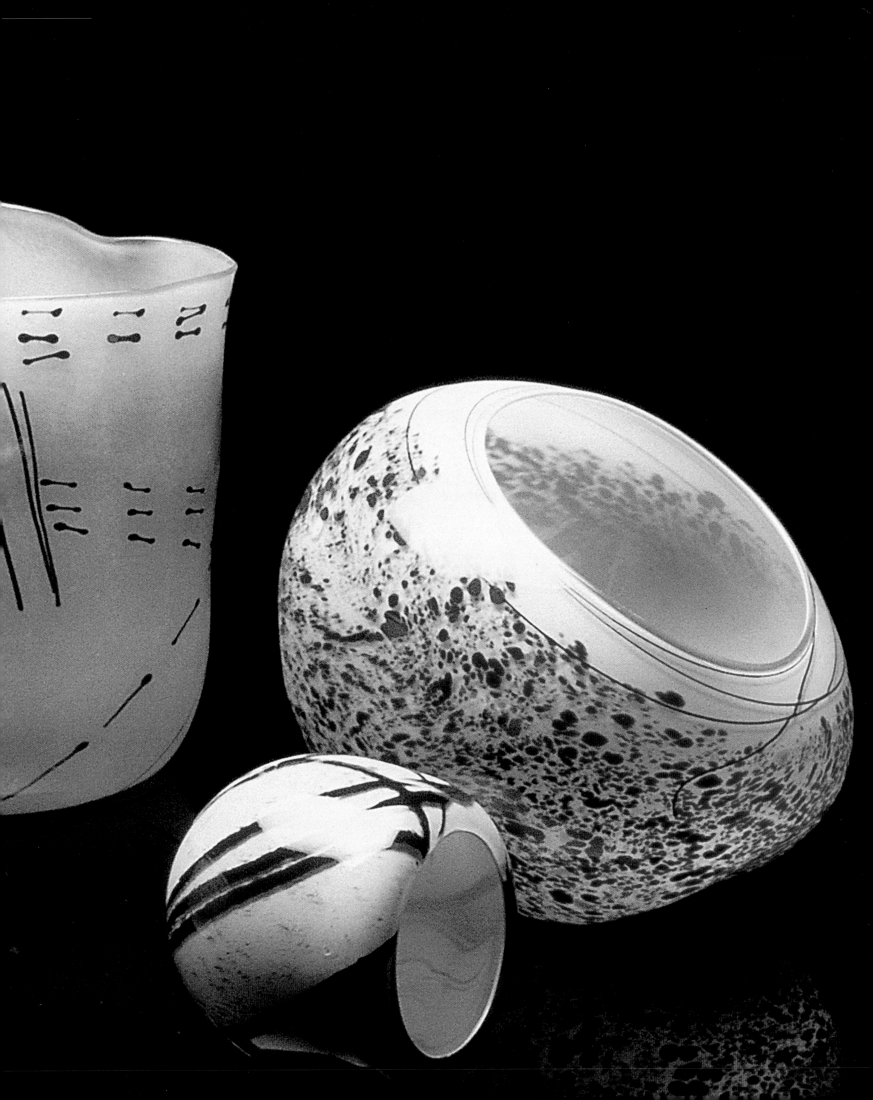

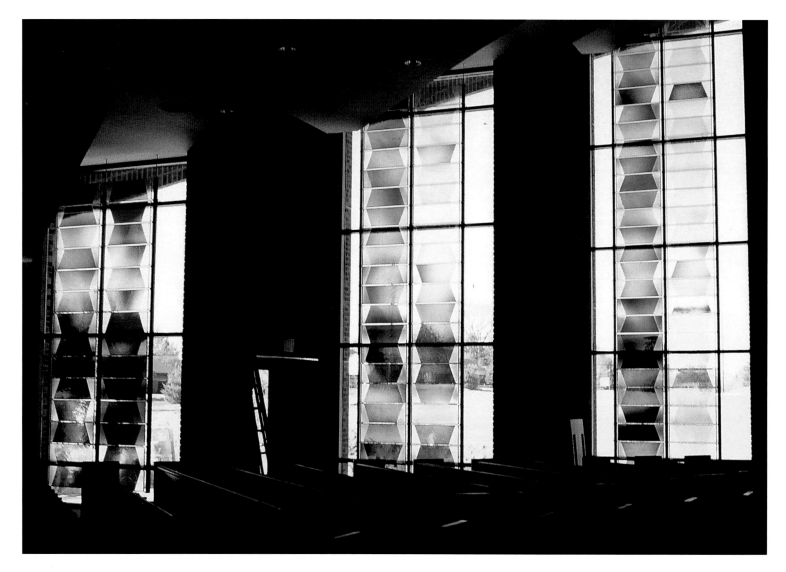

Above and Opposite
Window Installation, 1980, Shaare
Emeth Synagogue, St. Louis, Missouri

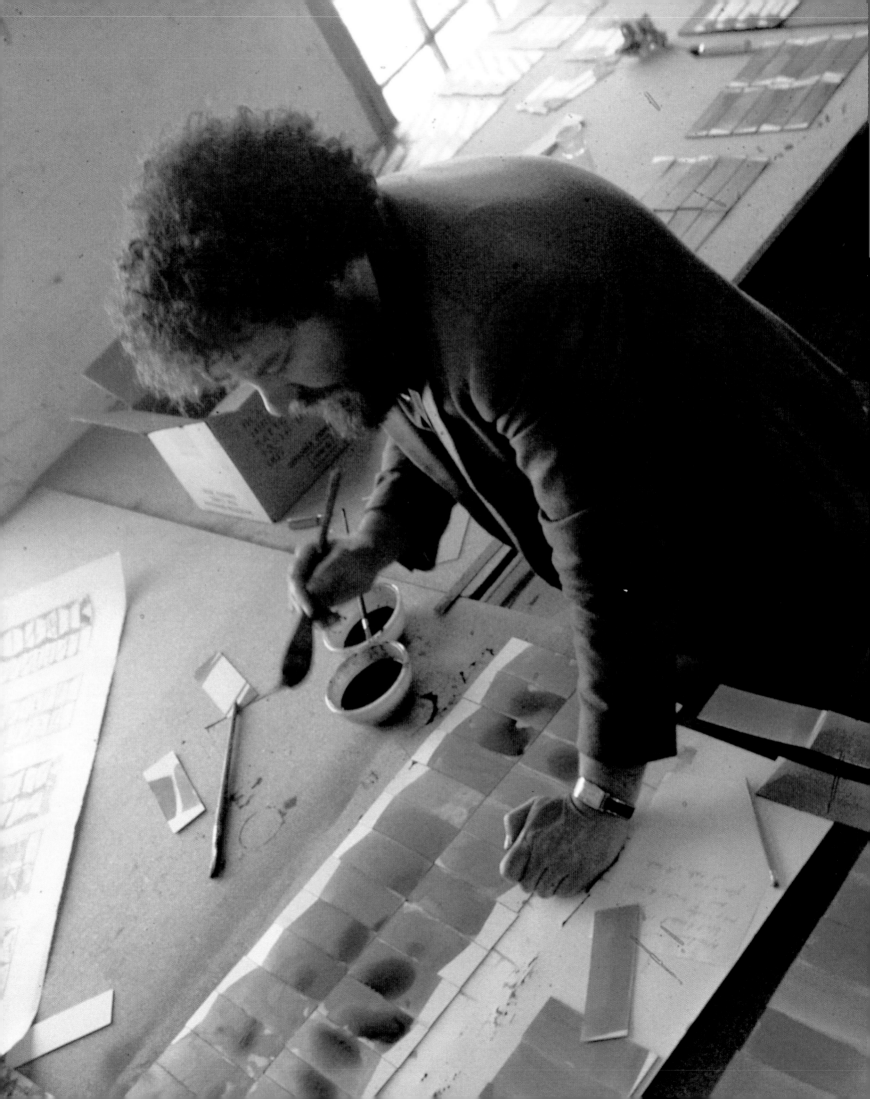

Below
Pilchuck Basket Set, 1979,
6" x 14" x 15"

Opposite
Early Baskets/Macchia, 1978–80

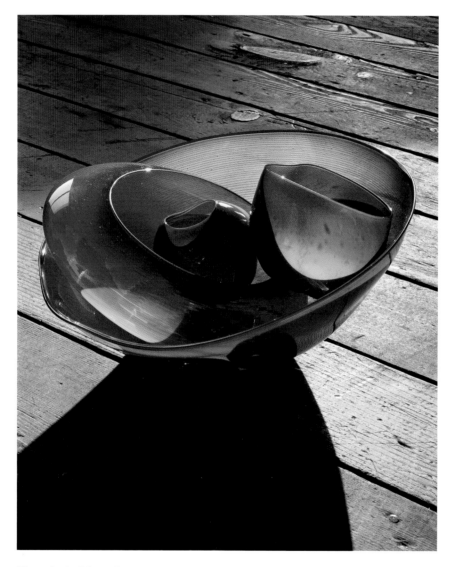

If one looked into these groupings of
Baskets rather than at them, new
worlds open up and one could lose
oneself to the seduction of forms
within forms within forms.
—Linda Norden, Dale Chihuly: Thirty
Years in Glass, 1966–1996, *1996*

Overleaf
Pilchuck Basket Group, c. 1979

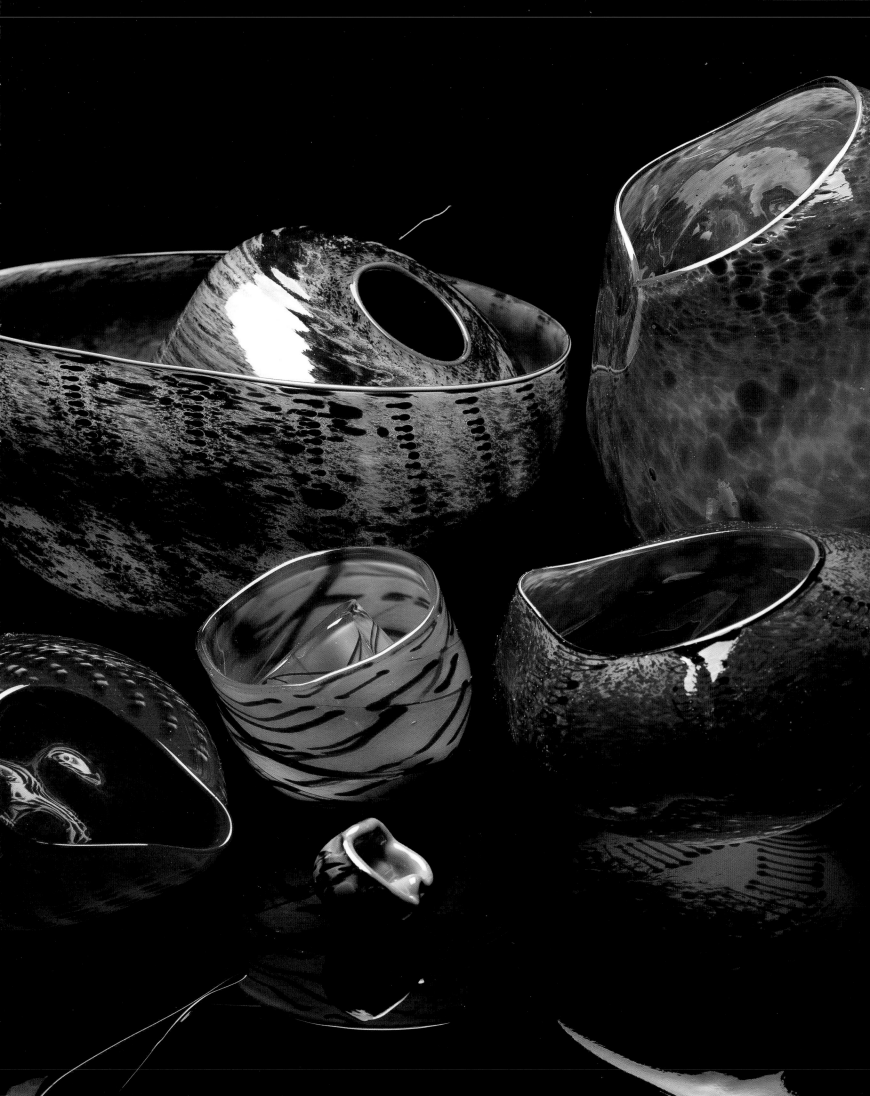

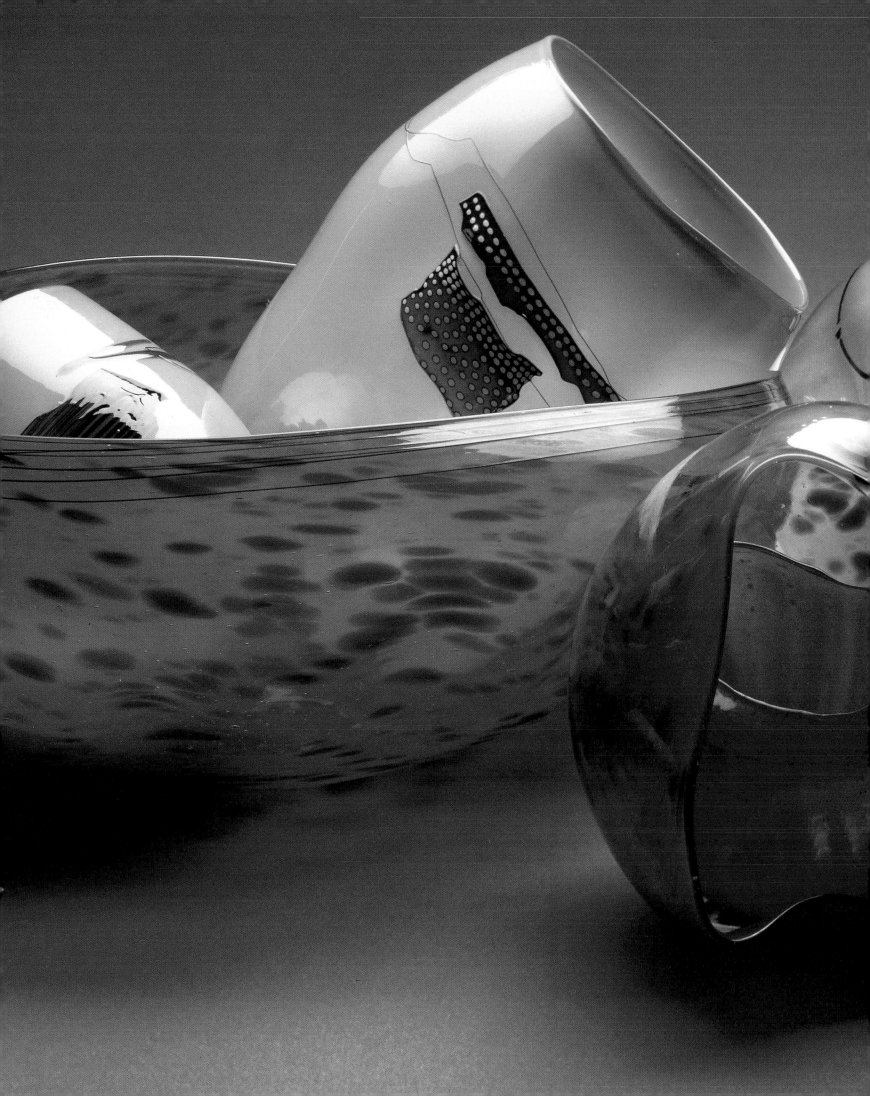

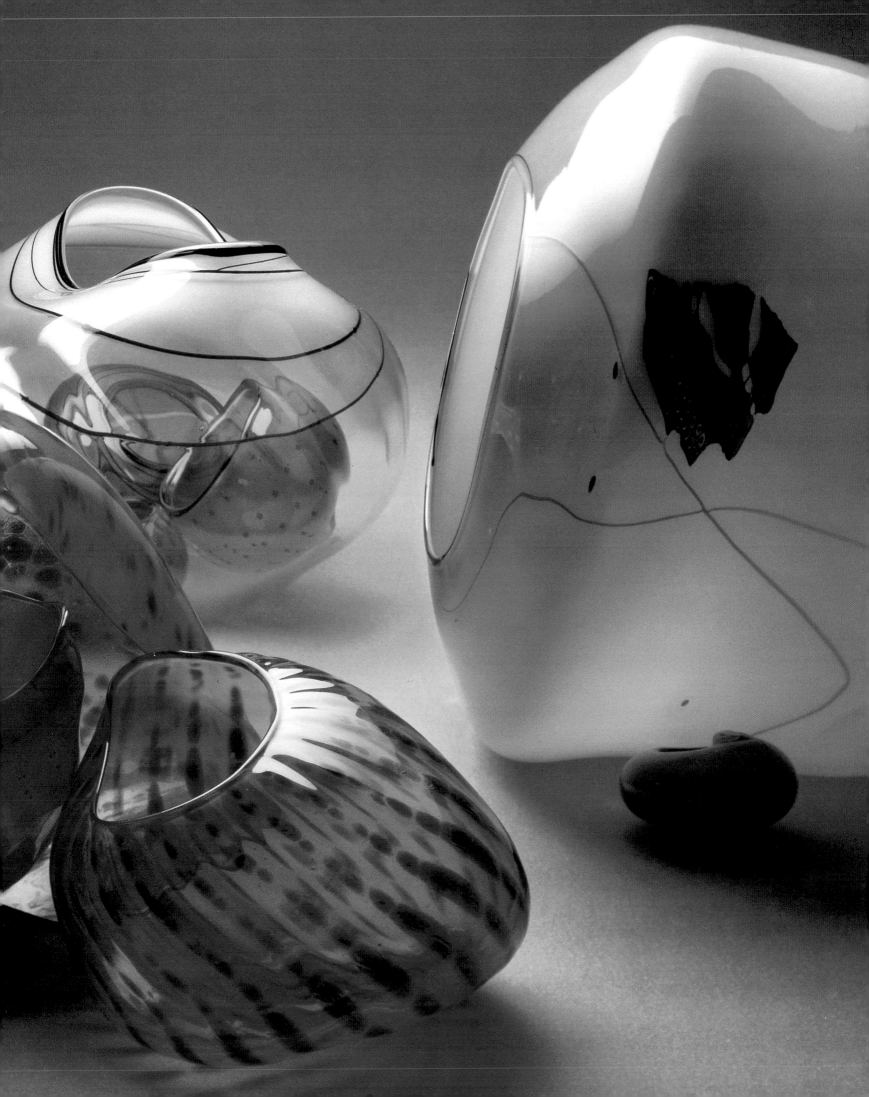

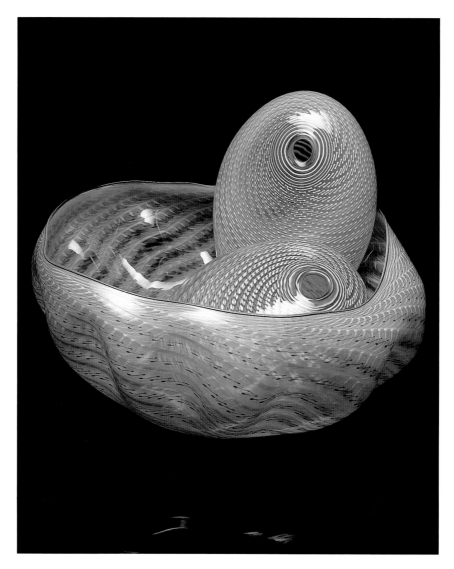

When thin glass threads are trailed over the ridges in a continuous motion, they adapt to the unique contours of each form so that . . . a fusion of form and decoration occurs, differing markedly from the applied patches of drawing on many of the earlier Baskets. . . . the new forms resemble sea urchins, distended sacks with small openings covered in pinpoints of white that spiral out from their opening. Other forms are more elegantly abstract. . . . None of the forms, however, represent anything. Rather, they are shells, and as such, imply protection and an earlier inhabitation by living forms—a loaded metaphor that again refers to process. . . .

—Linda Norden, "Dale Chihuly: Shell Forms," Arts Magazine, *June 1981*

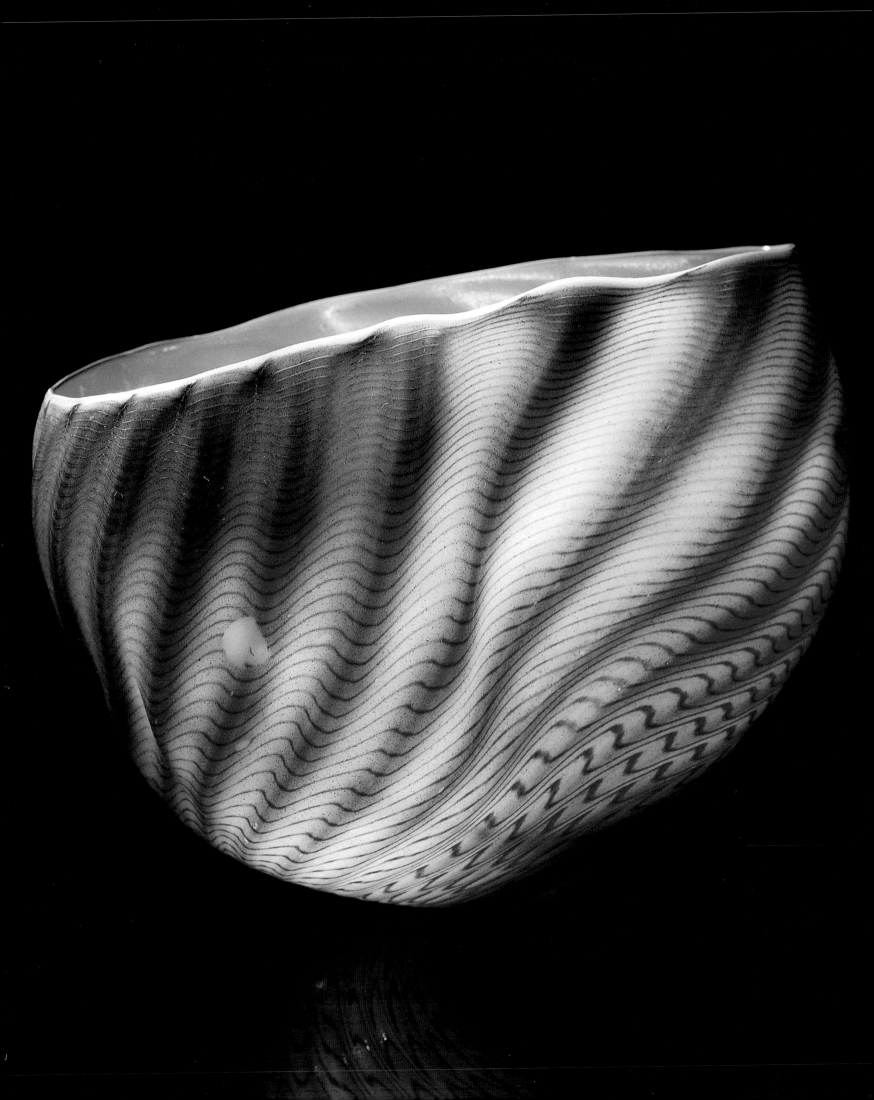

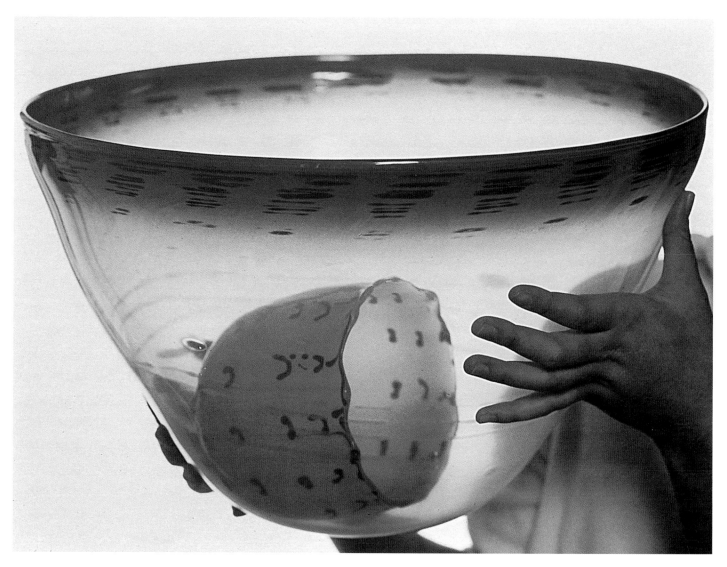

Above
Basket Pair, 1978, 16" x 18" x 18"

Overleaf
Pink and Opal Seaform Set, 1981,
15" x 24" x 22"

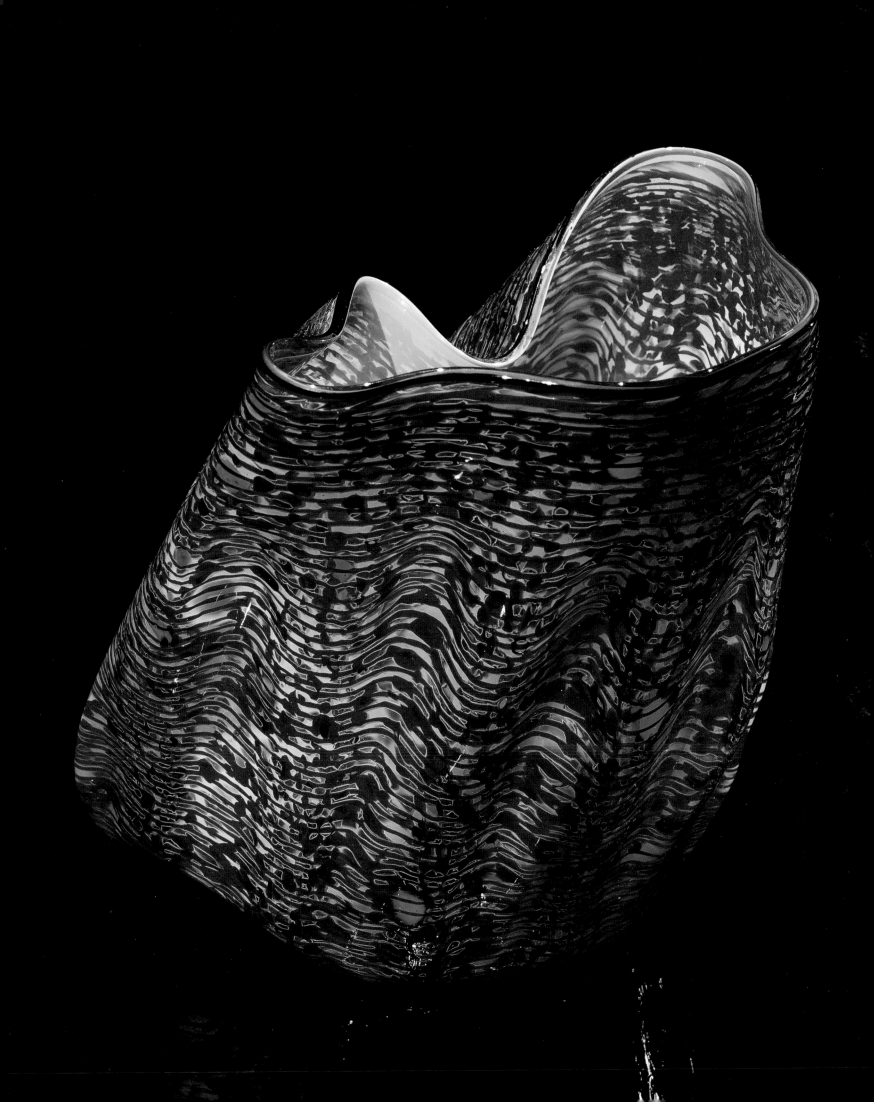

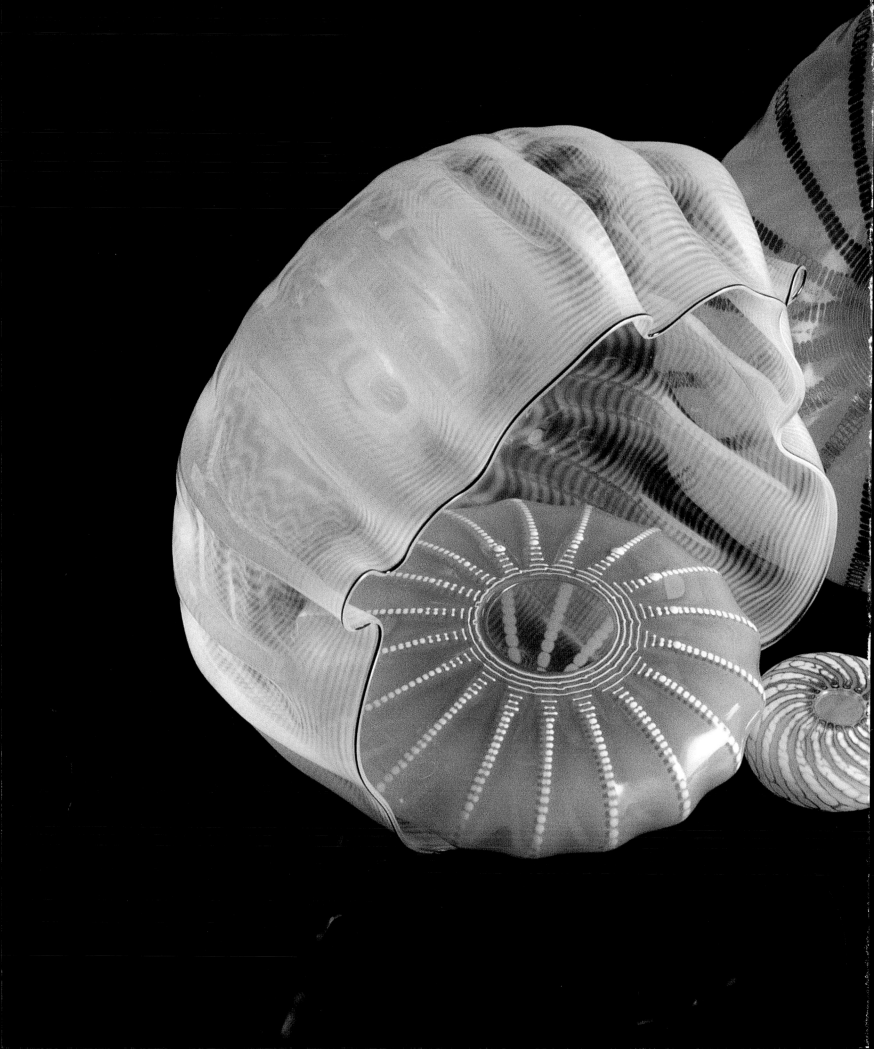

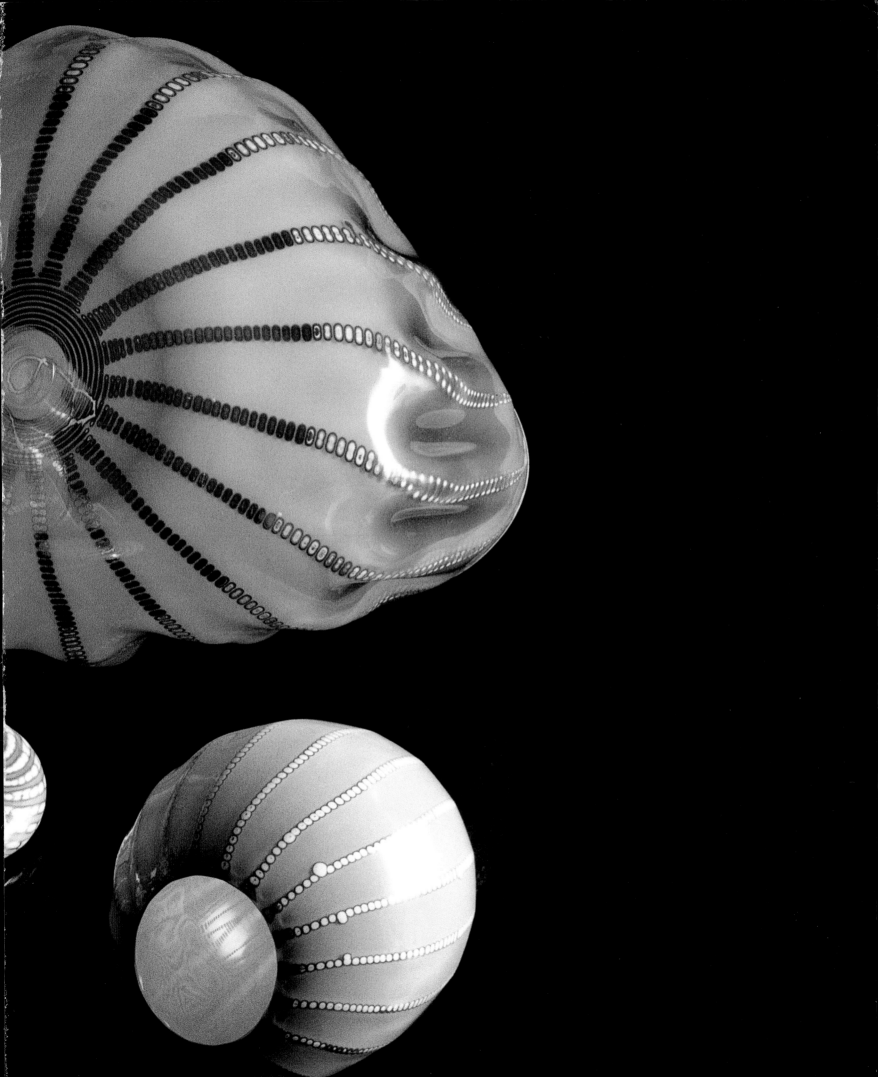

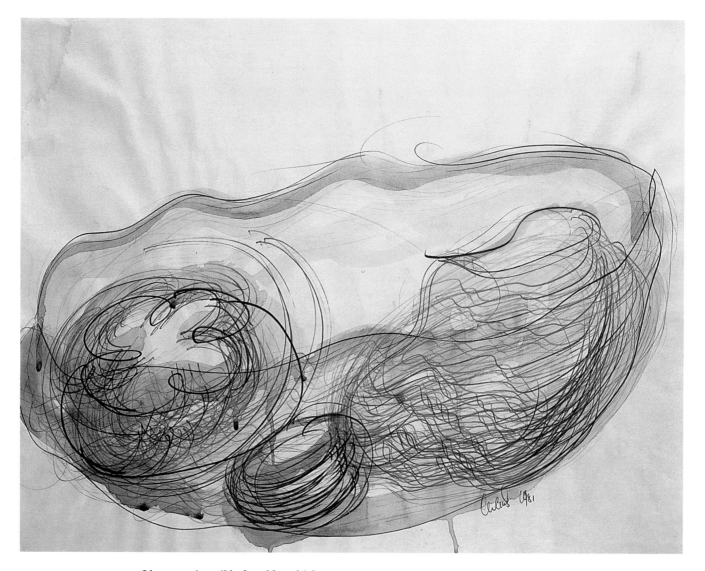

I began using ribbed molds, which
gave the forms a great deal more
strength and movement and made
them reminiscent of sea life....
In order to emphasize this delicate
quality, I worked primarily with
subtle colors and often only with
white.
—Dale Chihuly, Chihuly: Color, Glass
and Form, 1986

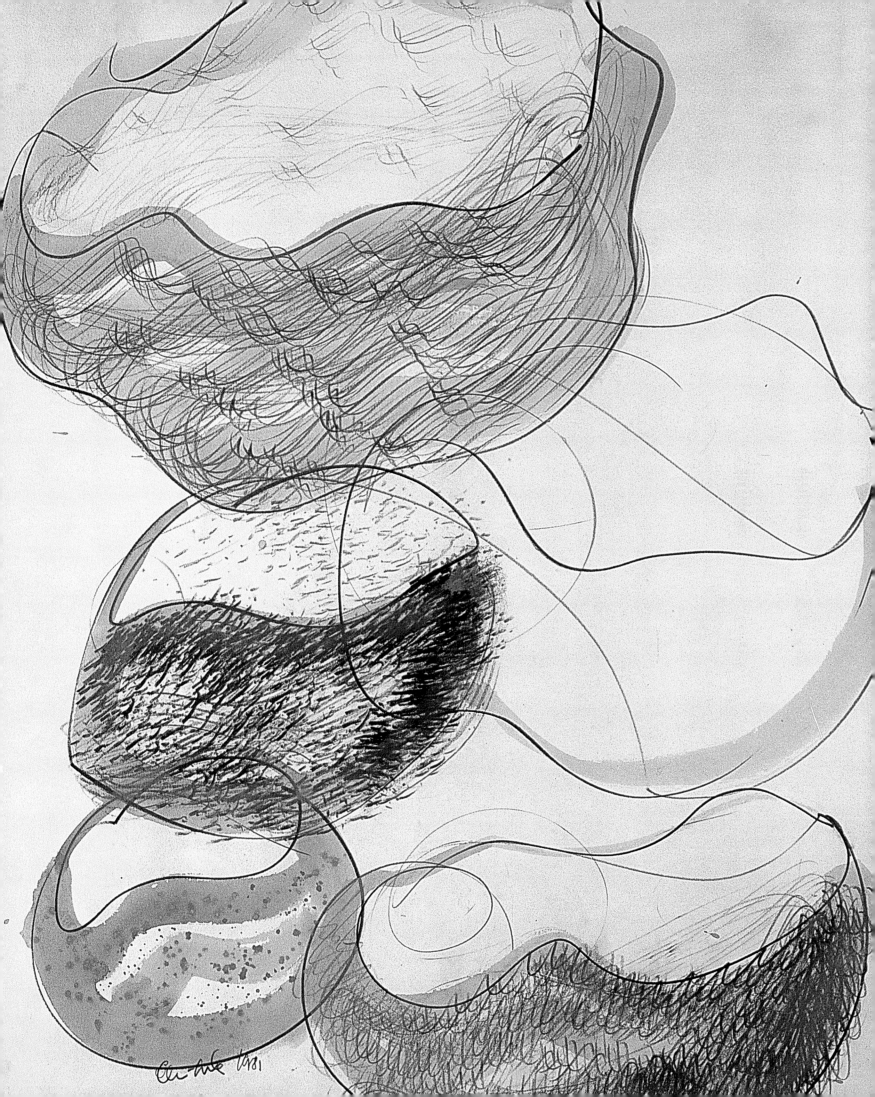

Below
Violet Macchia with Red Lip Wrap,
1991, 20" x 26" x 24"

Opposite
Cobalt Blue and Chartreuse Macchia,
1981, 6" x 10" x 7"

Overleaf
Oxblood Persian with Black Lip
Wrap, 1987, 5" x 10" x 8"

Oxblood and White Persian, 1986,
7" x 15" x 10"

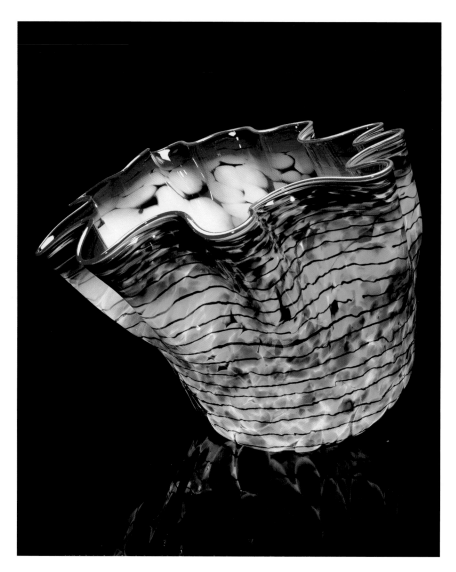

*The "Macchia" series began with my
waking up one day wanting to use
all 300 of the colors in the hotshop.
I started by making up a color chart
with one color for the interior,
another color for the exterior, and a
contrasting color for the lip wrap,
along with various jimmies and dusts
of pigment between the gathers of
glass. Throughout the blowing process,
colors were added, layer upon layer.*

*Each piece was another experiment.
When we unloaded the ovens in the
morning, there was the rush of seeing
something I had never seen before.
Like much of my work, the series
inspired itself. The unbelievable
combinations of color—that was the
driving force.*
—Dale Chihuly, Chihuly: alla
Macchia, *1993*

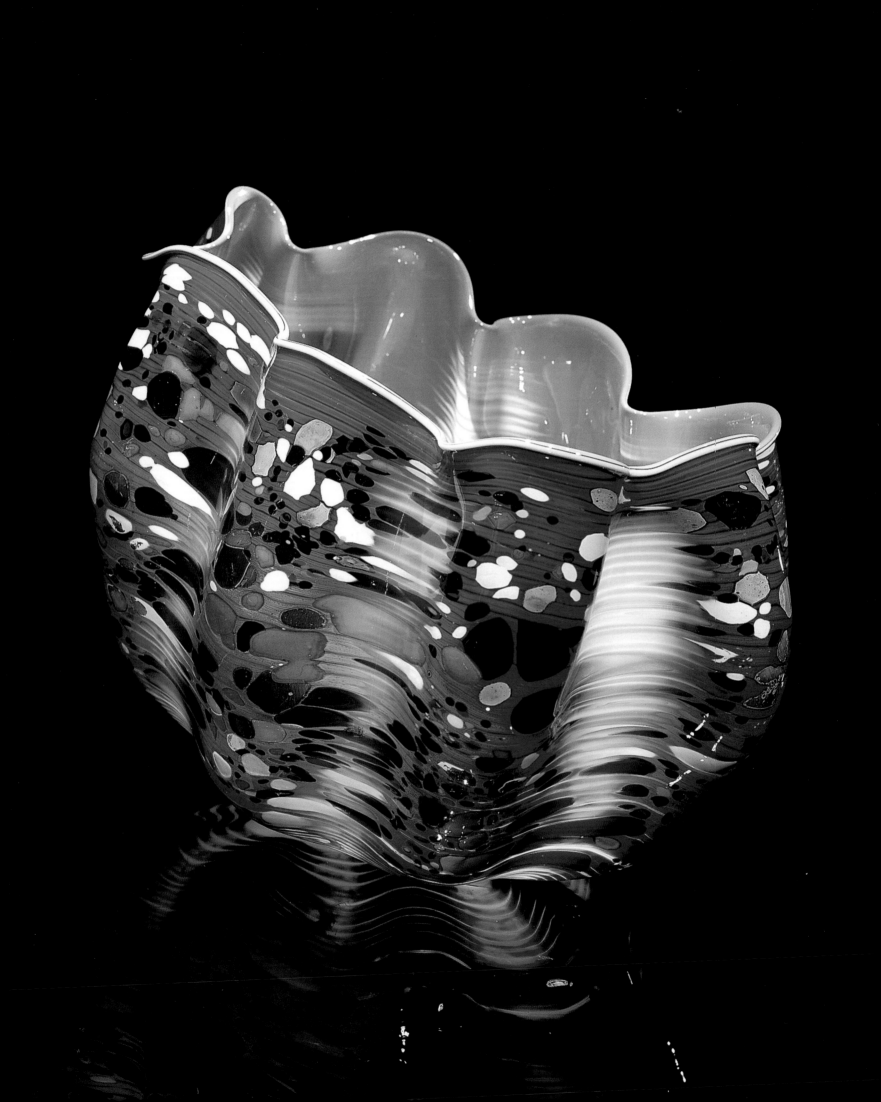

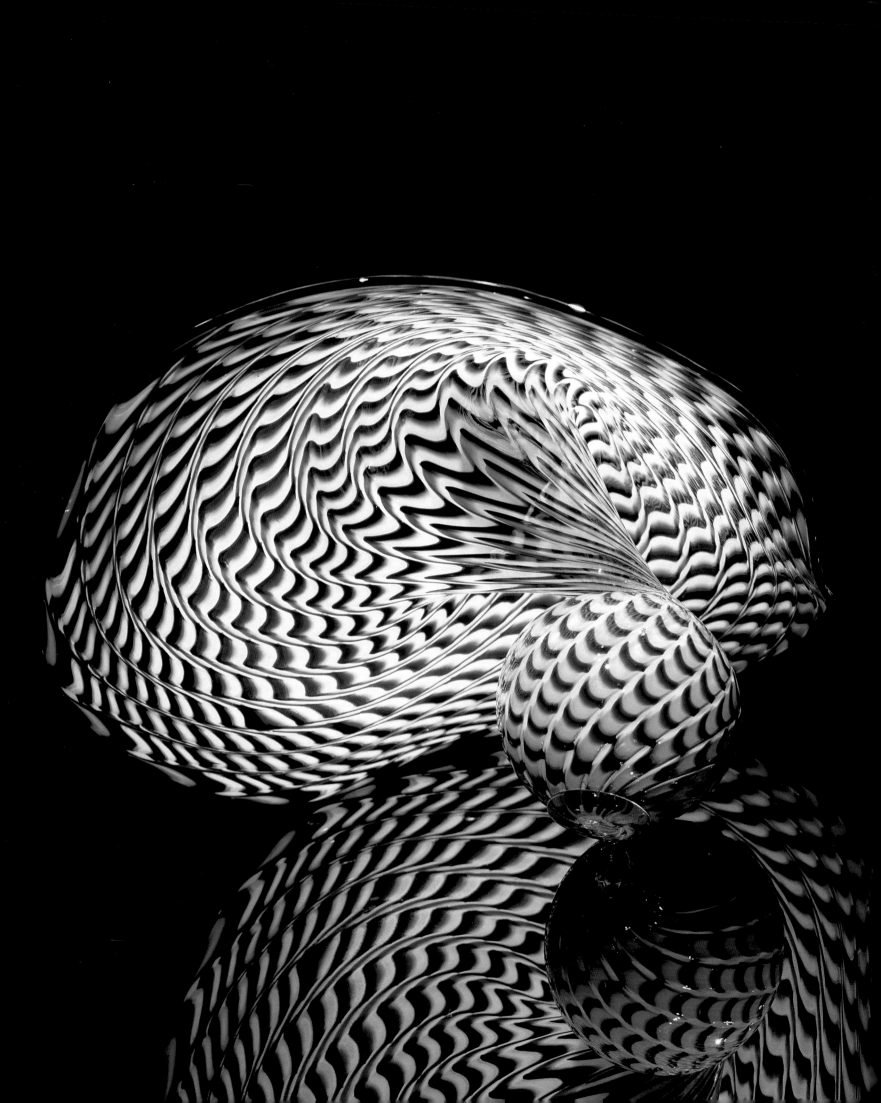

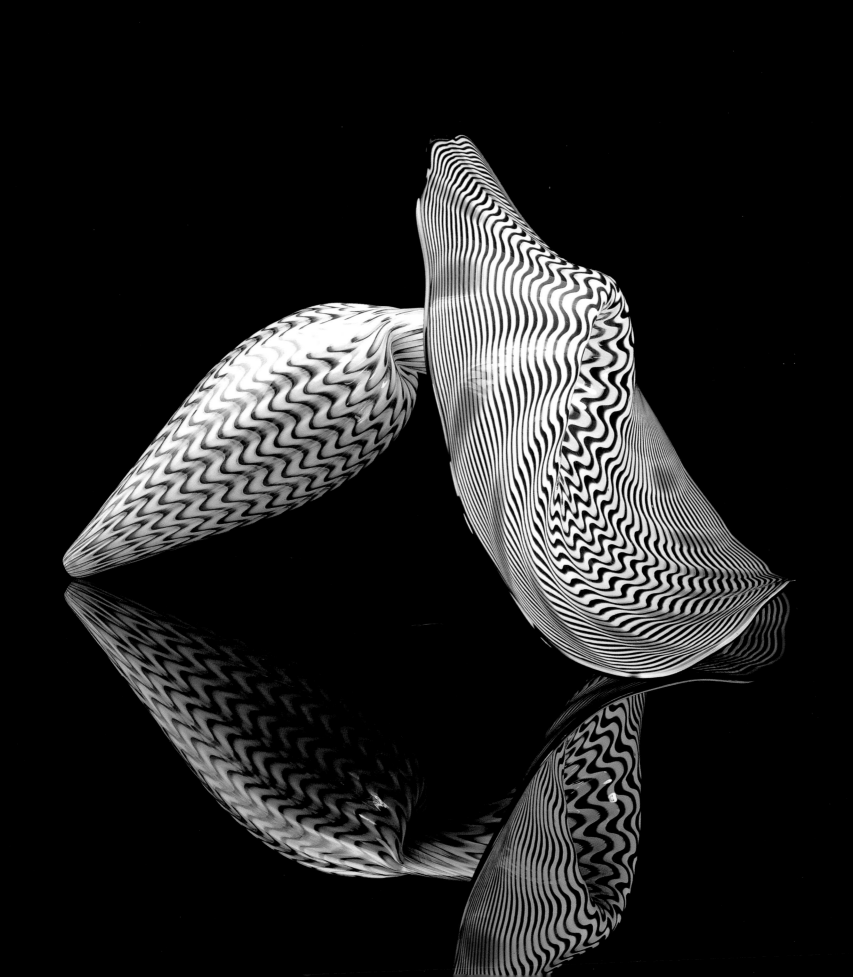

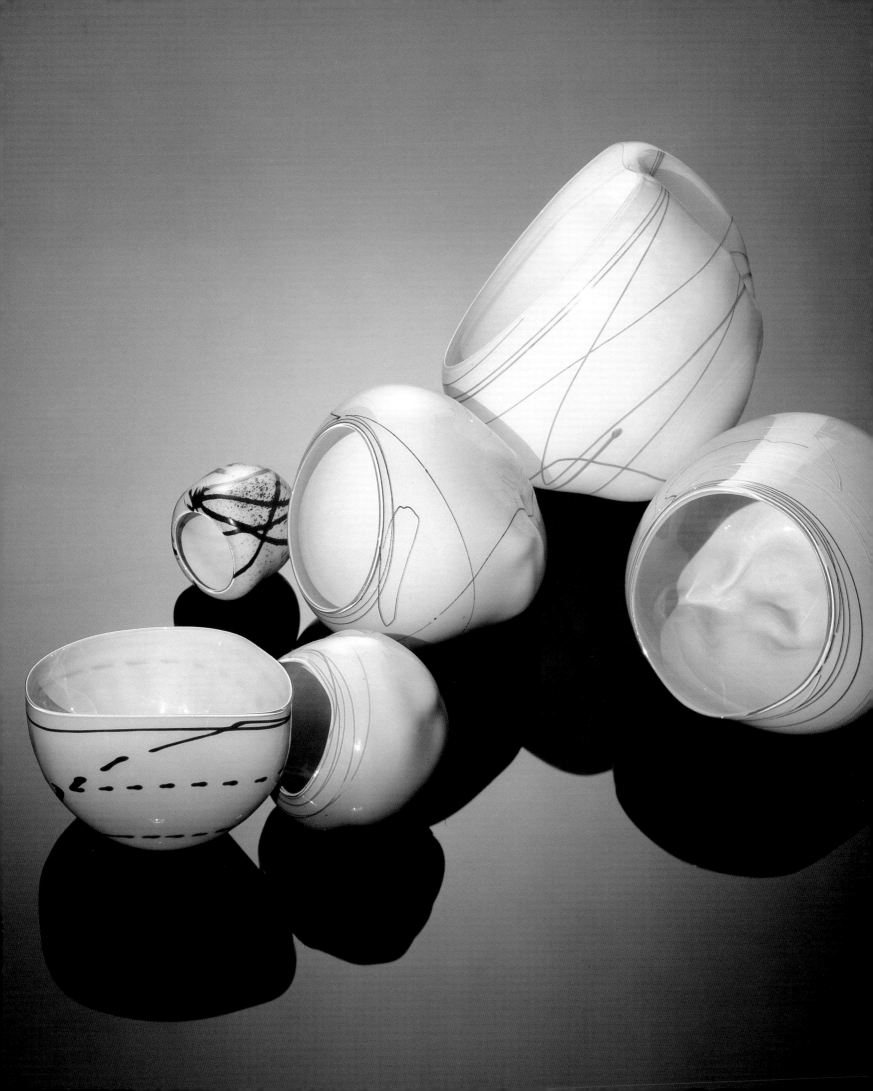

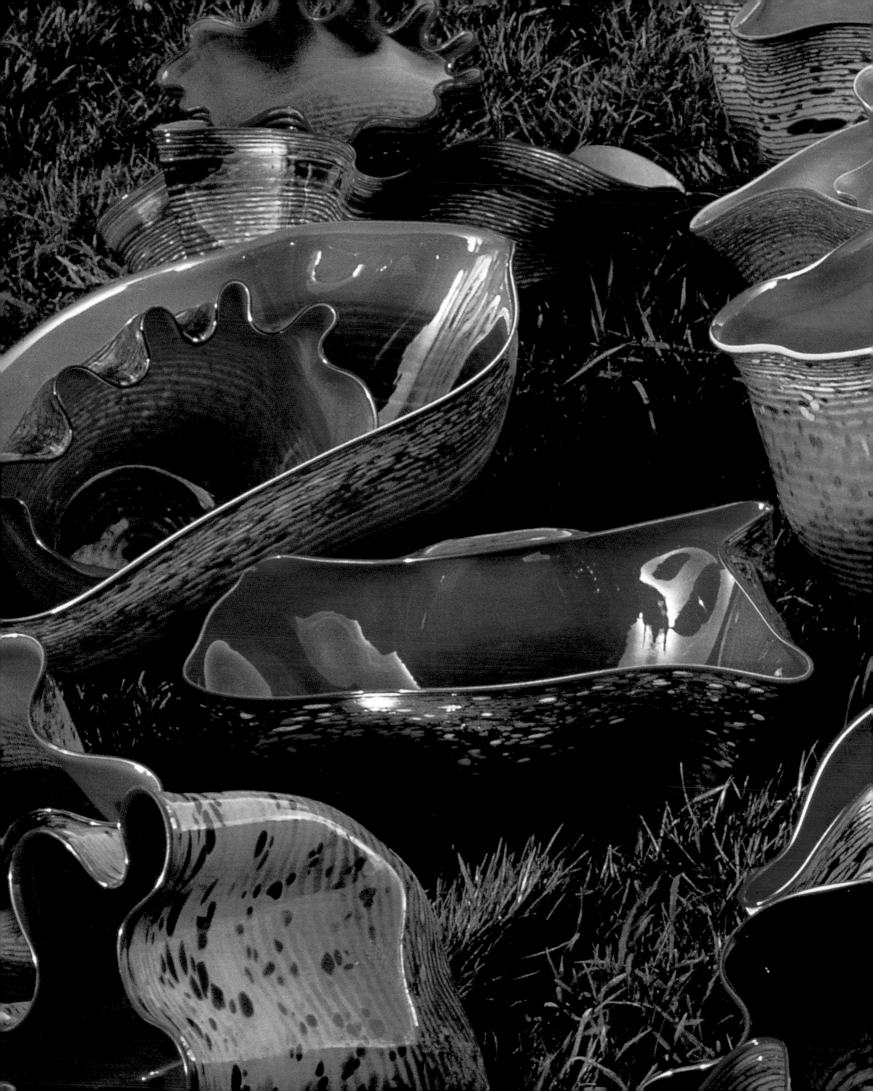

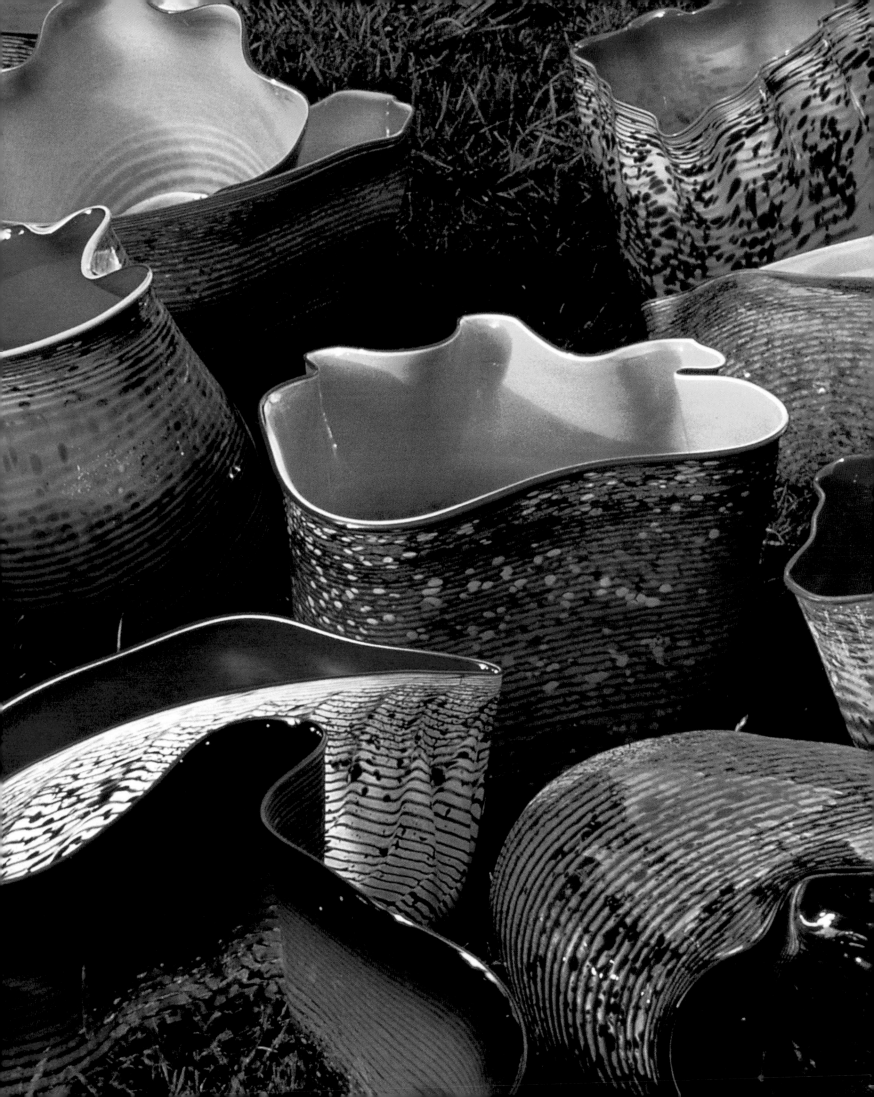

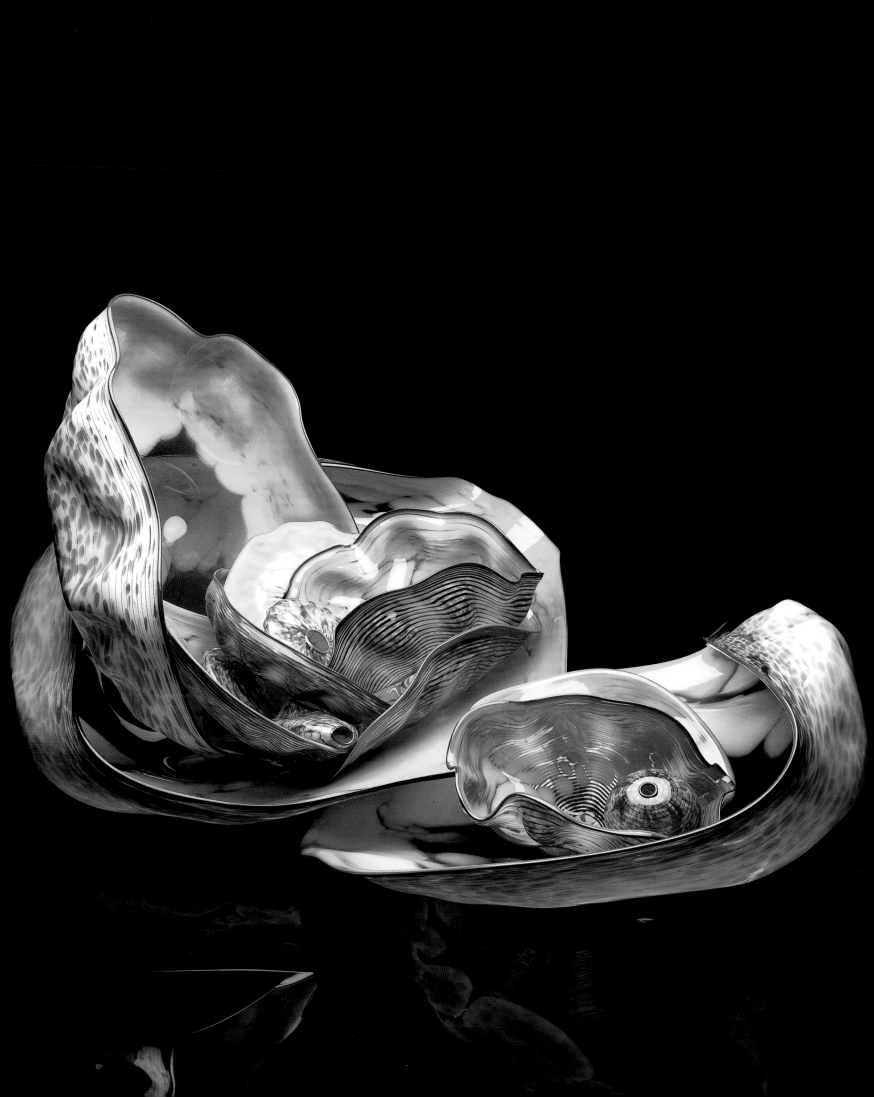

Opposite
Macchia Set, 1985, 18" x 28" x 36"

Below
Black and Red Macchia, 1981,
4" x 6" x 6"

Overleaf
Aventurine Green and Yellow
Macchia, 1981, 6" x 9" x 9"

Pink and Black Macchia, 1981,
7" x 9" x 8"

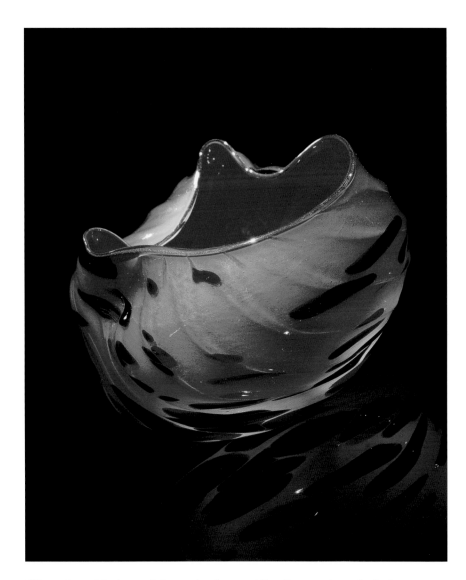

When glass objects reach the scale of Chihuly's Macchia *series, a new identity is achieved. Glass no longer has to pretend to be unassuming, undemanding and fragile, even though it continues to play on ephemerality. In the* Macchia, *the strength of the glass is suggested with references to geological formations. Seen under bright light they look like nature caught on fire, nature in molten flux, nature in the process of being created.*
—Robert Hobbs, "Chihuly's Macchia,"
Dale Chihuly: Objets de Verre, *1986*

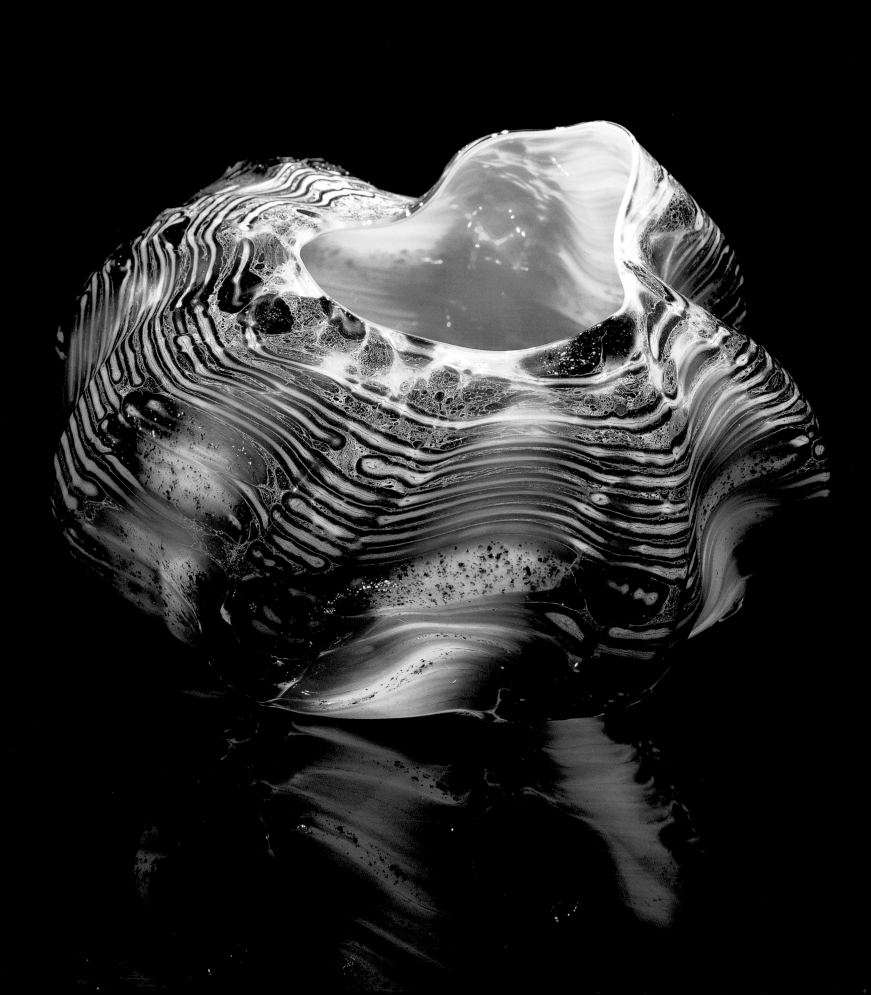

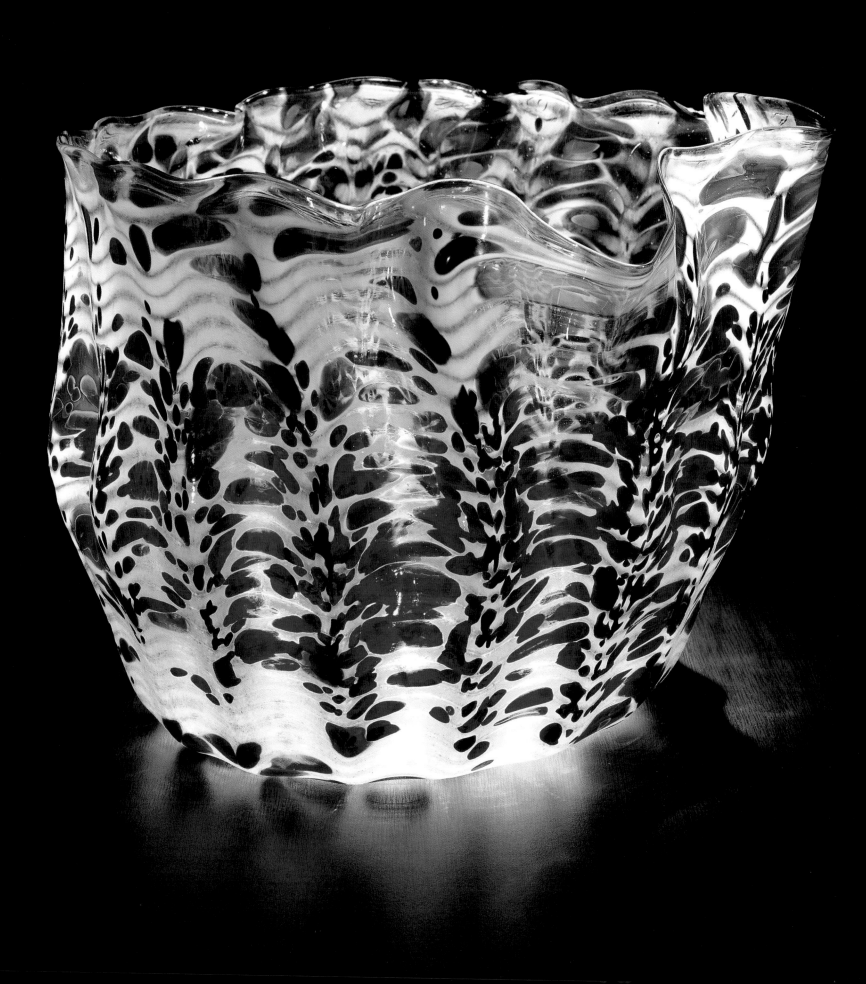

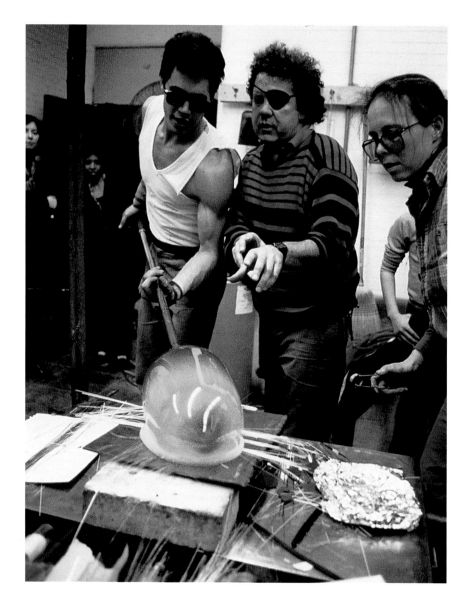

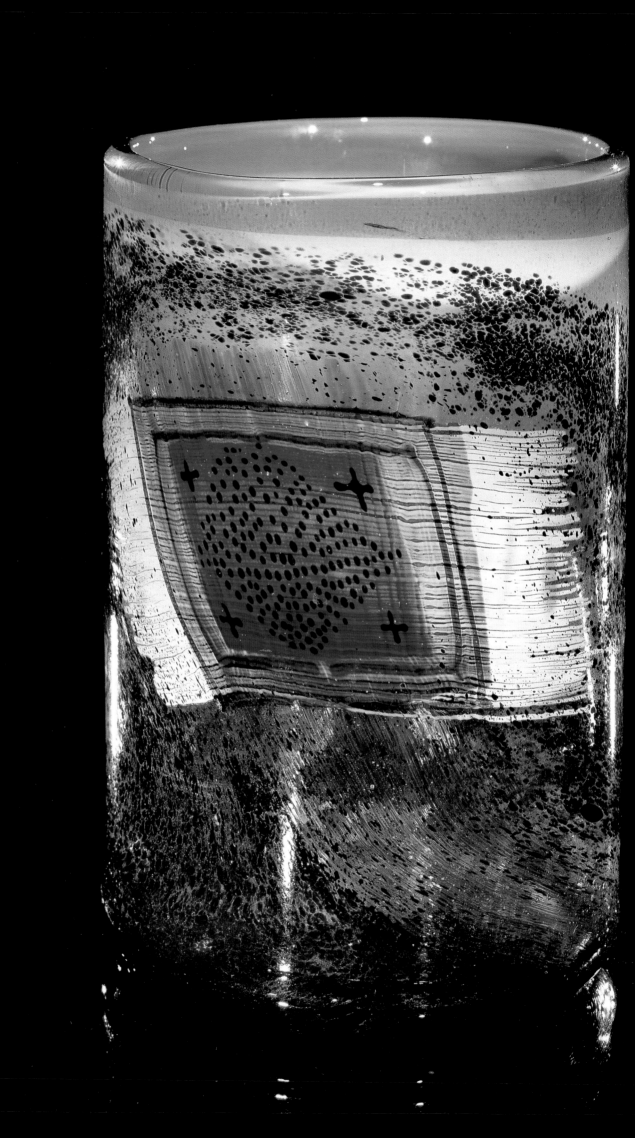

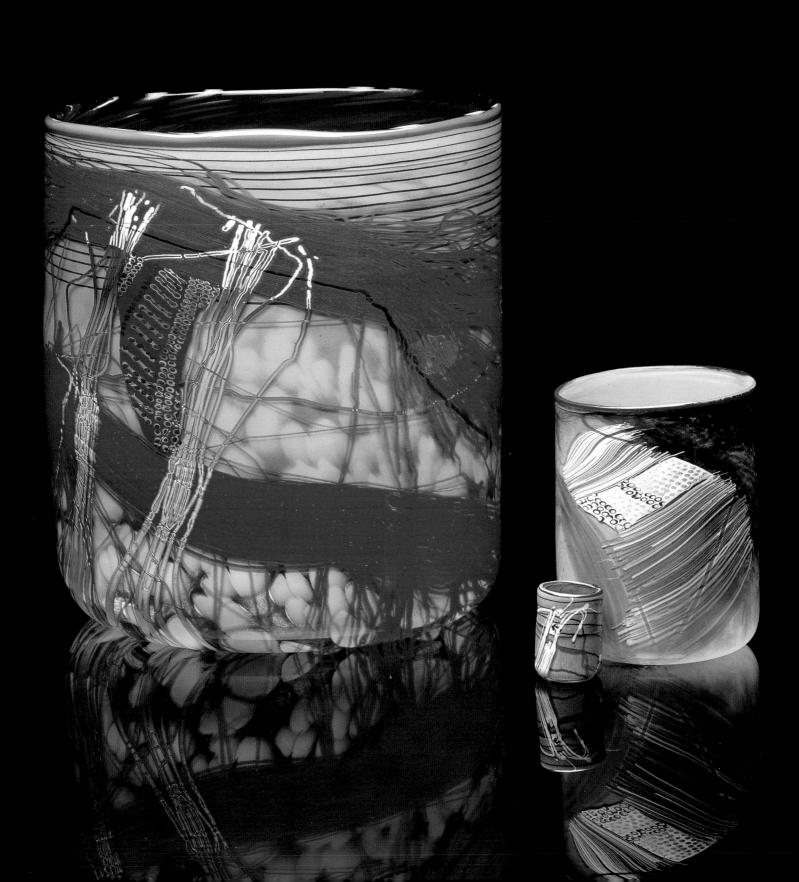

Opposite
Pilchuck Cylinders, 1984, largest
14" x 9"

Below
Turquoise and Yellow Cylinder, 1984,
15" x 8"

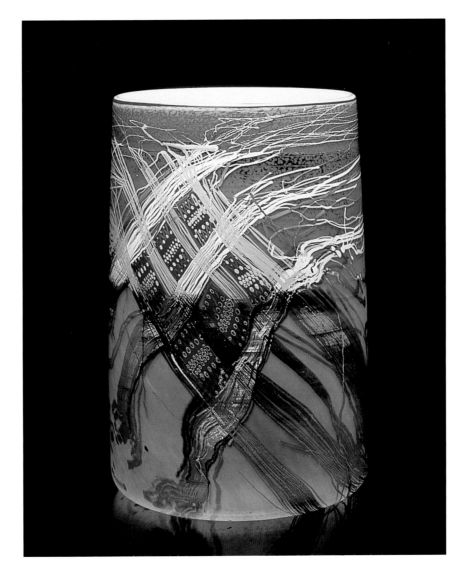

Overleaf
Pilchuck Cylinder, 1984, 15" x 7"

Pilchuck Cylinder, 1984, 12" x 8"

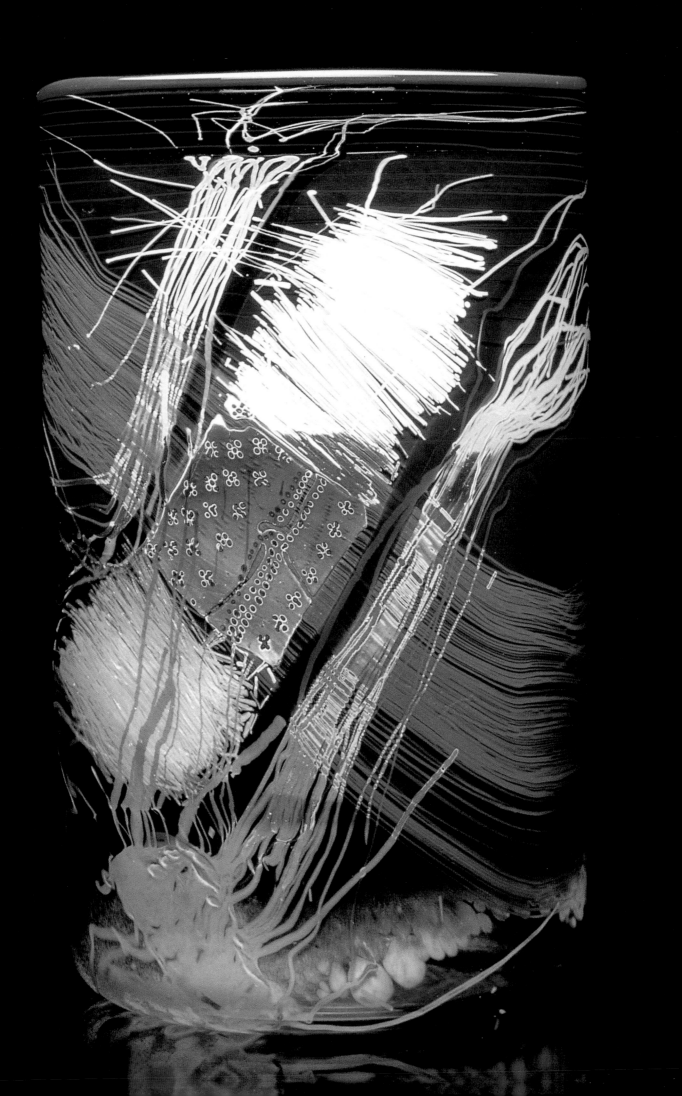

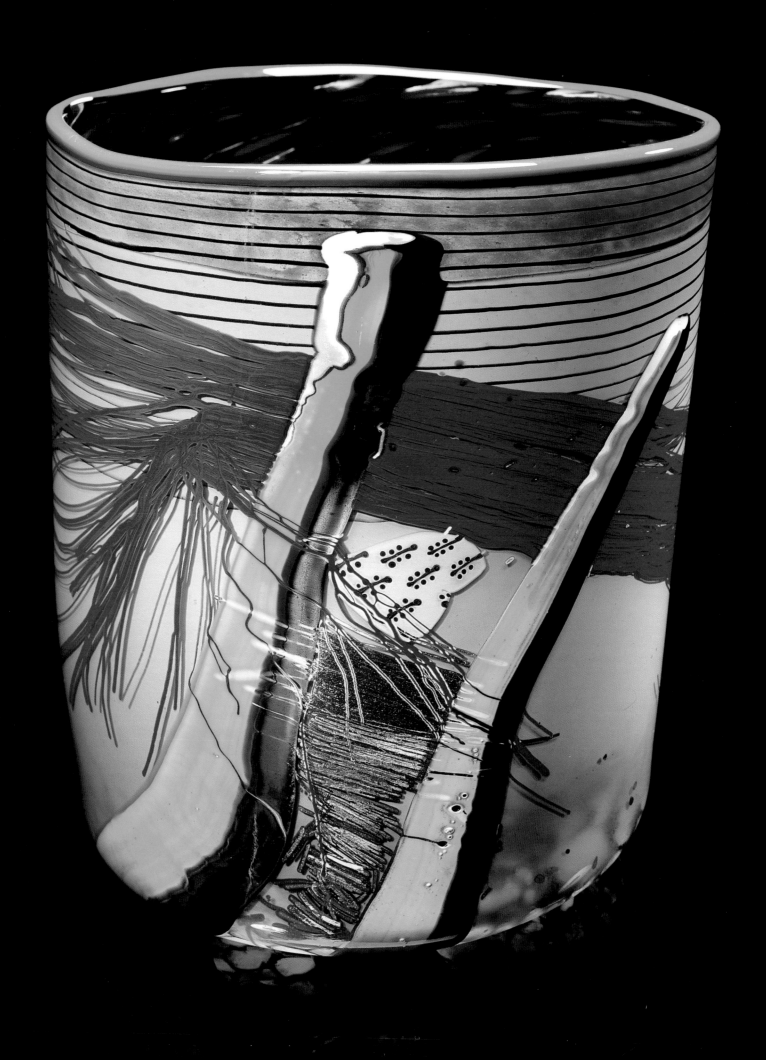

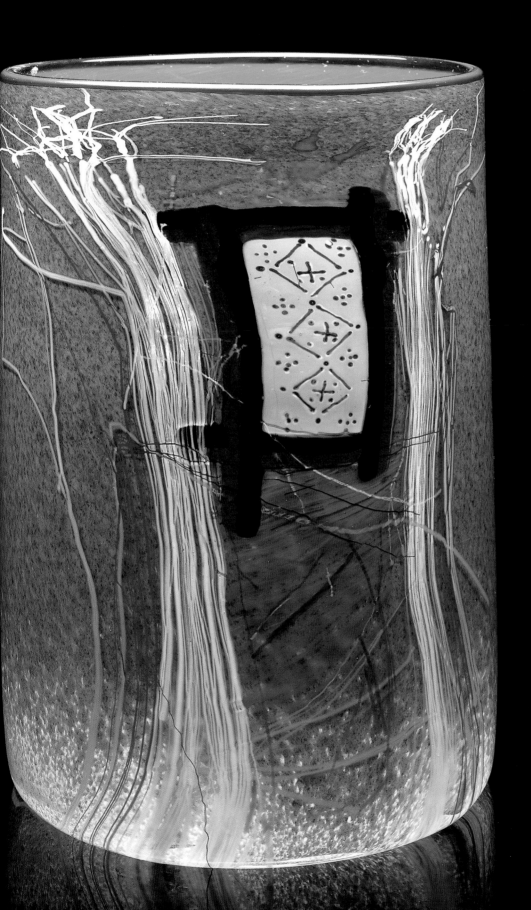

Opposite
*Pilchuck Cylinder (Navajo Blanket
Series), 1984, 13" x 9"*

Below
*Rhode Island School of Design,
Providence, Rhode Island, c. 1975*

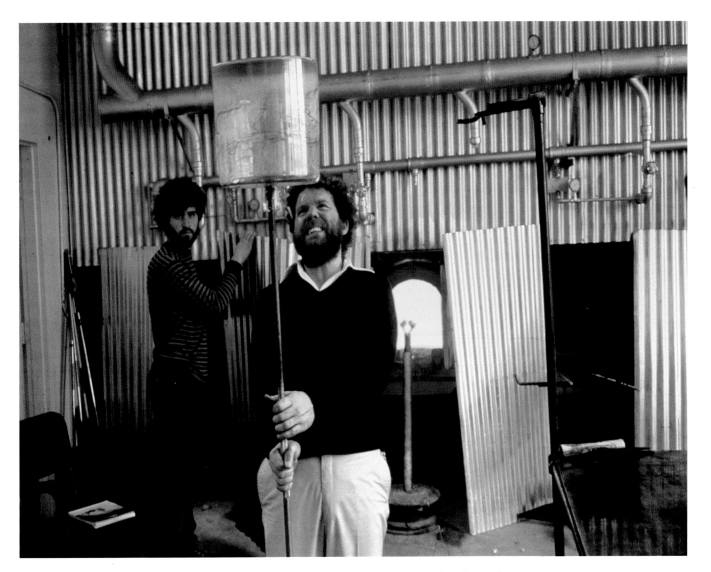

Although the woven image continues to act as a source of inspiration, we are not as conscious of the specific design origin . . . the warp and weft threads explode with an unprecedented emotional vitality. . . . Glass threads are assertively thrust helter-skelter. Boldly colored lip wraps on the cylinder's top edge become necessary to cap this energy from expanding vertically, while the warp and weft threads grasp the entire cylinder, *totally integrating the surface calligraphy with the ground. . . . There is no surface decoration here. The larger linear imagery has penetrated the glass creating an animated interior layer that complements and intensifies the expressive mood of these pieces.*
—Michael W. Monroe, "Drawing in the Third Dimension," Chihuly: Color, Glass and Form, *1986*

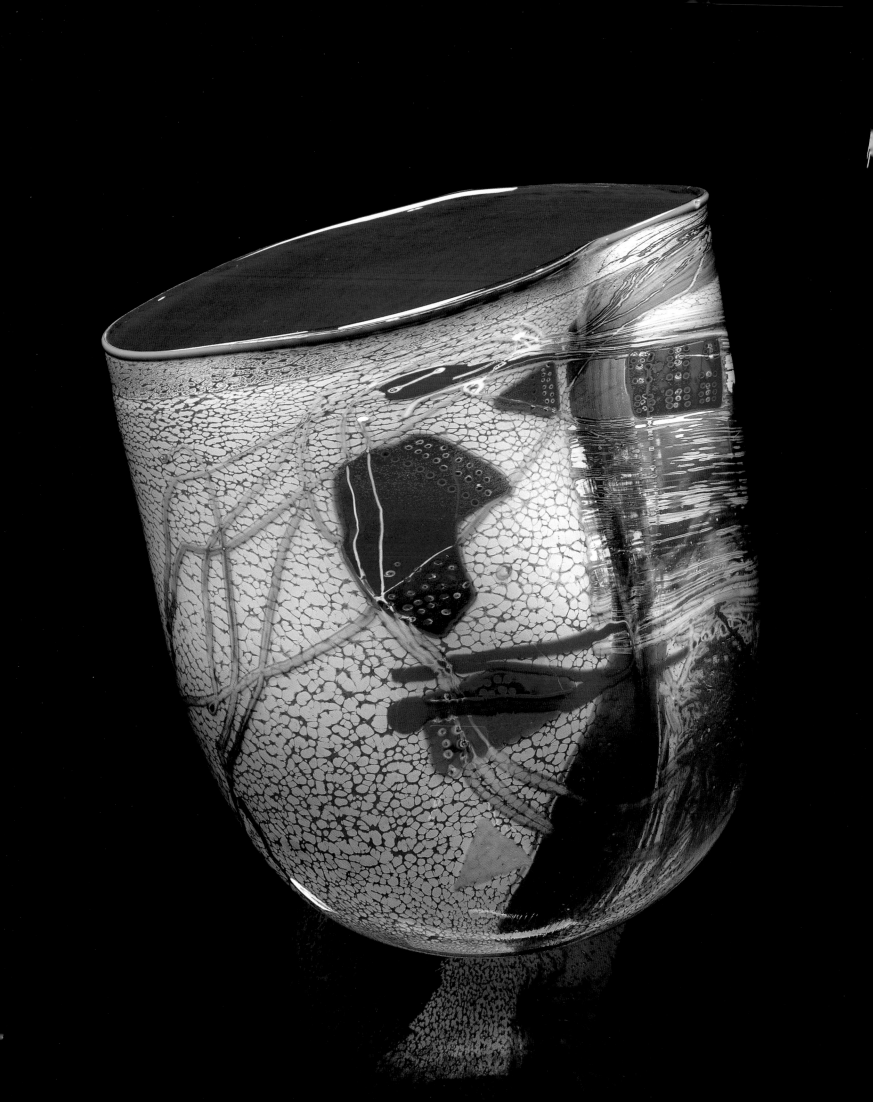

Below
Sky Blue Basket with Drawing,
c. 1984, 14" x 14" x 12"

Opposite
Aegean Blue Soft Cylinder with
Golden Lip Wrap, c. 1992,
18" x 20" x 20"

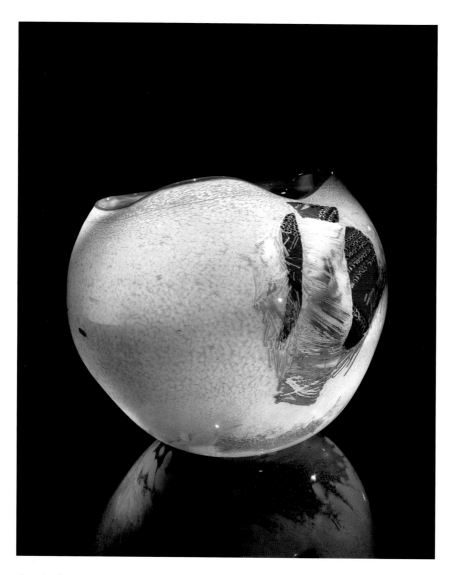

Overleaf
White and Black Seaform Set, c. 1981,
8" x 10" x 24"

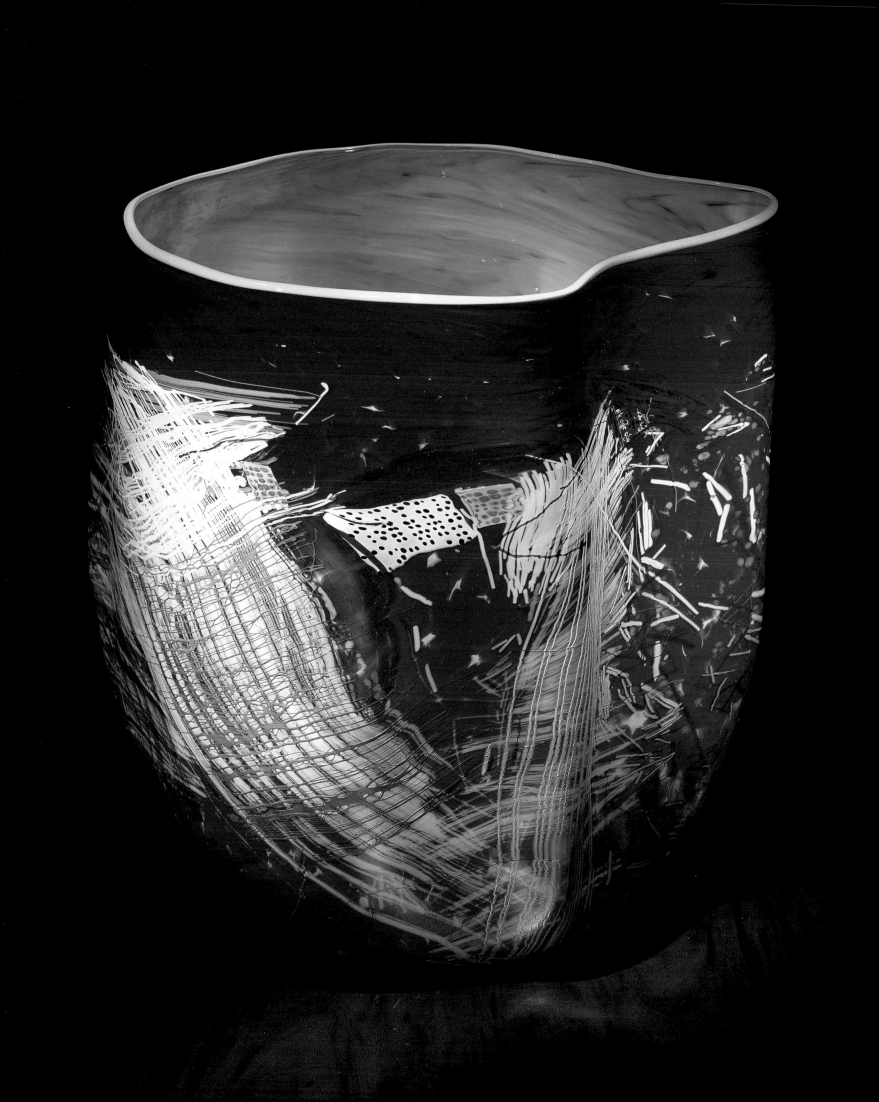

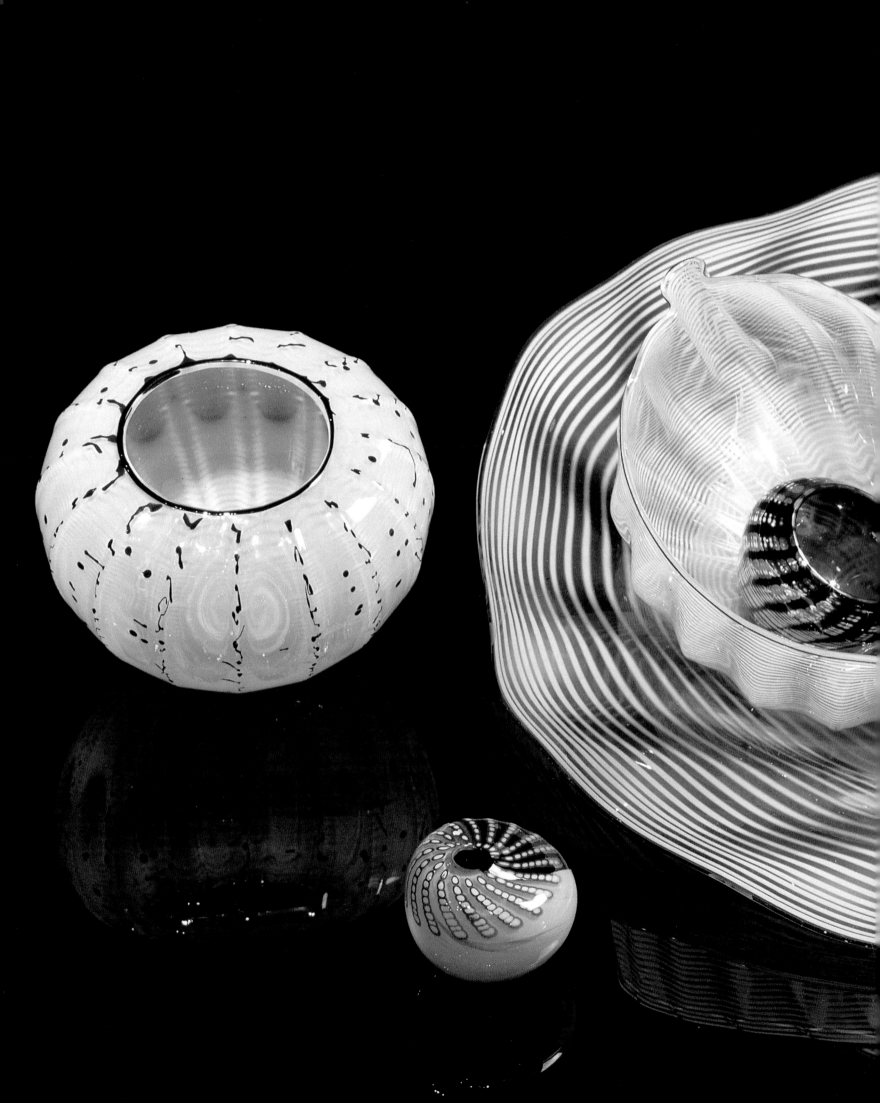

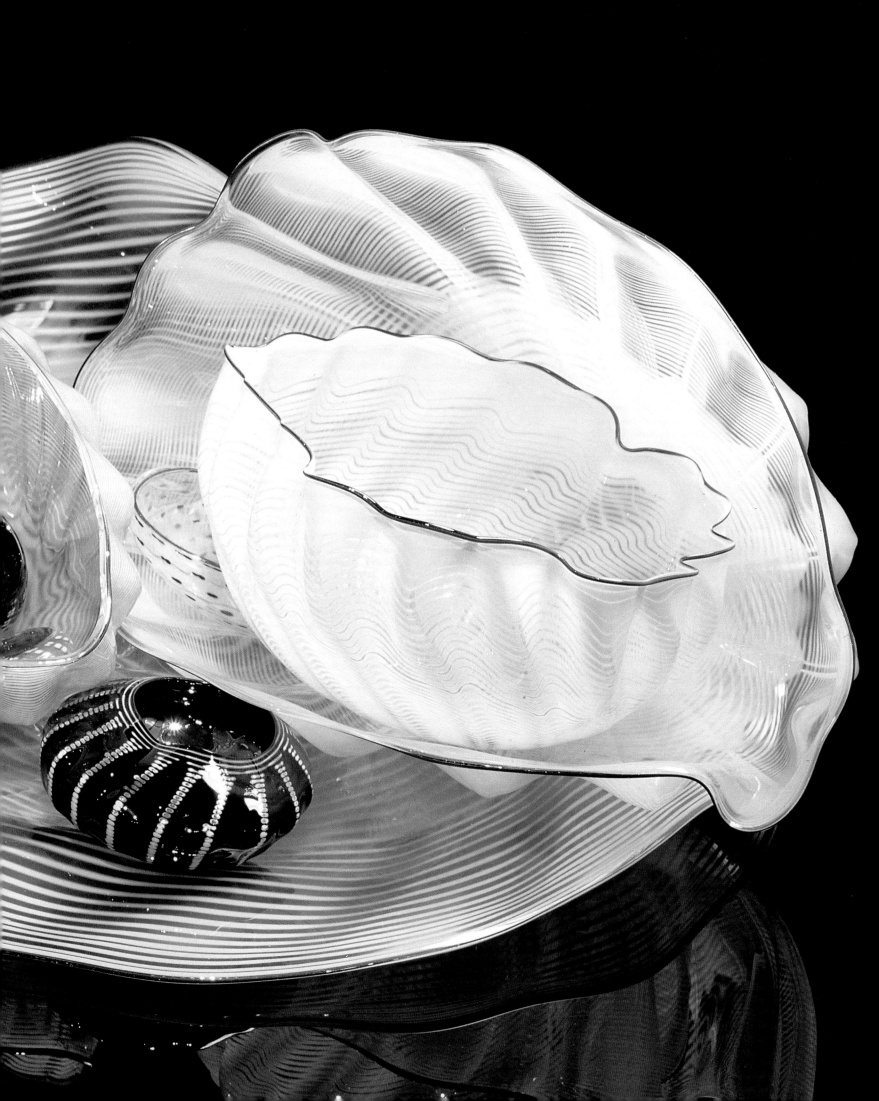

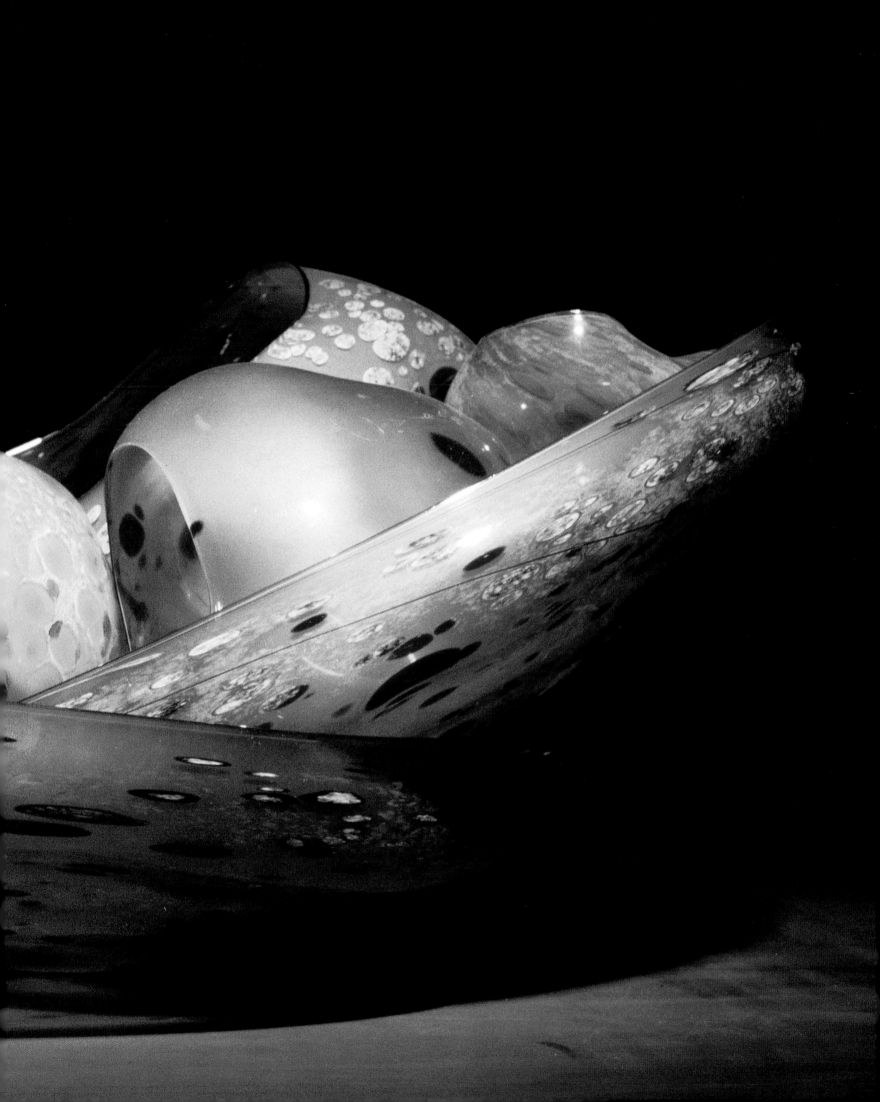

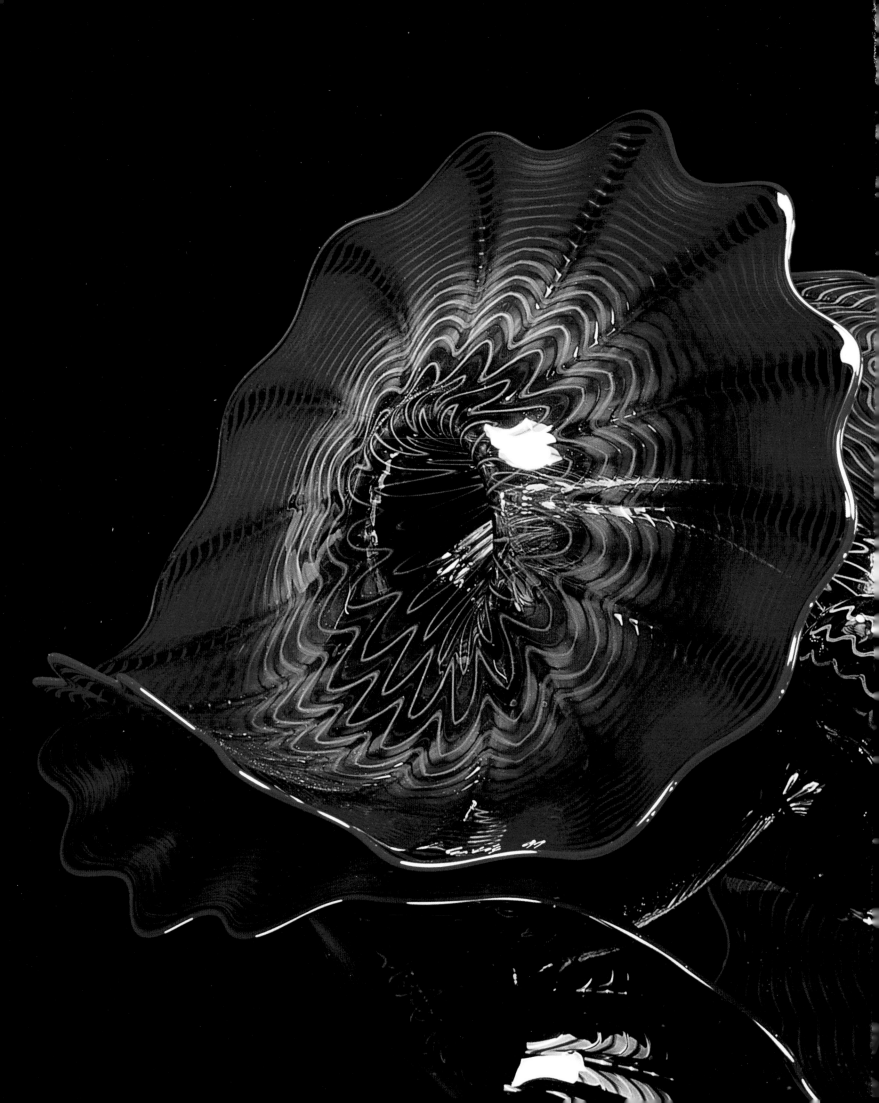

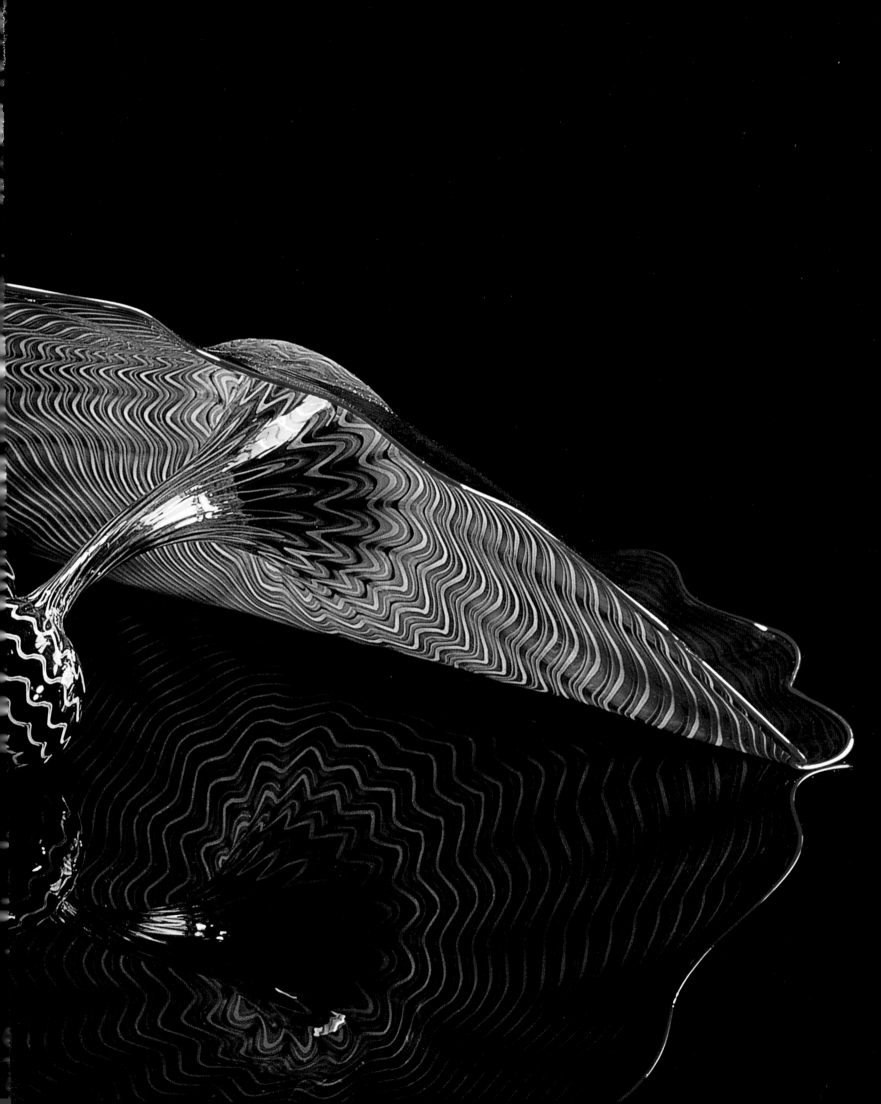

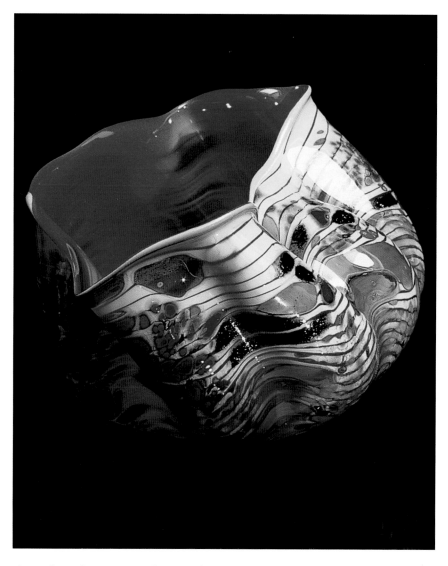

*Apart from the sensuous pleasure of
color and surface, the Macchia offer
the satisfaction of exploring how
material and manipulation interacted
in the making of them.*
—Roger Downey, "Glass Act," Seattle
Weekly, *12 August 1992*

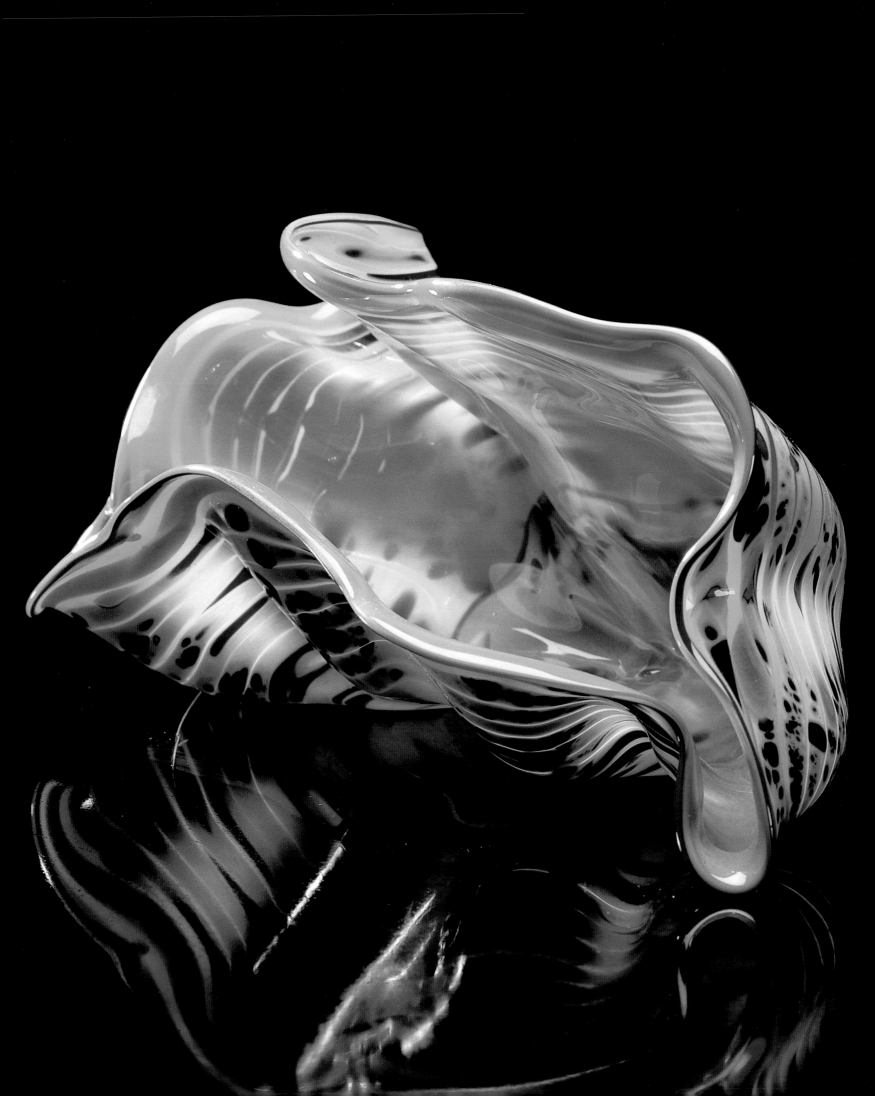

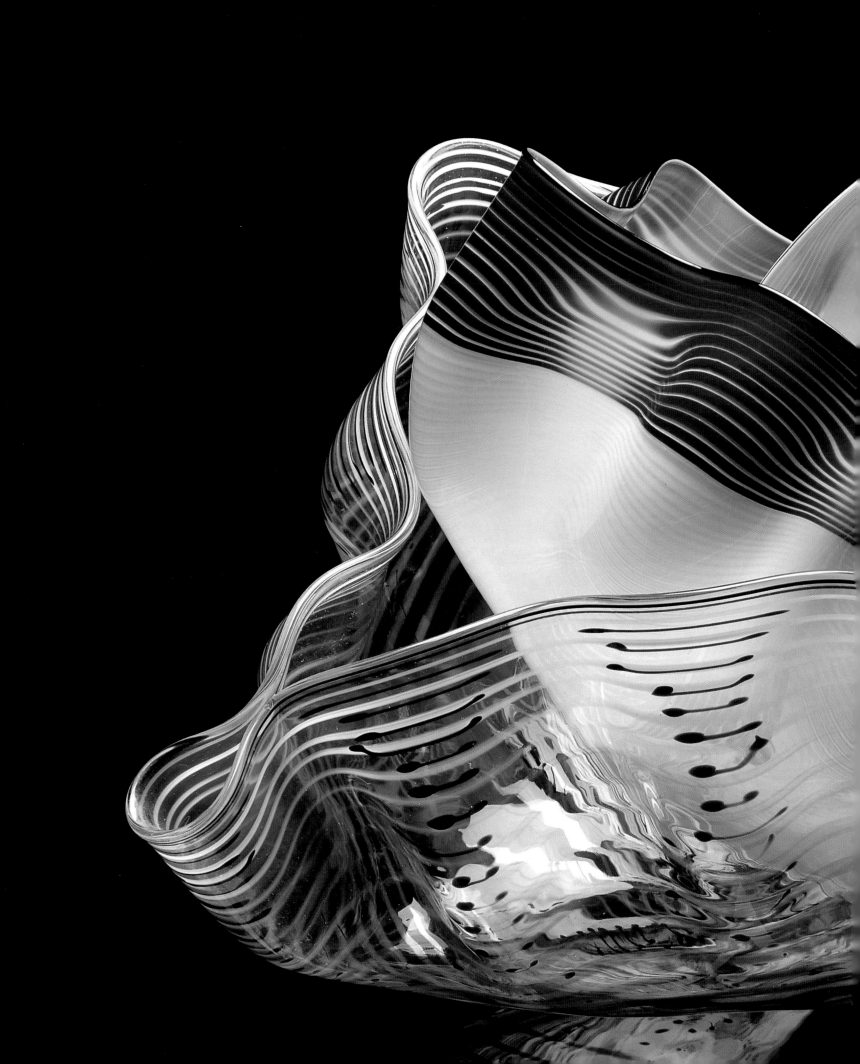

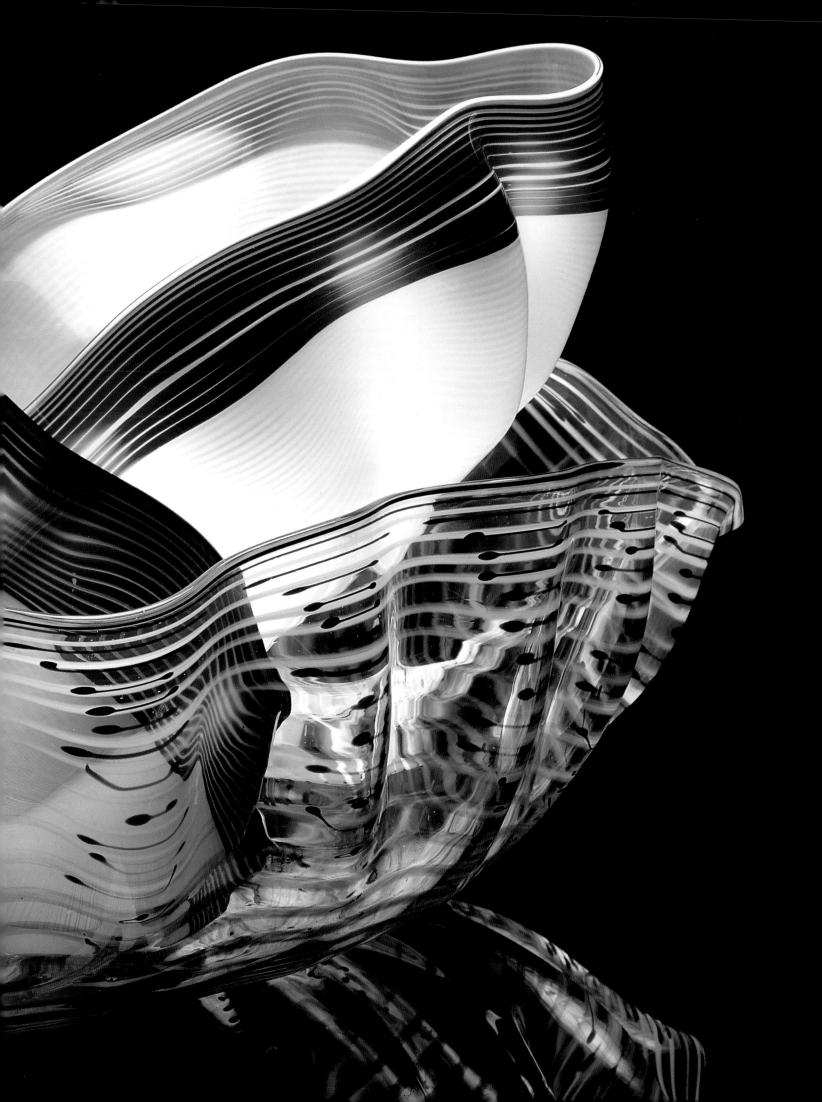

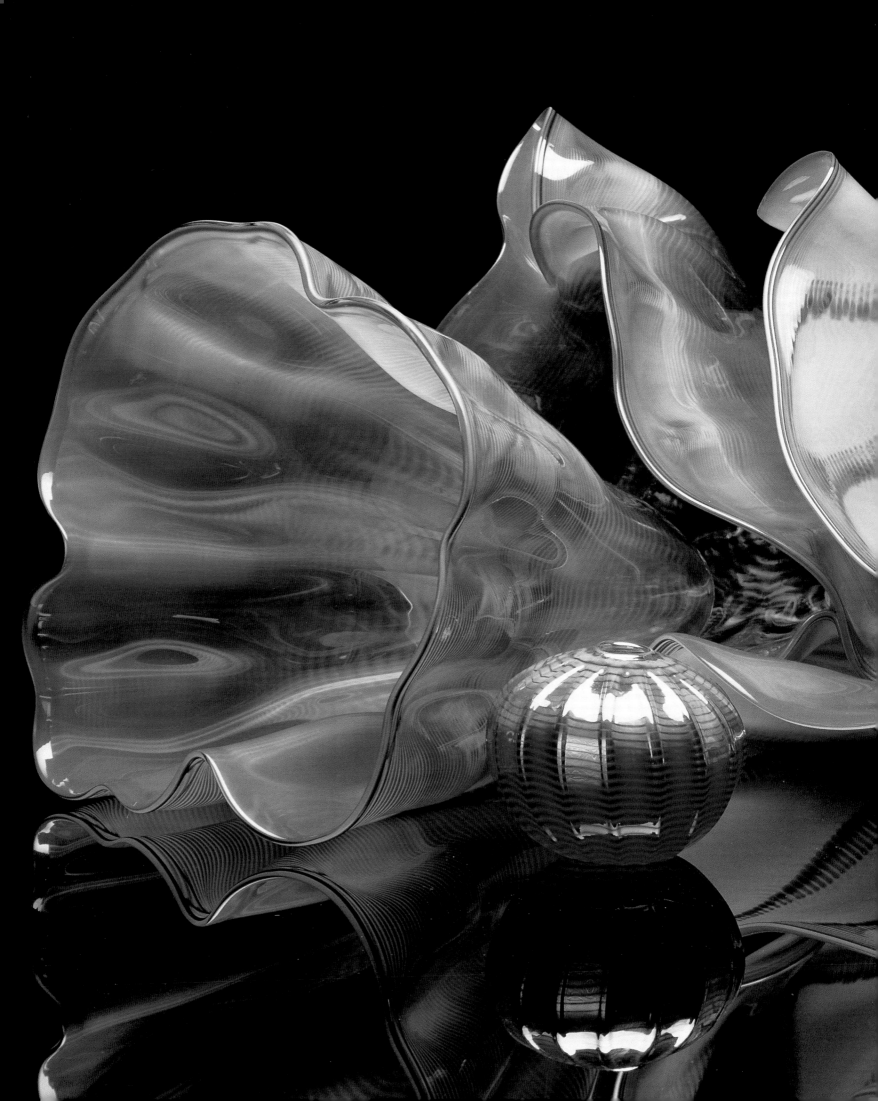

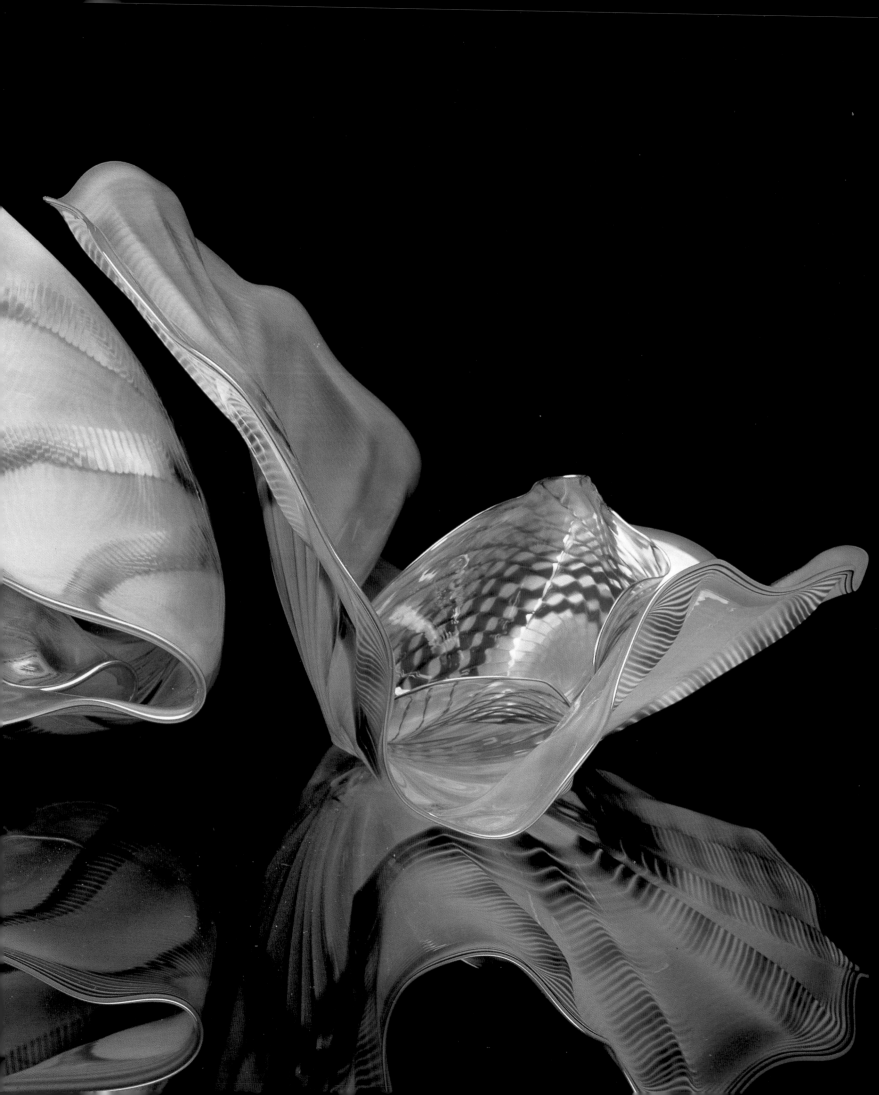

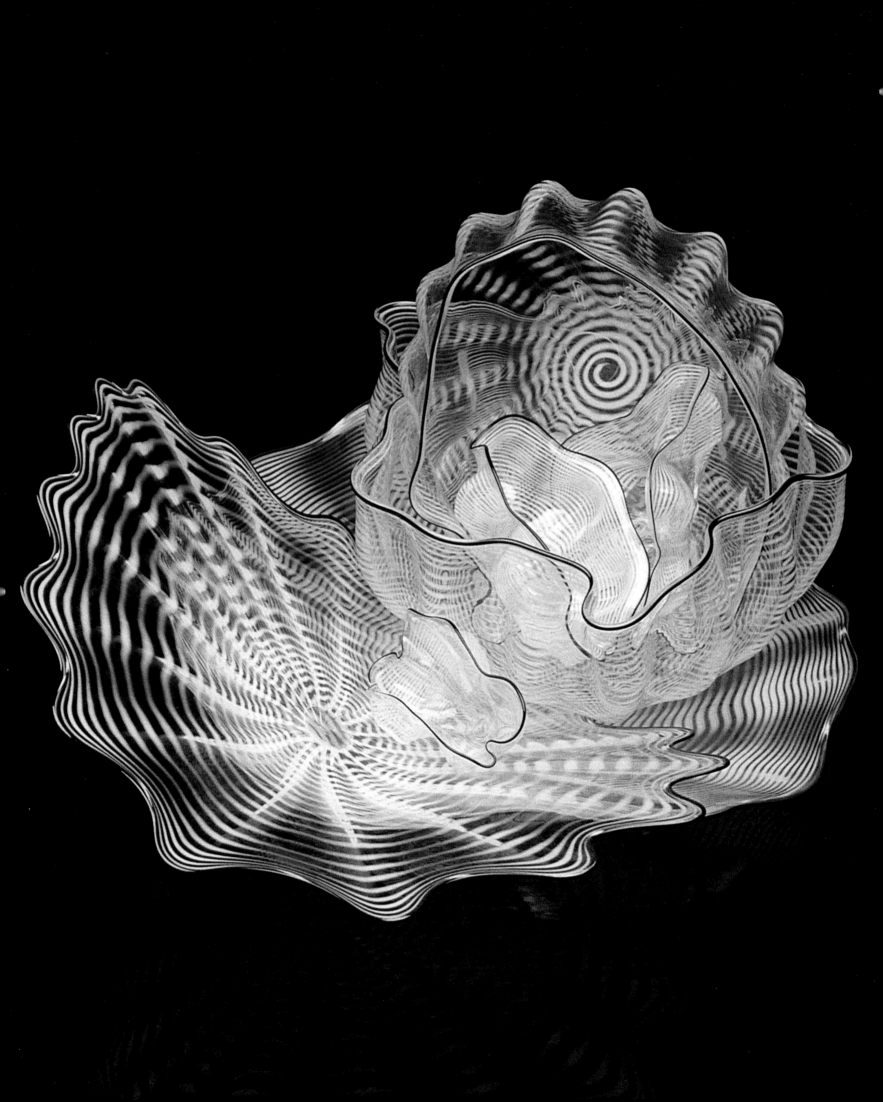

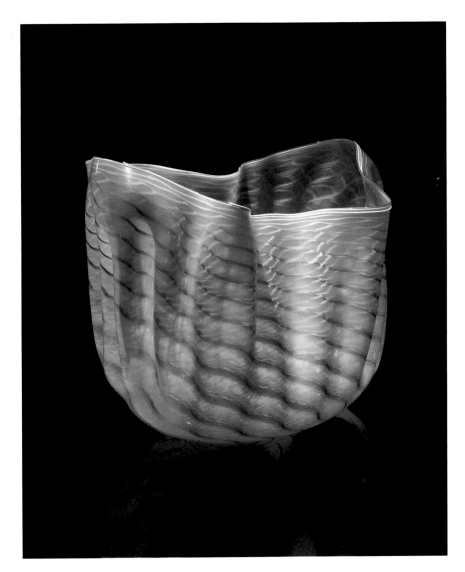

The Seaforms and the beauty and spirit reflected in each glowing rendition inspire those who see them to value and care for the living sea. Whatever else these wondrous glass objects are as reflections of skill, passion, teamwork and sheer genius, they are also tributes—a celebration of the sea that the child Chihuly first knew near Seattle, the wild ocean where he later sailed as a fisherman, the New England shore where he developed as an artist at the Rhode Island School of Design, the oceans and archipelagos that he sought worldwide, and, in due course, the Northwest Coast near the phenomenon known as The Boathouse, where he and the creative team who works with him now create miracles with glass.
—Sylvia Earle, Chihuly: Seaforms, *1995*

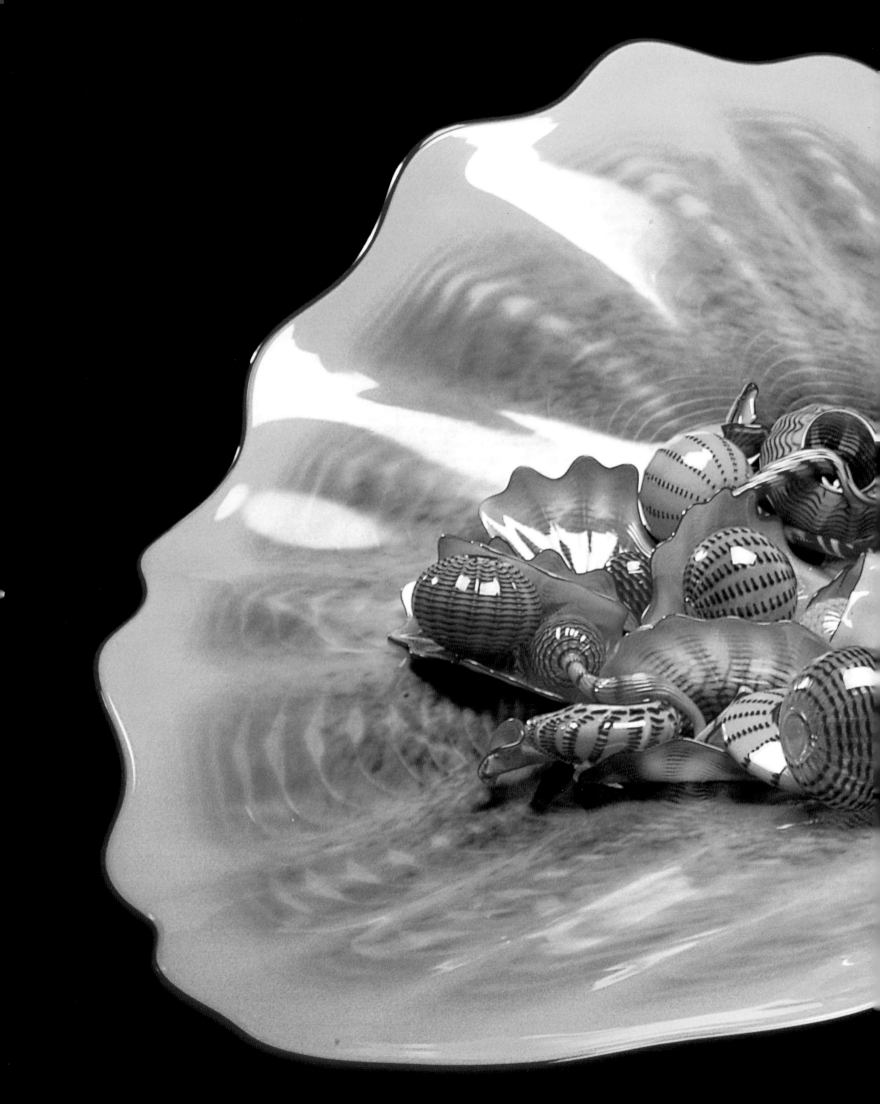

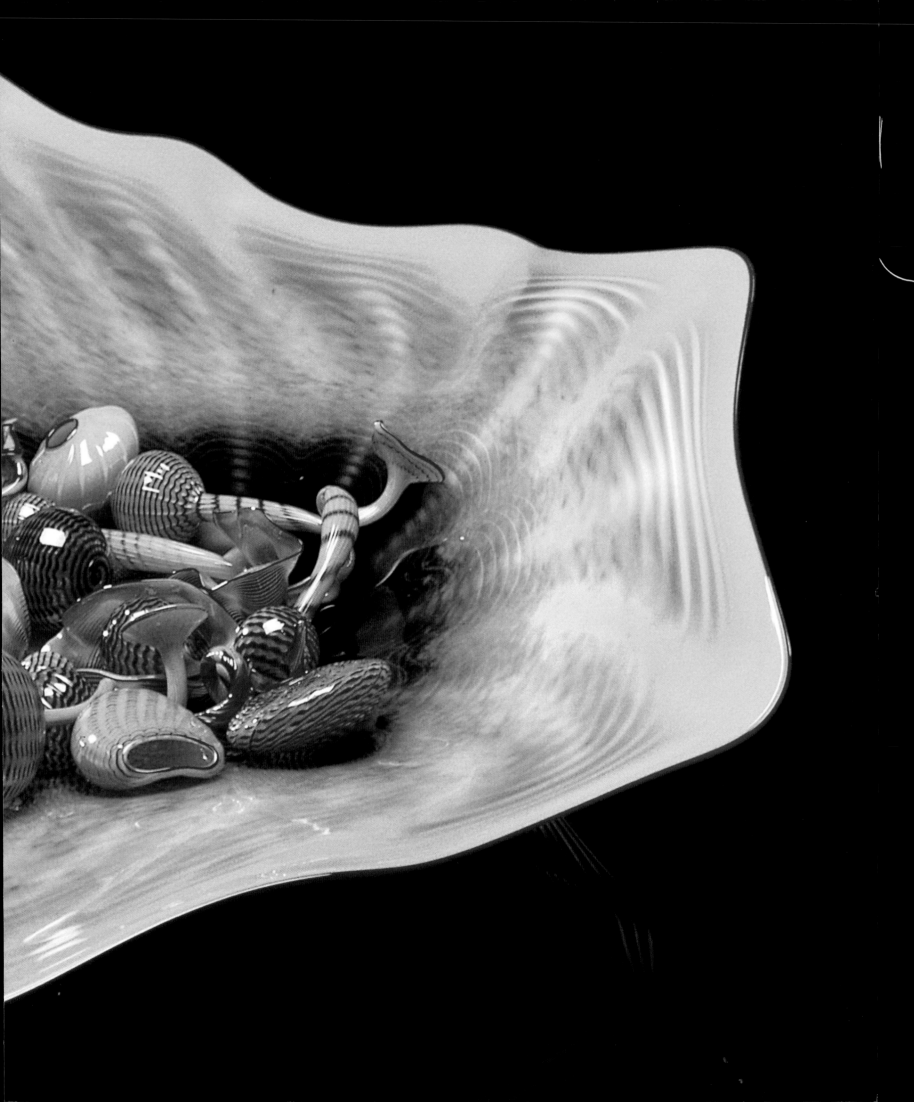

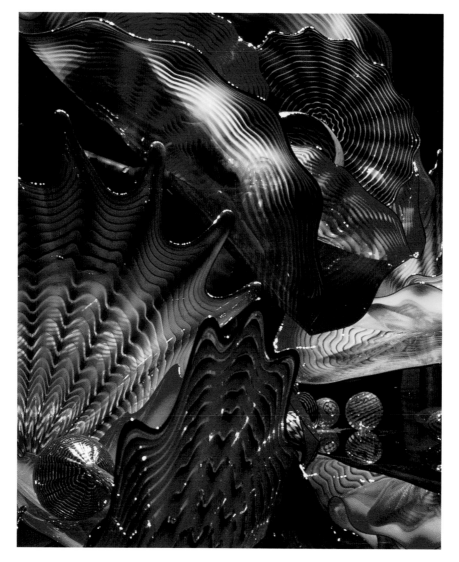

The individual elements in the Persians *still exude life. The elasticity of each form manifests glass's real character as a frozen liquid, as molecules held in suspension.... The individual elements composing the* Persians *simulate the rhythms and forces of life.... The delicacy and fragility of his glass as well as its tentative placement is an impression of this world: The series is like some wonderful perfume blown across the great central Iranian desert. The pieces allude to romance, mystery, an ancient world, and its survival in the present.... Existence, as the* Persians *suggest, is always tentative and precarious, always something to be fought and won ... at least momentarily.*
—Henry Geldzahler, Chihuly: Persians, *1988*

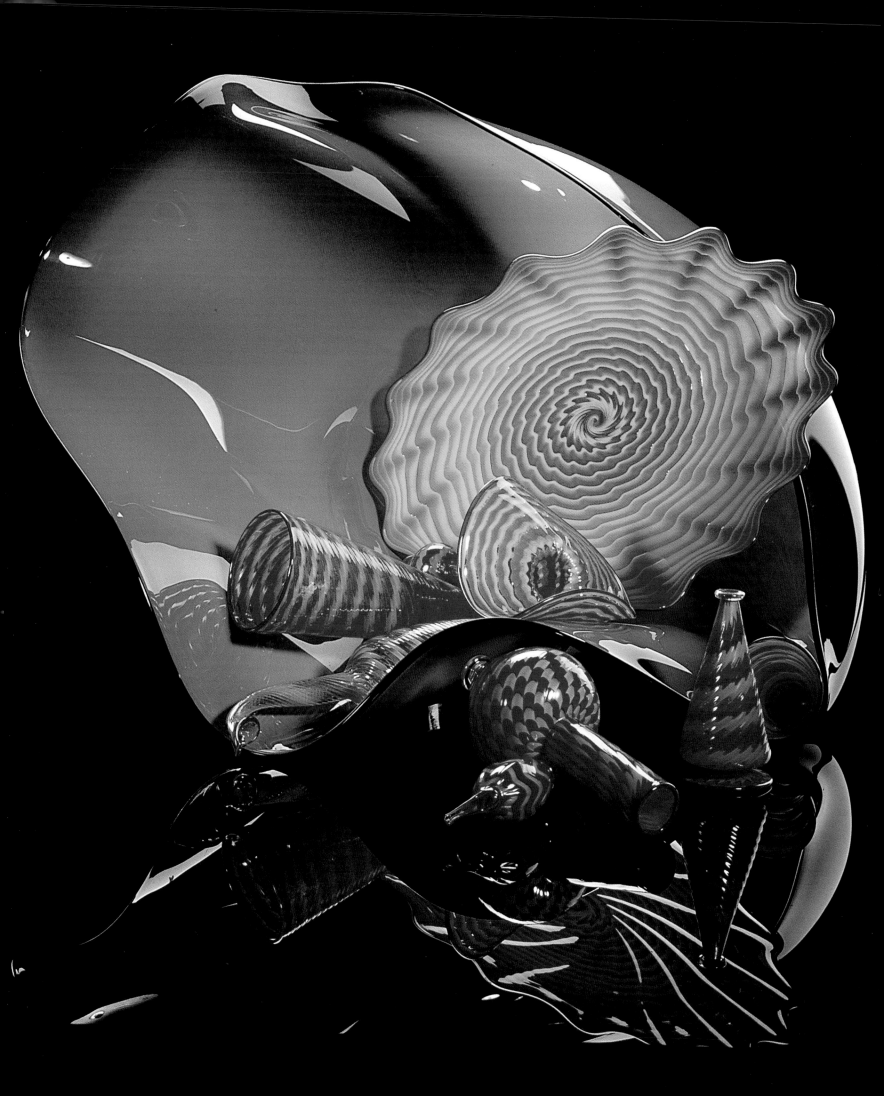

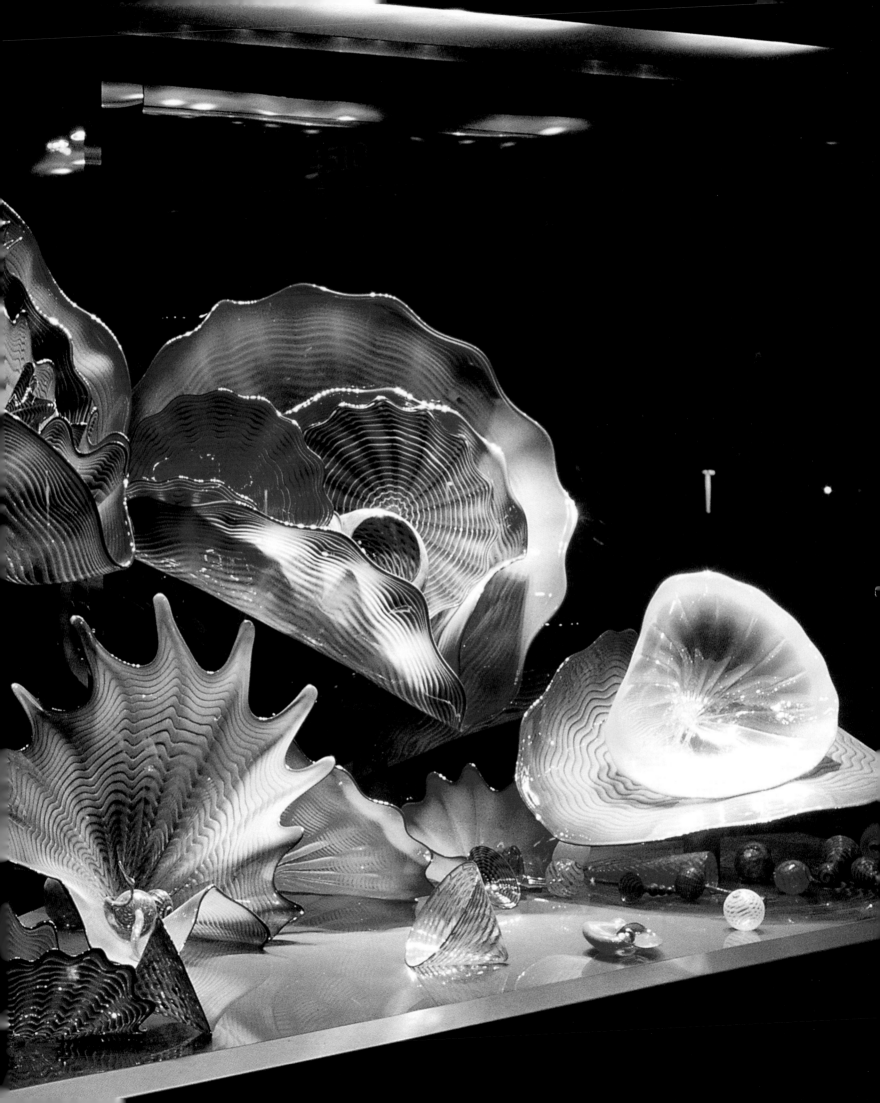

Previous
Chancellor Park Persian Installation,
1988, 6' x 14' x 12', La Jolla, California

Below and Opposite
Rainbow Room Frieze (detail),
Rockefeller Center, 1988, New York,
New York

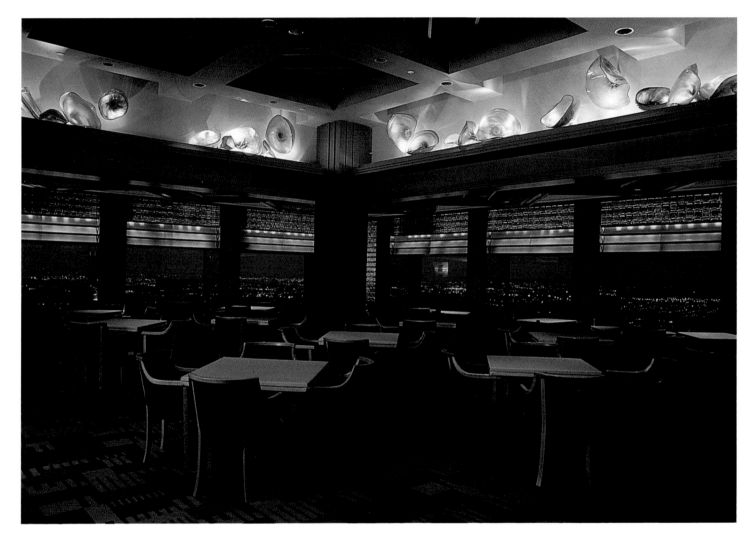

Chihuly began his Persian *series
in 1986 as a search for new forms—
form, always for Chihuly, being a
vehicle for color. Early works in
the series were oddly shaped and
intensely colored but were soon
transformed. . . . As Chihuly
continued to expand and modify*
his Persians, *he began to see their
potential for large, dramatic
installations.*
—Tina Oldknow, Chihuly:
Persians, *1997*

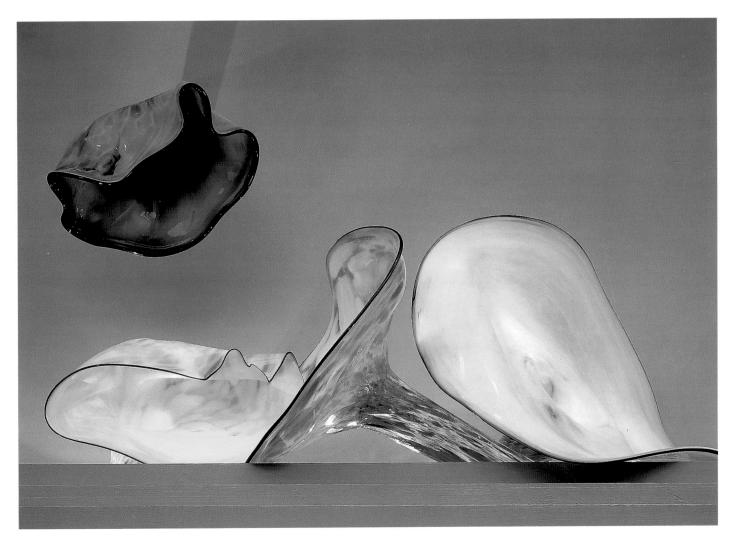

Overleaf
Prussian Blue Persian with Ruby Lip
Wrap, 1990, 18" x 32" x 36"

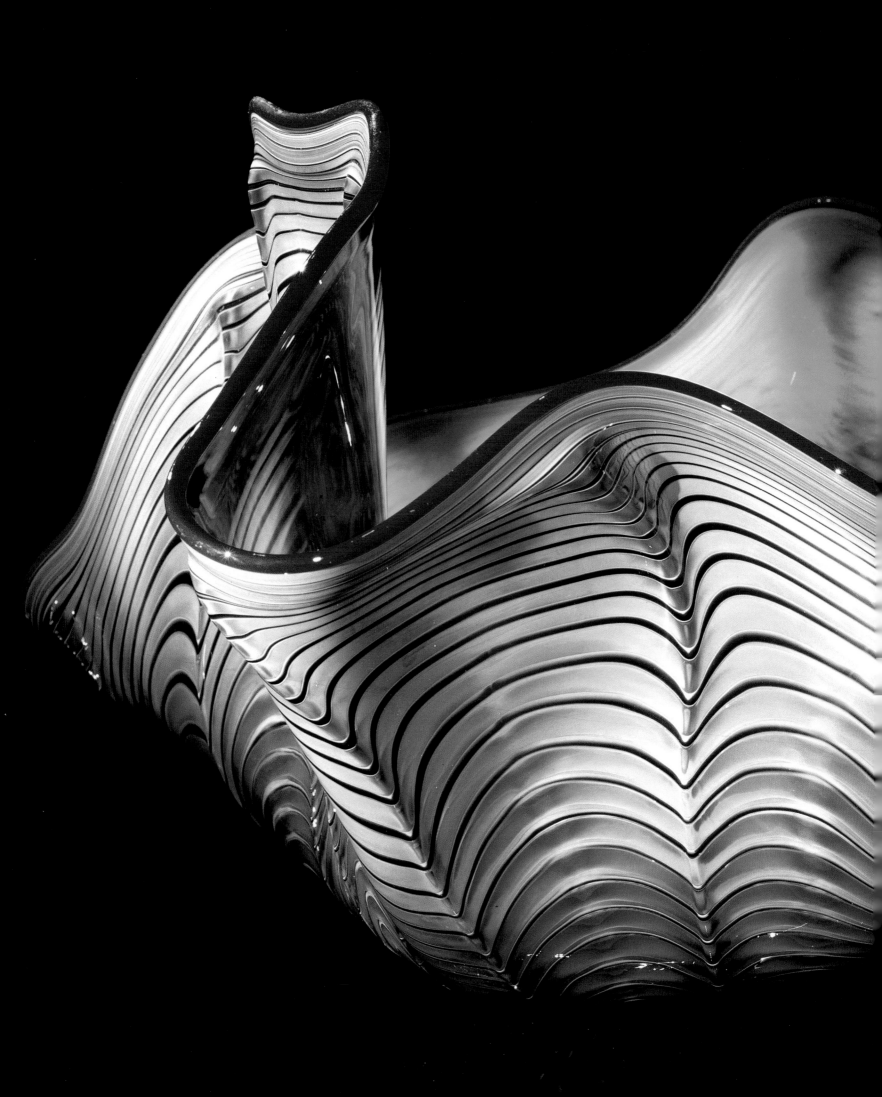

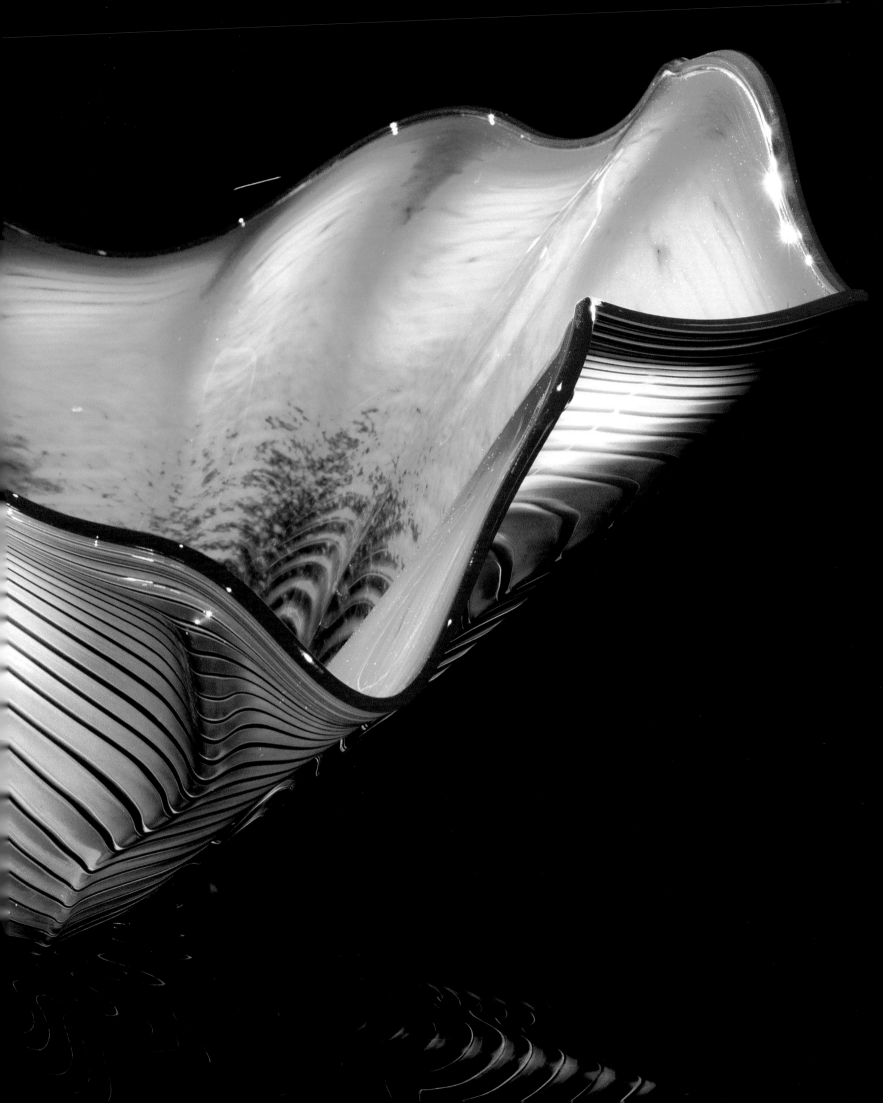

Below and Opposite
First drawings for Venetians, 1988,
charcoal and watercolor on paper,
22" x 30"

Lino Tagliapietra had been coming to Pilchuck for years, but I had never worked with European masters because my work had always been unorthodox and asymmetrical, and the idea of working with a European master didn't make sense. But Lino and I decided that we'd try to do something together, so I designed a series that was a take-off from some Venetian art deco pieces I had seen that were from the 1920s. And I was able to sketch them, and from those sketches, Lino began to work . . . I was lucky to have not only Lino, one of the really extraordinary glass masters of the world, but also Ben Moore, who speaks Italian and who is almost a son to Lino. Benny would organize the teams and Lino would sort of be the mentor. We'd do the most extreme pieces that I felt like imagining.
—Dale Chihuly, Dale Chihuly: Installations, 1964–1992, *1992*

Below
Venetian Drawing, 1988, charcoal and
watercolor on paper, 30" x 22"

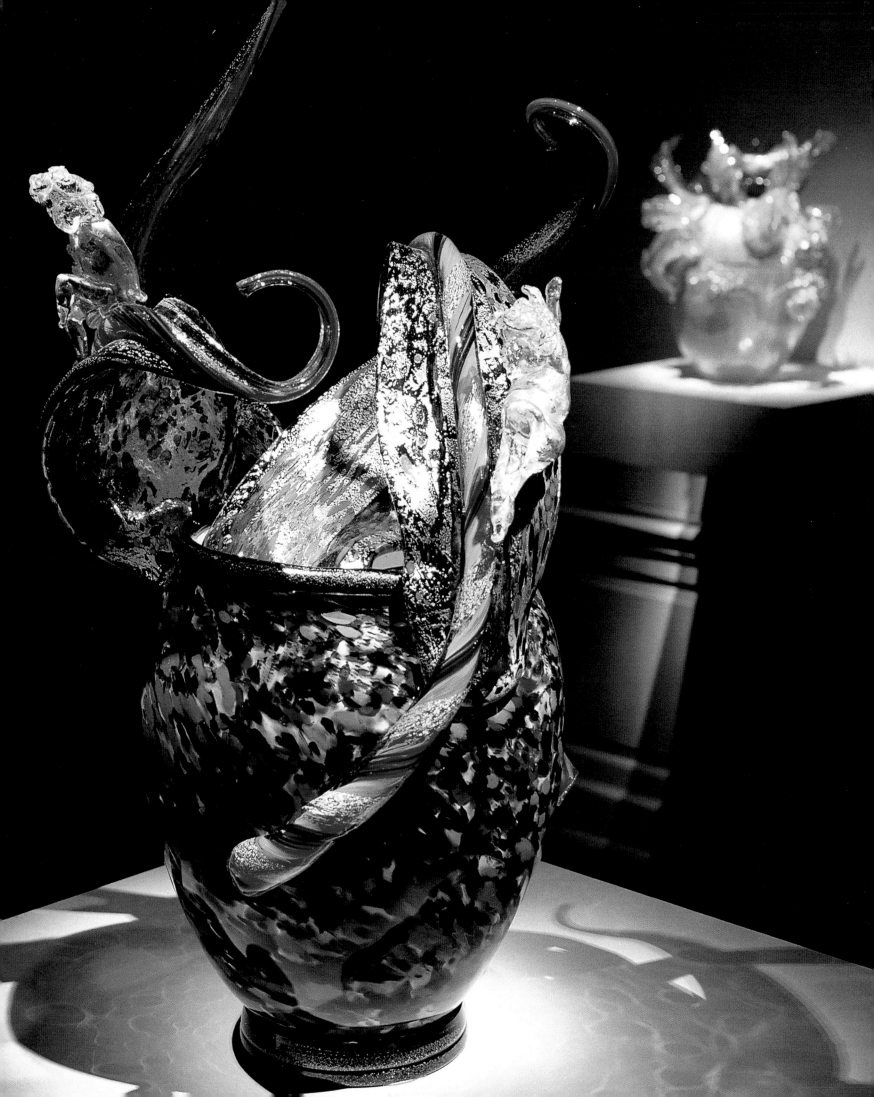

Opposite
Venetian Installation, 1997, Portland
Art Museum, Portland, Oregon

Below
Windsor Violet Venetian
with Green and Blue Slugs, 1989,
16" x 16" x 15"

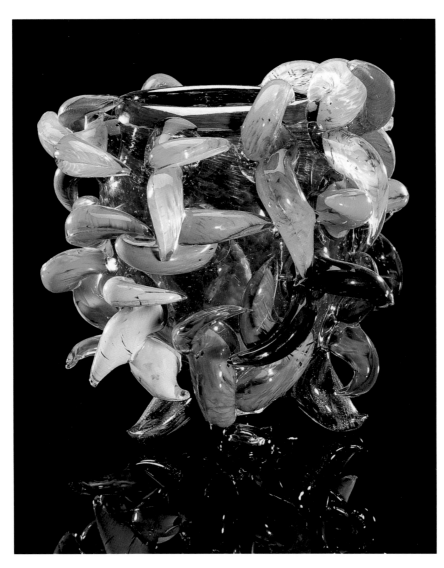

The Venetians *are challenging on every front: their chaste art-moderne vase forms explode in all directions with spikes, coils, flanges, wings, hooks; they vibrate with allusions, to knobby creatures of the sea bottom, Chinese cult bronzes, art-deco candy dishes, baroque reliquaries, a Martian cocktail shaker. . . . The* Venetians *are arty, but not in any reserved, highbrow way. They strain from extremes; garish color, grotesque disproportion between base and decoration, mannerist asymmetry.*
—Roger Downey, "Glass Act," Seattle Weekly, *12 August 1992*

I want to emphasize how important
the drawings came to be in
determining what I wanted to make.
While the team is working, I can walk
over to the drawing board and begin to
draw. Being able to move back and
forth between the pad and the drawing
table is what really allowed the series
to move so quickly.... Drawing is a
fluid process, like glass blowing is a
fluid process.
—Dale Chihuly, 1991

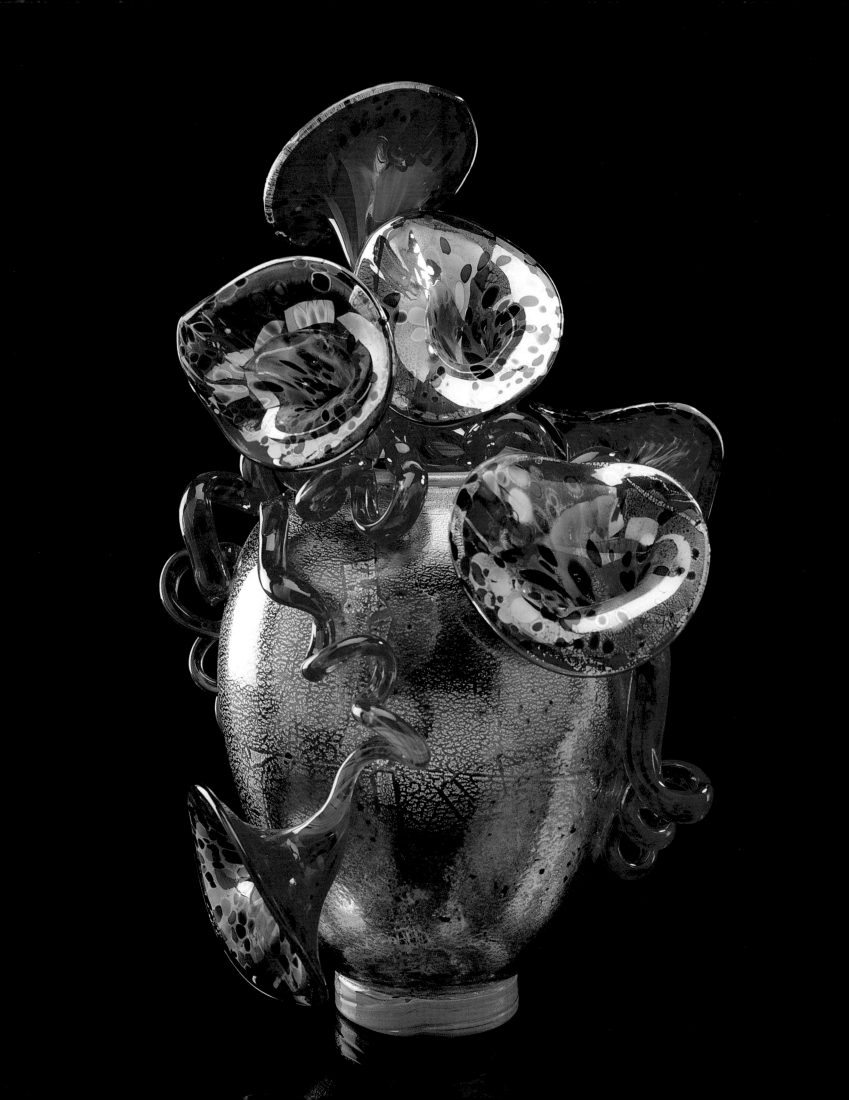

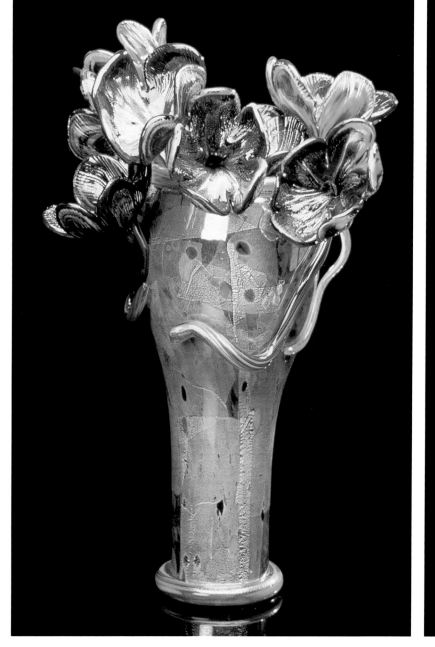

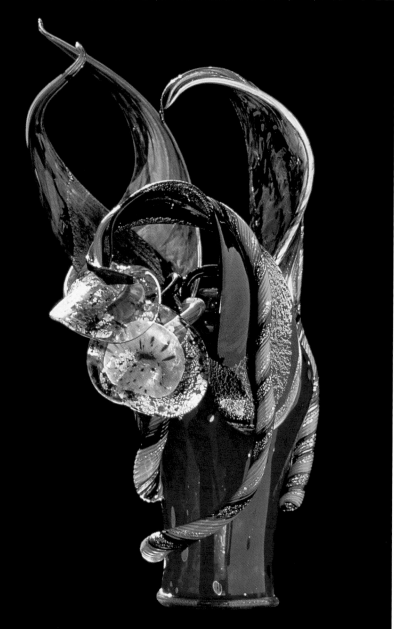

Overleaf
Venetian Drawing Wall at the
Boathouse, 1990, Seattle, Washington

157

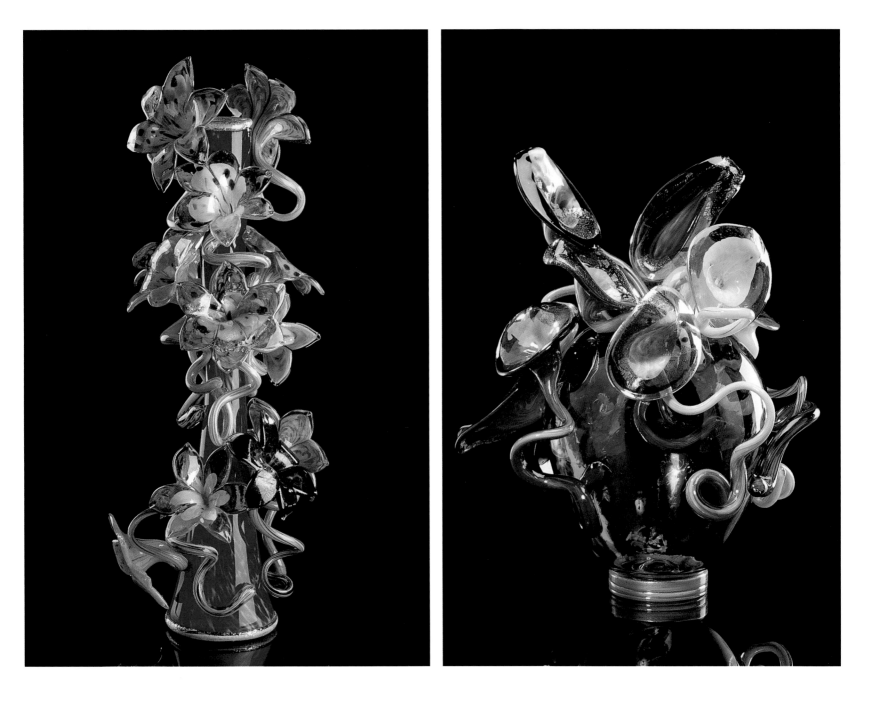

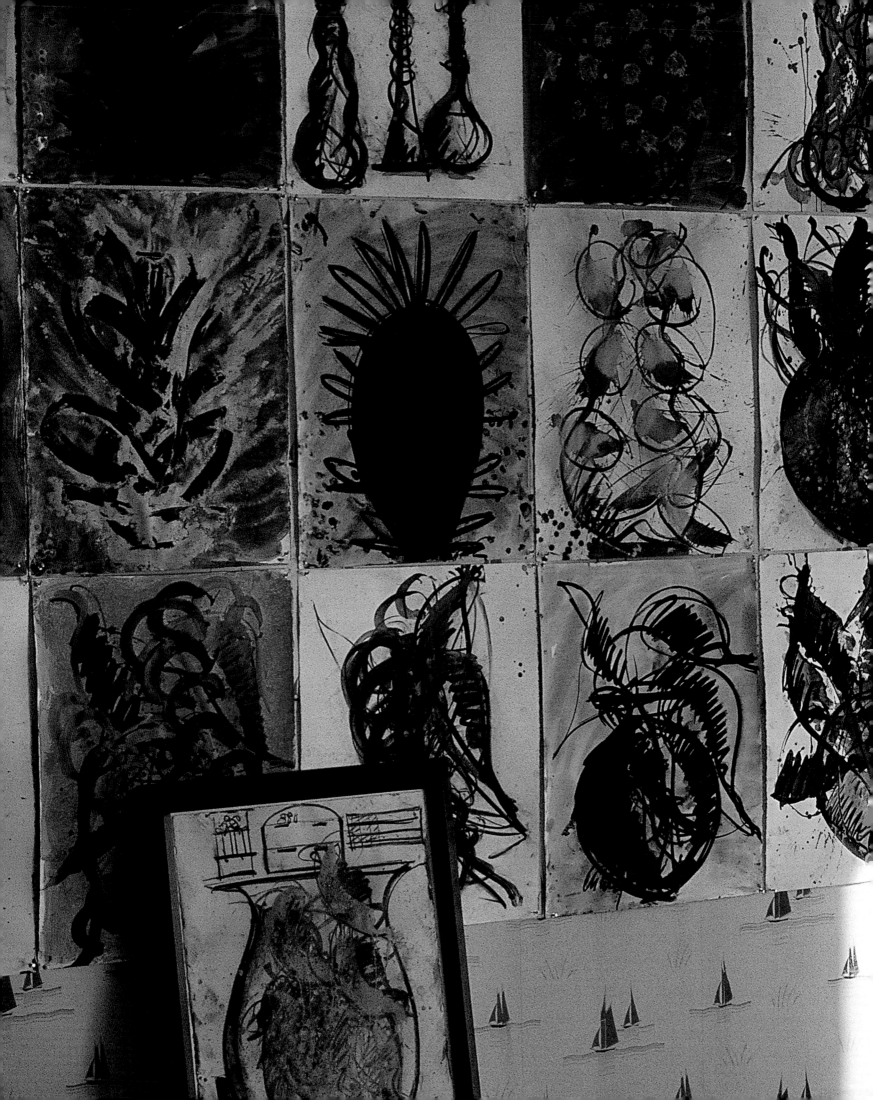

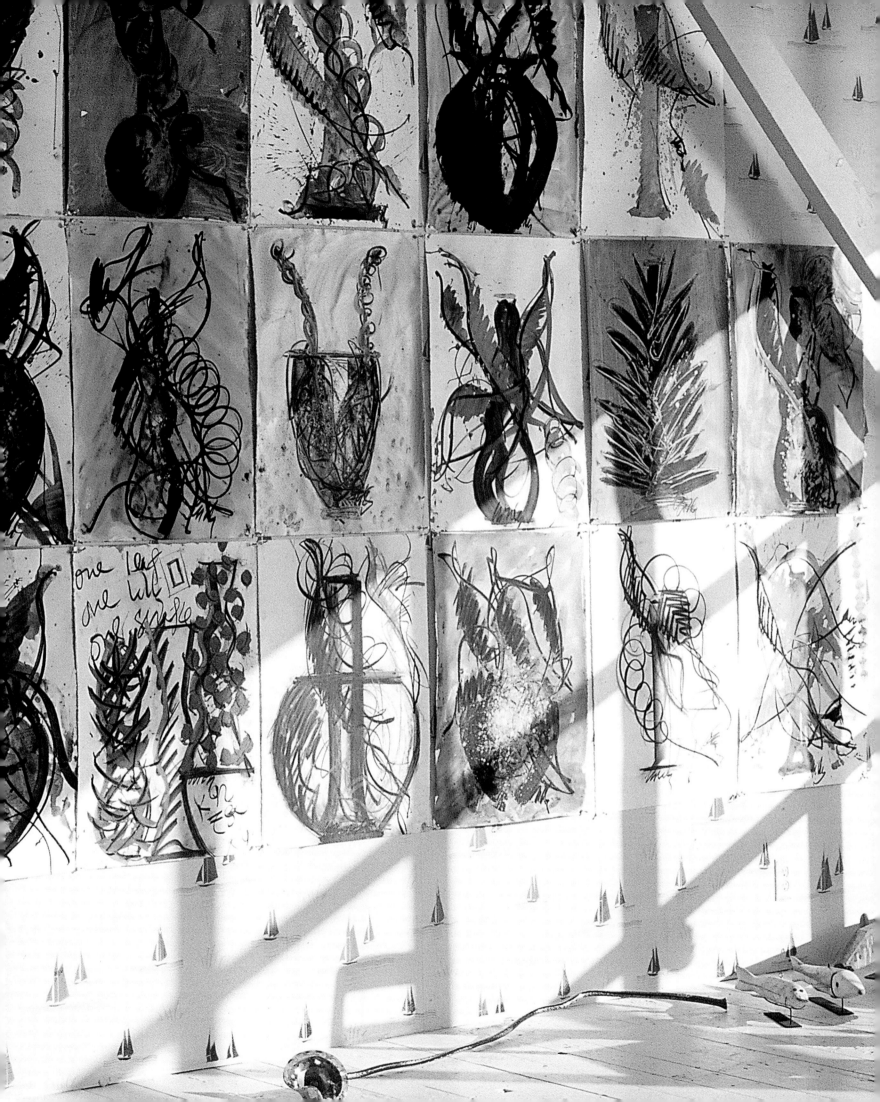

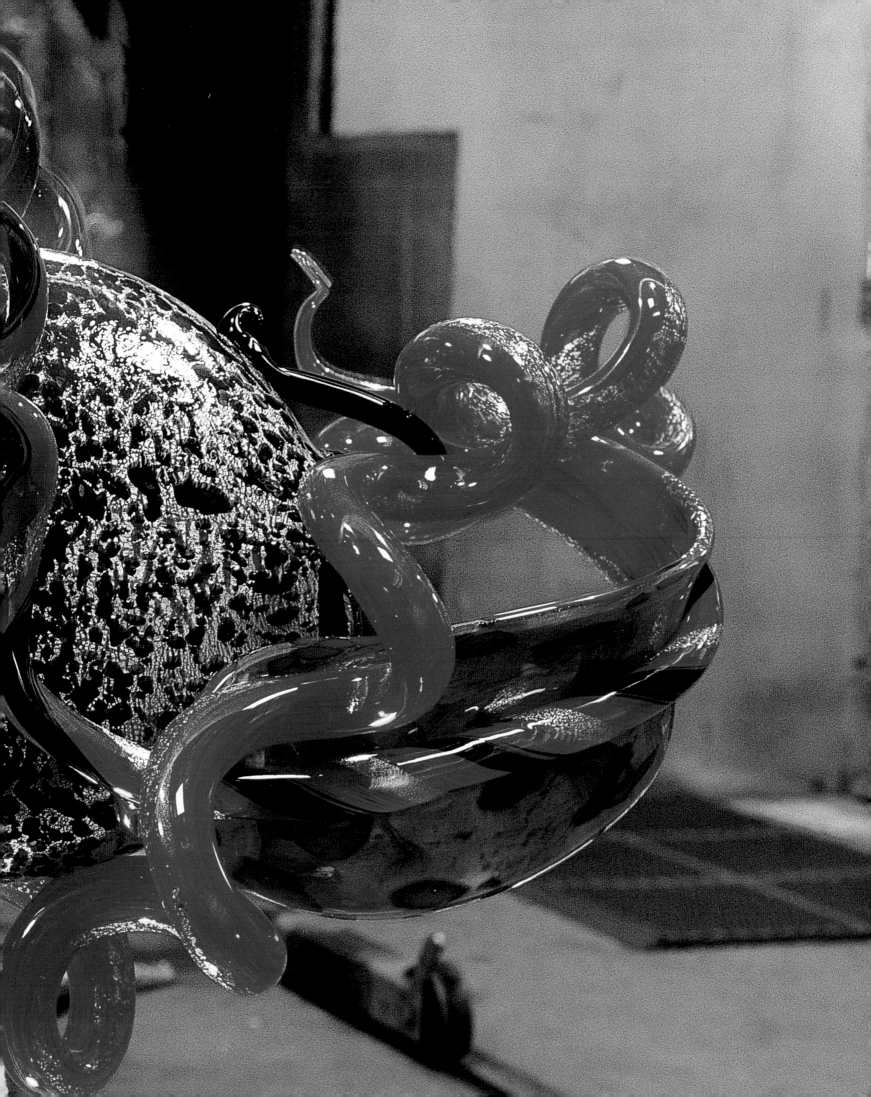

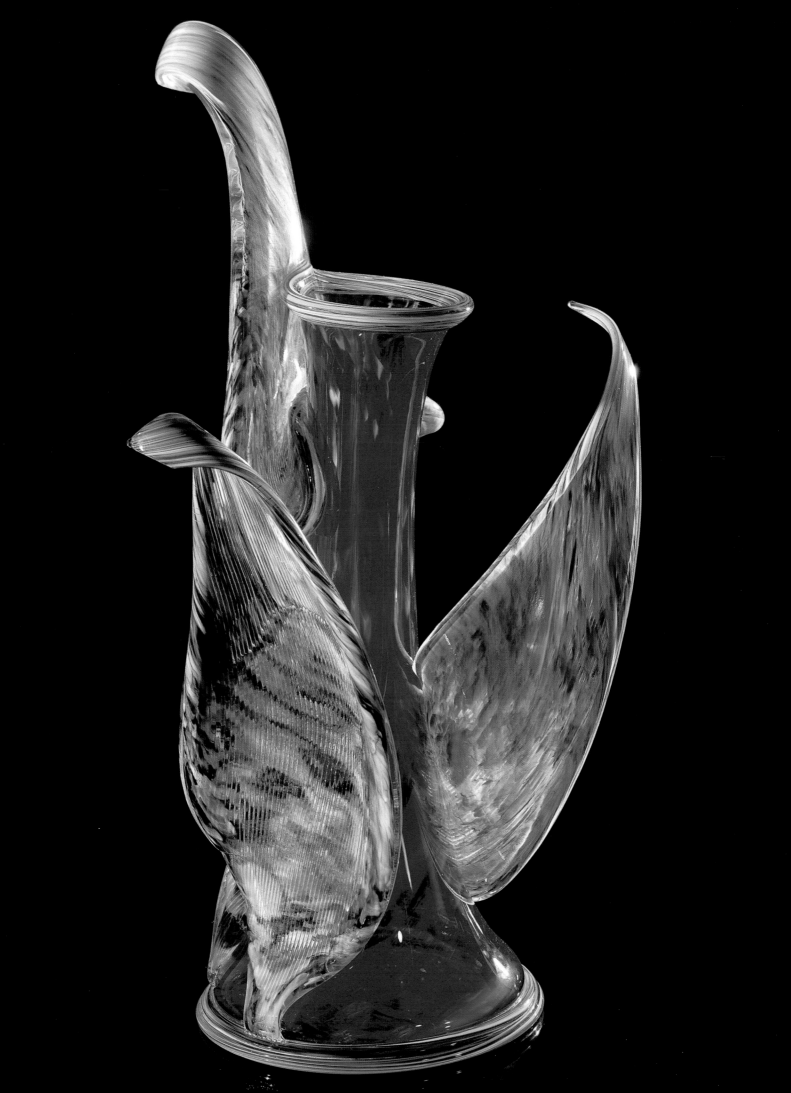

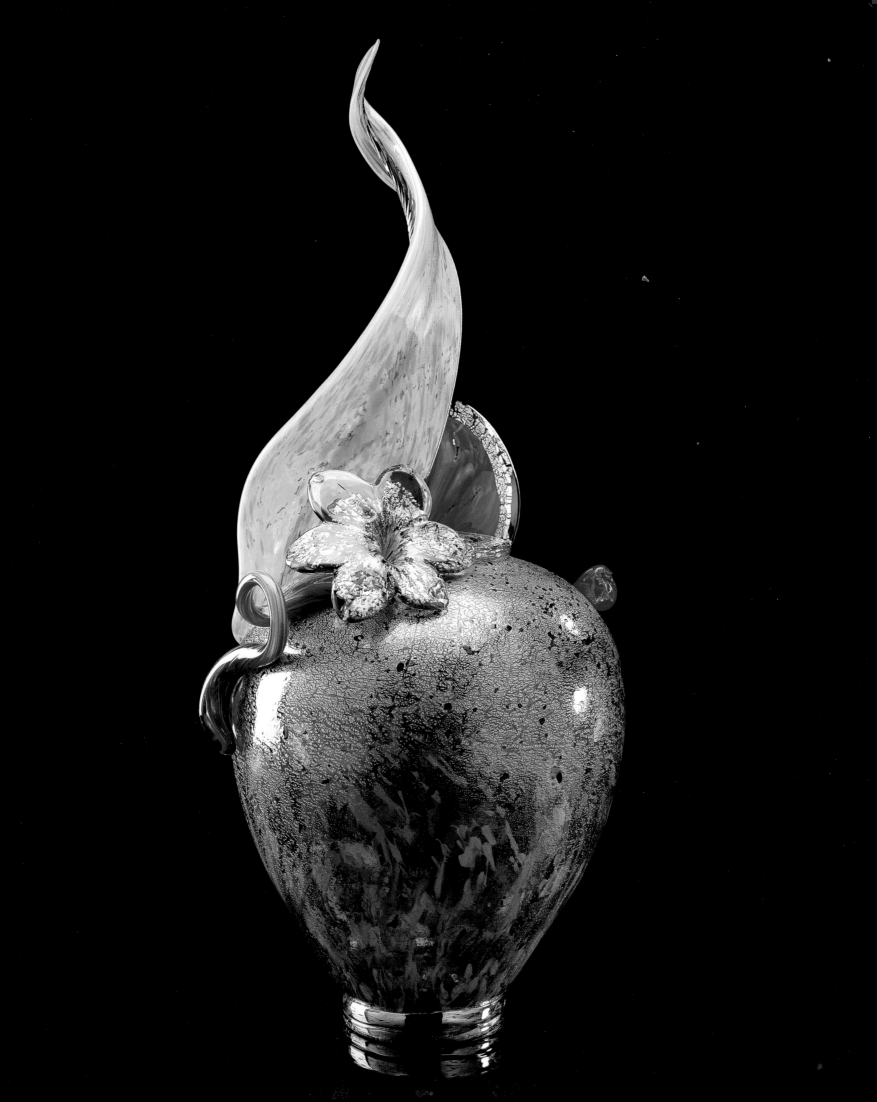

Tensions abound in the Venetians. Every attachment seems to indicate flux, a relentless, organic force impinging on the physical integrity of the classic form. Hot glass simulates or is affected by natural properties and realities—its fluidity and the spontaneity of working equates to the mysterious metamorphoses of living organisms, while physical forces of gravity can be utilized or challenged to suggest an independent vitalism. The vegetative and biomorphic decoration and ornamentation of the Venetians seem to both confirm and contradict the laws of nature. The works expand aggressively into space, like a living and growing thing. And like living things, each work of the Venetians has an individual character, a personality if you will, much more so than Chihuly's other series.

—Ron Glowen, Venetians: Dale Chihuly, 1989

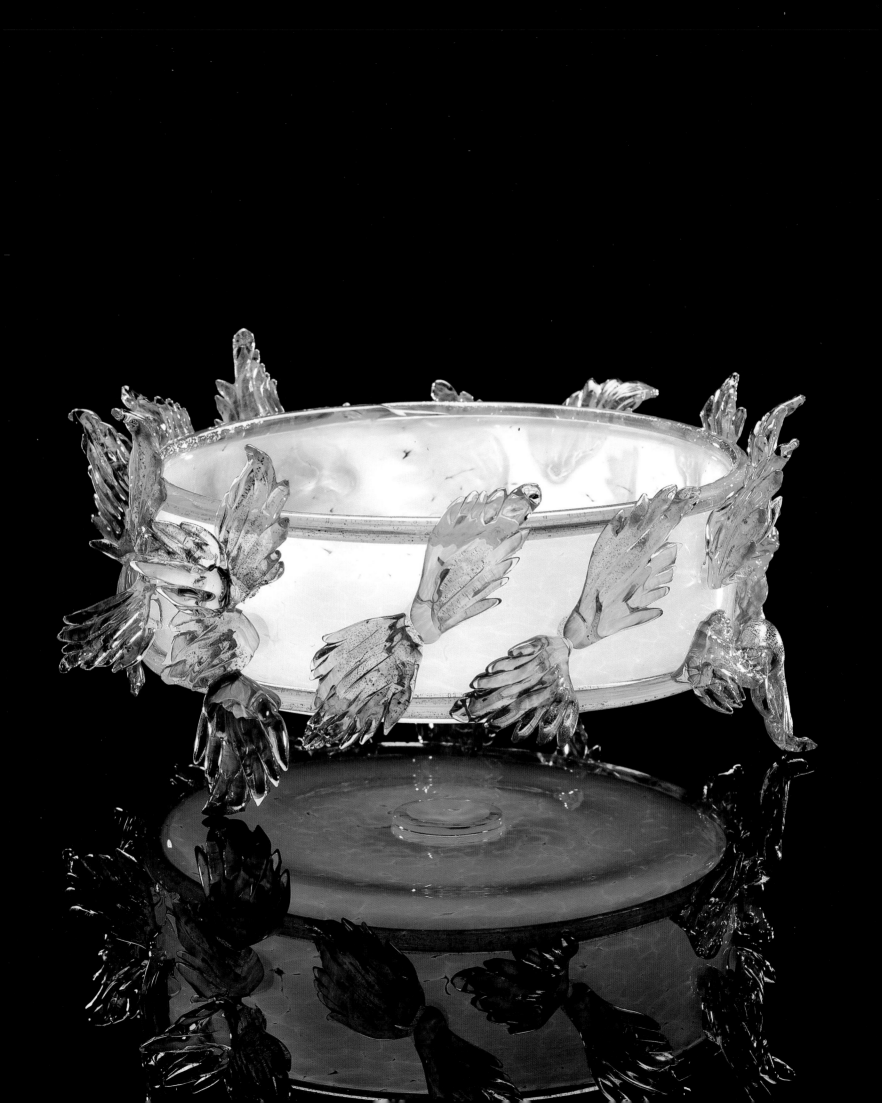

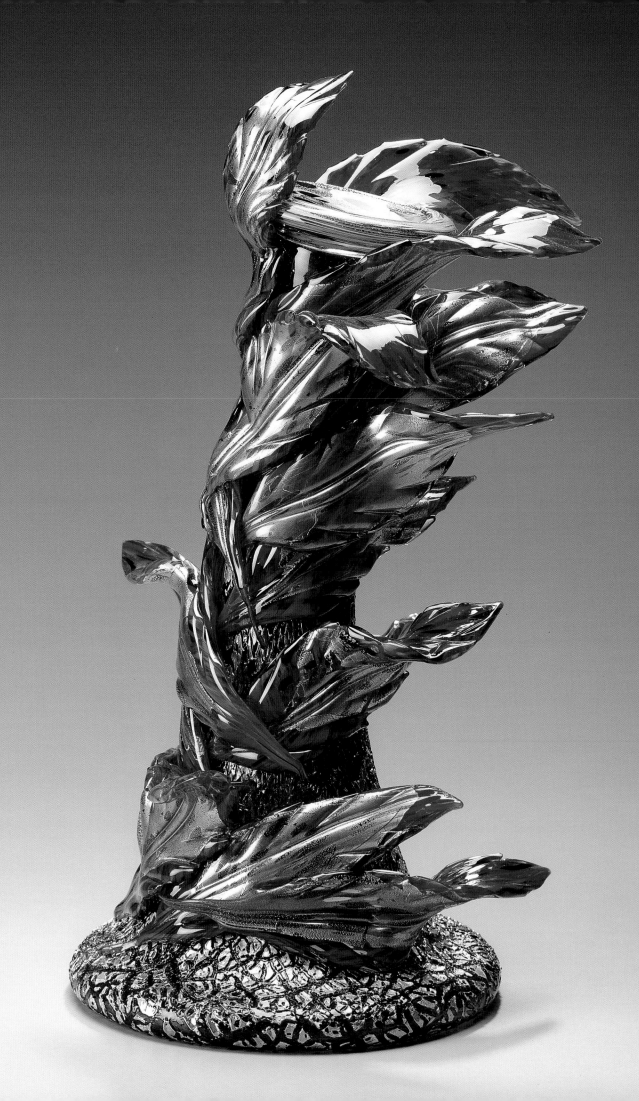

Opposite
Gold over Cobalt Venetian, 1989,
22" x 12" x 11"

Below
Rose Pink Venetian, 1990,
13" x 16" x 16"

Overleaf
Cadmium Yellow Basket Set with
Dark Oxblood Lip Wraps, 1993,
21" x 21" x 19"

Rose Madder Macchia with Paris Blue
Lip Wrap, 1993, 18" x 29" x 32"

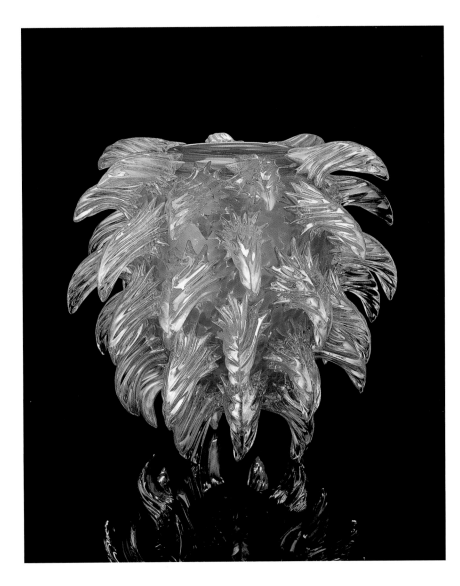

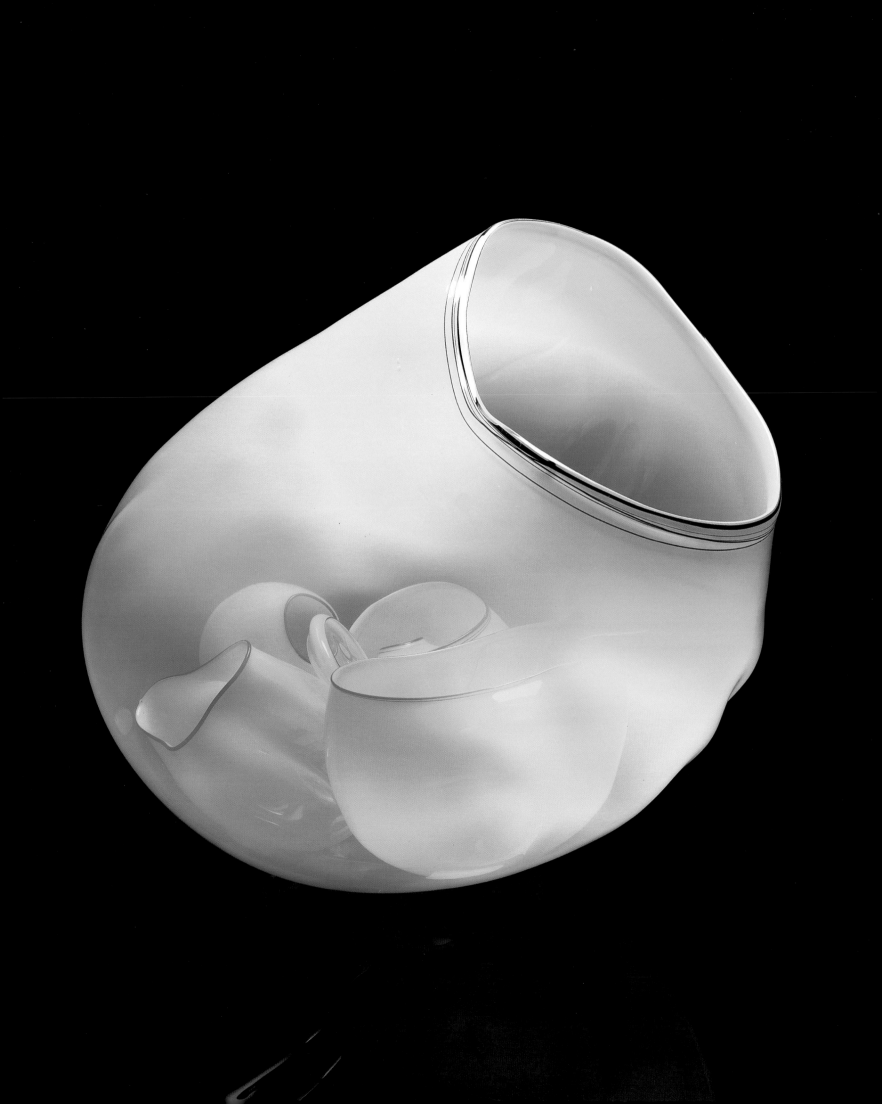

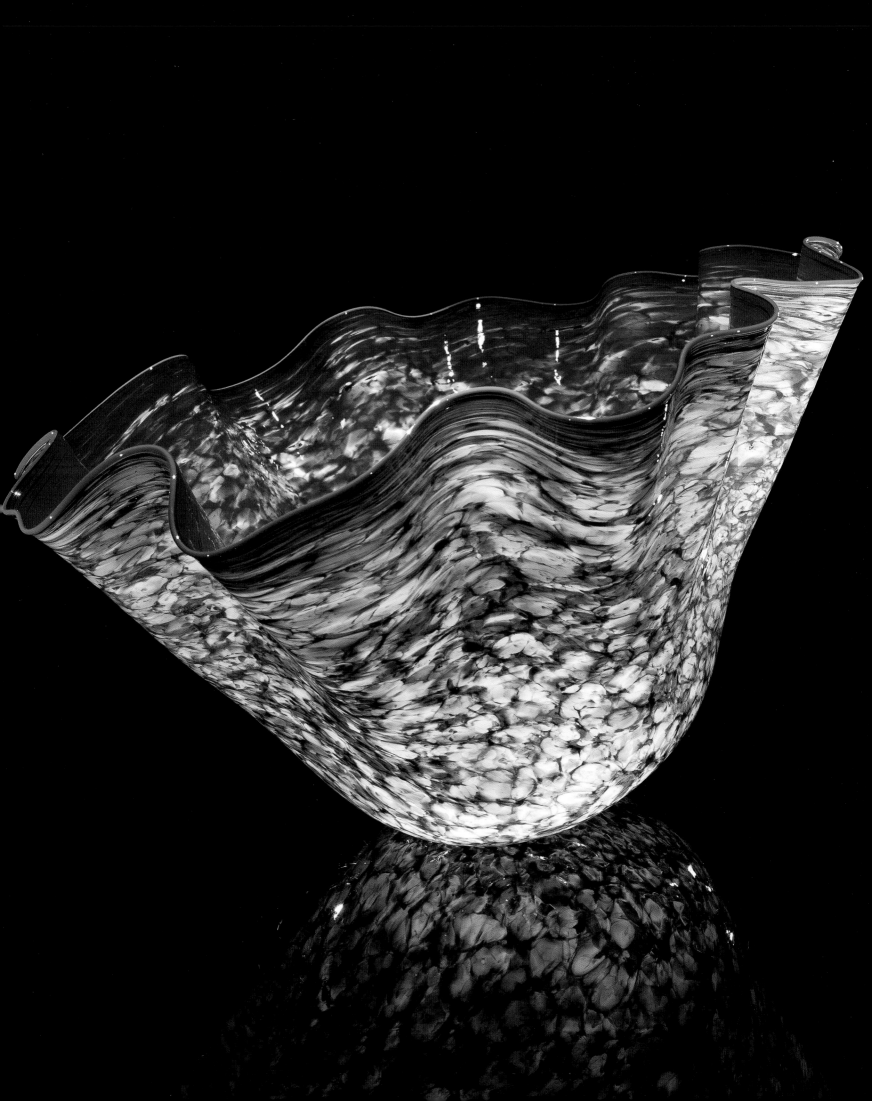

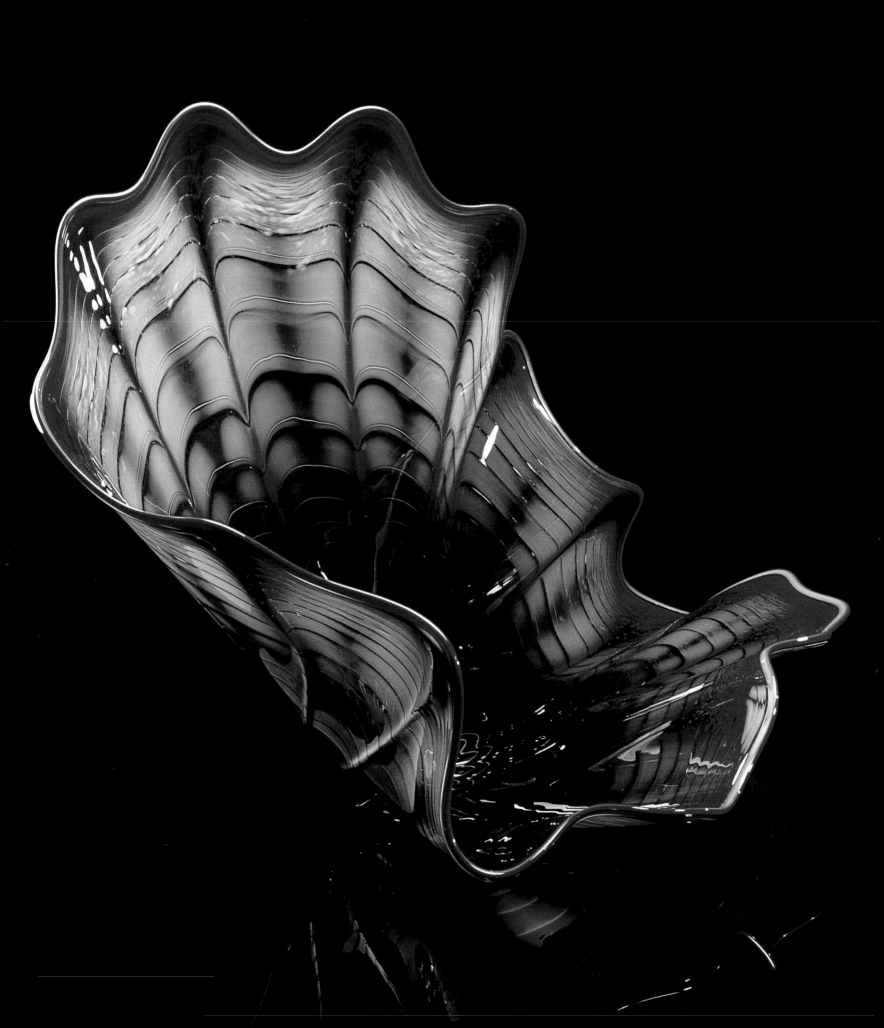

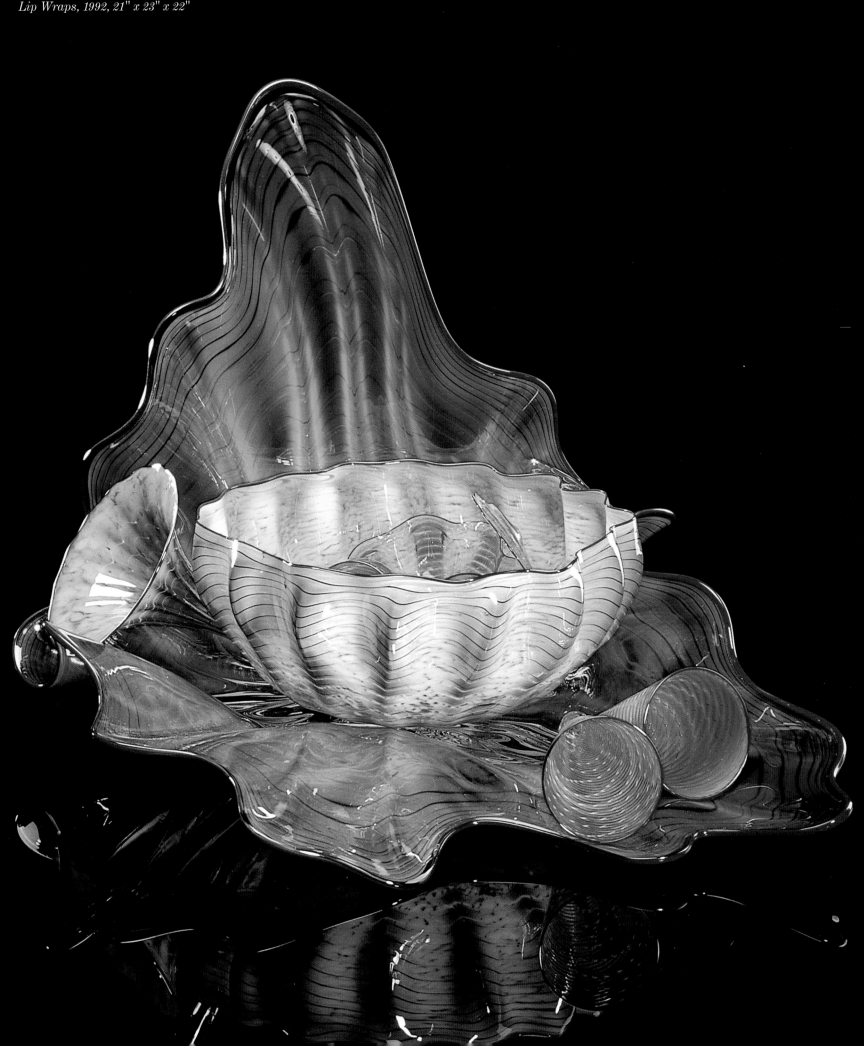

Leaf Green Persian Set with Orange
Lip Wraps, 1992, 21" x 23" x 22"

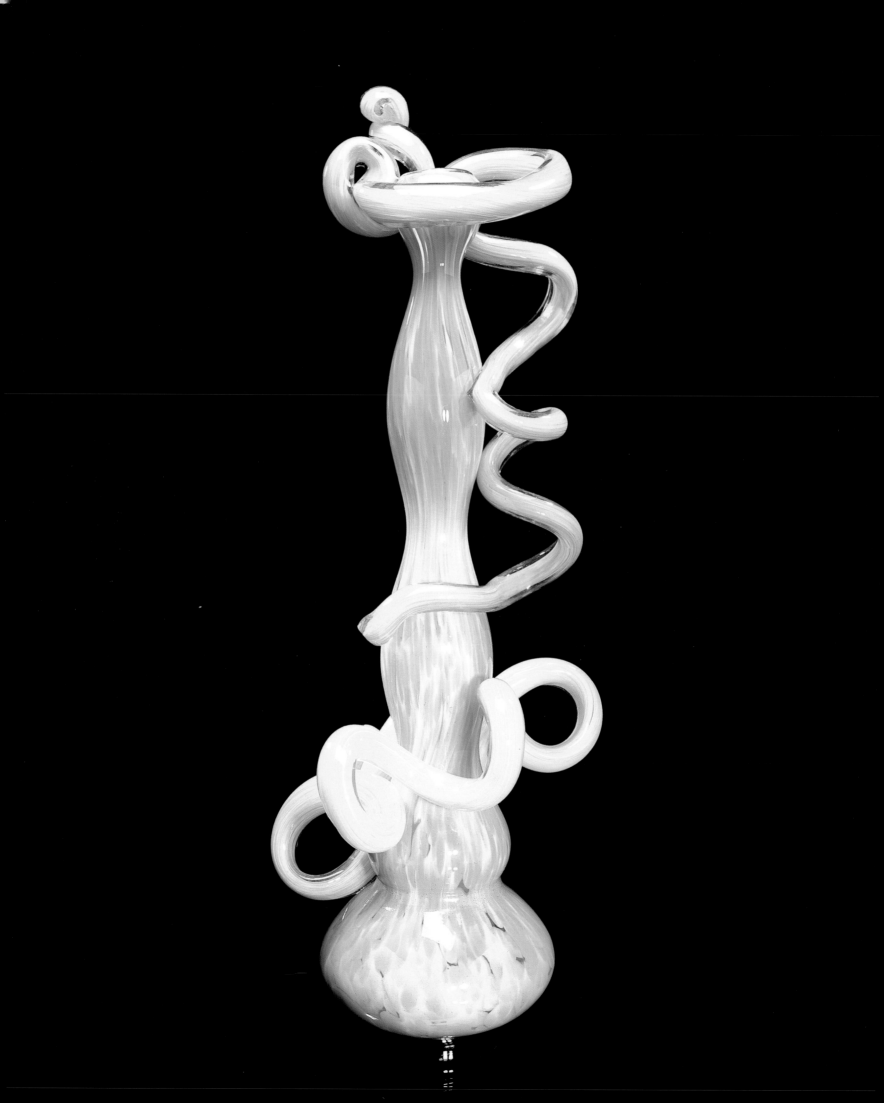

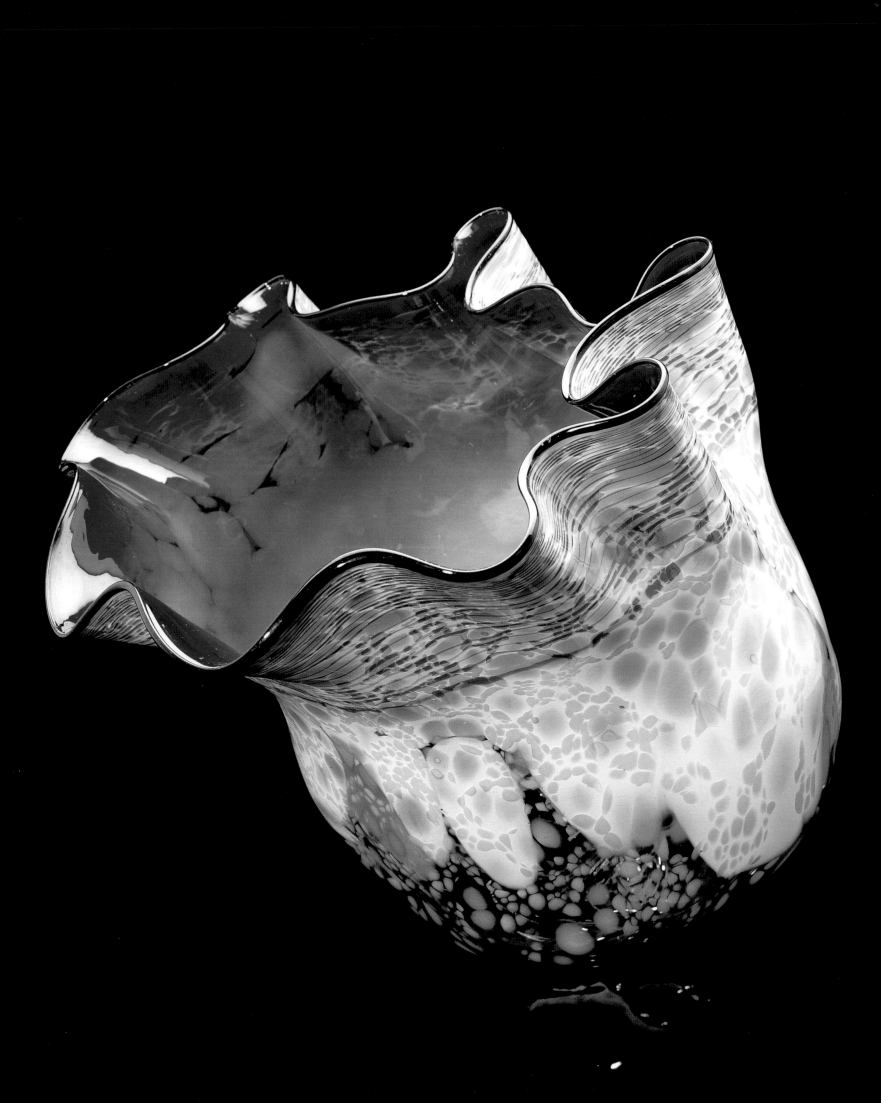

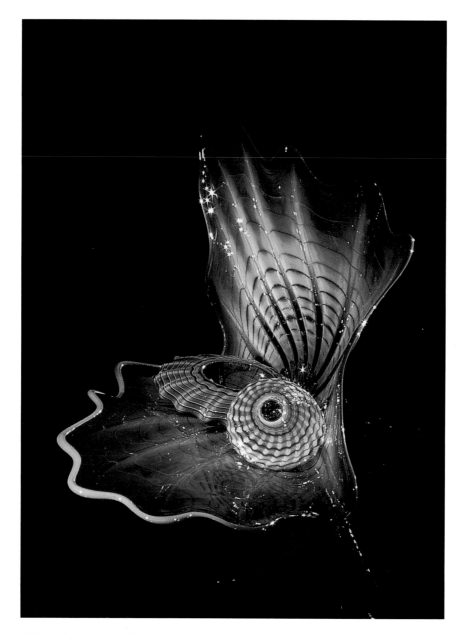

Although the natural beauty of glass is easily exploited, the use of its transformational properties is rarely attempted by artists who work in the medium. Chihuly is a master in the creation of transformational spaces through the construction of an impressive and persuasive mise-en-scene. The sources of his Persians *are classical Greek, Persian, Byzantine, Islamic, Venetian, and art nouveau, together representing an incredibly fertile palimpsest of ideas and influences. Yet for Chihuly, the* Persians *are only one expression of the underlying, purely abstract and formal objective of his work: the exploration of form and the glass itself as a vehicle for color, and the orchestration of color to create transformational environments.*
—Tina Oldknow, Chihuly:
Persians, *1997*

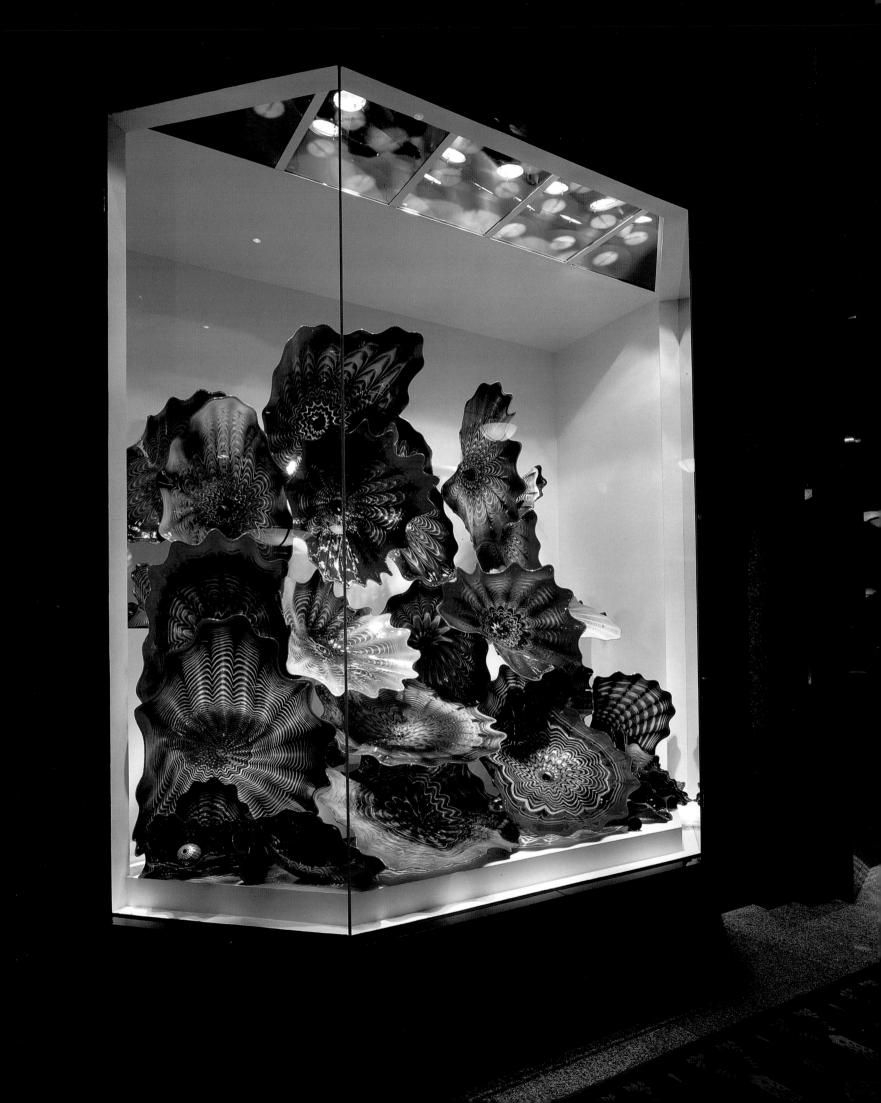

Below
*Ebeltoft Drawing, 1991, charcoal and
acrylic on paper, 30" x 22"*

Below
*Ebeltoft Drawing, 1991, charcoal and
acrylic on paper, 30" x 22"*

Opposite
*Sisters Drawing (detail), 1991,
charcoal and acrylic on paper,
41" x 29"*

Below
Ikebana Drawing, 1991, acrylic on
paper, 30" x 22"

Opposite
Ultramarine Blue Ikebana with
Yellow Floral Form, 1990,
49" x 15" x 15"

Overleaf
Boathouse hotshop, Seattle,
Washington

Chihuly grew up surrounded by flowers; his mother has a passion for gardening. . . . It is not too surprising that Chihuly has periodically turned to floral motifs. . . . To embellish his Venetians and complement and emphasize their larger scale, Chihuly created a series of elongated stems and blossoms, called Ikebana, after the stylized beauty of Japanese floral arrangements and reminiscent of the carved wood, gilt lotus blossoms that he admired on visits to Buddhist temples in Japan.
—Patterson Sims, Dale Chihuly:
Installations 1964–1992, *1992*

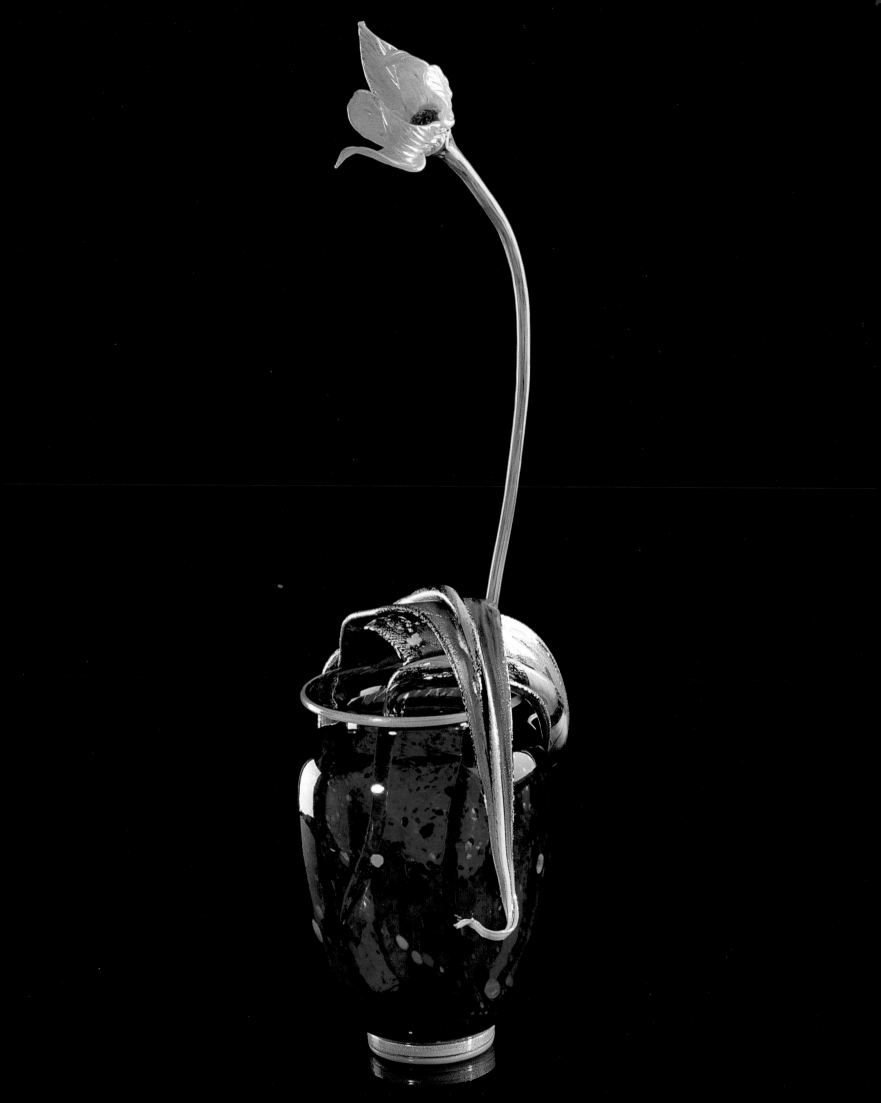

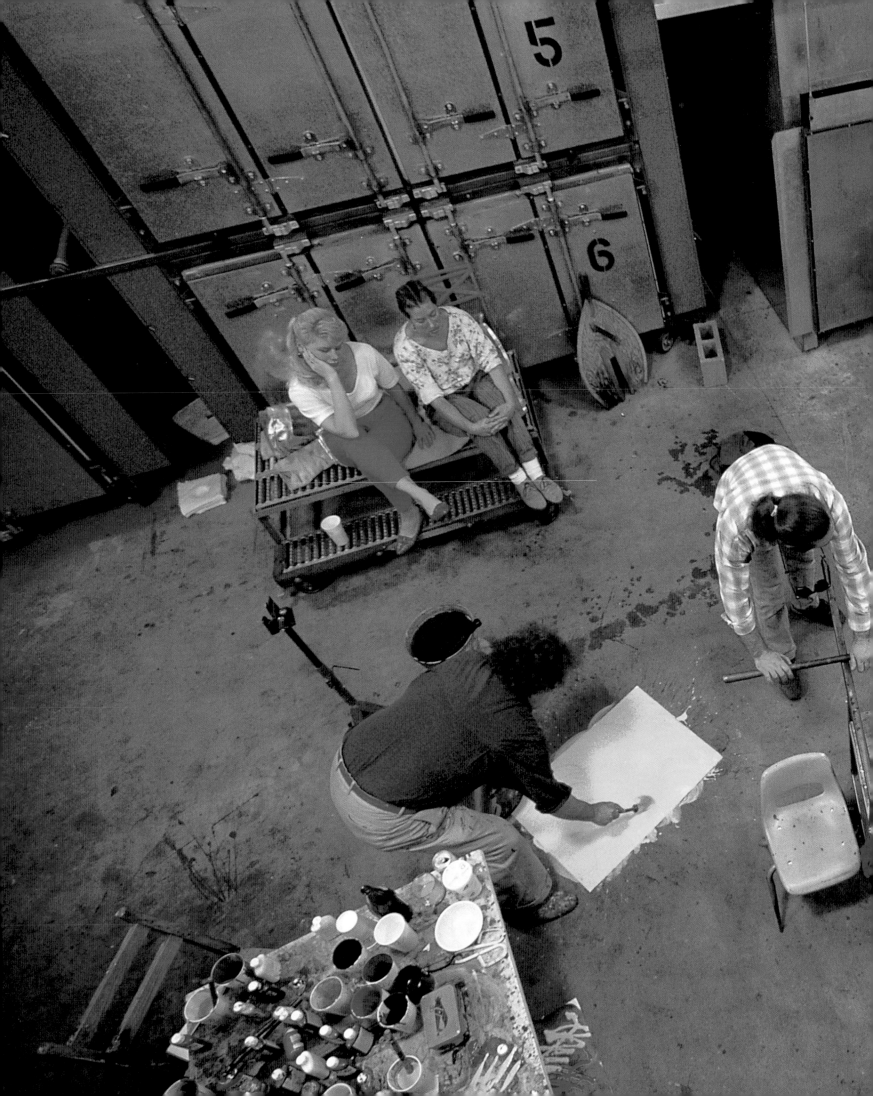

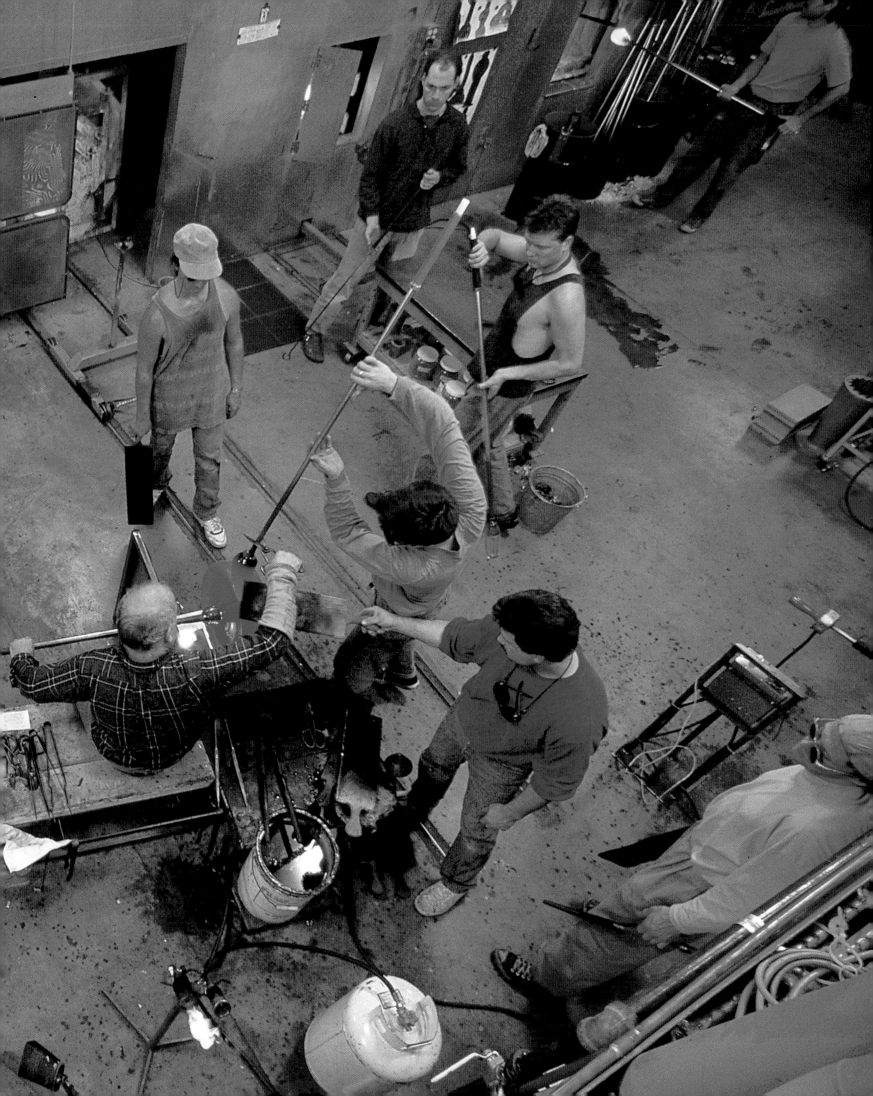

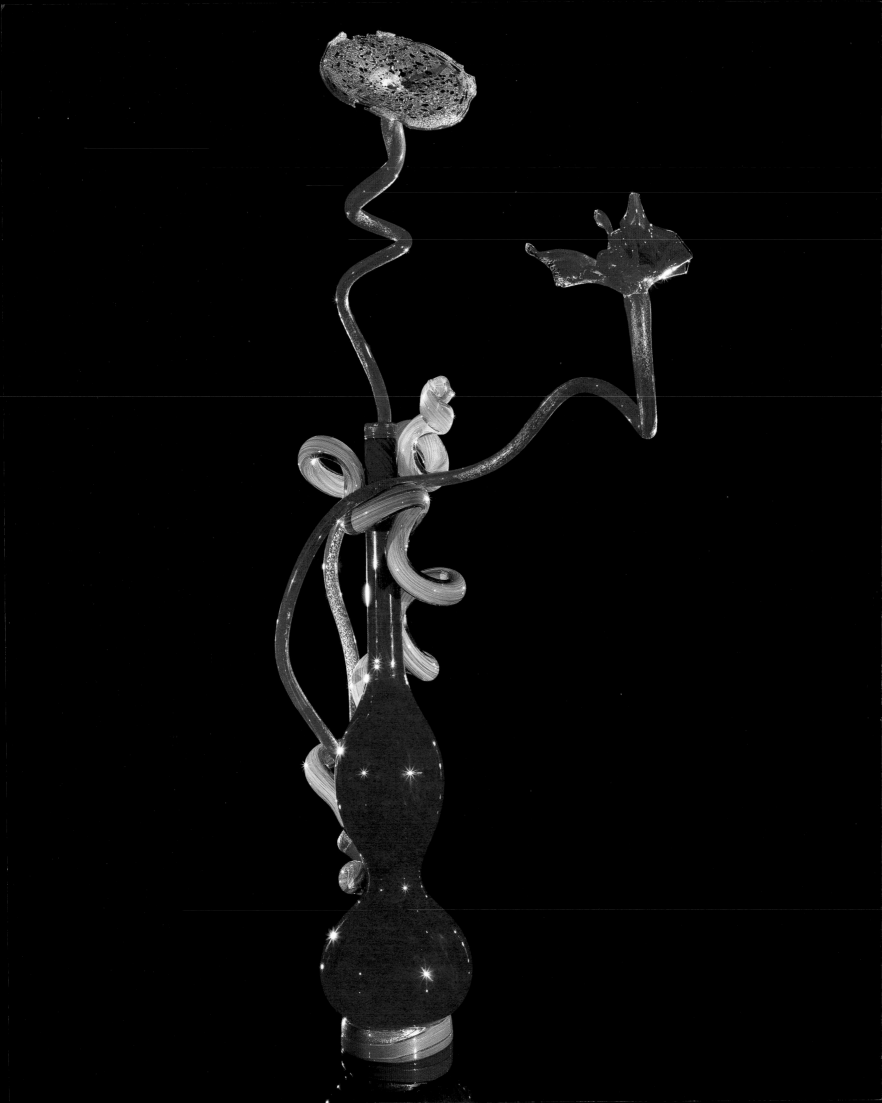

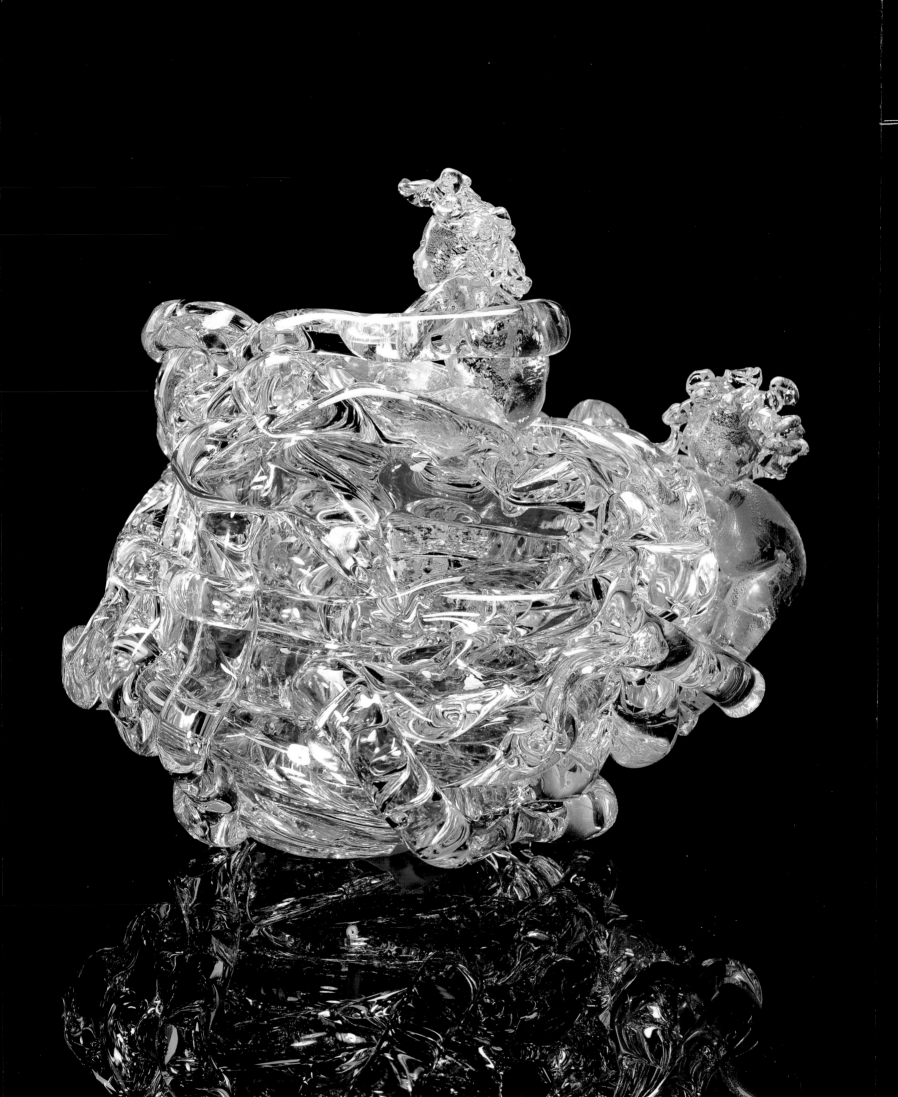

Previous
Ultramarine Blue Venetian with Two
Red Stems, 1991, 52" x 34" x 24"

Venetian Drawing, 1994, acrylic on
paper, 41" x 29"

Opposite
Spotted Blue and Green Translucent
Nested Putti, 1994, 9" x 10" x 8"

Below
Fax for Putti, 1994

CHIHULY STUDIO 509 NE NORTHLAKE WAY SEATTLE, WA 98105
TEL: 206 632 8707 FAX: 206 632 8825

*The glass master Pino Signoretto was
teaching a class at the Pilchuck Glass
School and I was asked to design a
piece that the maestro would execute.
I made a drawing of a vase with
several cupids on it. Normally I don't
like the look of figures in glass, but
the putti look just right in glass.
—Dale Chihuly, 1992*

Below
Ikebana Group, 1991, The Boathouse,
Seattle, Washington

Opposite
Venetian Drawing, 1993, 30" x 22"

Overleaf
Pilchuck Glass School, Stanwood,
Washington, c. 1986

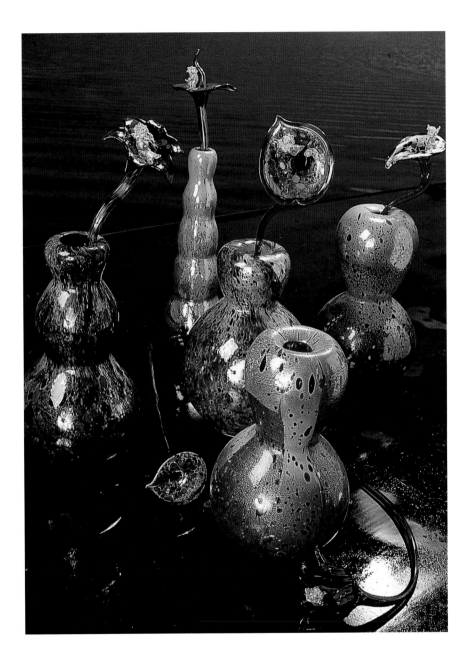

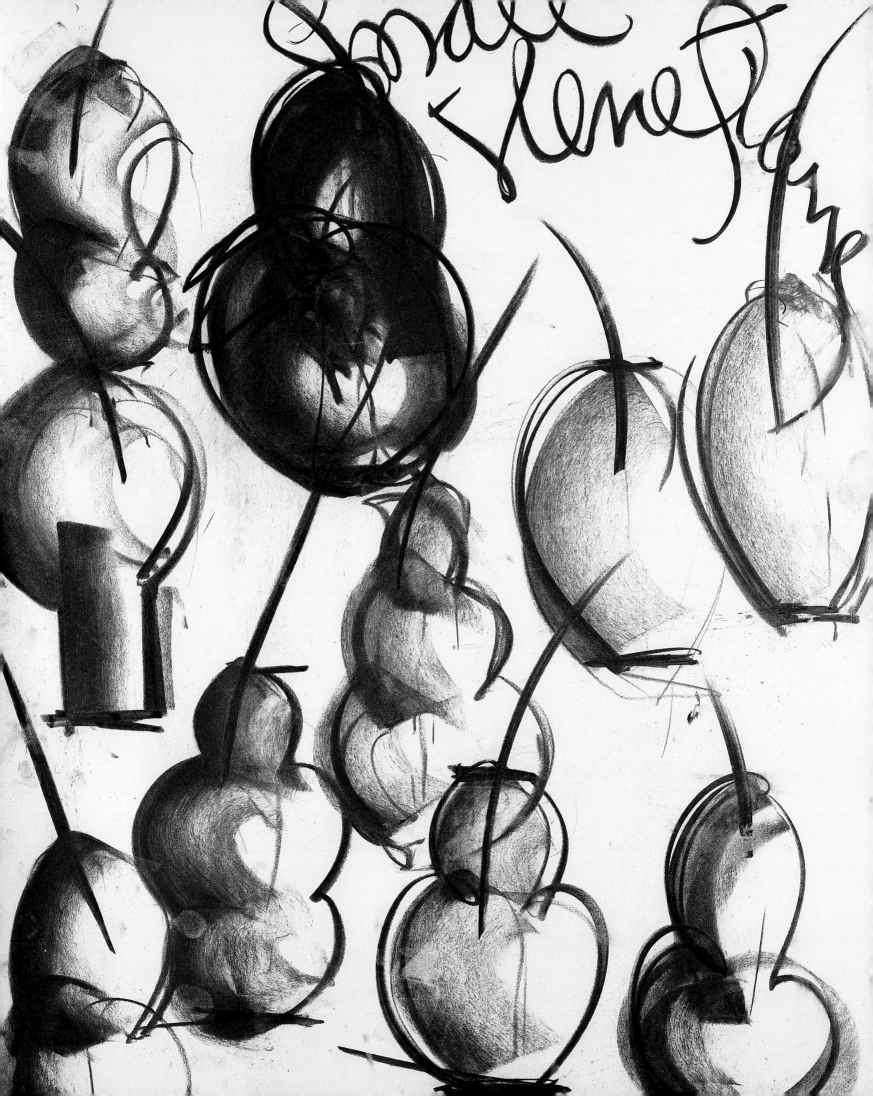

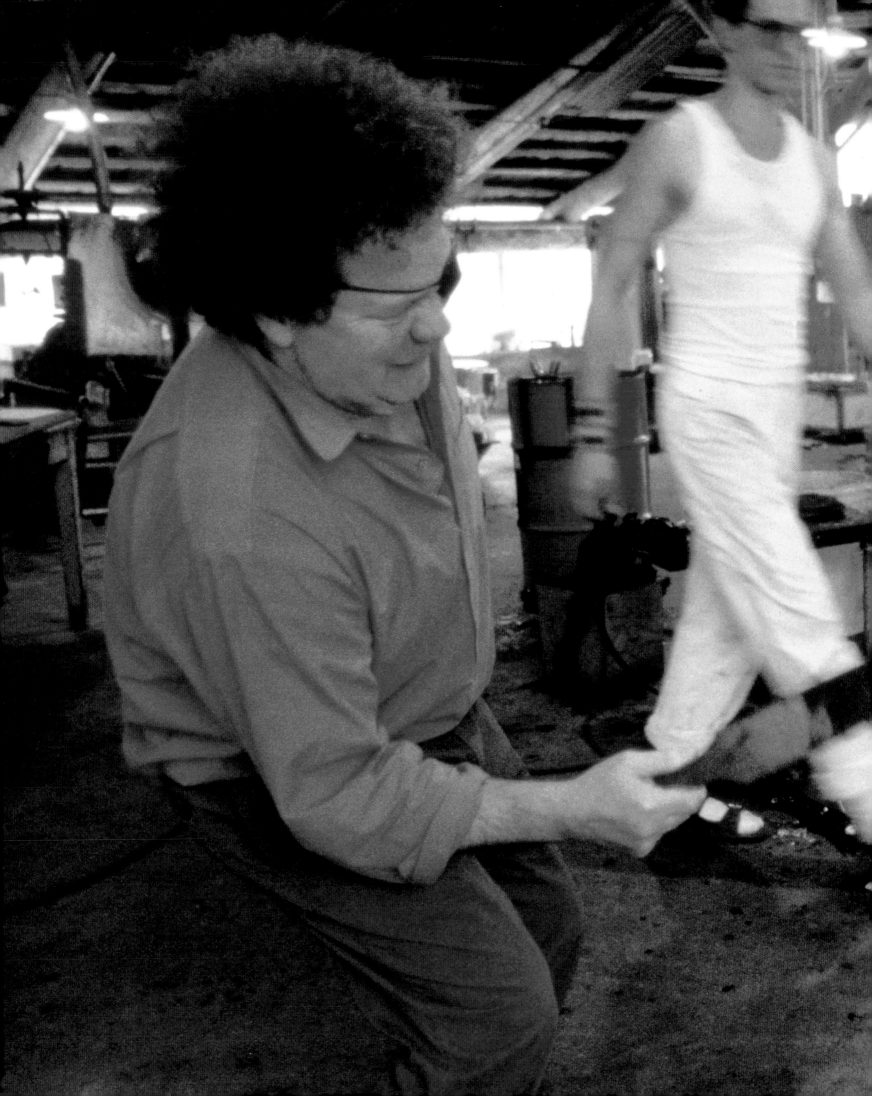

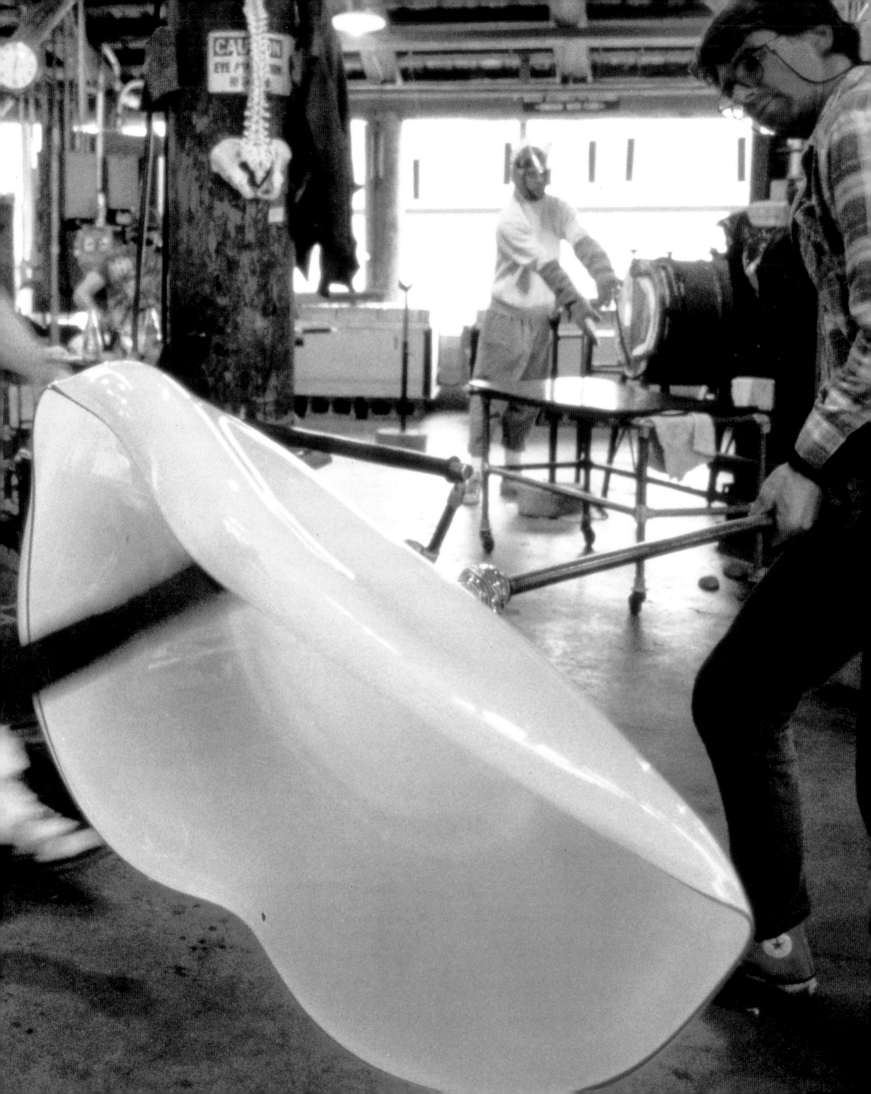

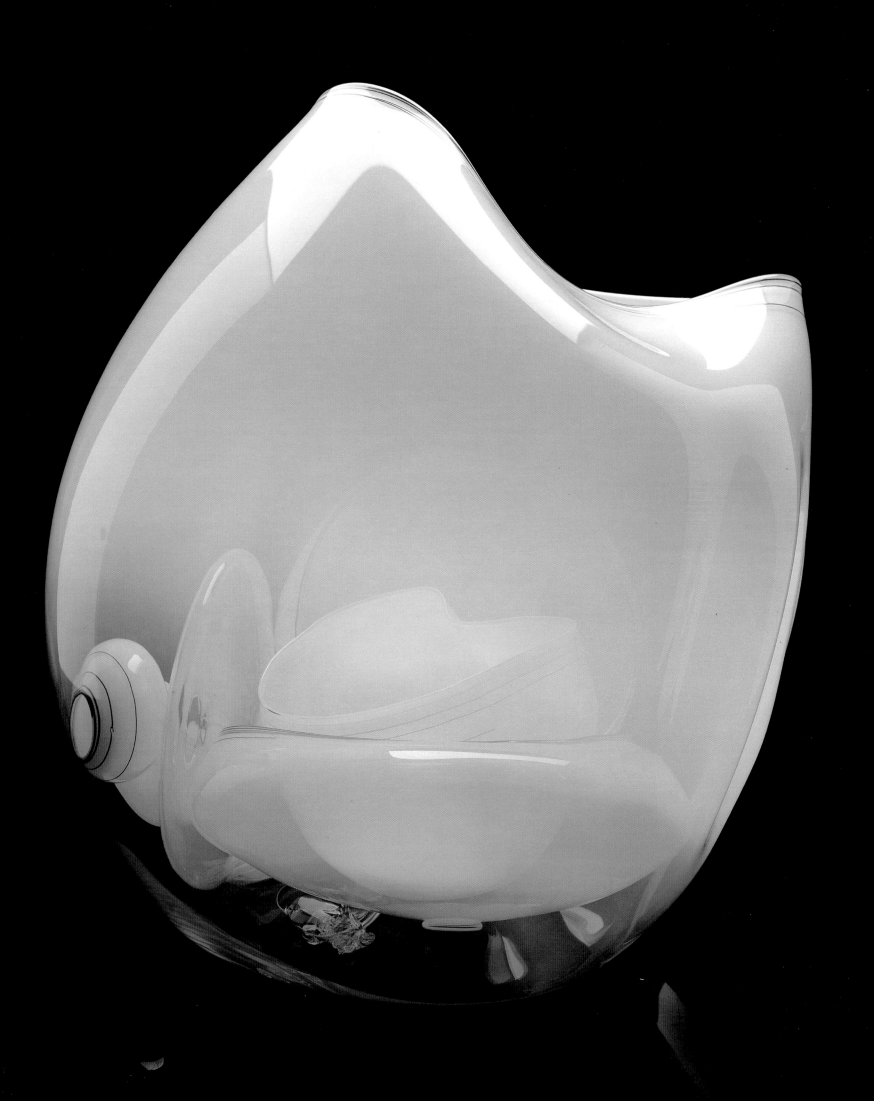

Previous
*Basket Drawing, 1994, acrylic on
paper, 41" x 29"*

*Alabaster Basket Set with Oxblood Lip
Wraps, 1991, 14" x 18" x 16"*

Below
*Gilded Ikebana with Dynamic Red
Flower, 1993, 24" x 14" x 14"*

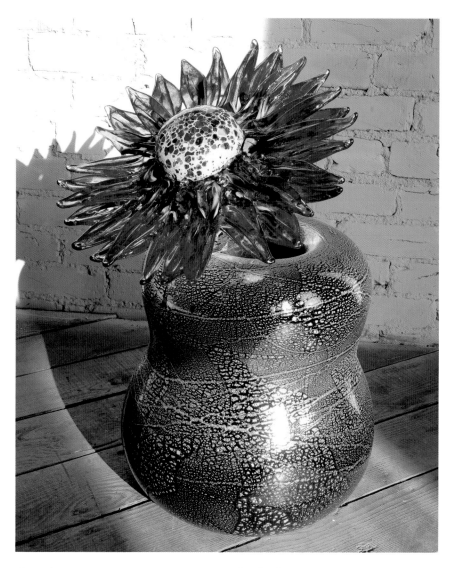

Opposite
*Purple Gold Ikebana with Four Clear
Coil Flowers, 1992, 30" x 24" x 22"*

Overleaf
*Gilded Ikebana with Ochre Flower
and Red Leaf, 1992, 30" x 40" x 16"*

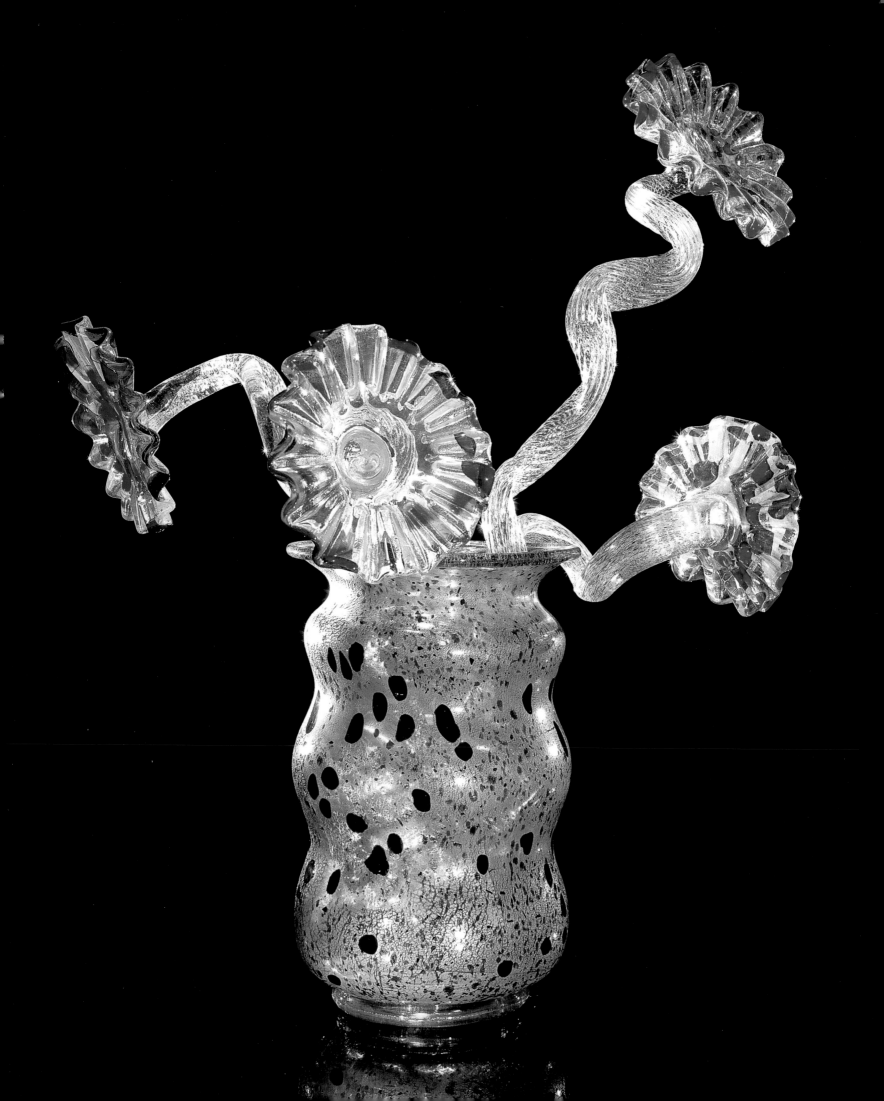

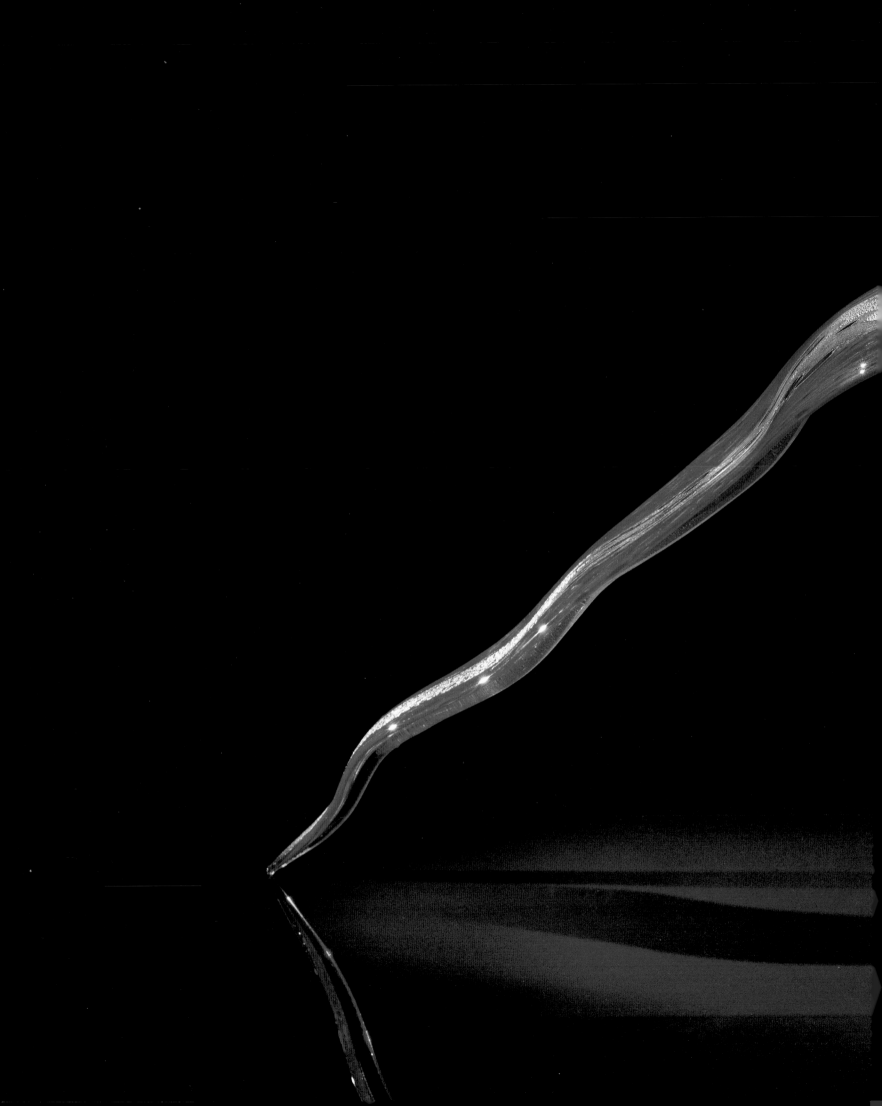

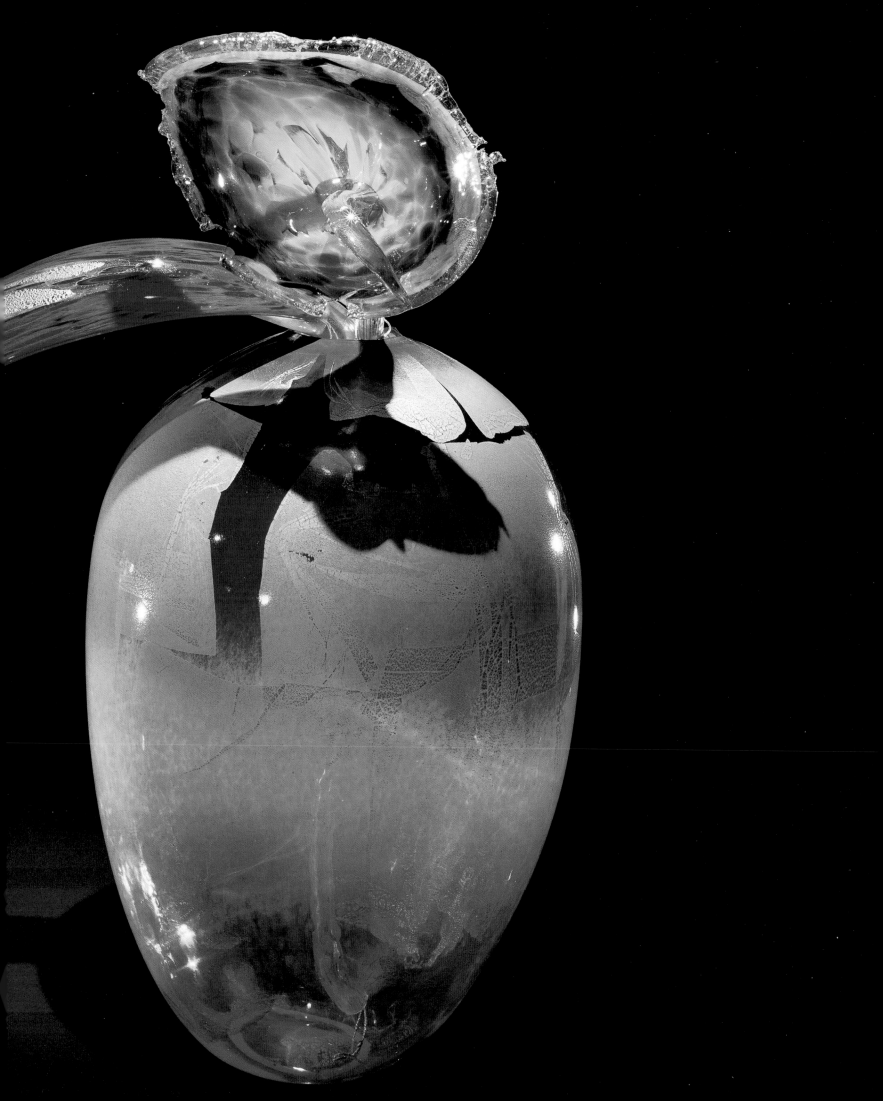

Iris Blue Seaform with Ruby Lip Wraps,
1981, 8" x 17" x 13"

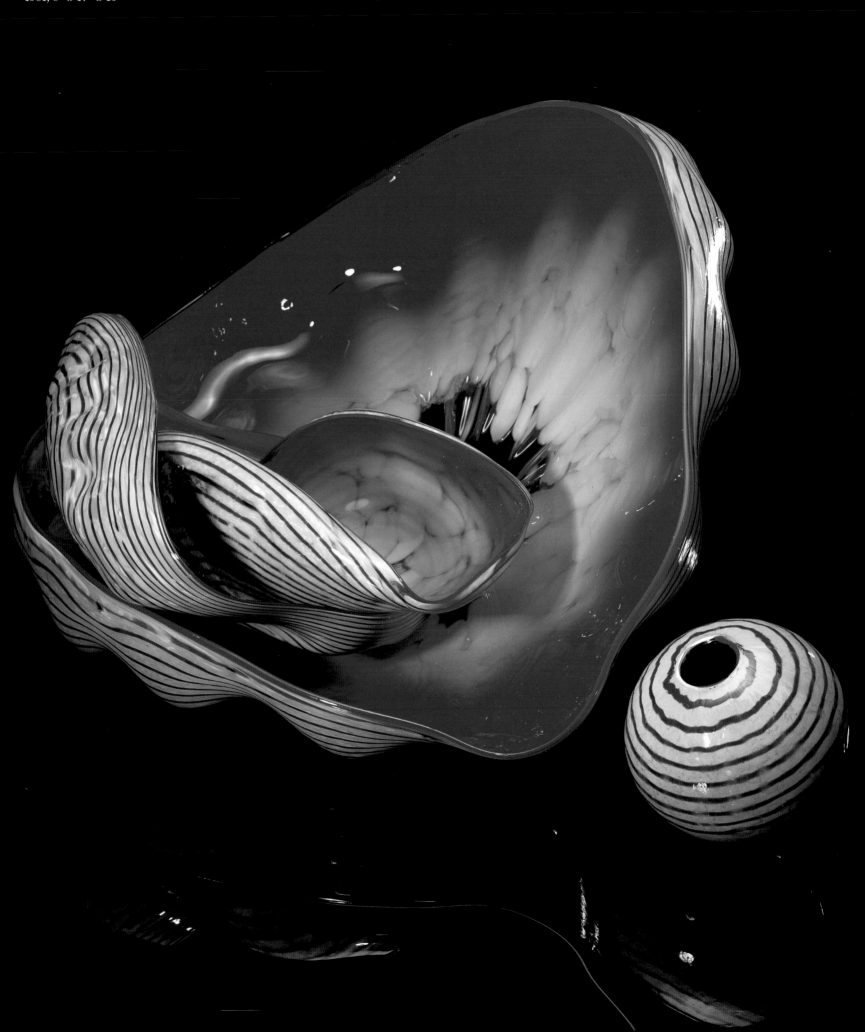

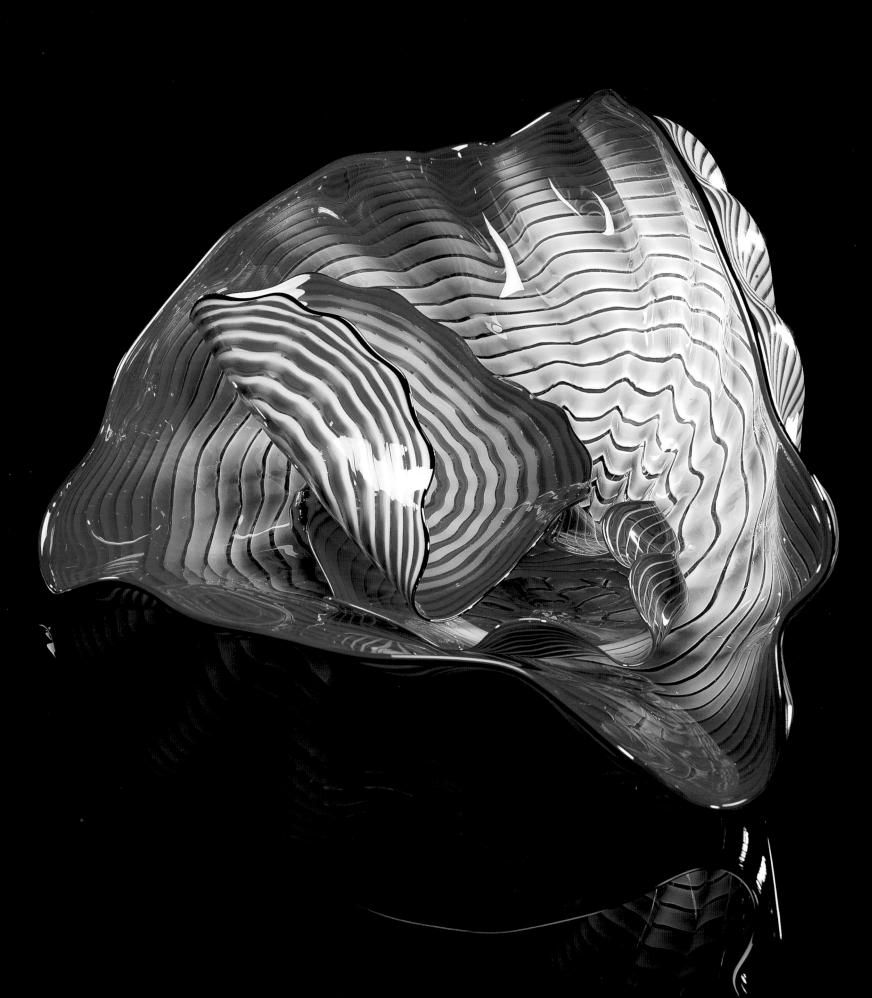

Lapis, Golden Ochre, and Mars Red
Persian Set, 1988, 14" x 25" x 18"

Opposite
Ebeltoft Drawing (detail), 1991,
acrylic on paper, 30" x 22"

Below
Ebeltoft Drawing, 1991, acrylic on
paper, 30" x 22"

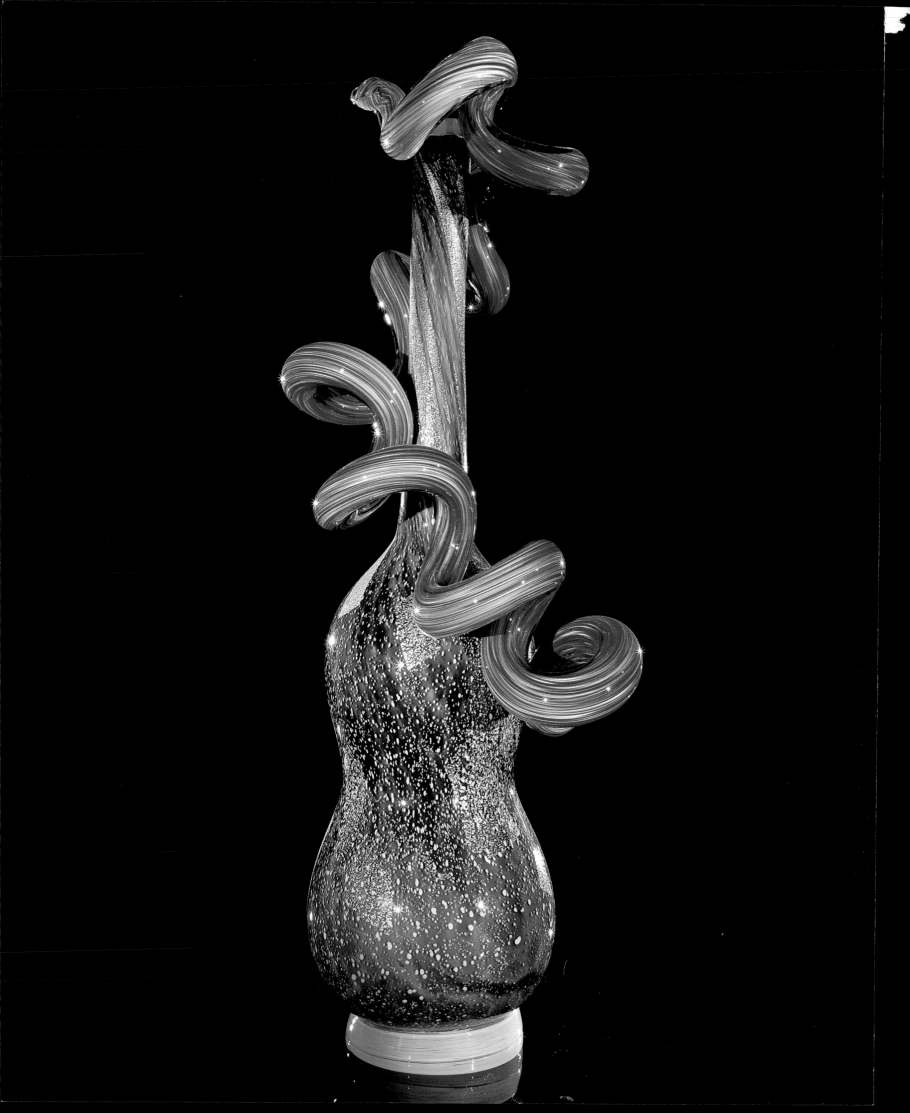

Opposite
Emerald Green Venetian with Violet
Coil, 1991, 35" x 12" x 11"

Below
Venetian in gloryhole

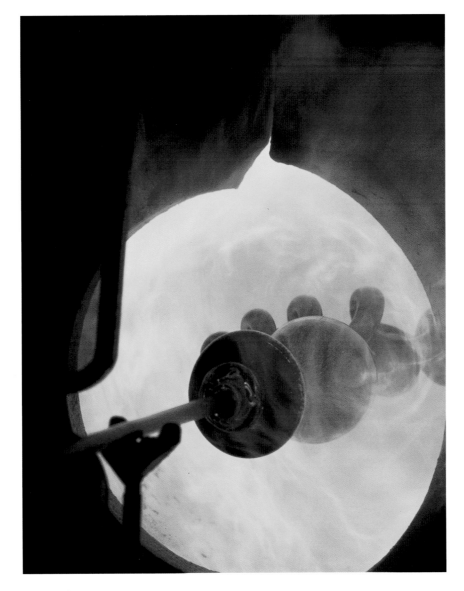

Overleaf
Lemon Yellow Macchia with
Turquoise Blue Lip Wrap, 1995,
21" x 35" x 28"

Transparent Blue Basket Set with
Black Lip Wrap, 1993, 20" x 20"

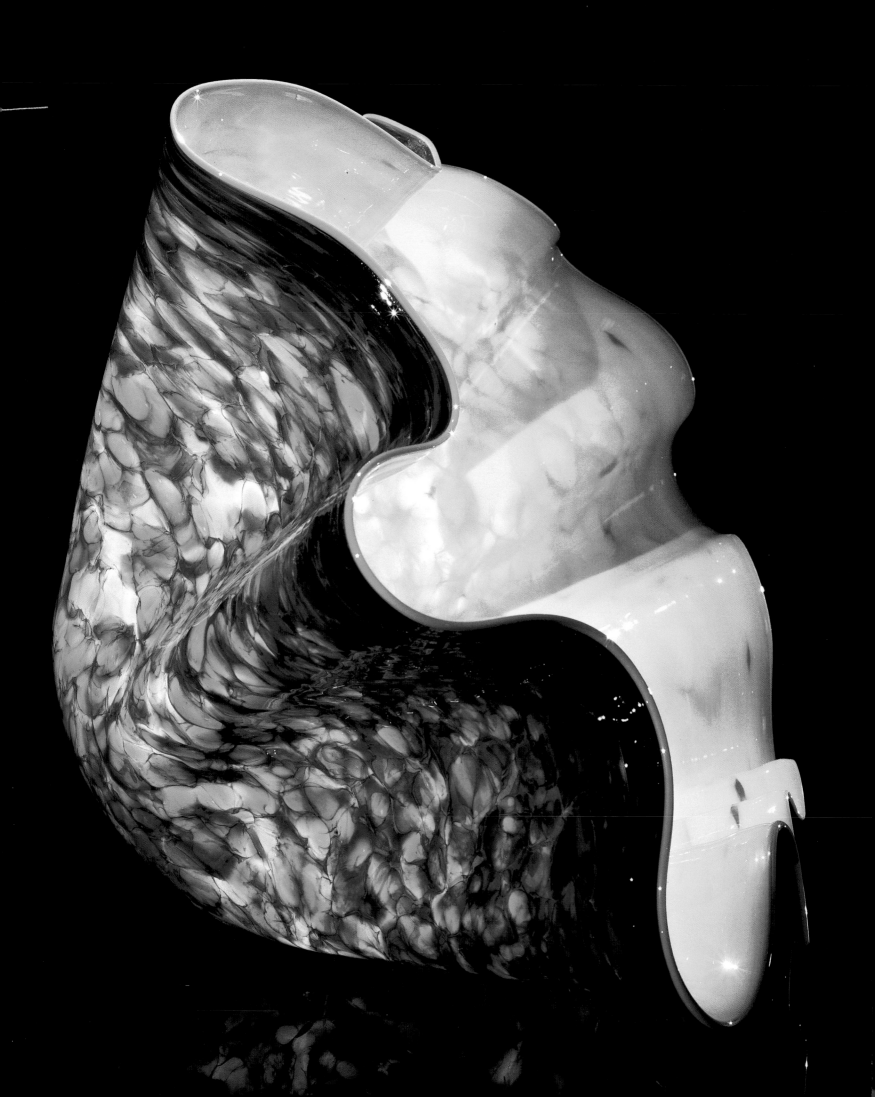

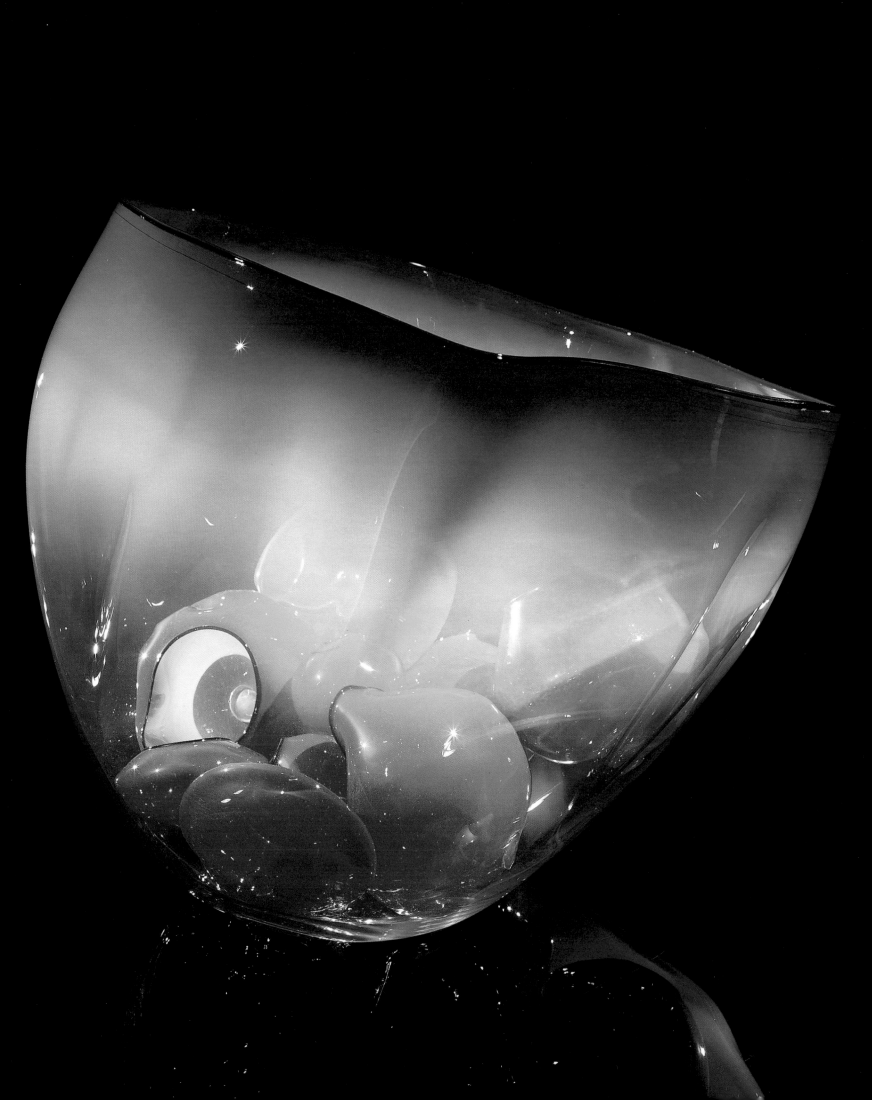

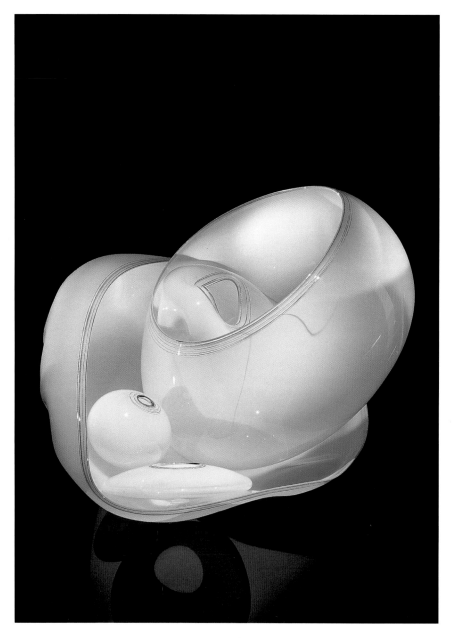

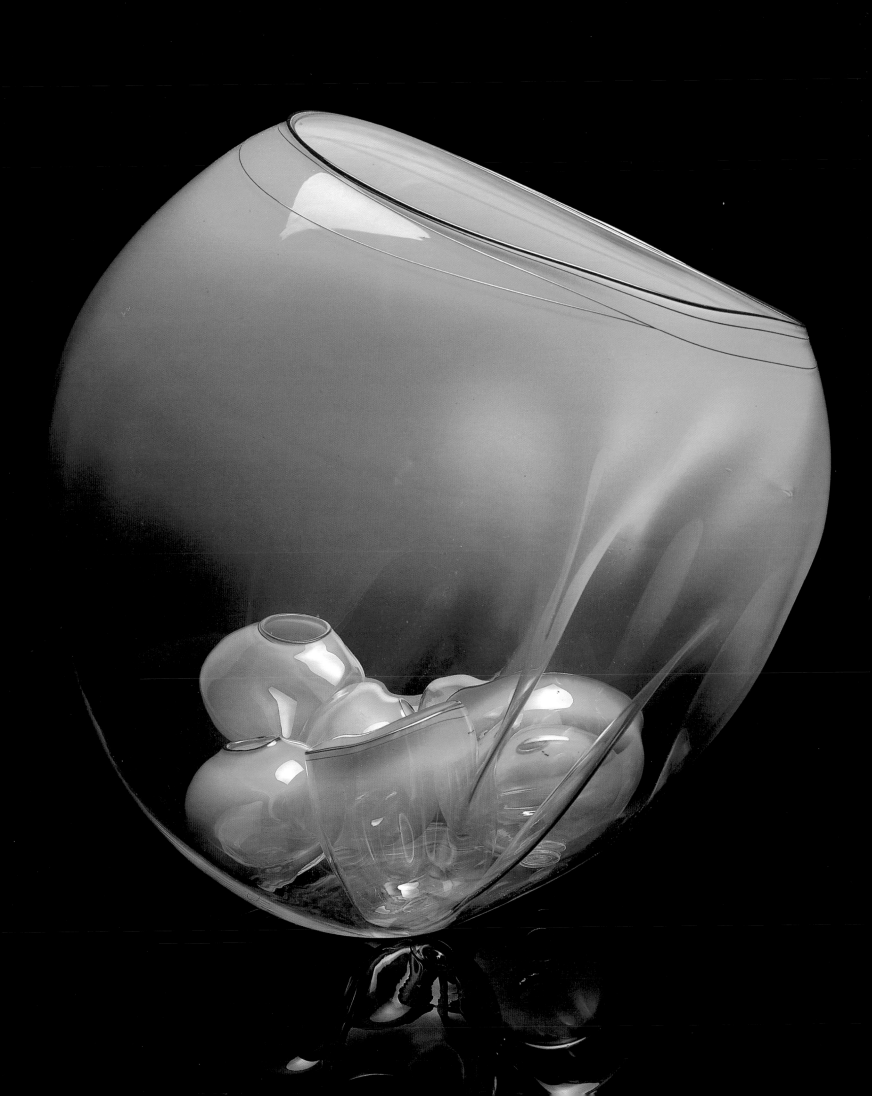

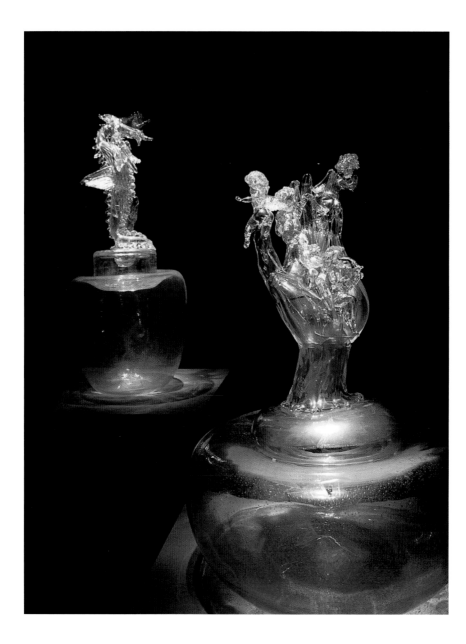

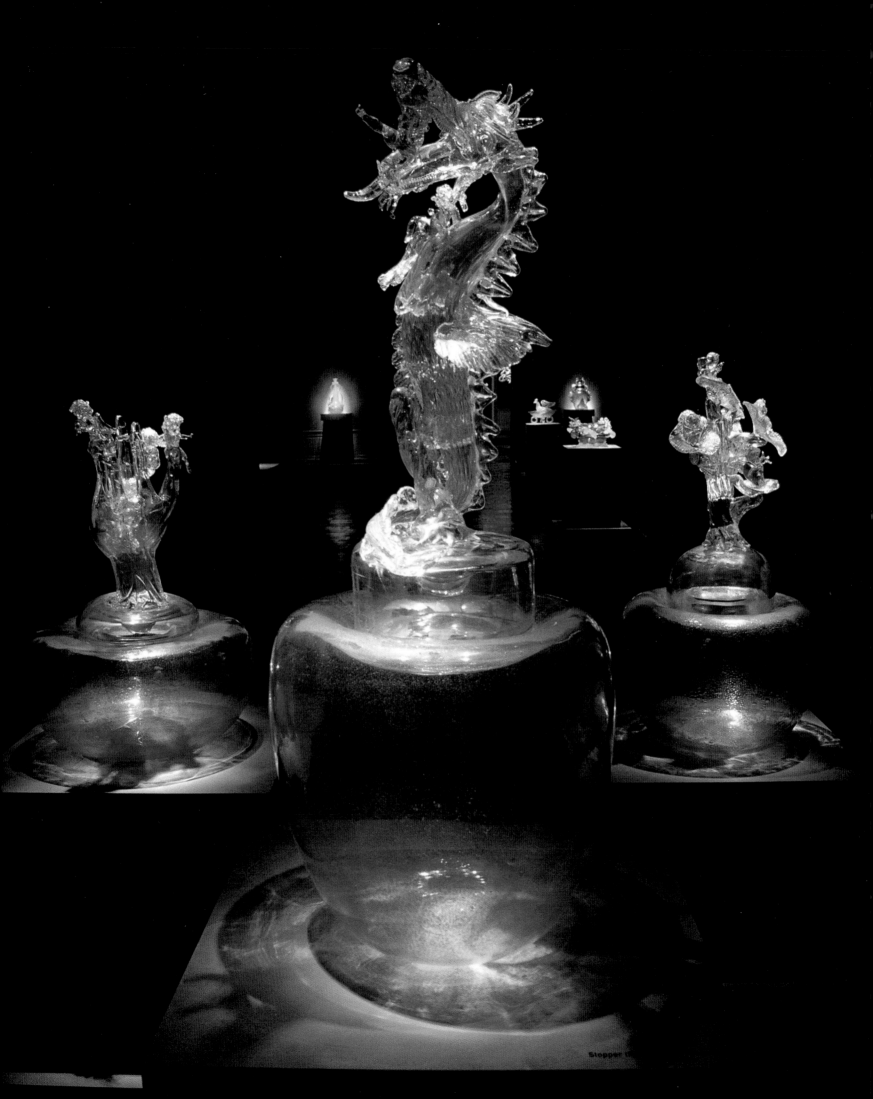

Below
Persian Wall Installation, 1995,
Palm Desert, California

Opposite
Niijima Float Installation, 1995,
Palm Desert, California

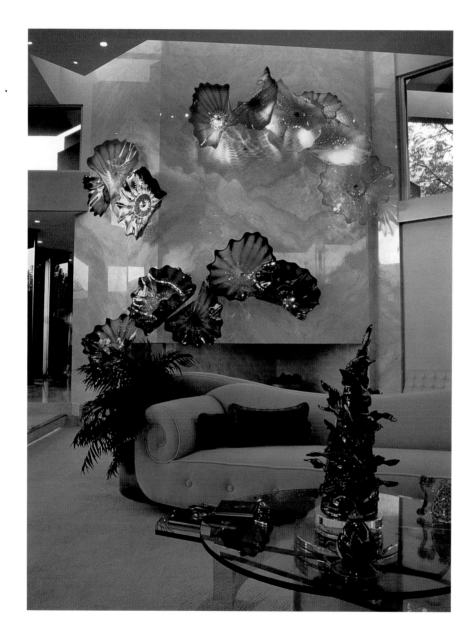

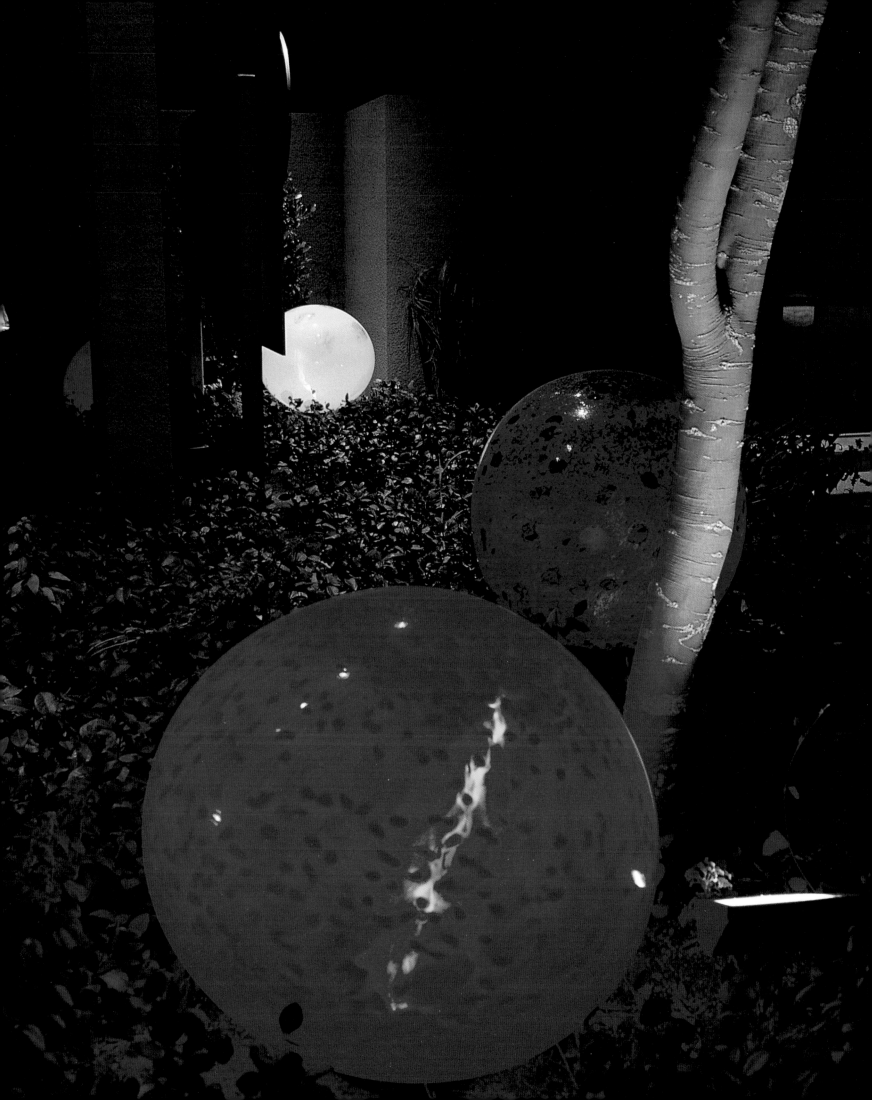

Below
Float Drawing, 1992, acrylic on paper,
60" x 40"

Opposite
Tower of Tobias, 1997, 34' x 7',
American Craft Museum, New York,
New York

Overleaf
Niijima Float Installation, 1991,
American Craft Museum,
New York, New York

The "Floats" . . . are really quite daring: they sit directly on the floor, spotlit, like benthic organisms under a diver's spotlight or jellyfish washed up on a beach or (as Chihuly suggests through their names) glass fishing-net floats. Their surfaces—several of the "Floats" feature a gold-leaf technique developed during the Venetians series as well as streams of tiny air bubbles—suggest swirling current, pebbly streambeds, and biological organisms. Their coloring is as richly layered as Japanese lacquer or an undersea reef. It's this tension—between the fantasy world of high artifice and the natural world in its infinite mystery and variety—that gives these most recent works a greater significance.
—Justin Spring, "Dale Chihuly: Charles Cowles Gallery," ARTFORUM, *Summer 1992*

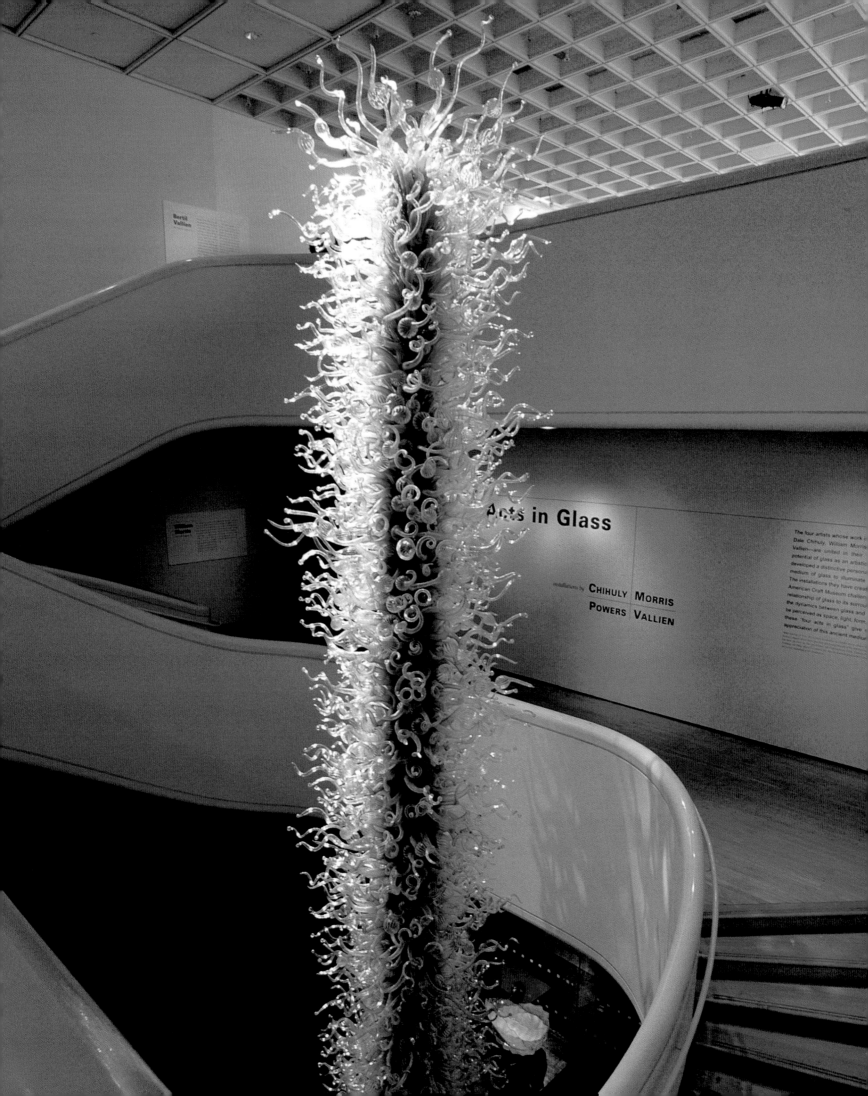

Acts in Glass

installations by CHIHULY MORRIS
POWERS VALLIEN

Bertil
Vallien

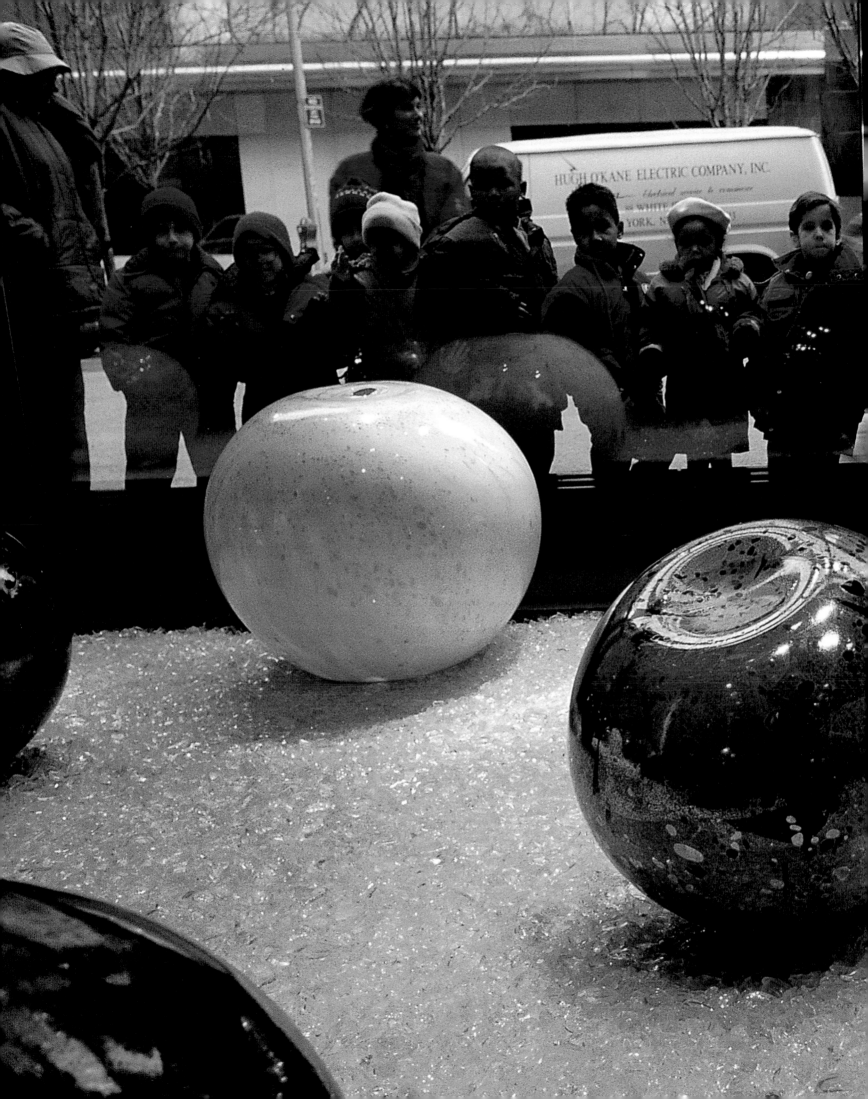

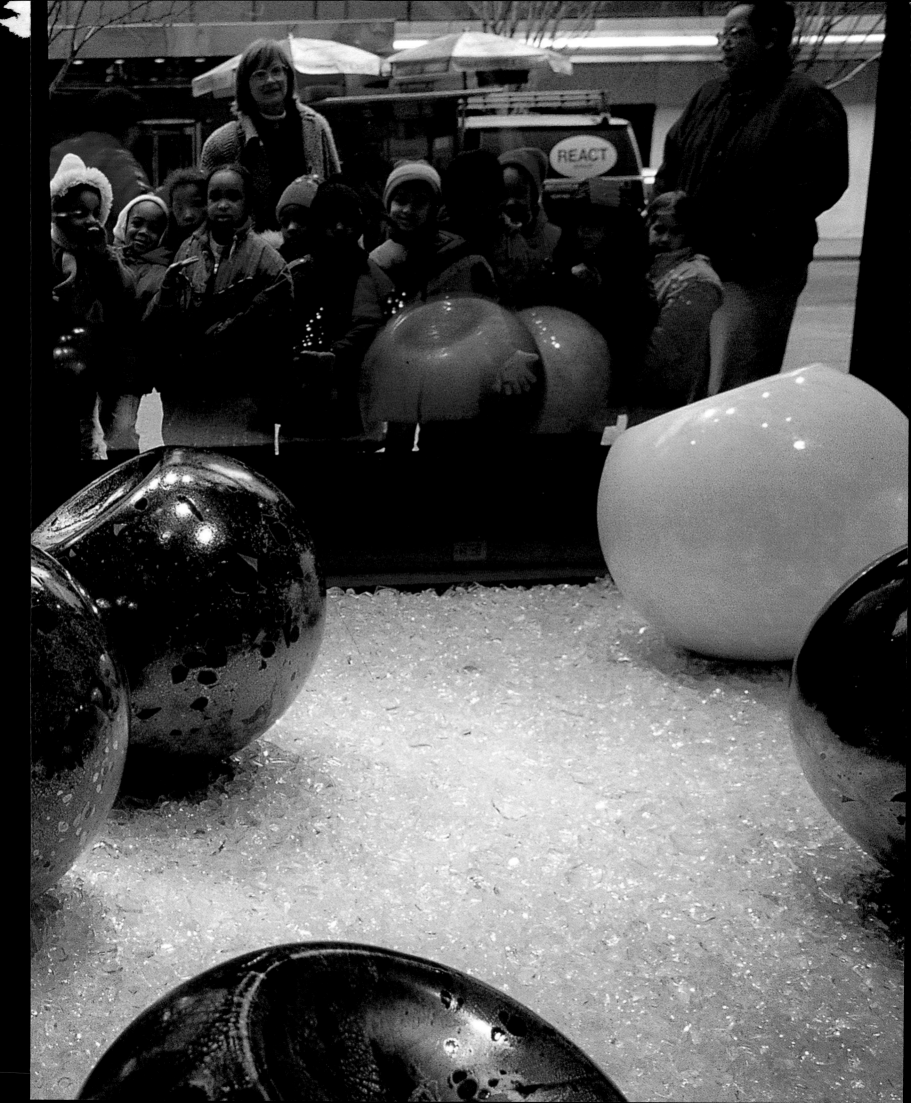

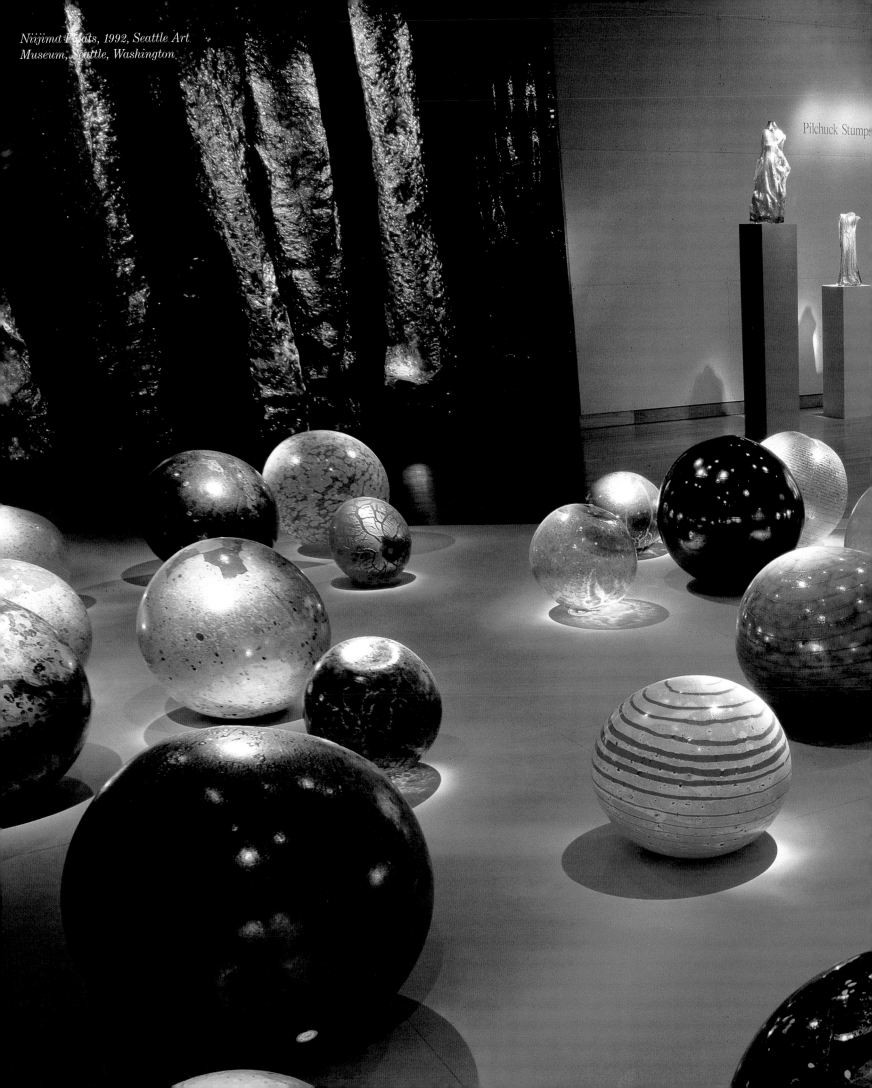

Niijima Floats, 1992, Seattle Art Museum, Seattle, Washington

Pilchuck Stumps

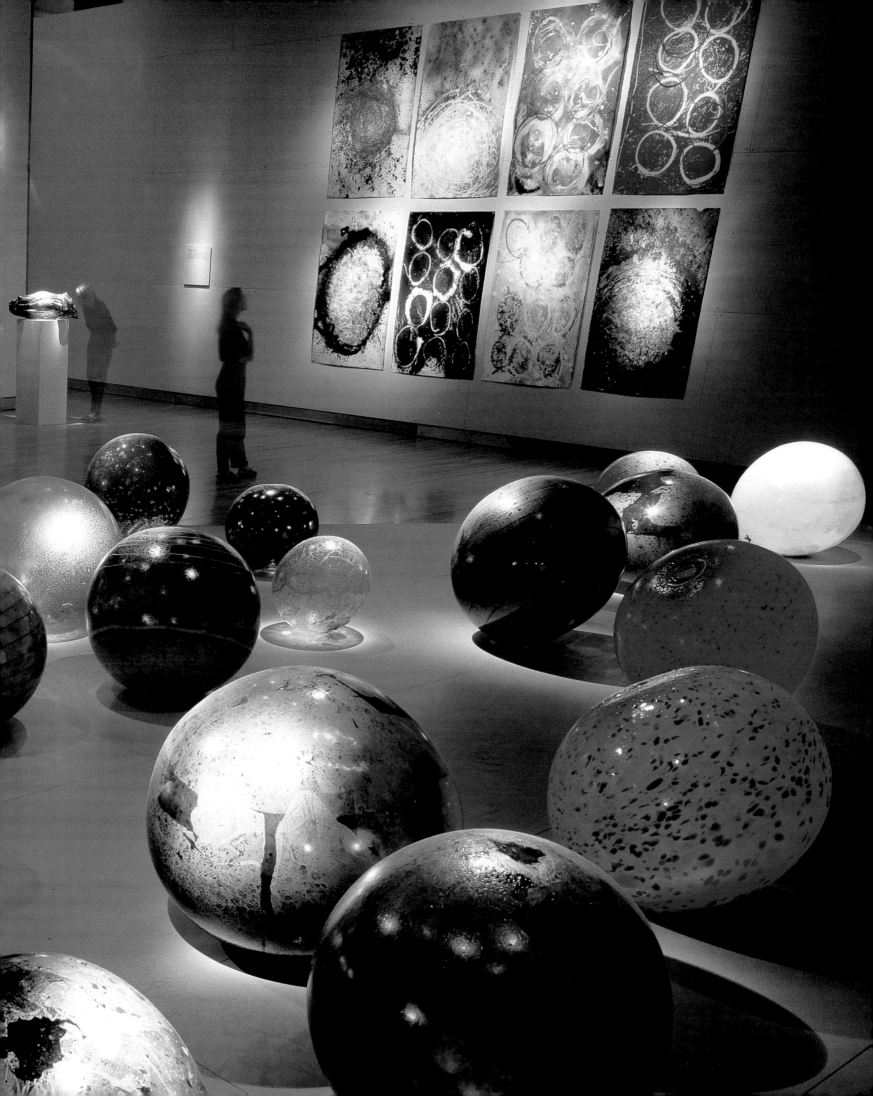

Below
Green Clubs, 1996, LongHouse
Foundation, East Hampton, New York

Opposite
Black Saguaros, 1996, LongHouse
Foundation, East Hampton, New York

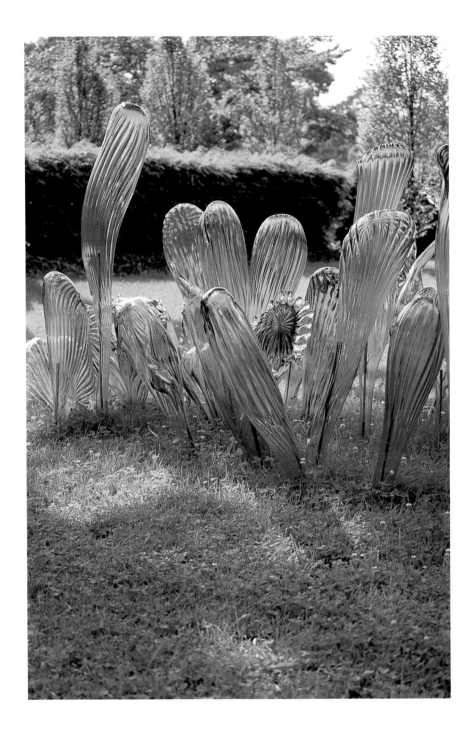

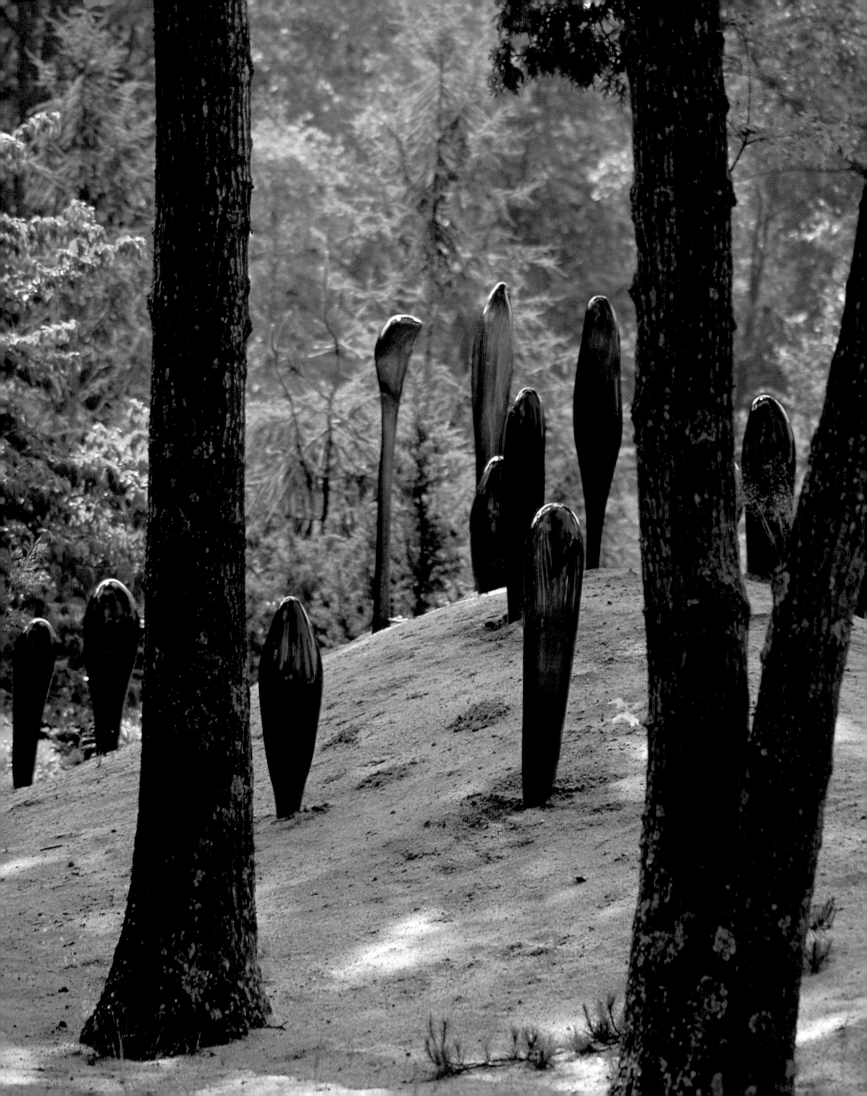

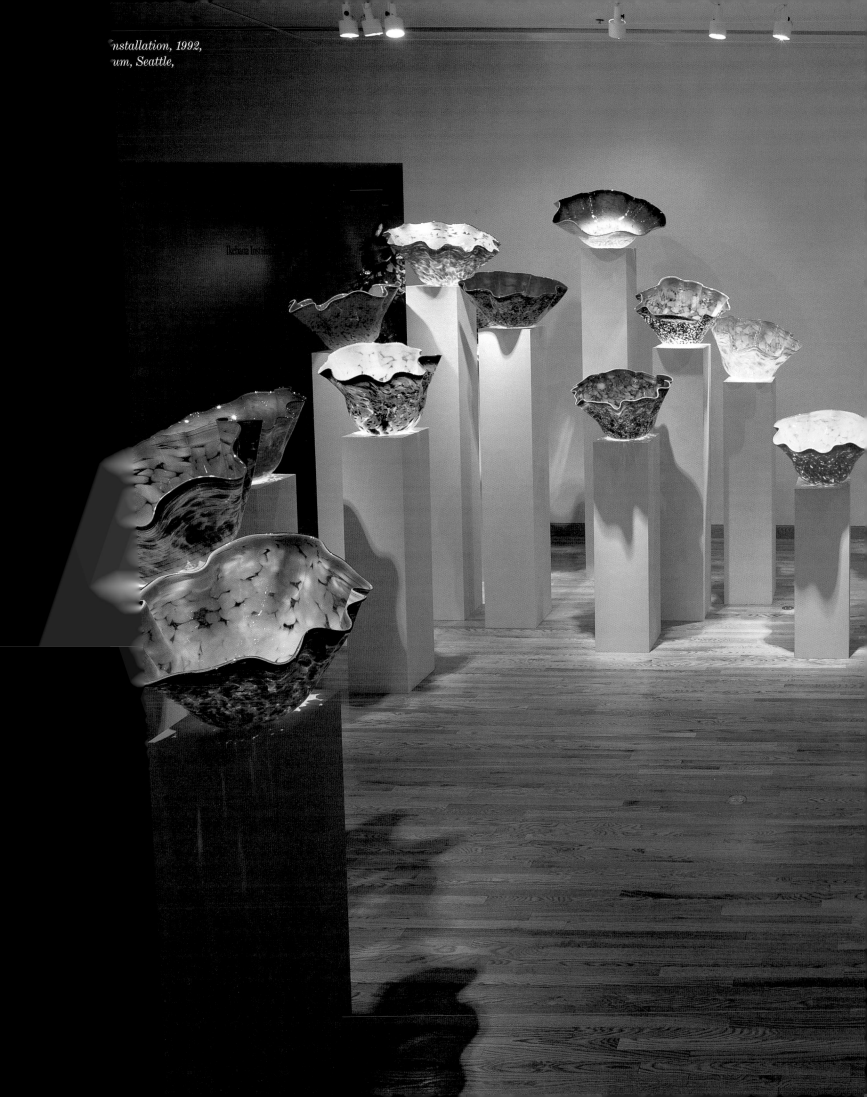

Installation, 1992,
um, Seattle,

Installation, 1992,
um, Seattle,

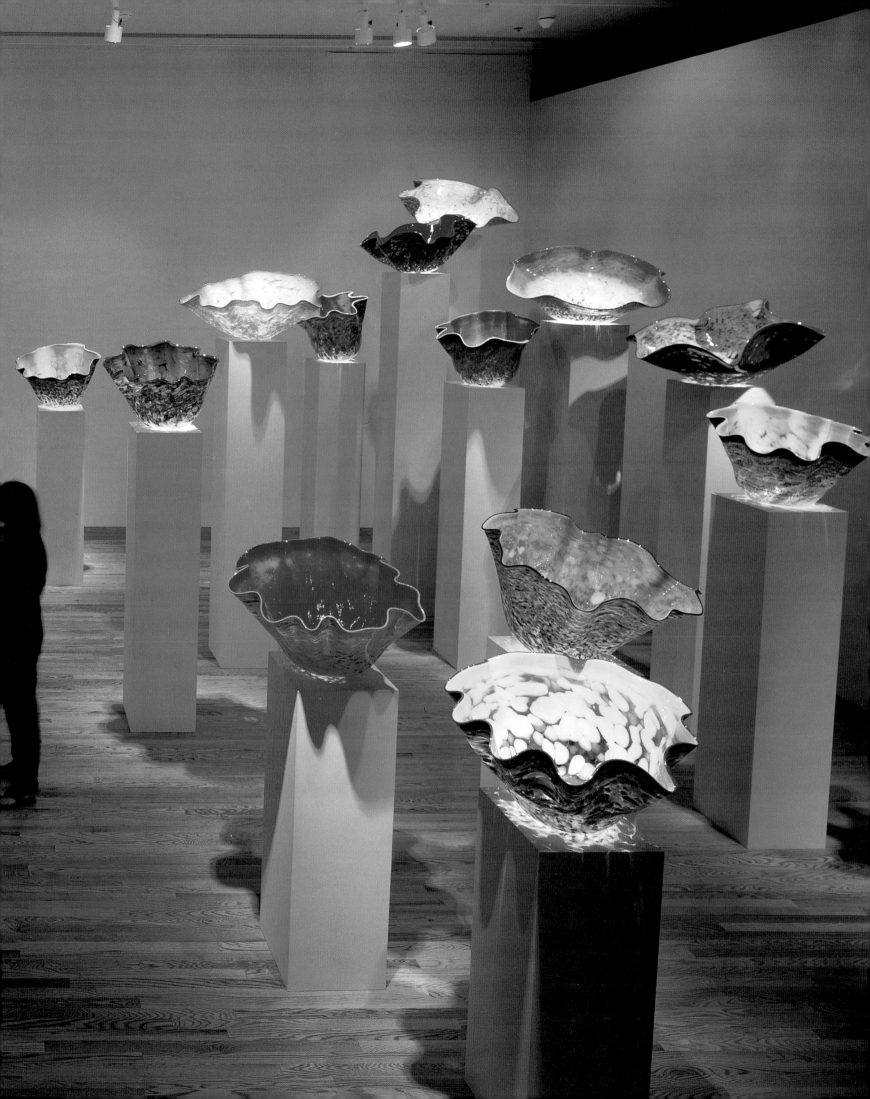

Below
Persian Pergola, 1994, Dallas Museum
of Art, Dallas, Texas

Opposite
Persian Pergola, 1997, Albright-Knox
Art Gallery, Buffalo, New York

224

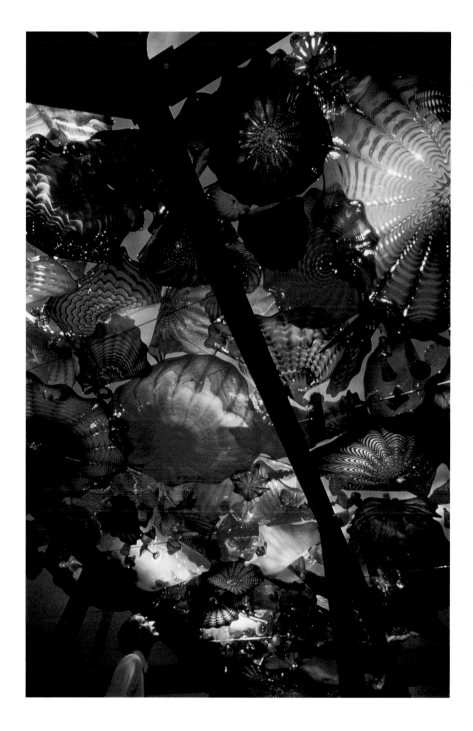

Below
Persian Pergola, 1994, Dallas Museum
of Art, Dallas, Texas

Opposite
Persian Pergola, 1997, Albright-Knox
Art Gallery, Buffalo, New York

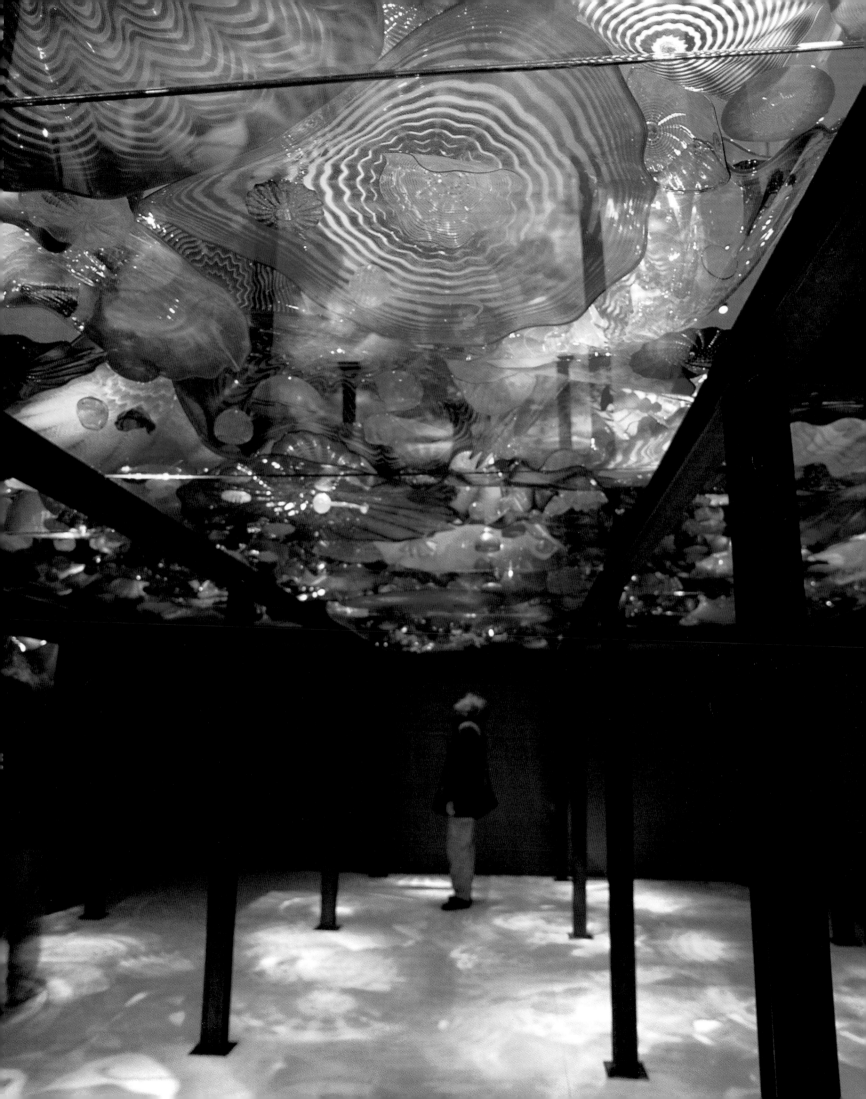

I made the first chandelier in 1992 for my show at the Seattle Art Museum. It was a big show, the entire second floor, and there was an area that wasn't working. At the last minute, I had the glassblowers start making a very simple shape—one of the easiest forms one can blow. It is also strong and simple, and I knew it would hang well. I put 10 or 15 blowers on the project, and we made it in a few days and then hung it in the museum before mocking it up completely. It was a little risky, but I was very confident. I put a large black granite table, 8 by 8 feet, under the piece to keep viewers back and to have a reflection.
—Dale Chihuly, 1996

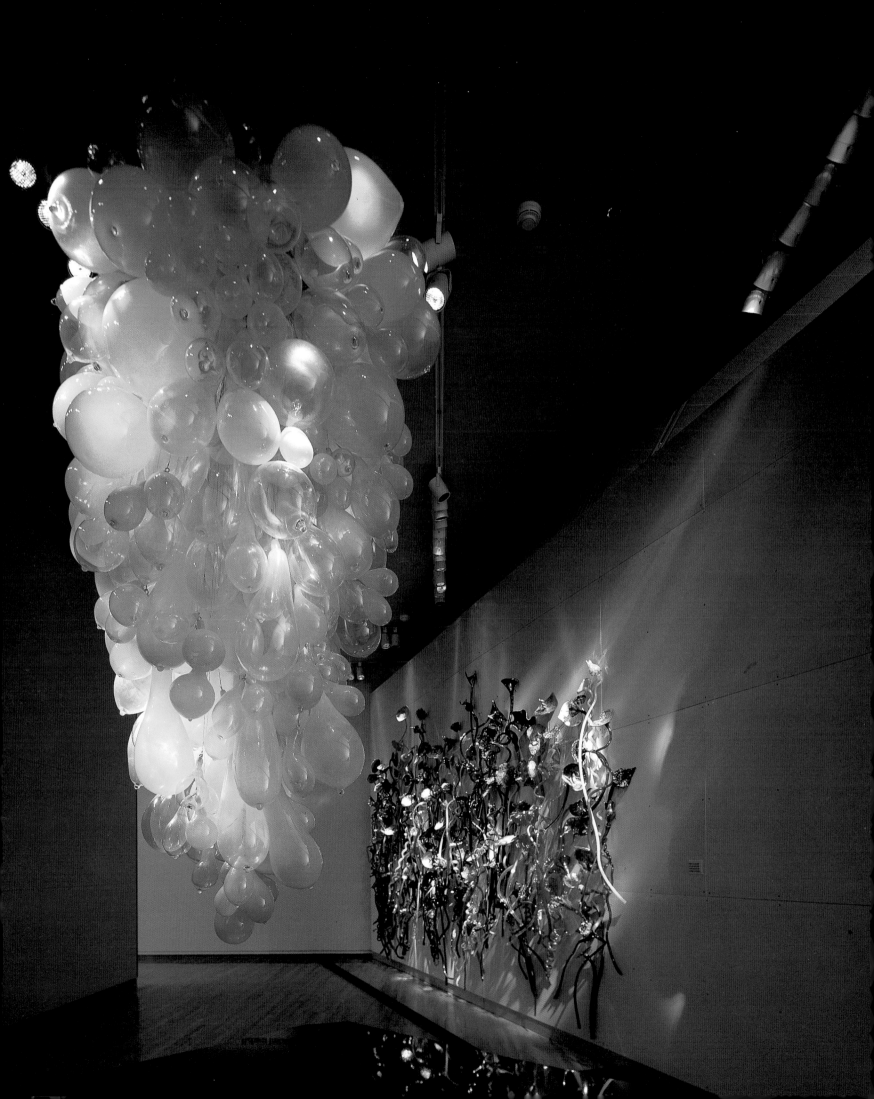

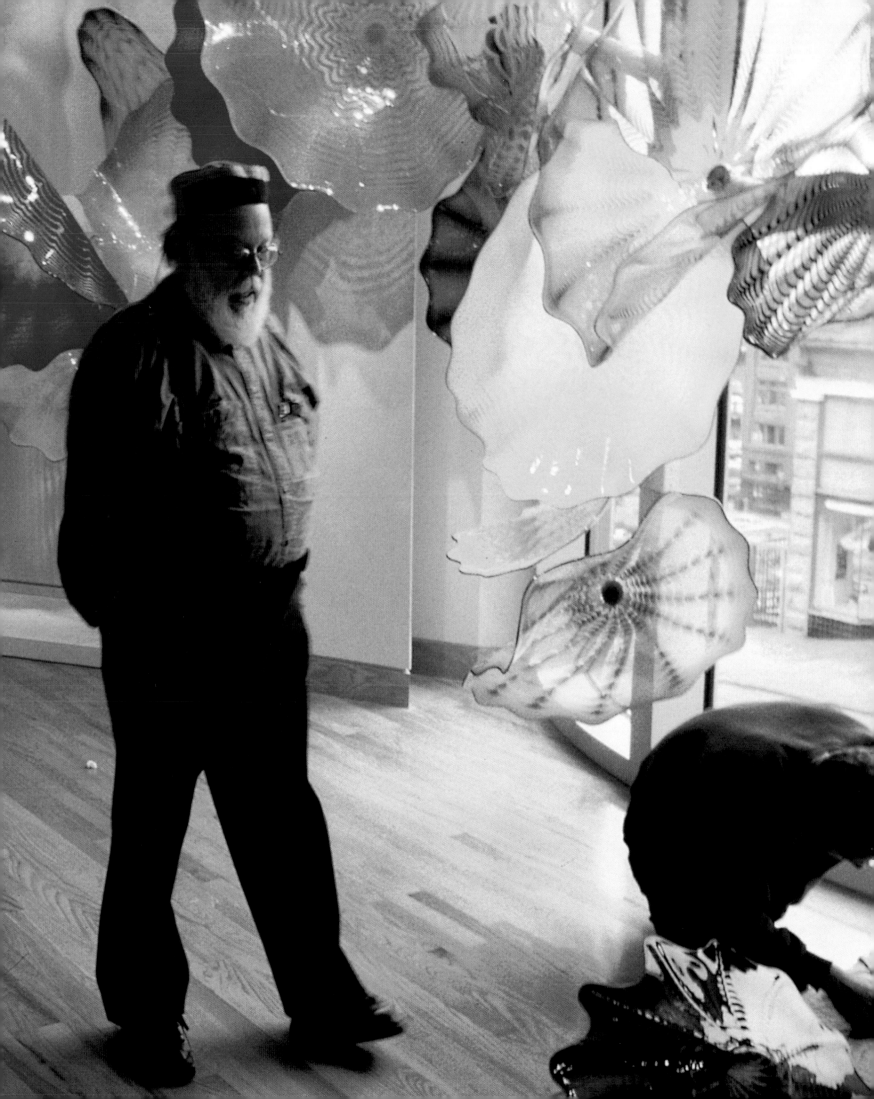

*The delightful thing about much new
art of quality is its mischievous ability
to break the rules. Chihuly successfully
resists being trapped in many of the
pigeonholes that make for neat
categories, but leech art of its
complexity. First, he confidently
bestrides the distinction between craft
and art. And second, he has never felt
the need to choose between abstraction
and representation—between the
natural and the invented—which has
proven the great bugaboo in art all
these years.*
—*Henry Geldzahler,* Chihuly: Color,
Glass and Form, *1986*

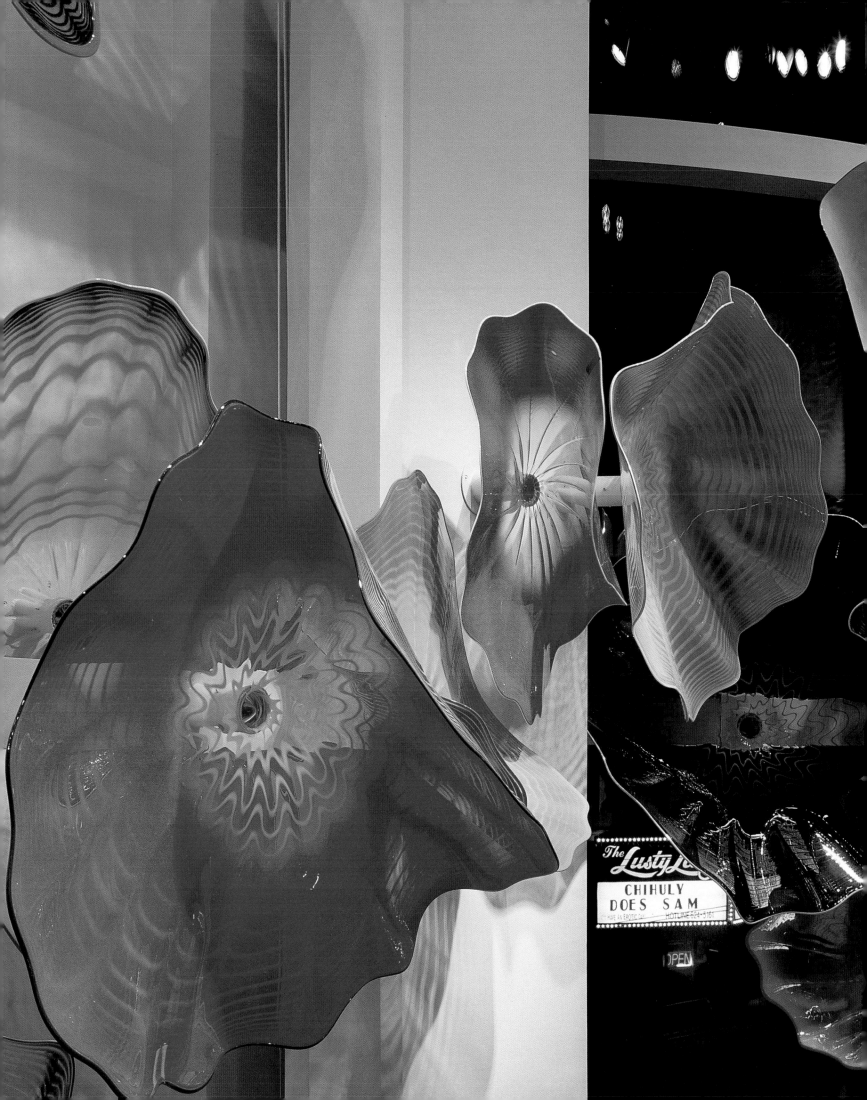

The Lusty L
CHIHULY
DOES SAM

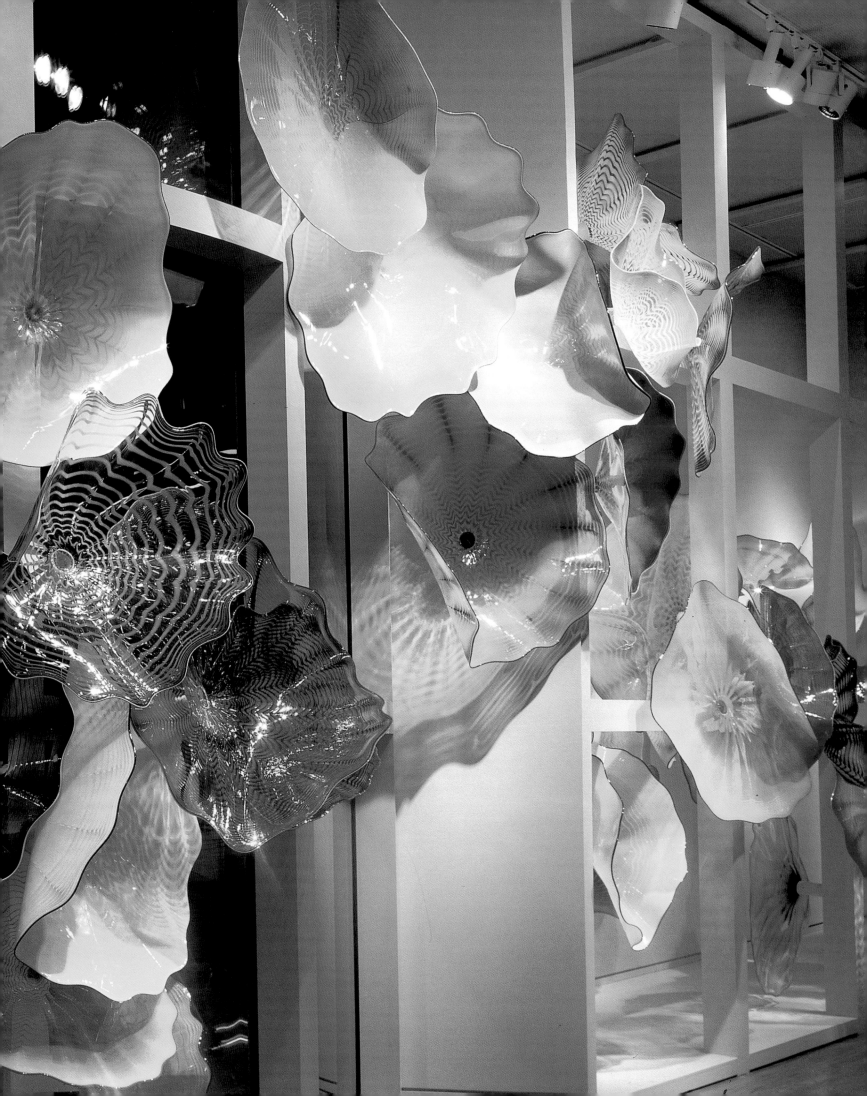

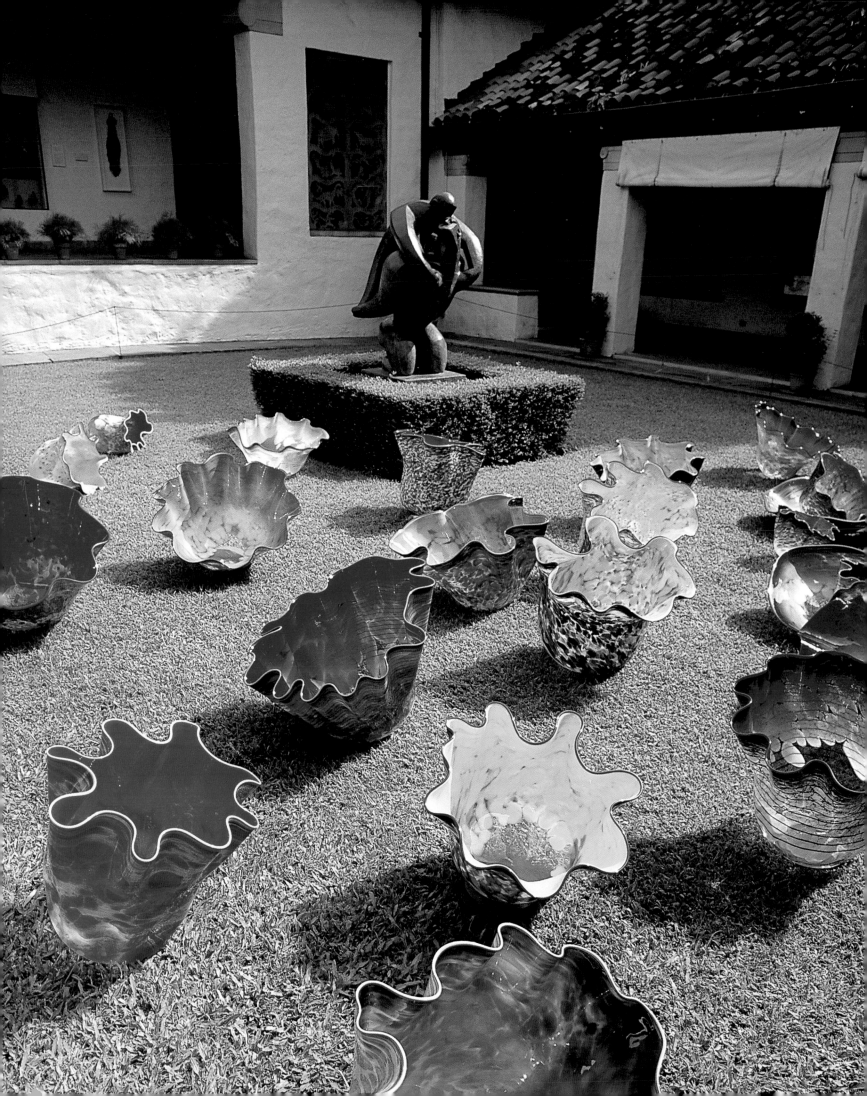

Opposite
*Macchia Installation, 1992, Honolulu
Academy of Arts, Honolulu, Hawaii*

Below
*20,000 Pounds of Ice and Neon,
1992, Honolulu Academy of Arts,
Honolulu, Hawaii*

233

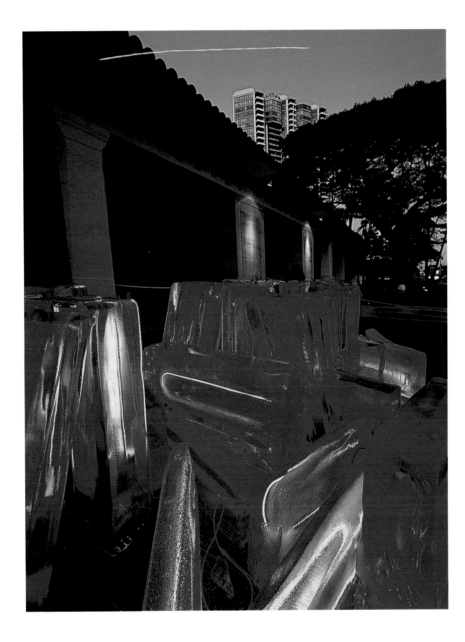

Below
Ikebana Installation, 1992, Honolulu
Academy of Arts, Honolulu, Hawaii

Opposite
Niijima Float Installation, 1992,
Honolulu Academy of Arts,
Honolulu, Hawaii

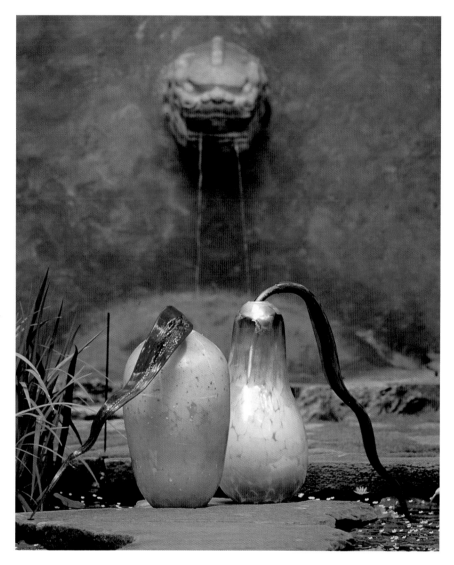

*It's interesting that the most difficult
series I have ever blown are the Floats,
considering a sphere is the easiest
form to make in glass. It's the most
natural form you could blow. But it's
not natural at this scale. . . .*
—Dale Chihuly, 1992

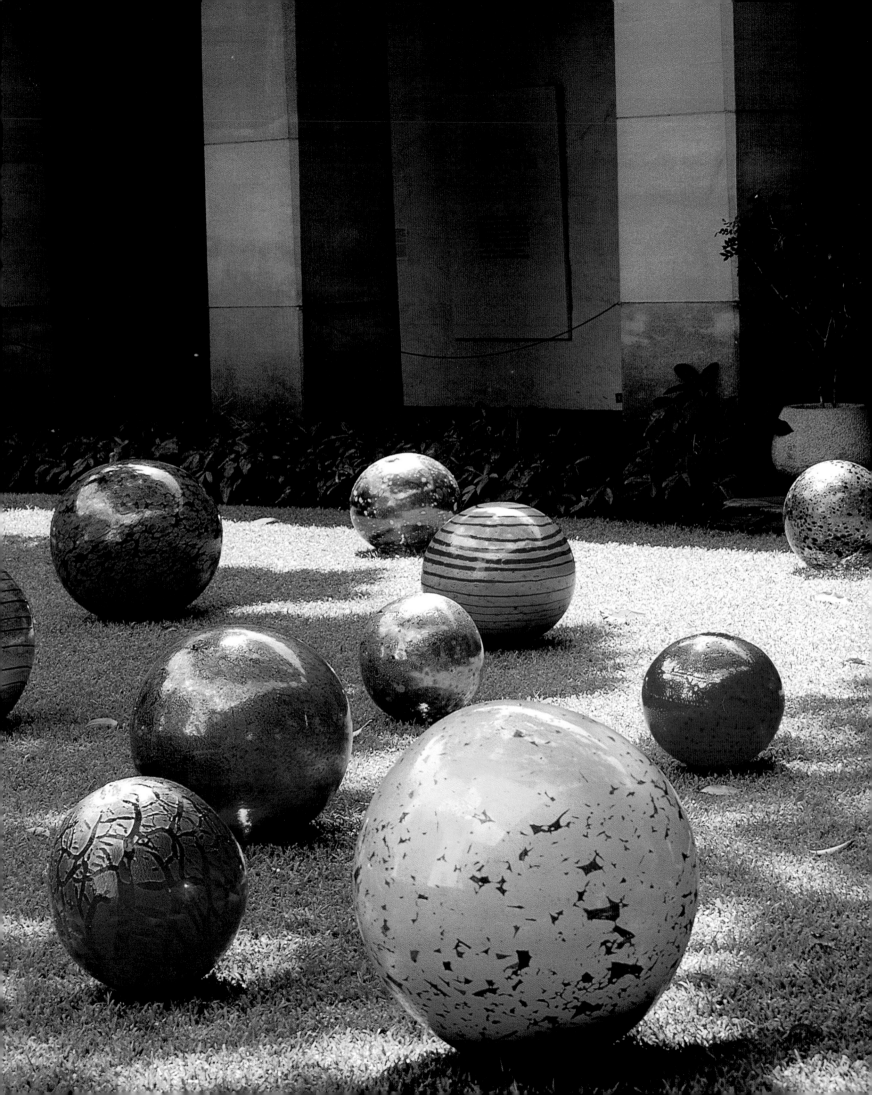

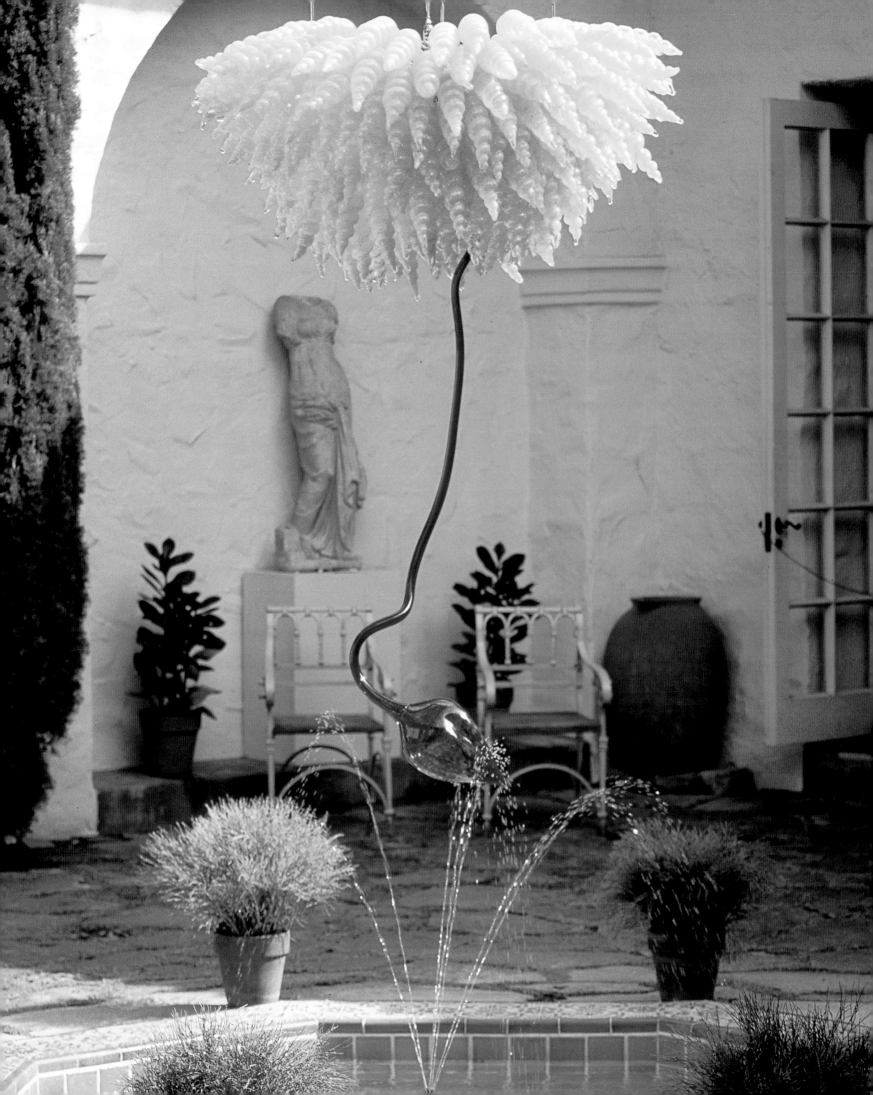

Opposite
Lemon Yellow Chandelier with Cobalt
Blue Stem, 1992, 7' x 3' x 3', Honolulu
Academy of Arts, Honolulu, Hawaii

Below
Neodymium Chandelier with Putto,
1993, The Boathouse, Seattle,
Washington

237

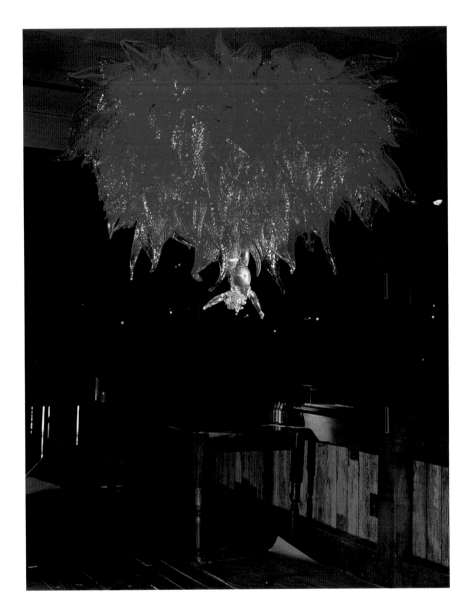

Above
Drawings for the sets of the Seattle Opera's presentation of Claude Debussy's Pelléas et Mélisande, 1992, mixed media on paper, 29" x 41" each

Below
Opera Drawing, 1992, acrylic on paper, 60" x 40"

Opposite
Arkel's Apartment, 1993, Pelléas et Mélisande, Act I, Scene 2, Seattle, Opera, Seattle, Washington

What Dale did with the sets was to encase the stage space with a shiny black plastic box. Inside that box he placed an array of weird things, which the ingenious Seattle Opera technical staff (Robert Schaub, director) crafted out of plastic and fabric, enlarging Mr. Chihuly's original glass models. Each of Debussy's 14 floating, disparate scenes thus becomes an eerie, pitch-dark space dominated by a monstrous, evocative glowing object, ominous or evil in its shape, but seductively luscious in its bright opalescent or translucent colors.
—David Littlejohn, The Wall Street Journal, *March 31, 1993*

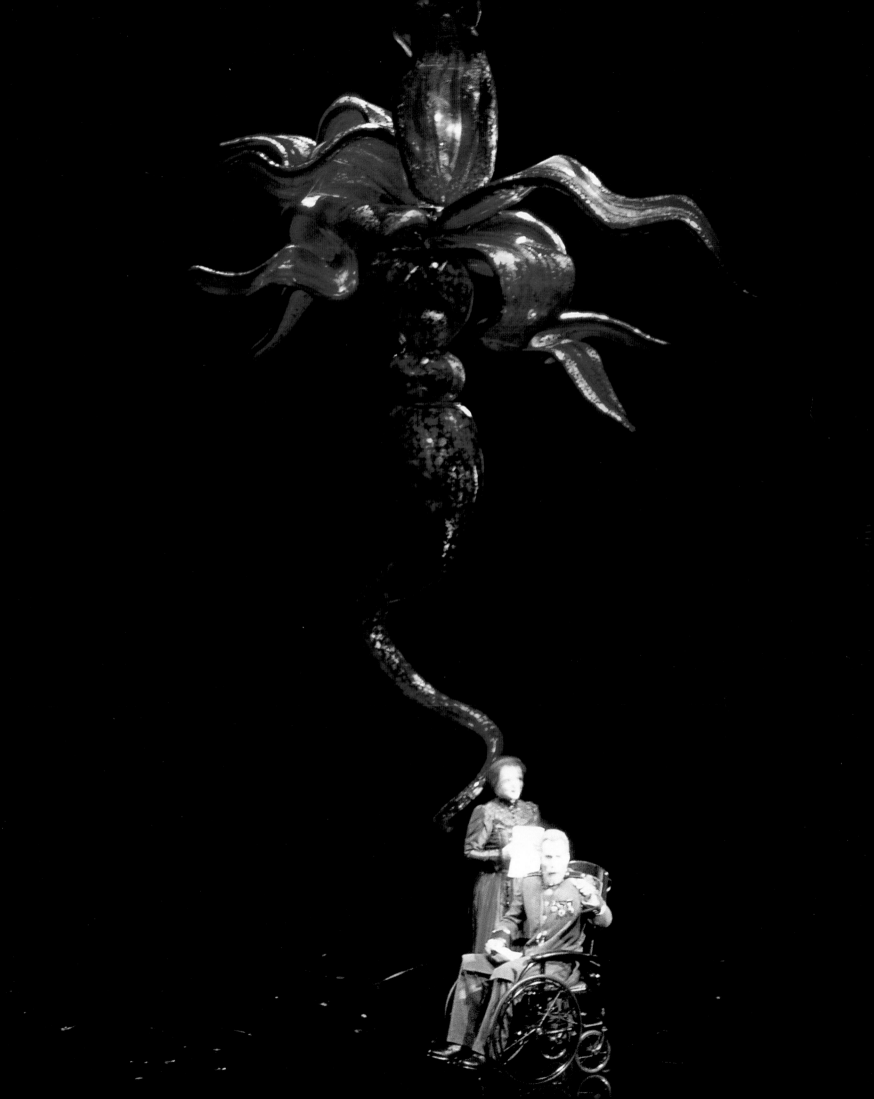

Below
Drawing for Golaud's Room, 1992,
acrylic on paper, 41" x 29"

Opposite
Golaud's Room, 1993, Pelléas et
Mélisande, Act IV, Scene 1, Seattle
Opera, Seattle, Washington

A delicate scrim, like a veil of netting, stretched almost invisibly across the stage, helping to blur your perceptions slightly and to make the glasslike sets look even more like real glass. Nearly all of them did, sometimes so strikingly that when Mélisande climbed into one exotic structure, you almost wanted to shout, "Hey! You can't climb into that! That's a Chihuly!"
—Melinda Bargreen, "After seeing sparkling sets, opera fans have difficulty keeping quiet," The Seattle Times, 15 March 1993

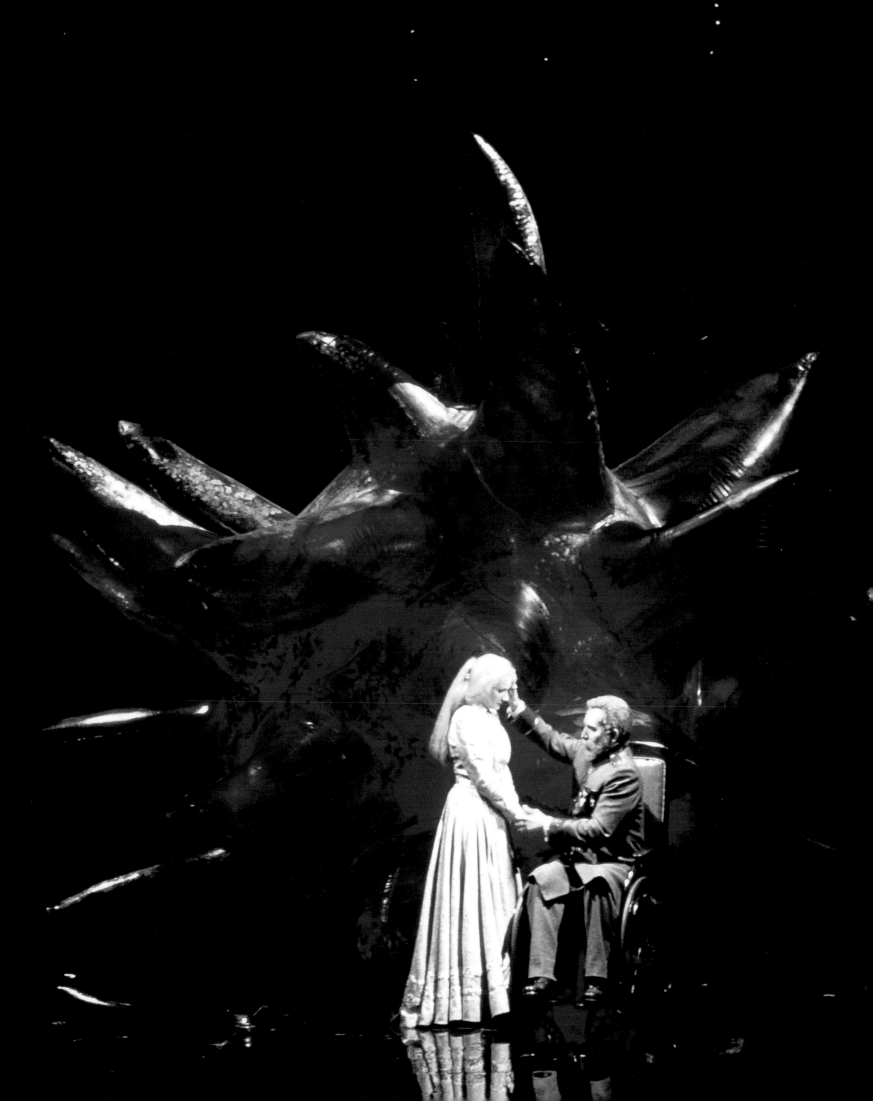

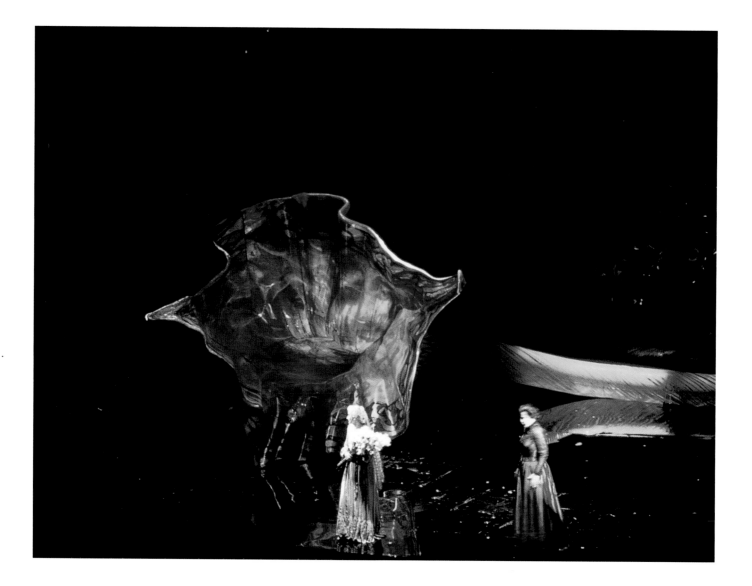

Above
*The Well, 1992, mock-up for Pelléas et
Mélisande, Act II, Scene 1, Seattle
Opera, Seattle, Washington*

Overleaf
*The Forest, 1993, Pelléas et Mélisande,
Act I, Scene 1, Seattle, Opera, Seattle,
Washington*

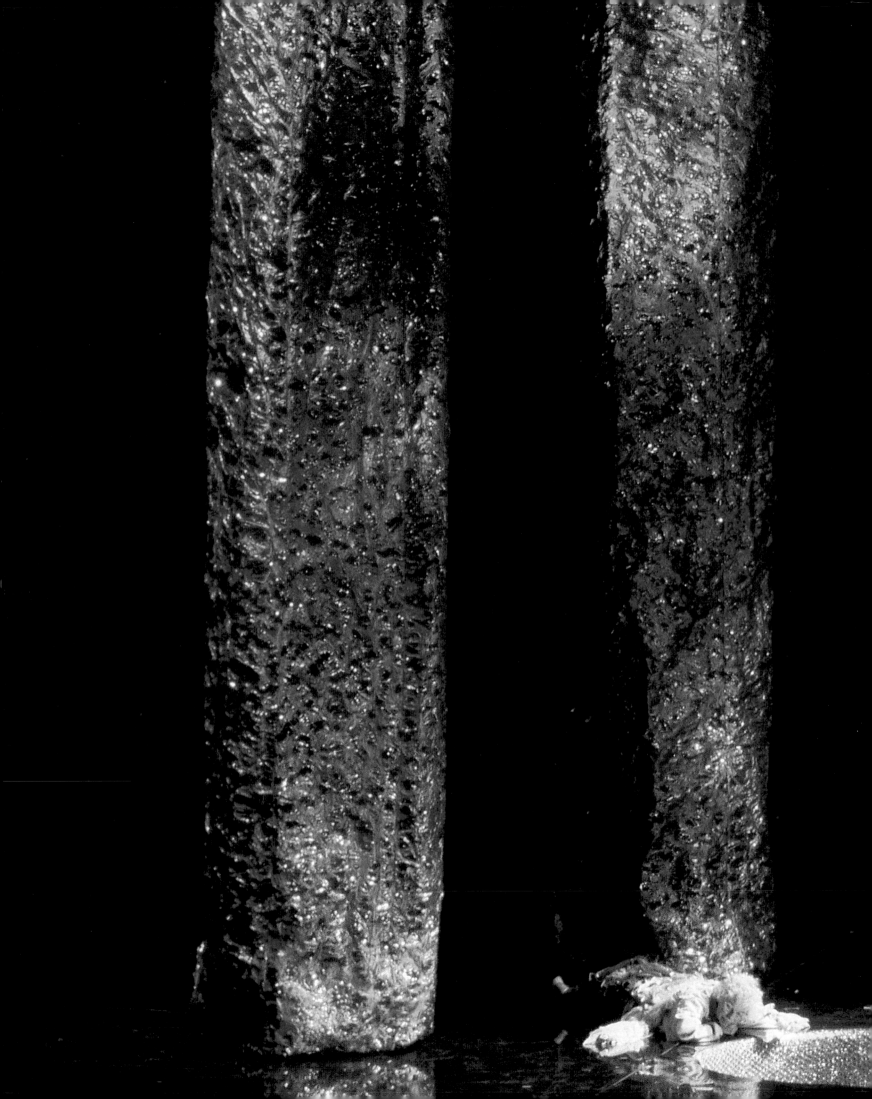

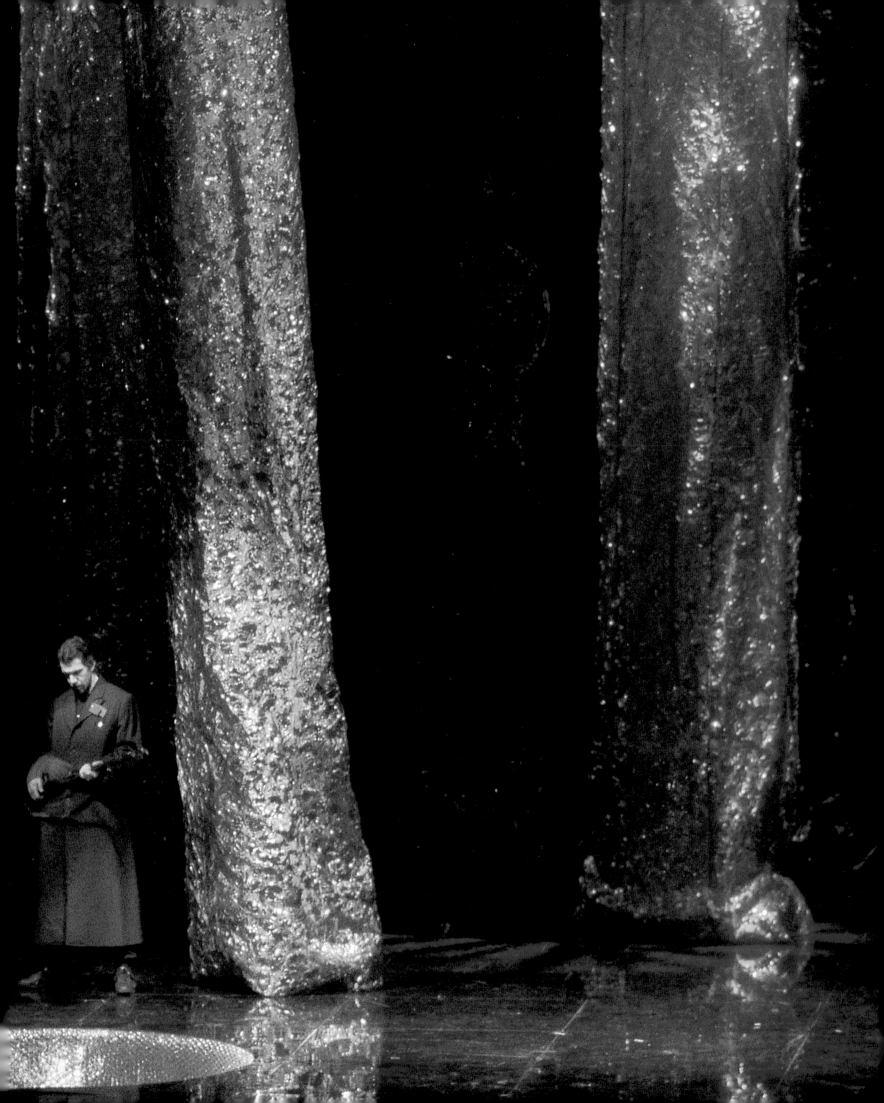

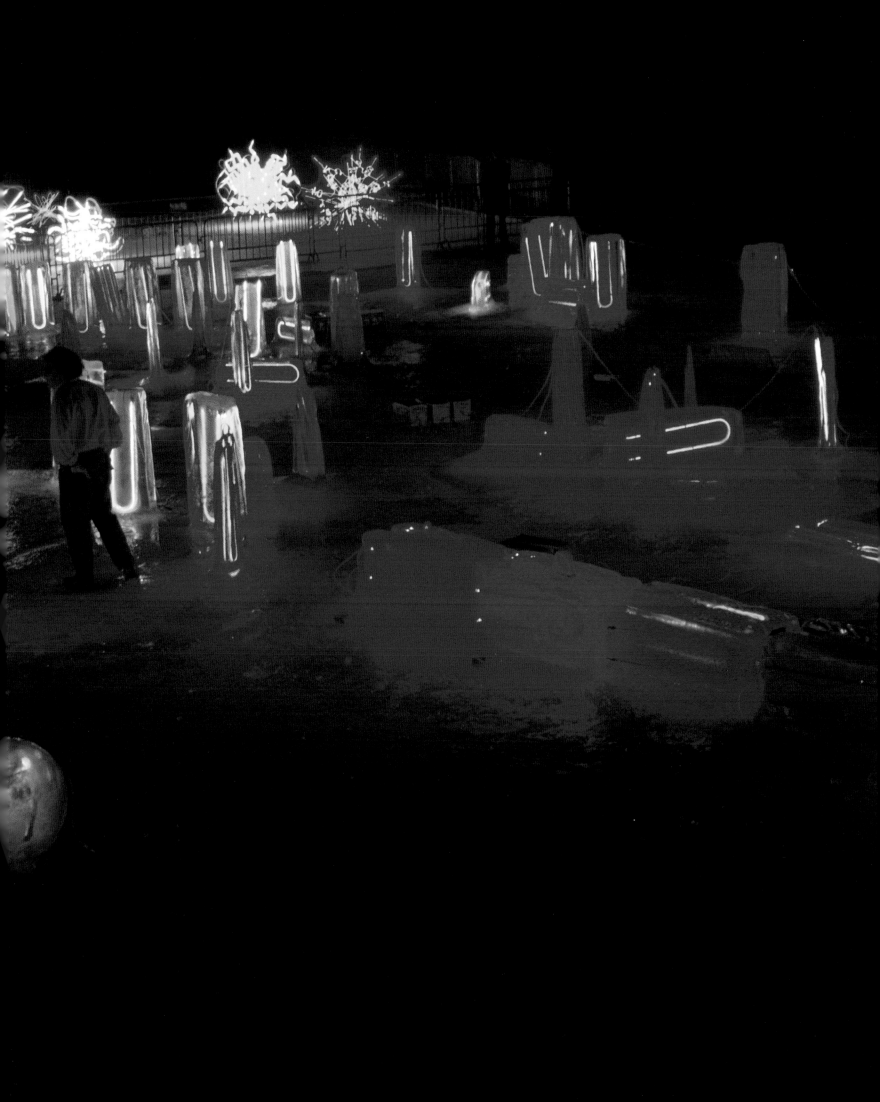

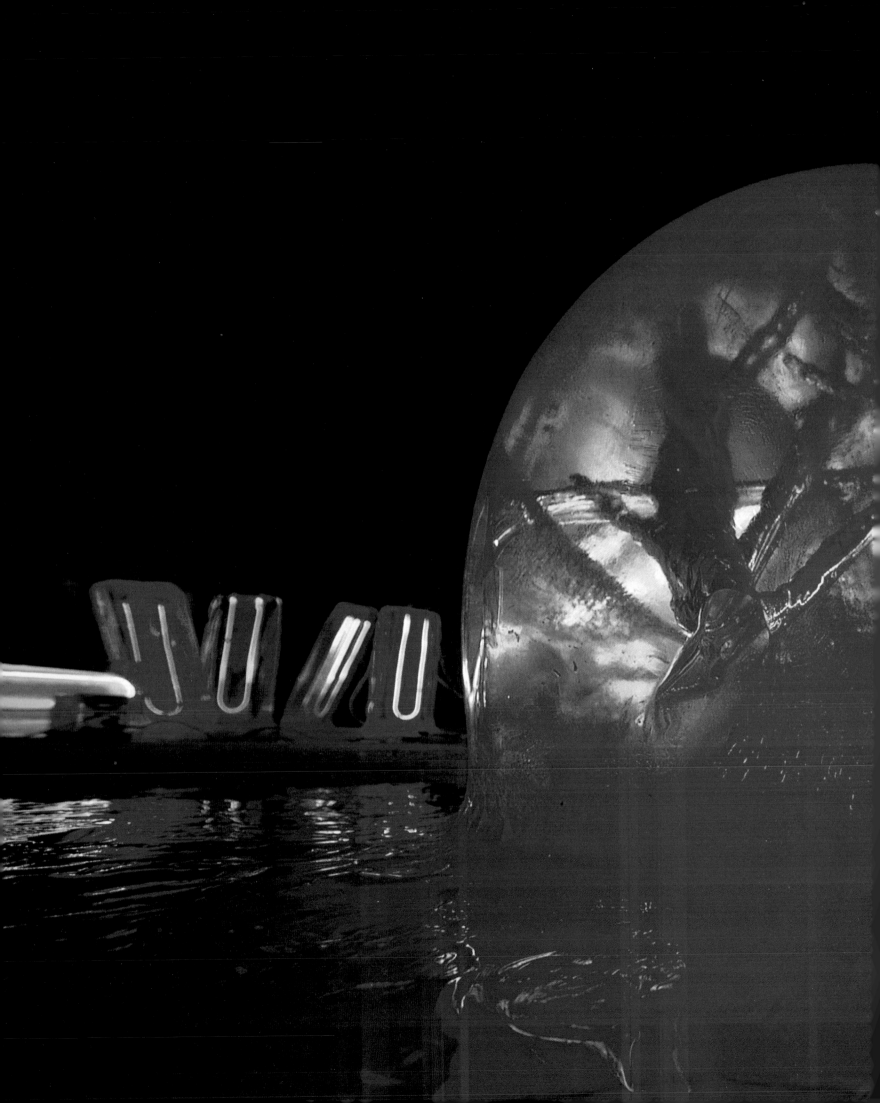

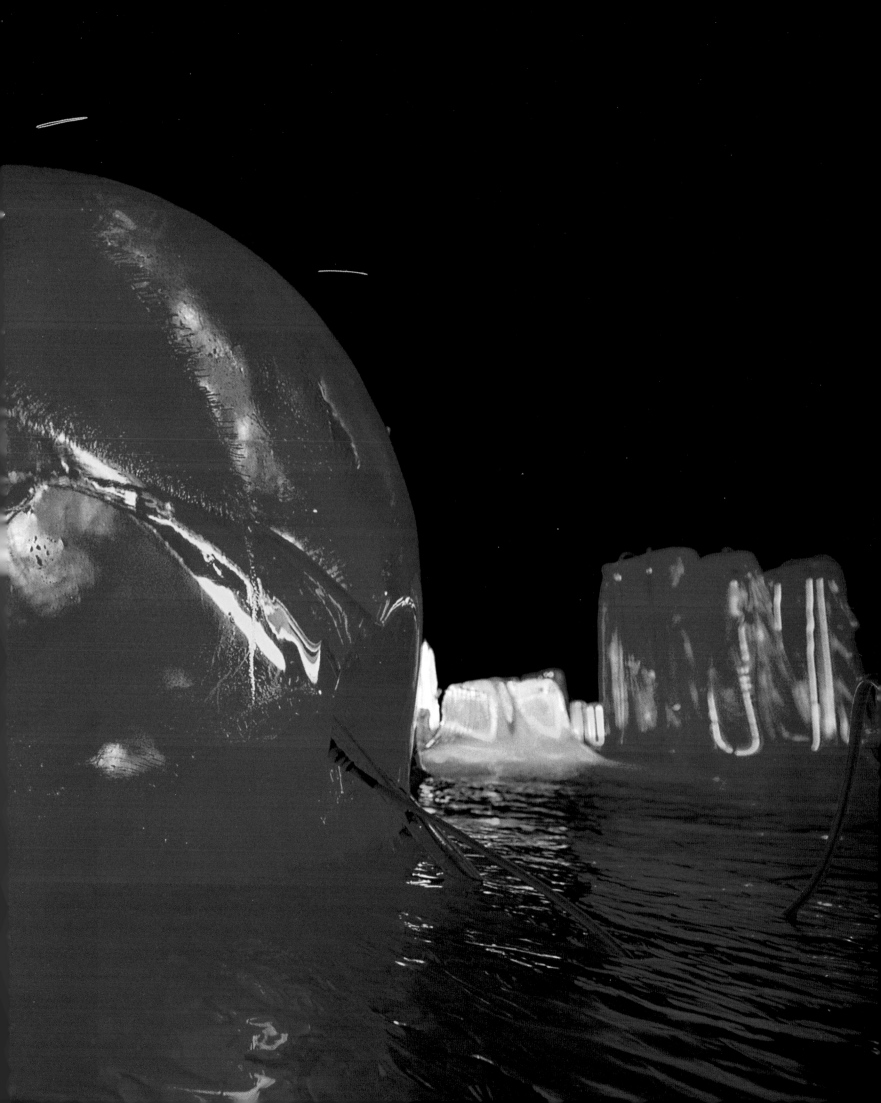

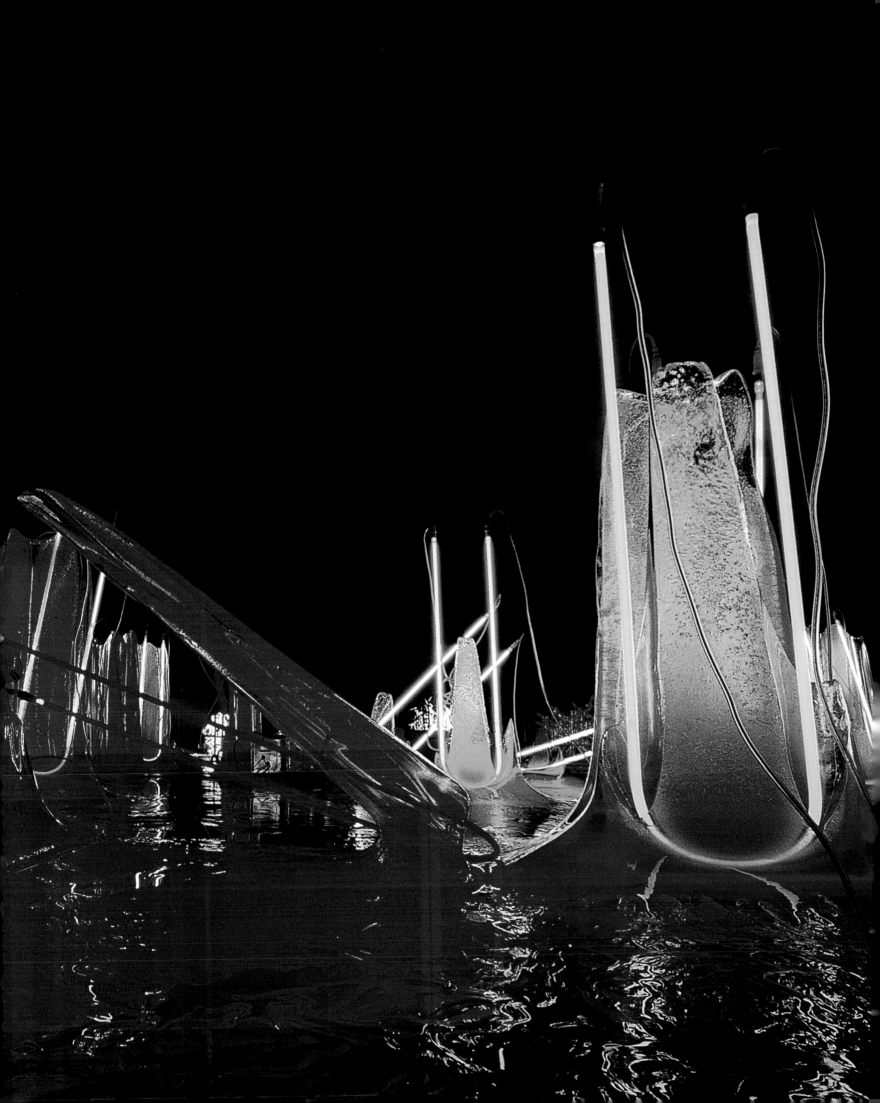

Previous and Opposite
100,000 Pounds of Ice and Neon
(detail), 1993, Tacoma Dome, Tacoma,
Washington

Below
Fax for a Seaform/Persian Ceiling for
Lagerquist Concert Hall, 1994

Glass is the most magical of all materials. It transmits light in a special way, and at any moment, it might break. Public installations are my favorite form of art because so many people get to see them. I'm lucky that my work appeals to so many people of all ages. It's more accessible than most public work. A lot of that has to do with the material.
—Dale Chihuly, Dale Chihuly: Installations 1964–1992, 1992

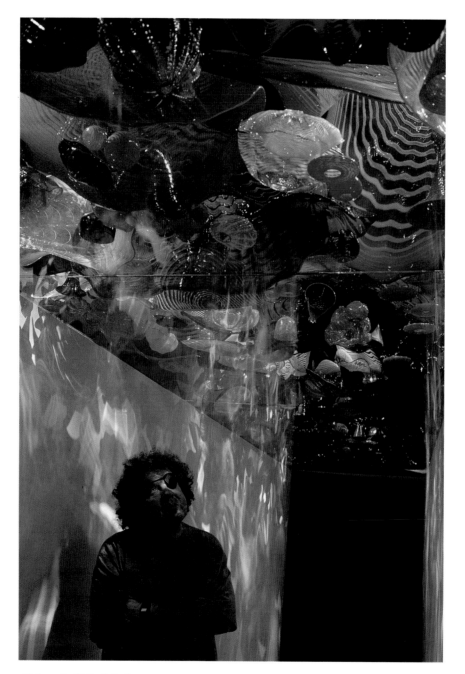

Although Chihuly's forms are essentially abstract, they seem nature based, evocative of spiraling forms and coiled growths sometimes found in marine creatures—sea anemones or mollusk shells. The undulating sides, swirling lips and progressively spaced stripes suggest they may have been shaped by eddying water or gusts of wind. Though the scalloped edges are in fact stationary, their apparent fluidity hints at potential movement like the swaying of organisms responding to tidal changes. The wall mounting offers an "aerial" view. . . . Their flaring sides appear to respond to gravity, but as they hang, the pull is not toward the floor.
—David Bourdon, "Chihuly: Climbing the Wall," Art in America, June 1990

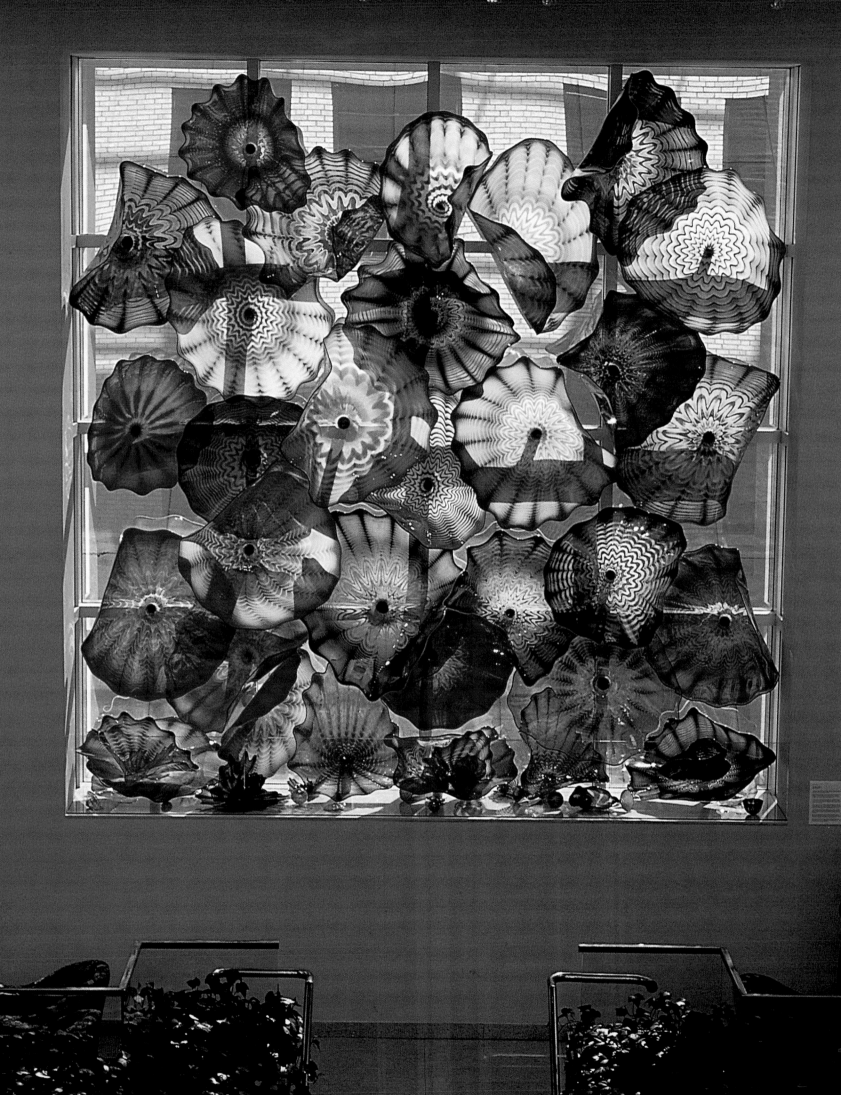

Opposite and Below
Malina Window, 1993, 16' x 16',
Little Caesar Enterprises, Inc.,
Corporate Headquarters, Fox Office
Center, Detroit, Michigan

255

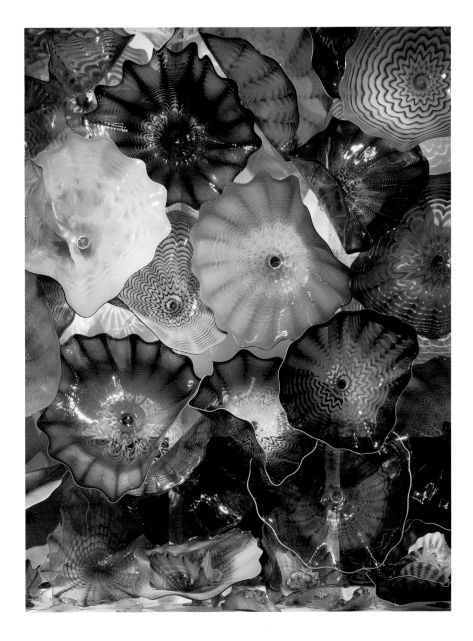

Below
Chihuly begins a series of paintings
with specially formulated dyes on
polymer and glass panels.
The Boathouse, Seattle,
Washington, 1997

Opposite
Window Installation, 1997, glass stain
and acrylic paint on thermoplastic
panels, 6' x 8' each, Minneapolis
Institute of Arts, Minneapolis,
Minnesota

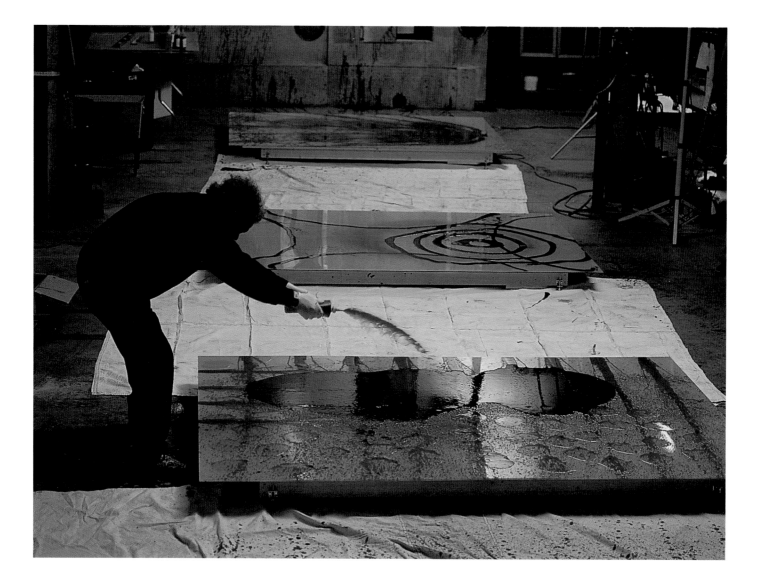

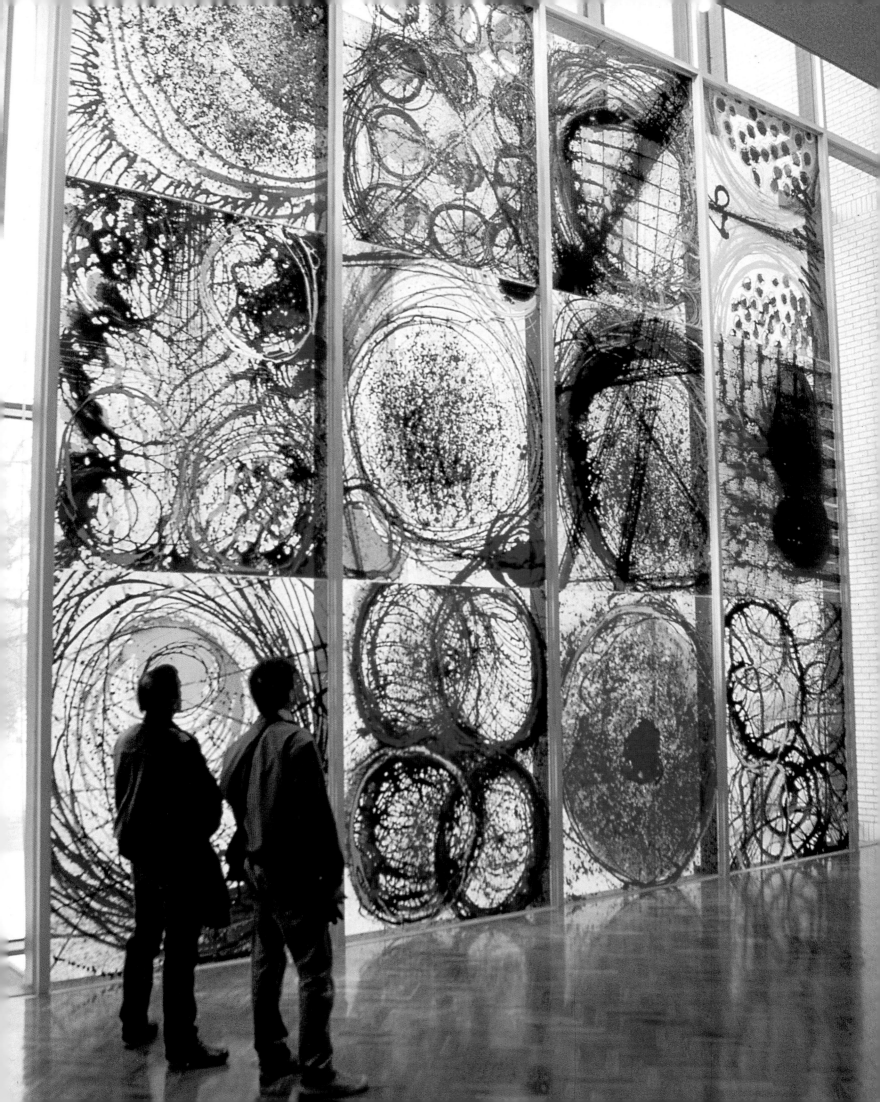

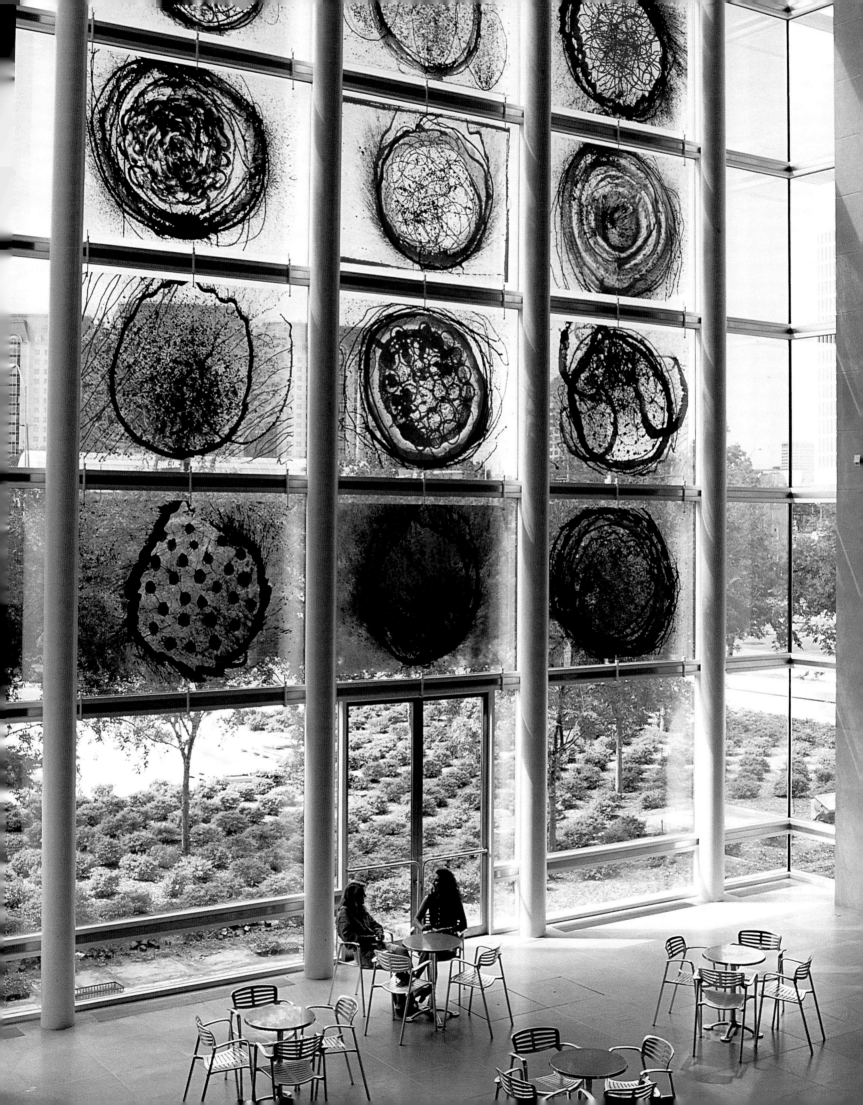

Opposite
Window Installation, 1994, glass stain
on thermoplastic panels, 6' x 8' each,
Dallas Museum of Art, Dallas, Texas

Below
Fax for Window Installation for
Dallas Museum of Art, 1994

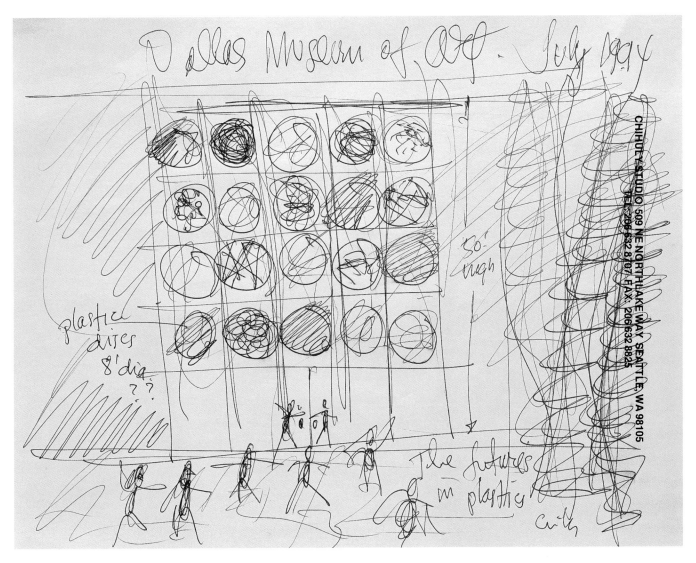

Overleaf
Cobalt Blue Chandelier, 1994,
20' x 9' x 3', Union Station,
Tacoma, Washington, made
possible by The News Tribune and
The Boeing Company

Monarch Window, 1994, 40' x 22' x 3',
Union Station, Tacoma, Washington,
made possible by an anonymous
donation

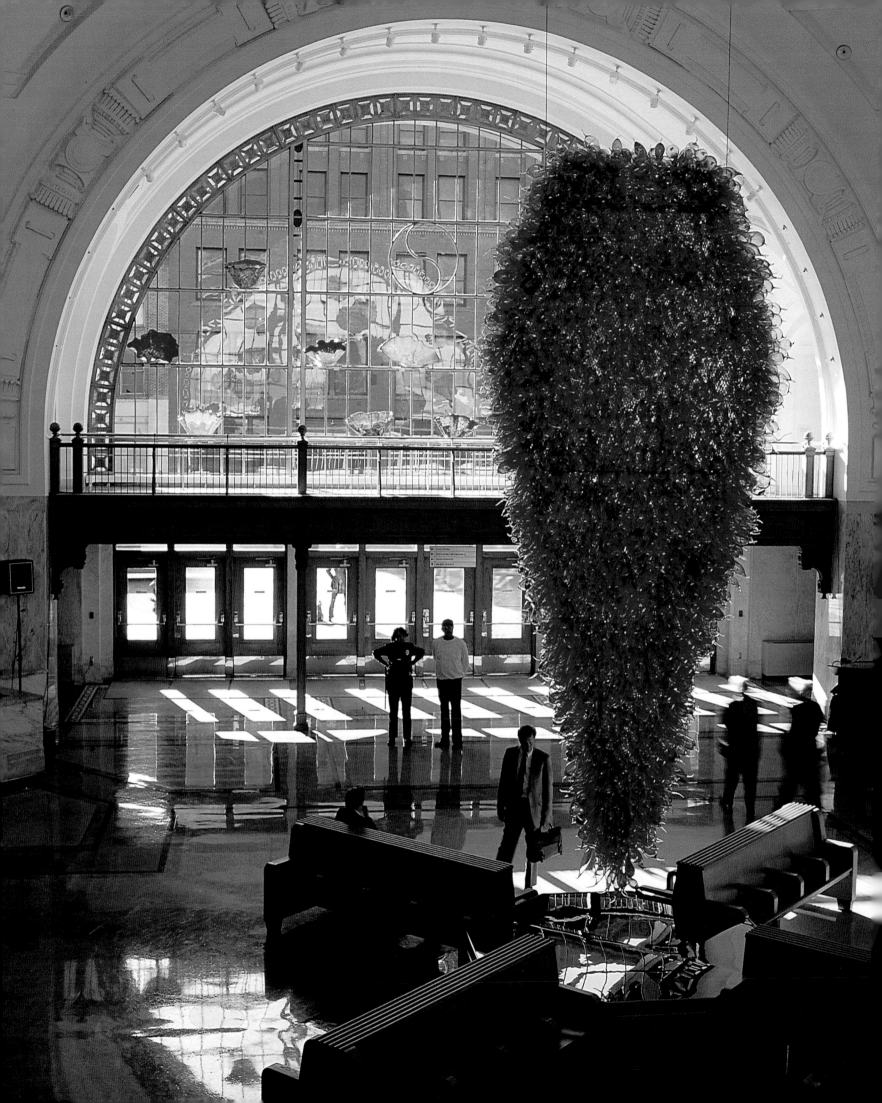

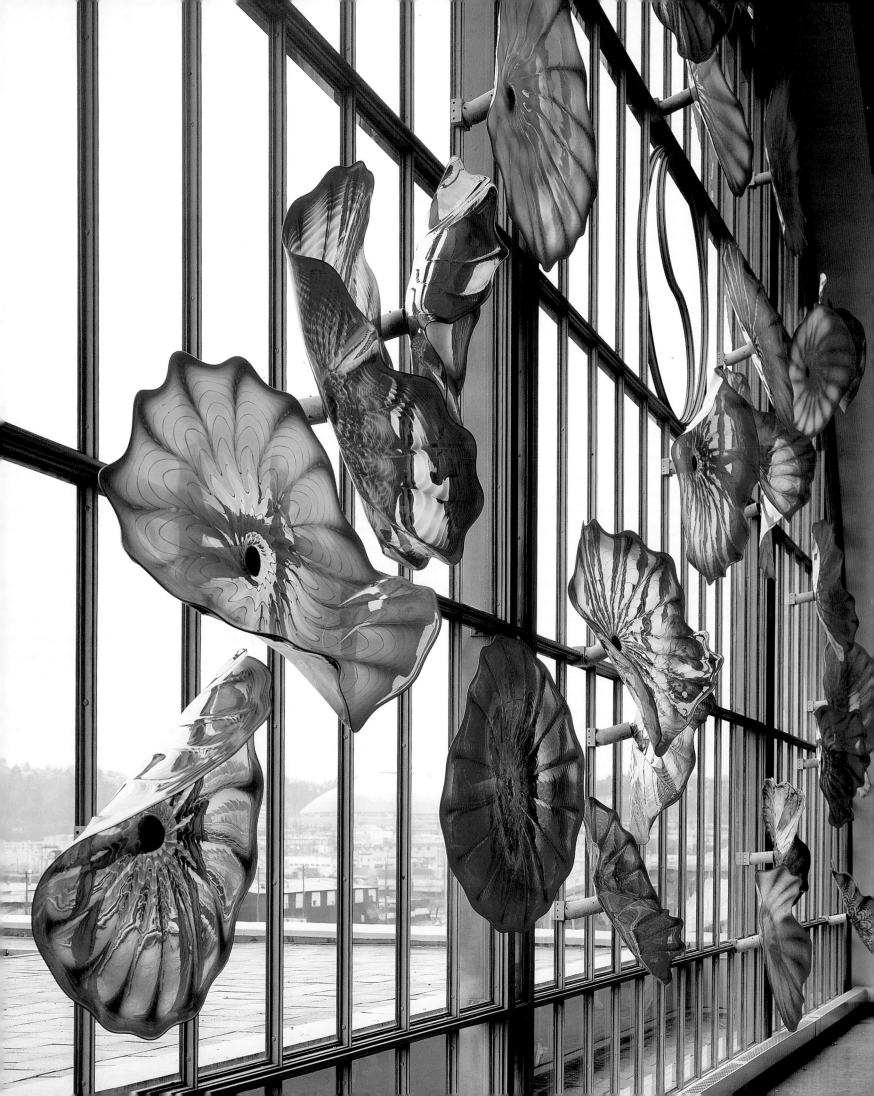

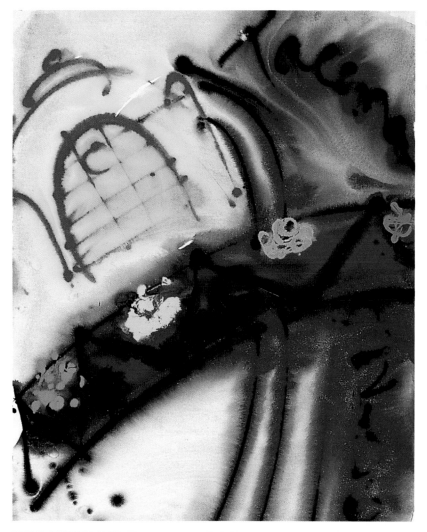

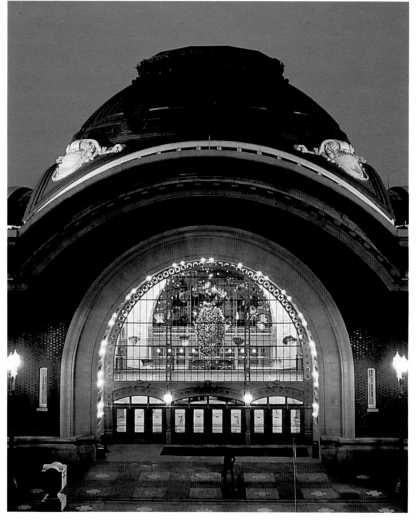

Above
Bridge Drawing (detail), 1994, acrylic and charcoal on paper, 30" x 22"

Below
Chihuly at Union Station (exterior), 1994, Union Station, Tacoma, Washington

Opposite
Basket Mural, 1994, acrylic on paper, 40' x 22' overall, Union Station, Tacoma, Washington, made possible by Hillhaven Corporation, Pierce County Medical, William W. Philip, and The Greater Tacoma Community Foundation

Union Station's elegant entry room has four main archways. Two are east and west windows, and Chihuly uses them to good effect. The eastern window has dozens of large, rippled orange glass "plates" floating in front of it. Chihuly thinks of them as butterflies, hence the title, the "Monarch Window."
—Regina Hackett, "Tacoma's Glassman," Seattle Post-Intelligencer, 24 March 1994

A beaux arts masterpiece built in 1911, Union Station in Tacoma, Washington, is now on the National Register of Historic Places. It underwent a $10 million renovation and is now a federal courthouse. Chihuly created five large-scale installations.

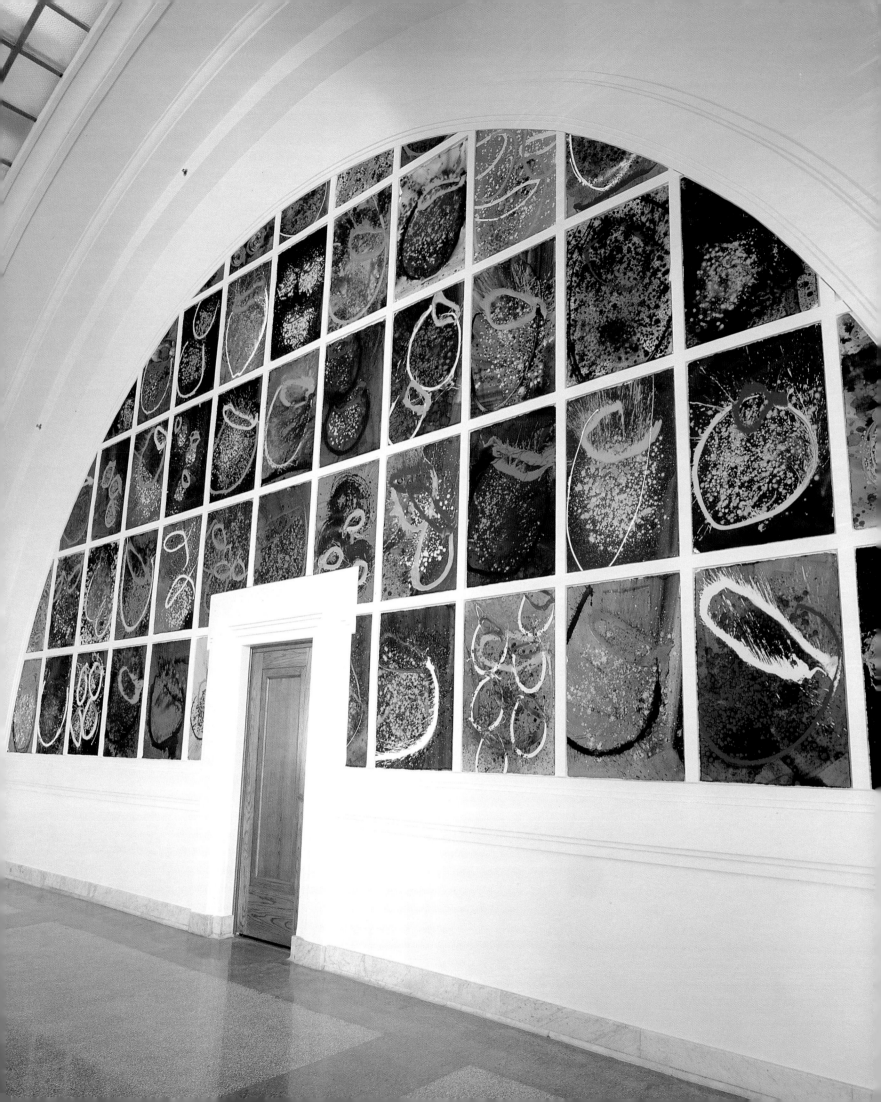

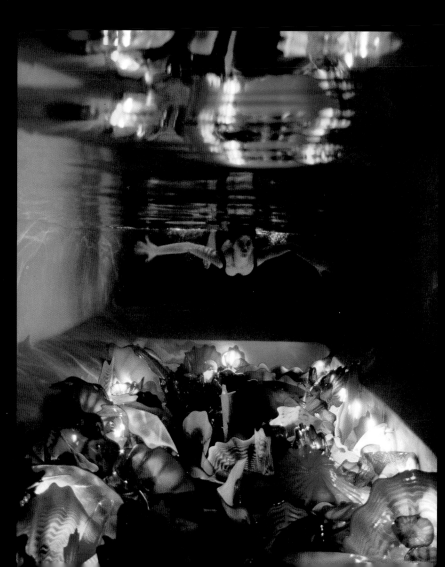

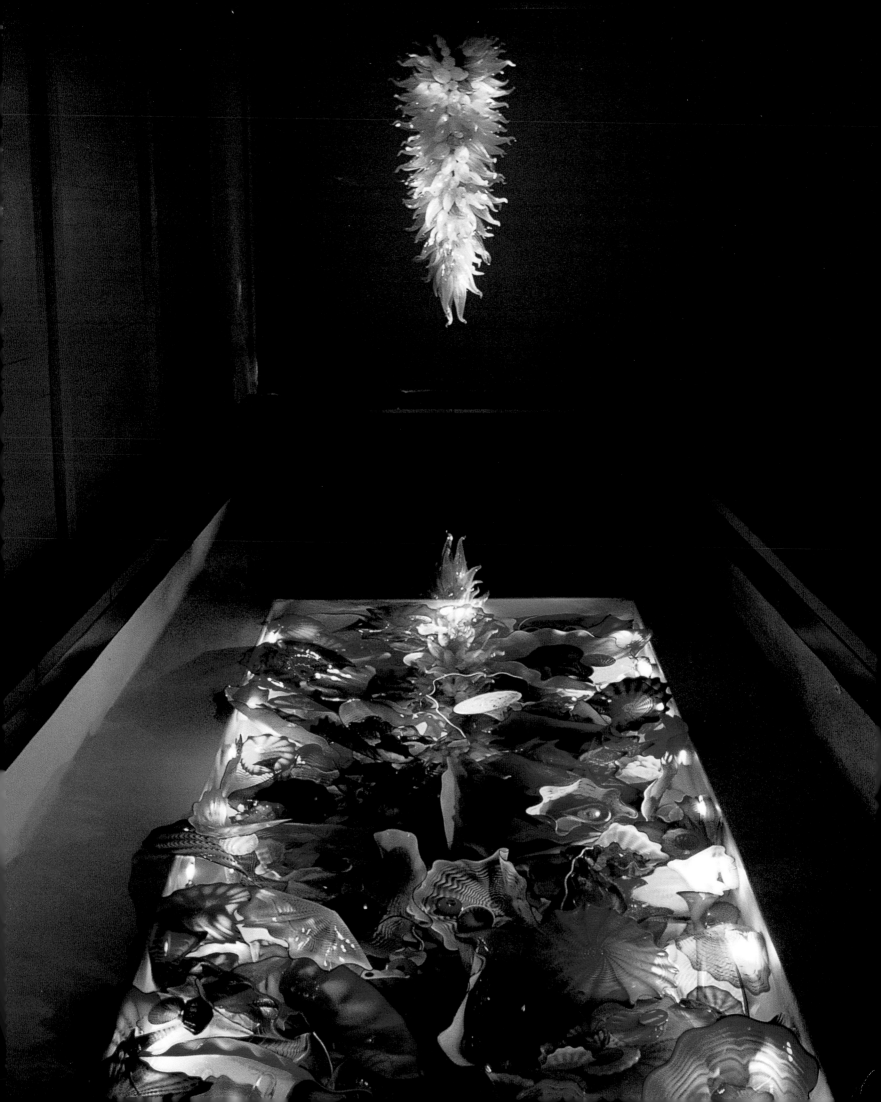

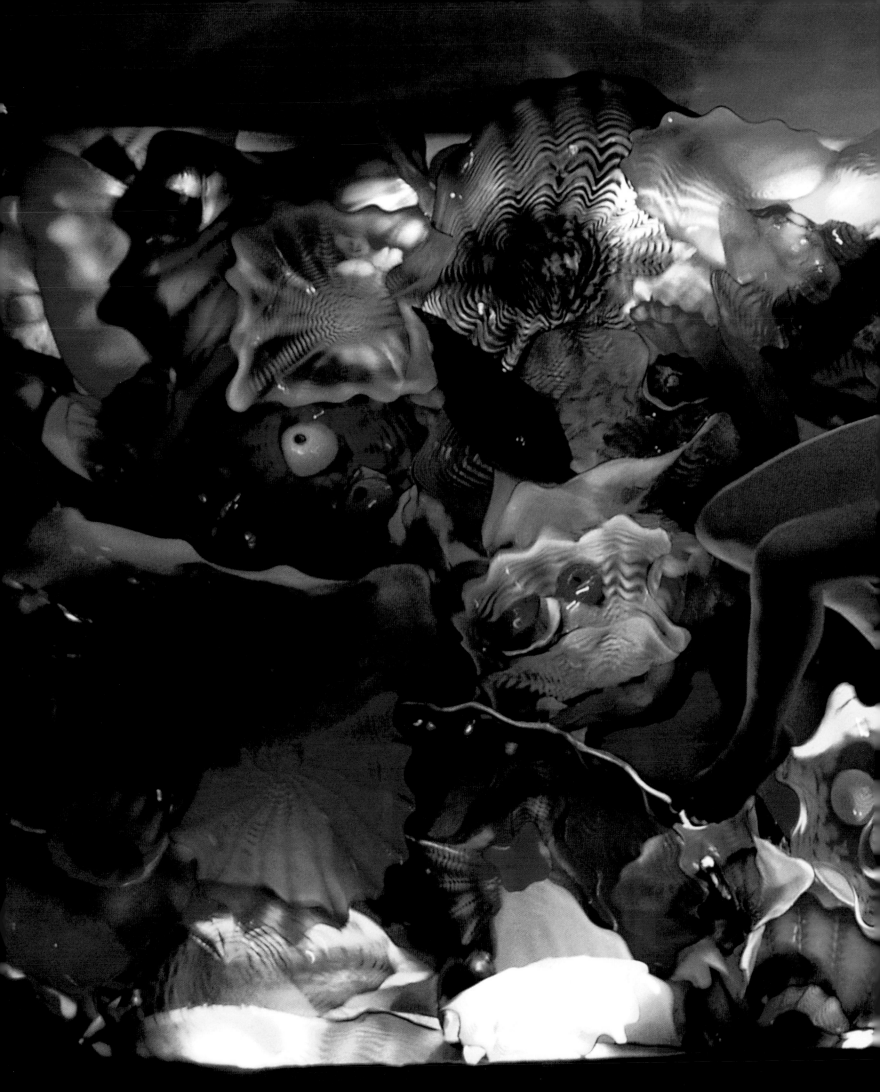

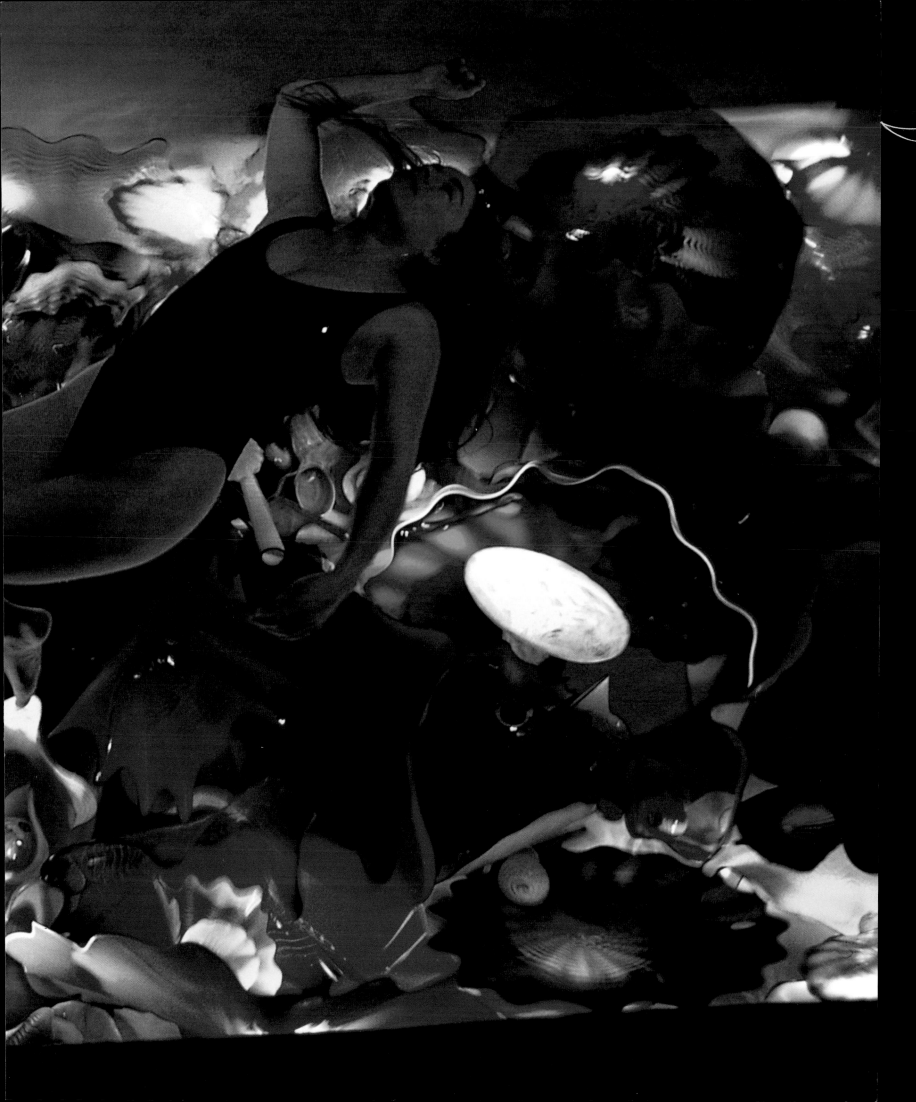

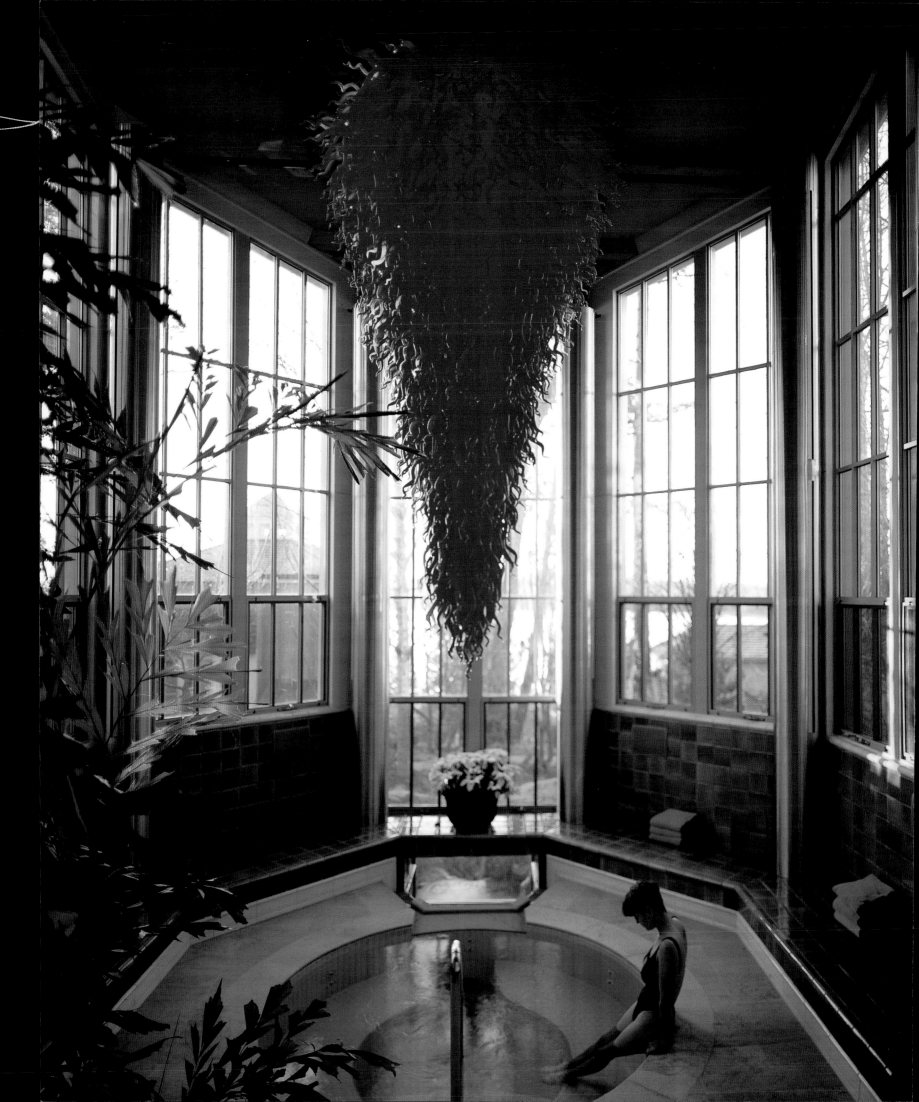

Opposite
Neon Red Chandelier, 1995, 11' x 6',
Seattle, Washington

Below
Orange Hornet Chandelier, 1993,
10' x 7', Portland, Oregon

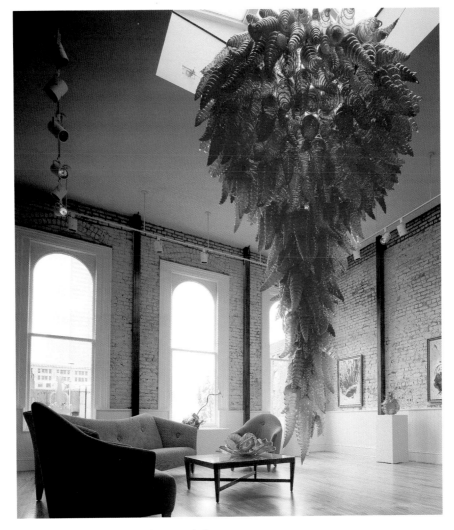

What makes the Chandeliers work for
me is the massing of color. If you take
up to thousands of blown pieces of
one color, put them together, and then
shoot light through them, now that's
going to be something to look at.
Now you hang it in space and it
becomes mysterious, defying gravity
or seemingly out of place—like
something you have never seen before.
—Dale Chihuly, 1996

270

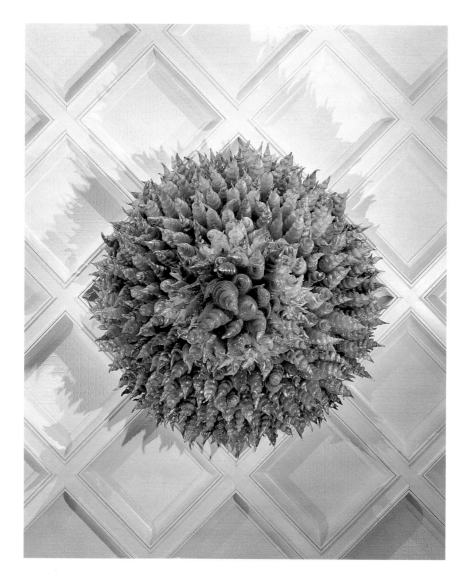

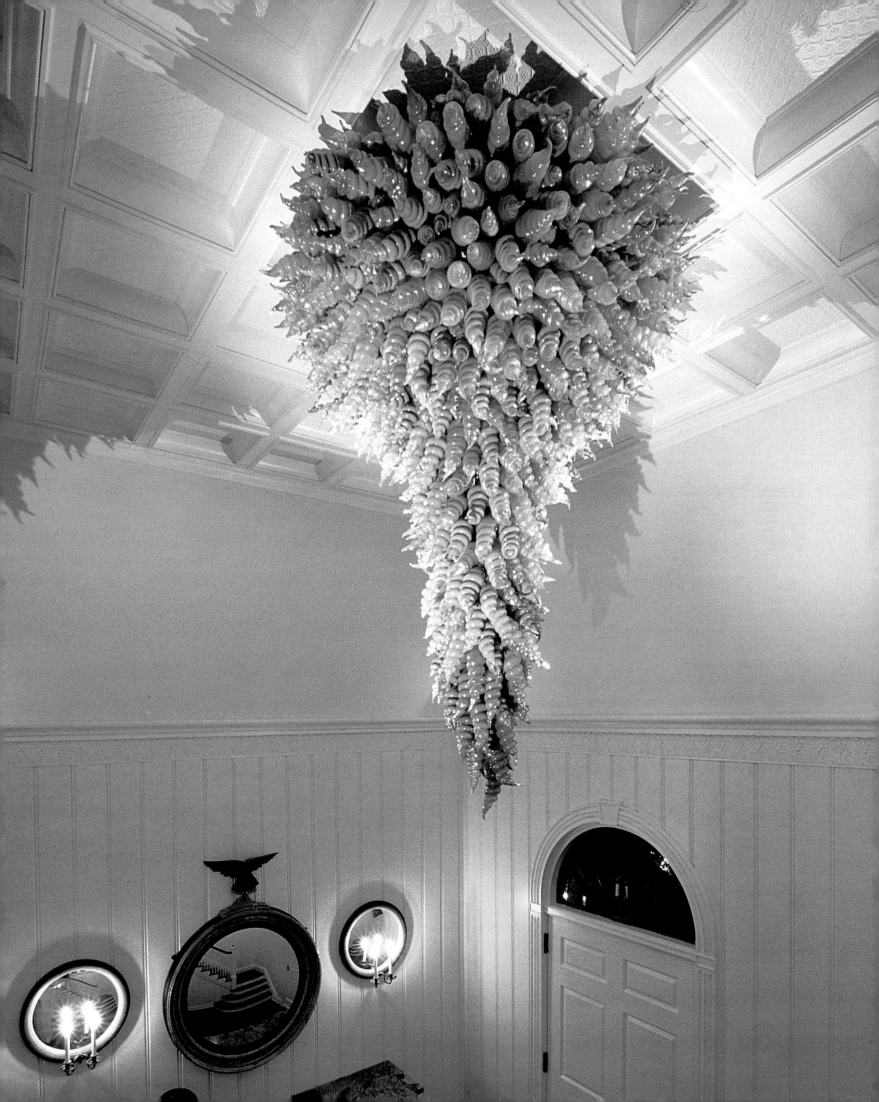

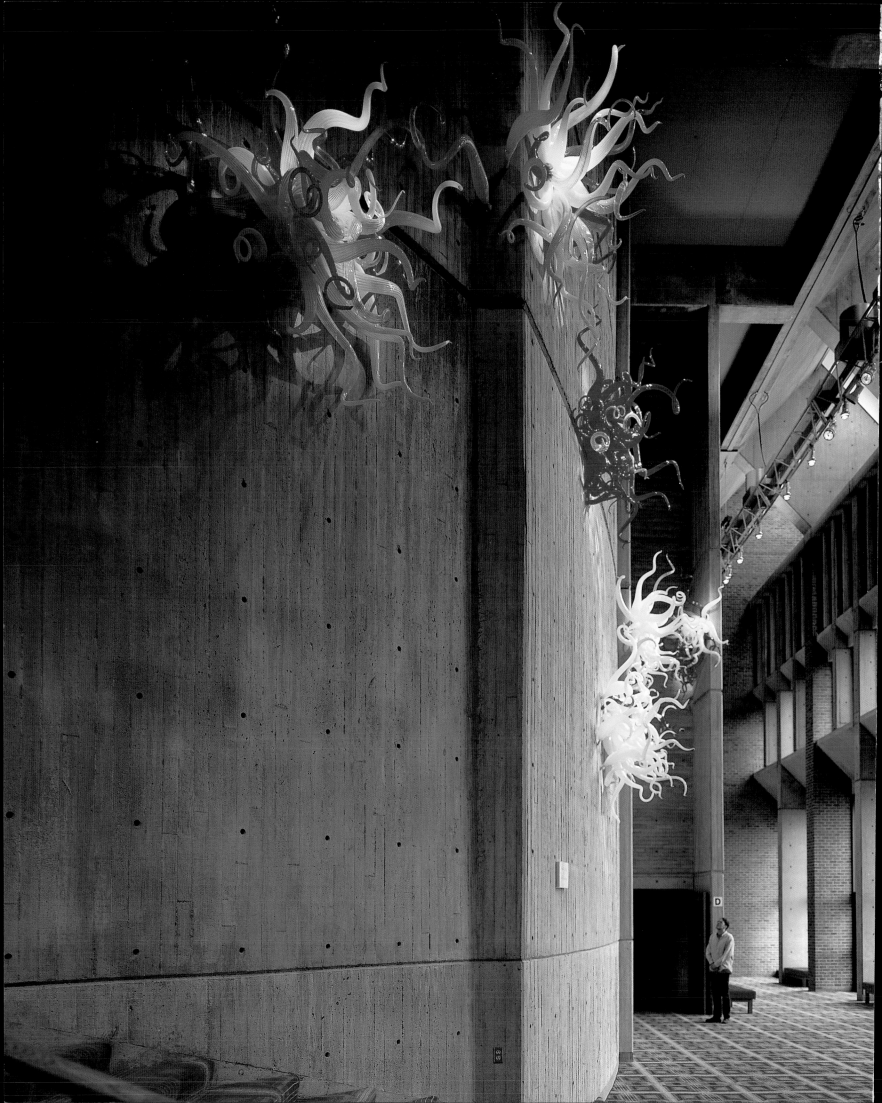

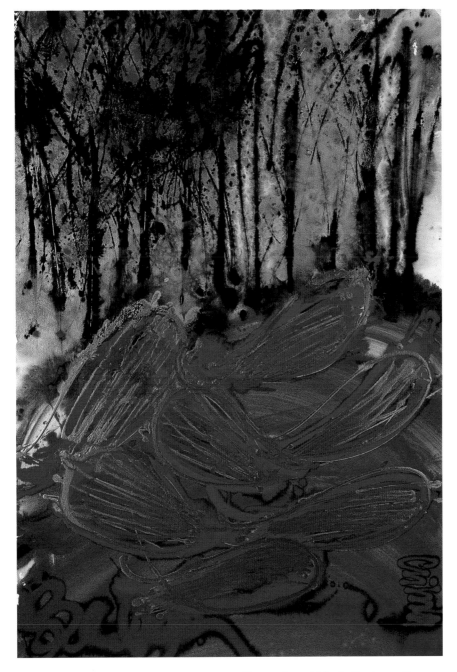

Above
Nuutajärvi Drawing, 1995, acrylic
on paper, 60" x 40"

The session at Nuutajärvi was the
first session for "Chihuly Over
Venice," and in some respects it was
the most innovative and creative.
Chihuly not only created a remarkable
series of glass forms but developed
new techniques for displaying them
in the landscape.
—Henry Adams, Dale Chihuly: Thirty
Years in Glass, 1966–1996, *1996*

Below
*Tree Spears, 1995, Nuutajärvi,
Finland*

Opposite
*Water Spears, 1995, Nuutajärvi,
Finland*

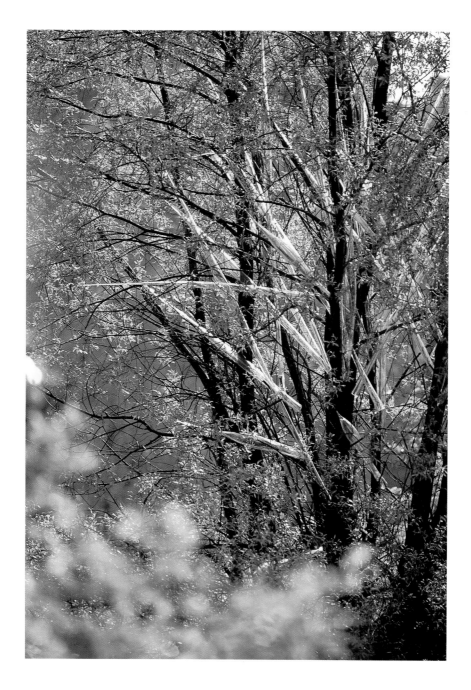

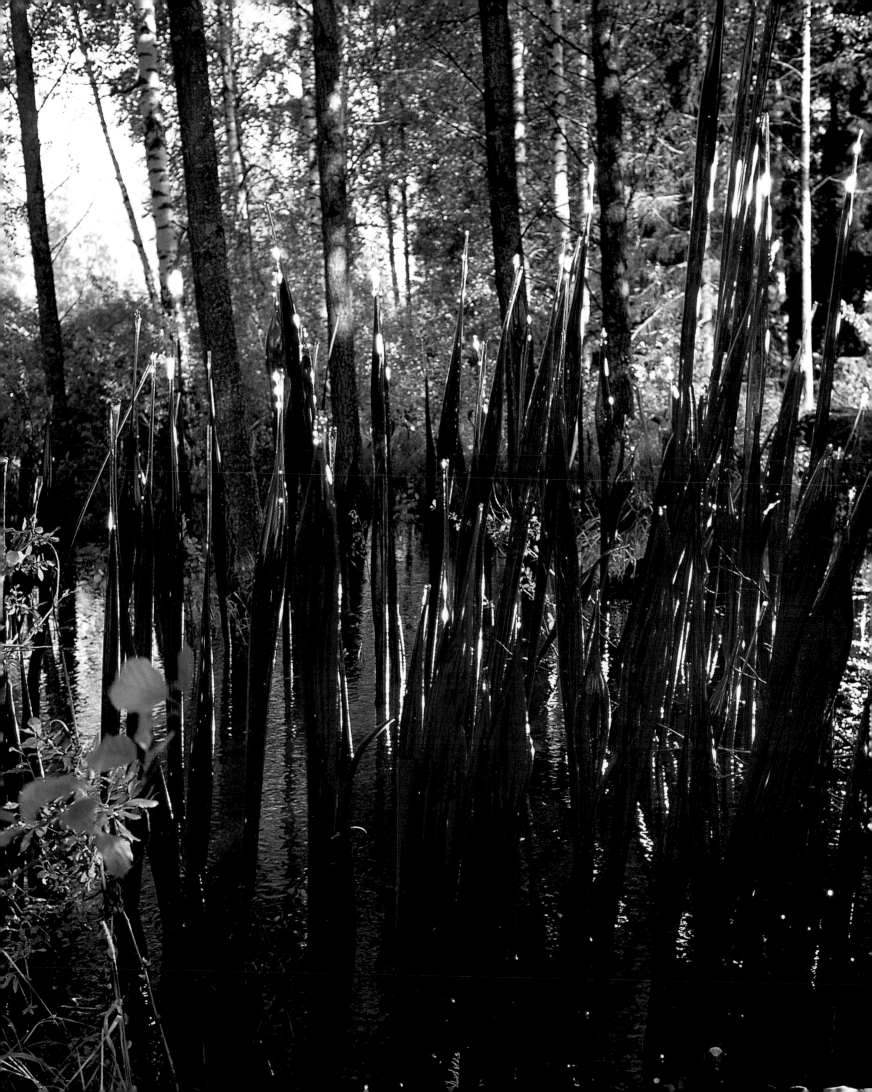

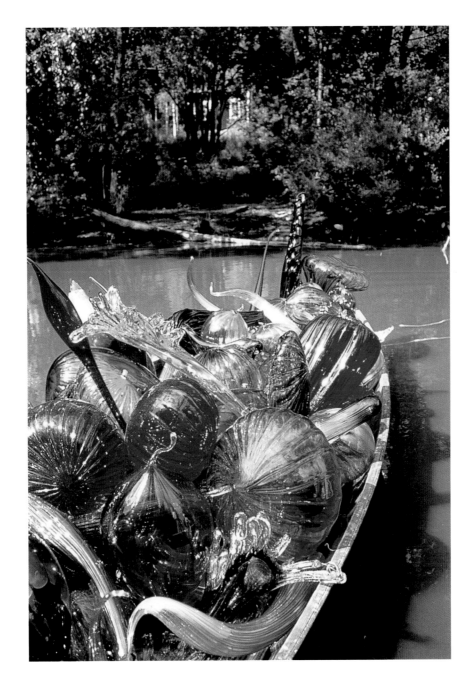

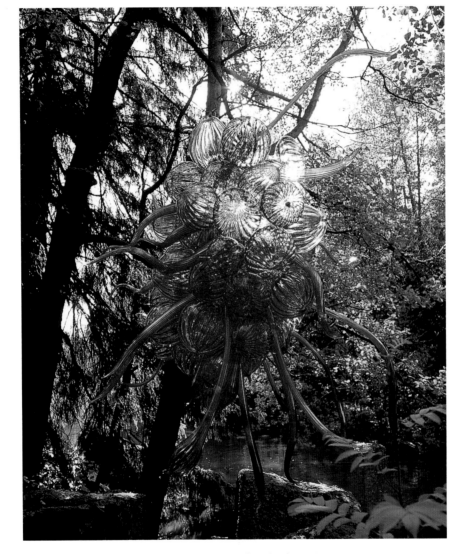

Overleaf
Belugas and Seal Pups, 1995,
Nuutajärvi, Finland

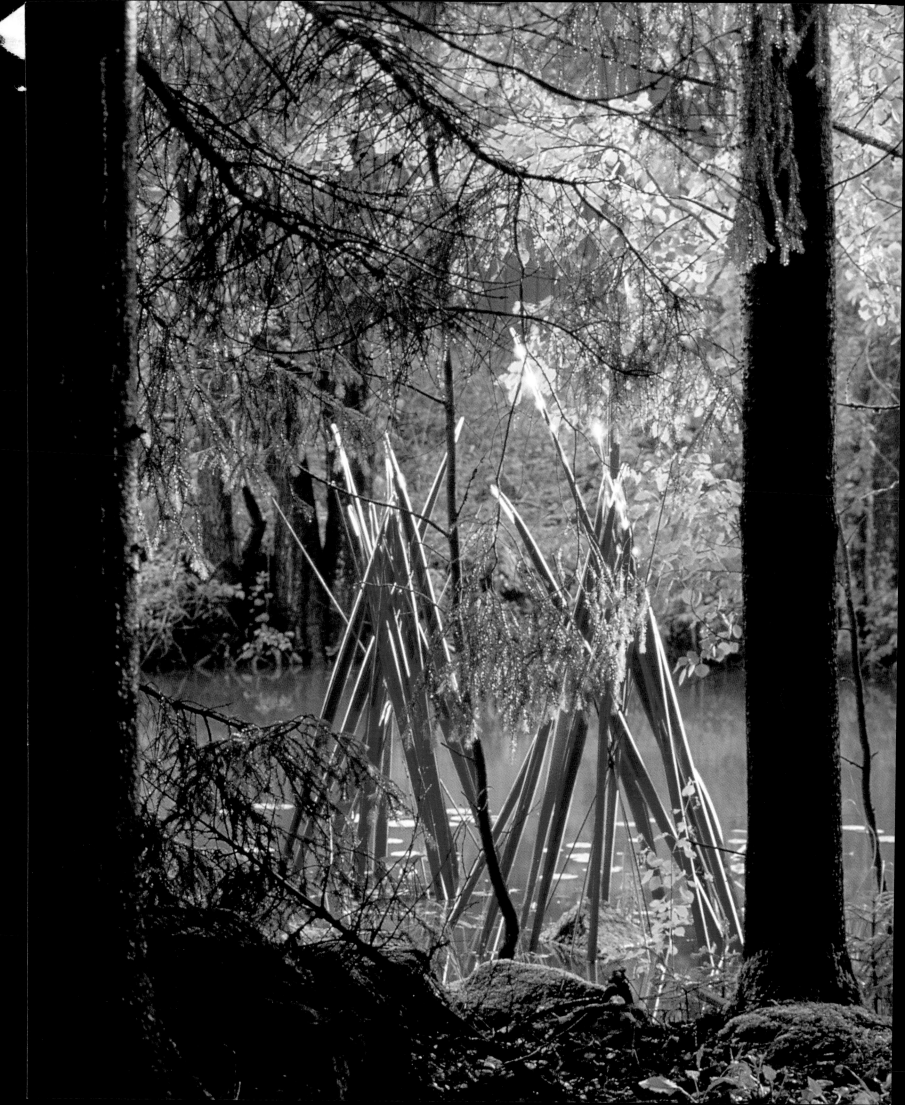

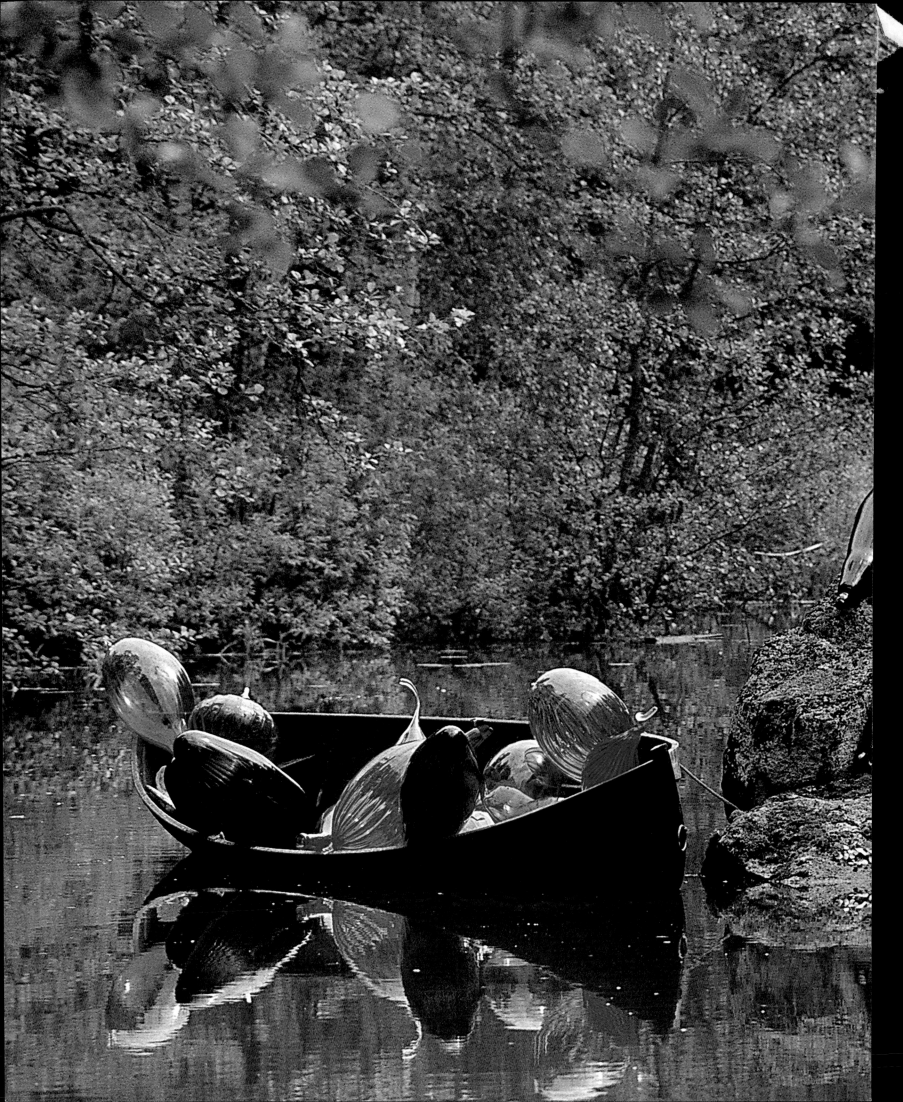

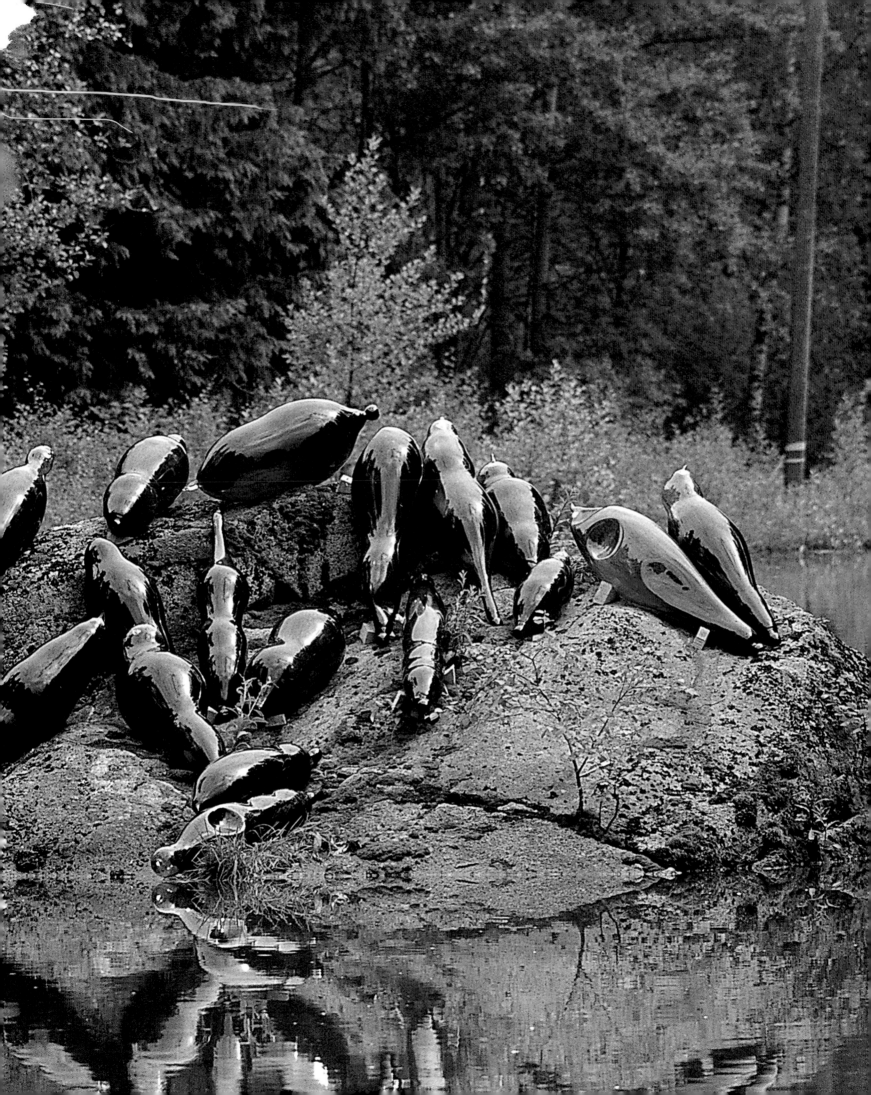

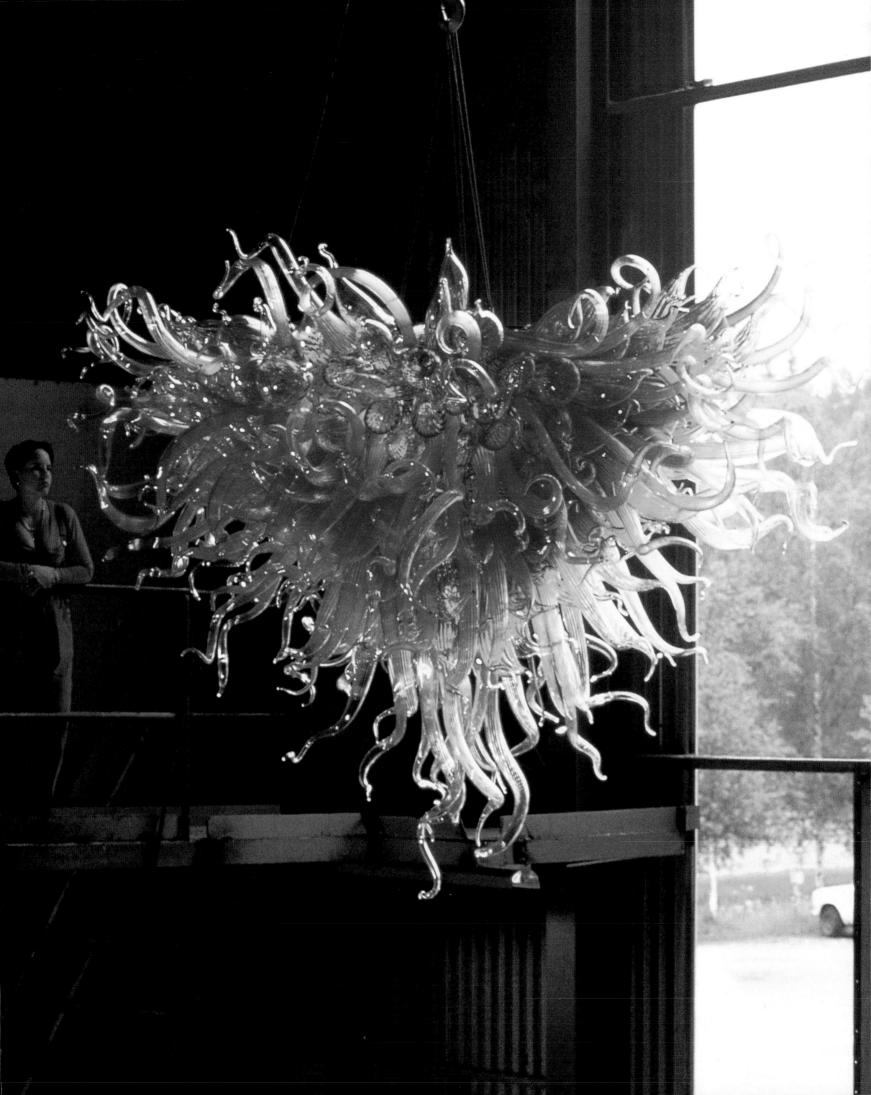

Opposite
Turquoise Chandelier, 1995,
8' x 11', Nuutajärvi, Finland

Below
Fax for Chandelier installation at
Lismore Castle, 1995, Ireland

CHIHULY STUDIO 509 NE NORTHLAKE WAY SEATTLE, WA 98105
TEL: 206 632-8707 FAX: 206 632-8825

Below
Destruction Room Chandelier, 1995,
10' x 7', Lismore Castle, Ireland

Opposite
Frog Foot Chandelier, 1995,
12' x 6', Lismore Castle, Ireland

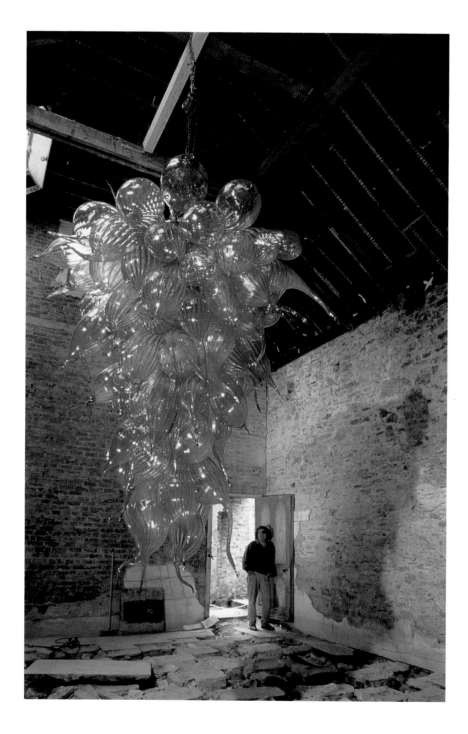

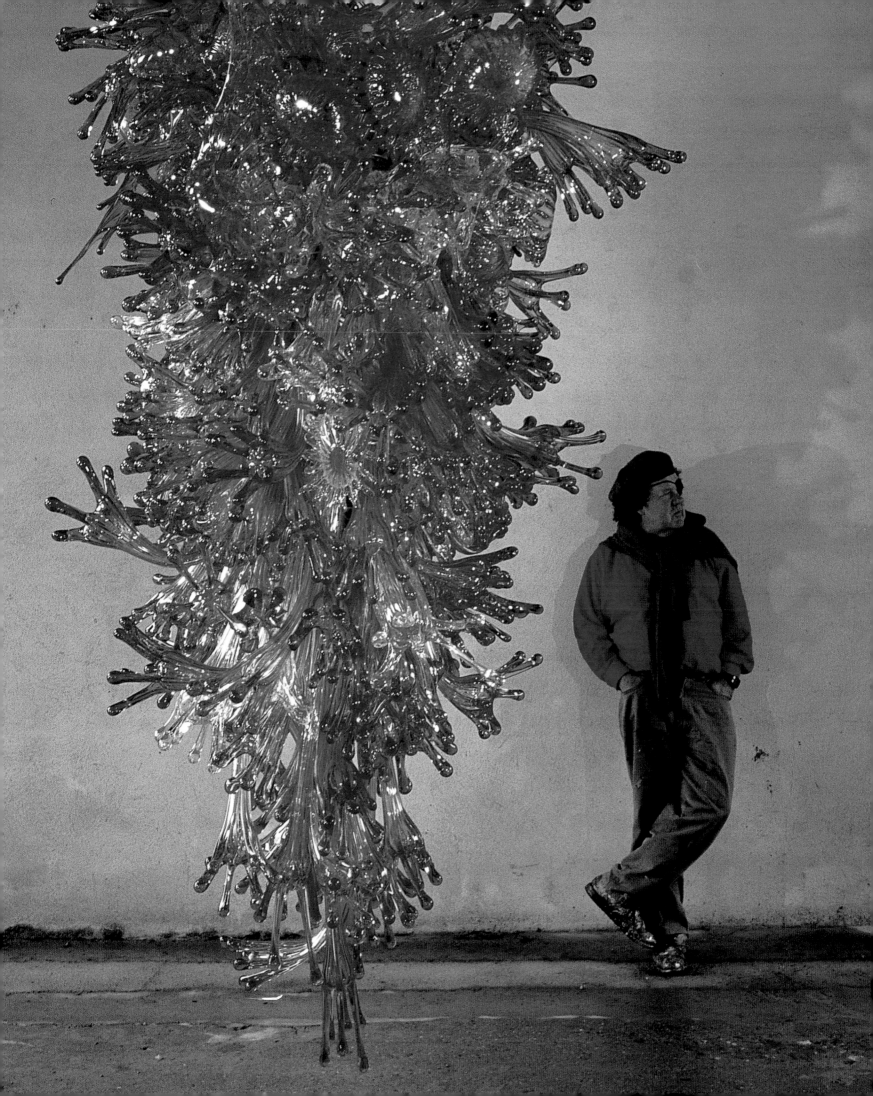

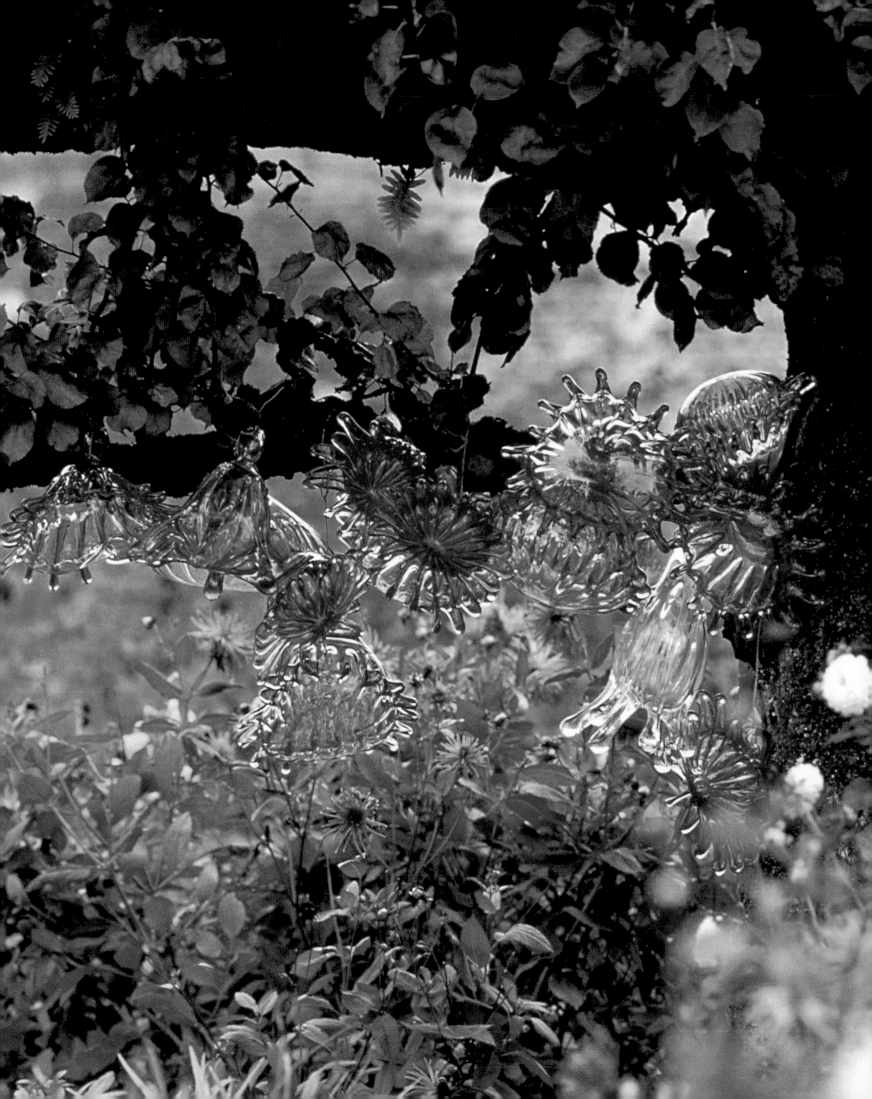

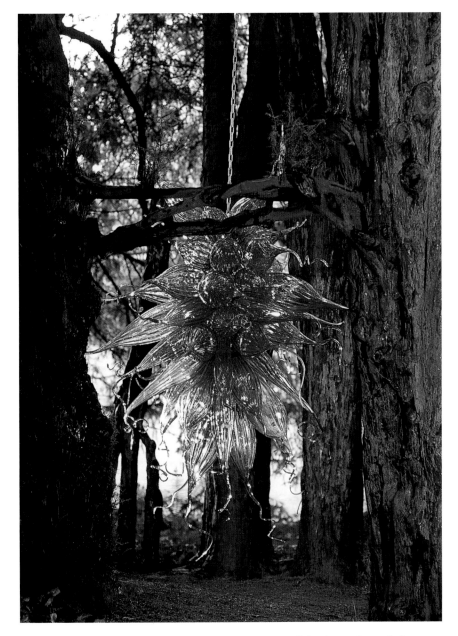

Beauty is beguiling, of course, and Chihuly simply seems incapable of creating much that's not beautiful. One of the most successful installations at Lismore Castle was a delicate-looking wasp nest of amethyst glass tendrils suspended between magnificent rows of ancient yew trees. When the brilliant late afternoon light shone through the canopy of boughs, the chandelier was stunning, glittering like a giant jewel. It was impossible not to be at least momentarily mesmerized.
—Robin Updike, "Man of Glass,"
The Seattle Times, *3 December 1995*

Below
From left to right, Rich Royal,
John Kiley, Chihuly, Martin Blank,
Robbie Miller at Waterford Crystal,
Waterford, Ireland, 1995

Opposite
Waterford Crystal, Waterford,
Ireland, 1995

Chihuly Over Venice took 18 months to
complete. In each location Chihuly's
team of glassblowers worked with
resident artisans. Collaboration was
the mainstay of Chihuly's working
method. He frequently communicates
his visions to workers through vividly
colored paintings . . . but the execution
involves dozens of professionals
working under his direction.
—Alice Thorson, "Art, come stay
awhile," The Kansas City Star,
27 December 1996

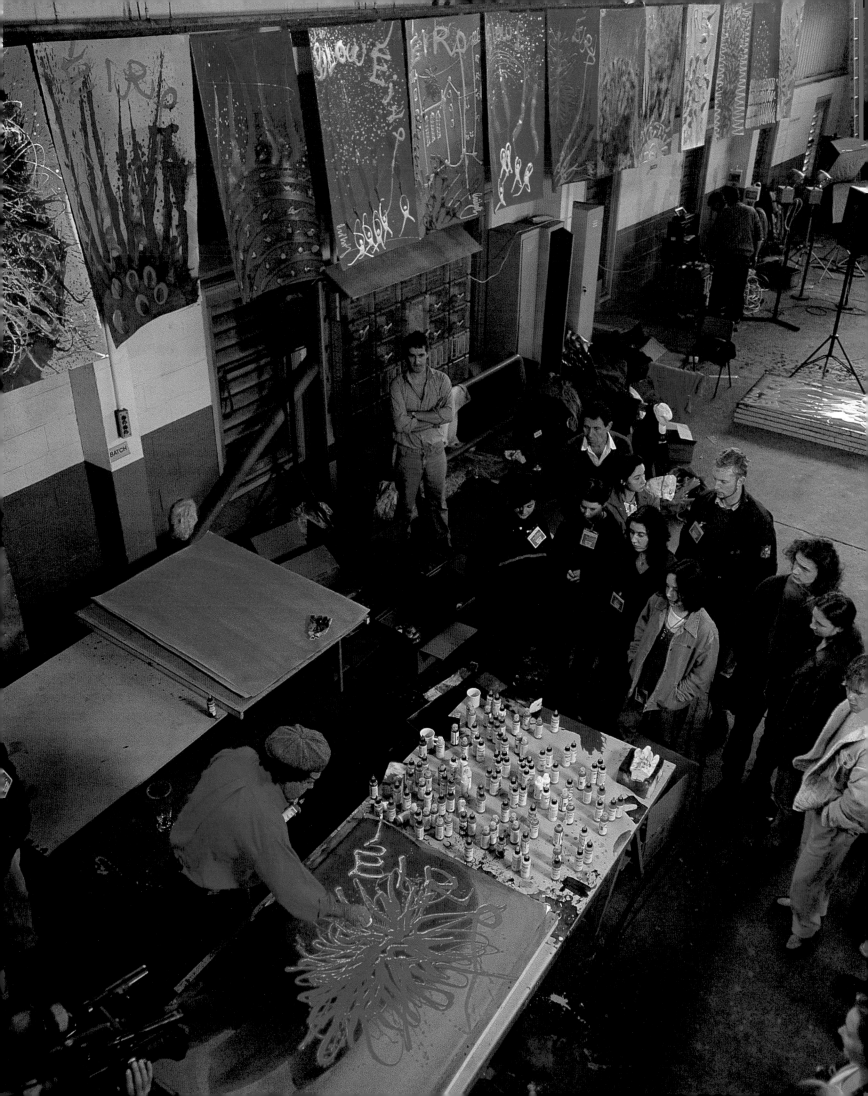

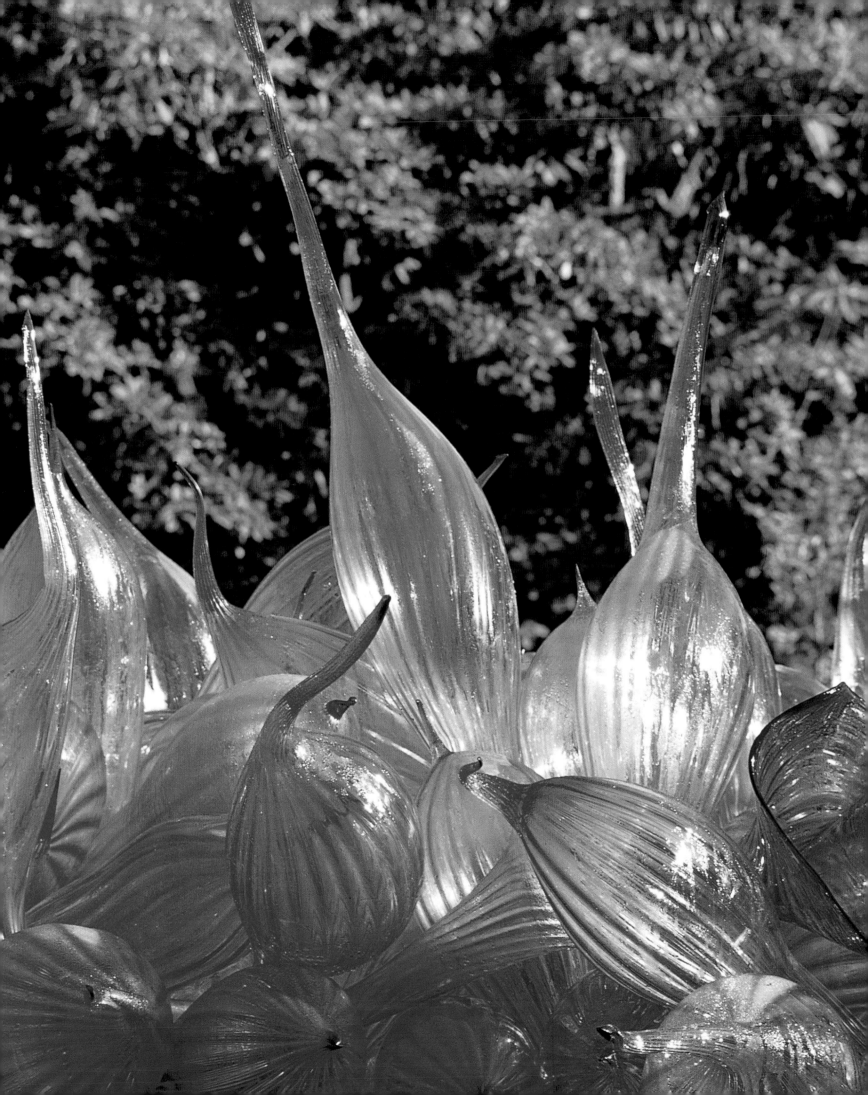

Opposite
Garden Installation, 1995, Lismore
Castle, Ireland

Below
Glass hand blown at Waterford
Crystal and assembled at Lismore
Castle, 1995, Ireland

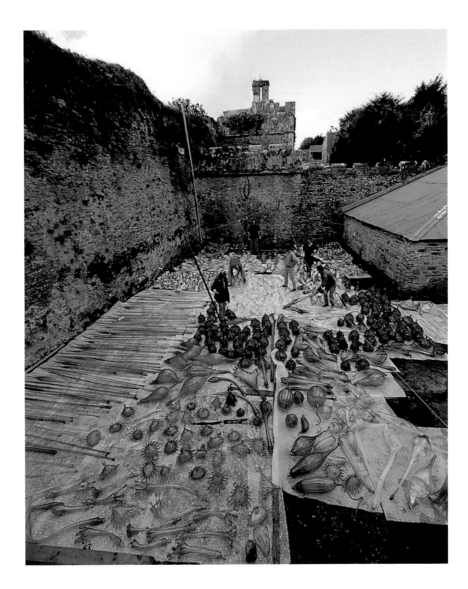

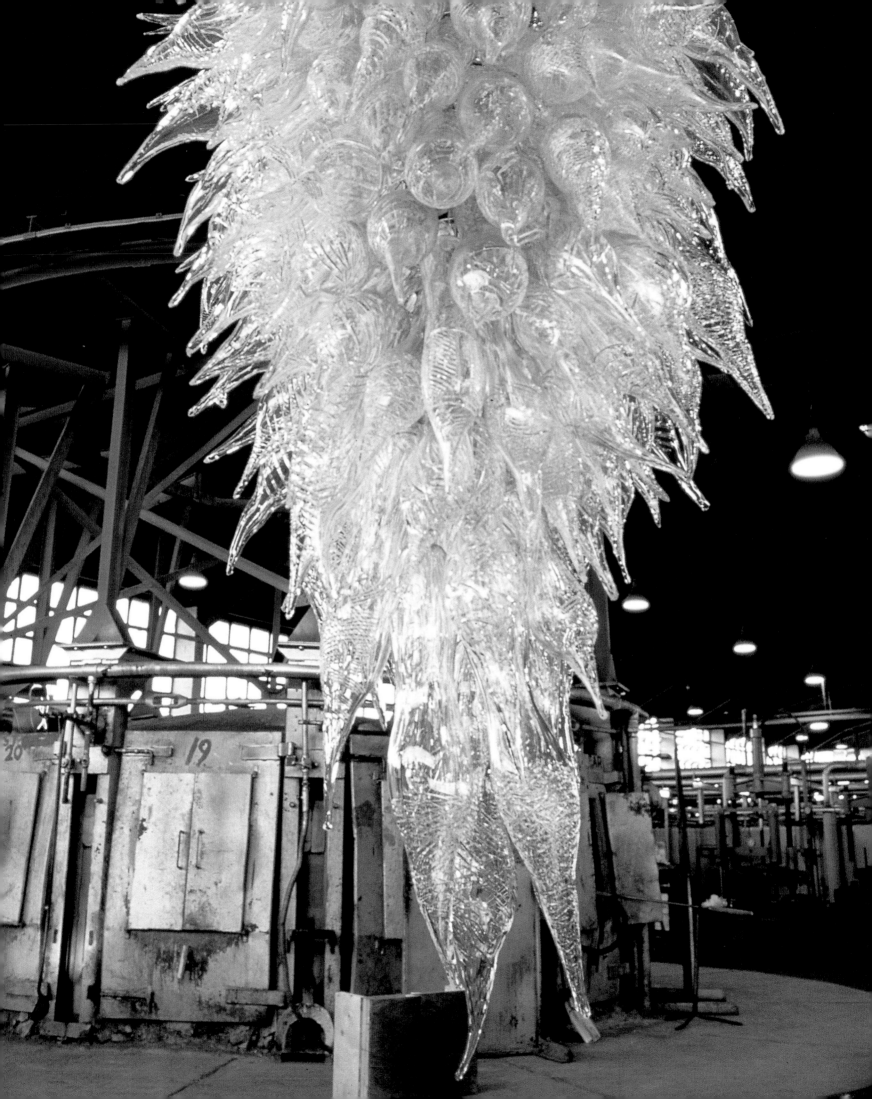

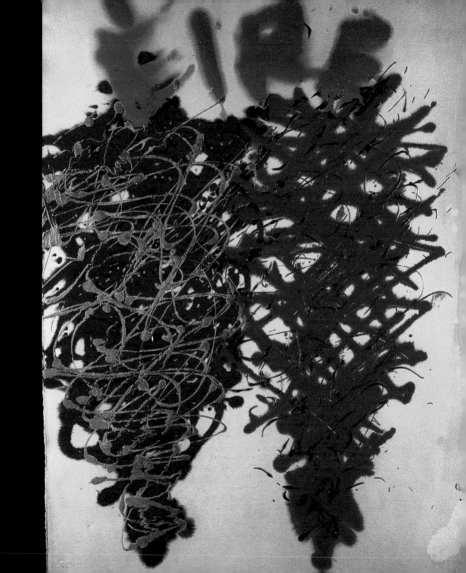

Below
Monterrey Drawing, 1996, acrylic on paper, 41" x 29"

Opposite
Mexican Plaza Chandelier, 1996, 10' x 5', Monterrey, Mexico

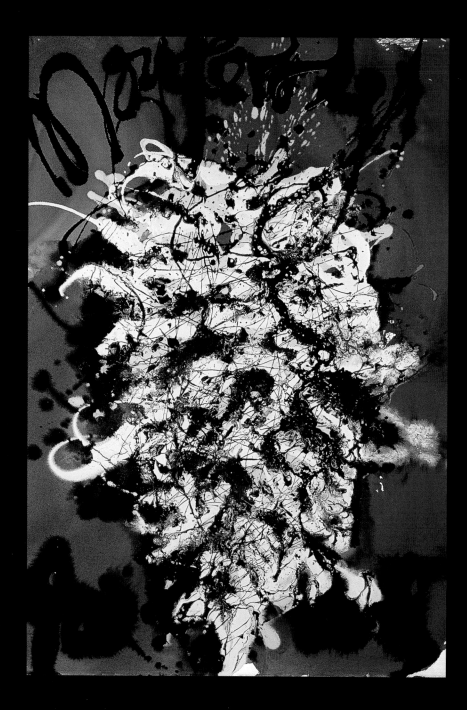

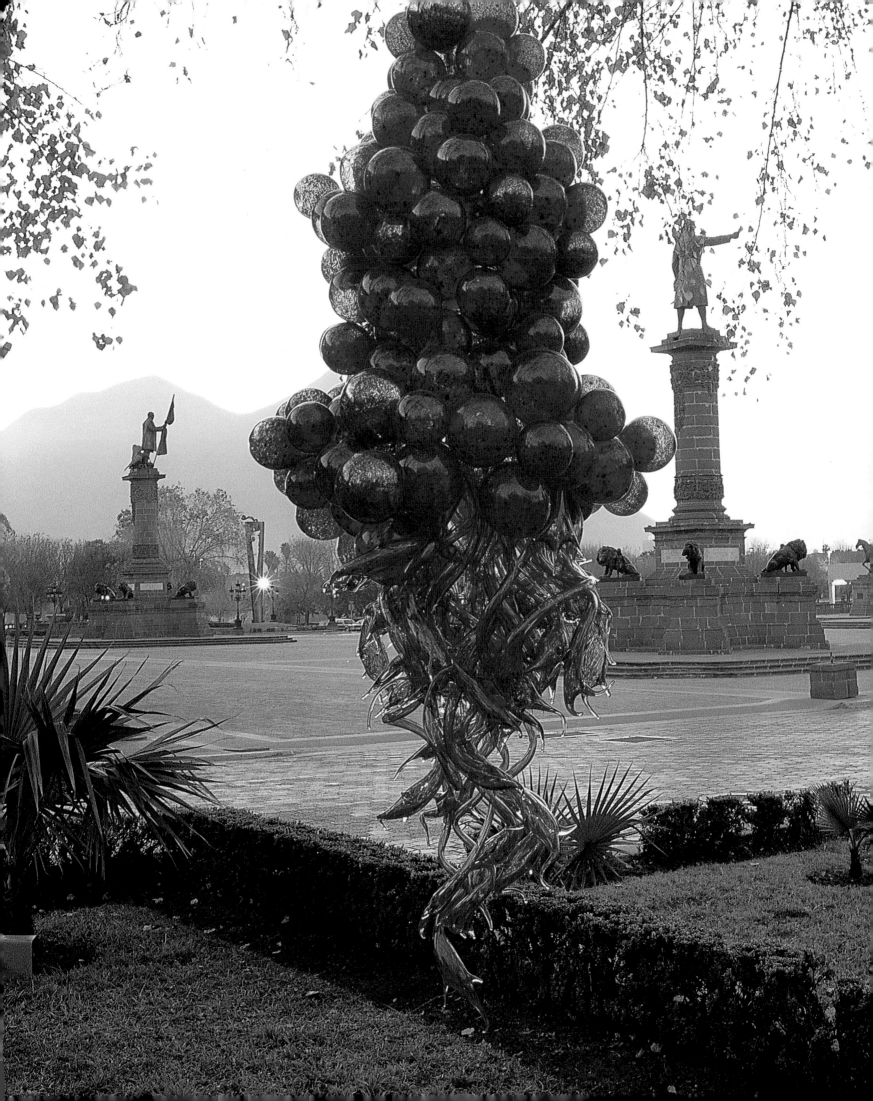

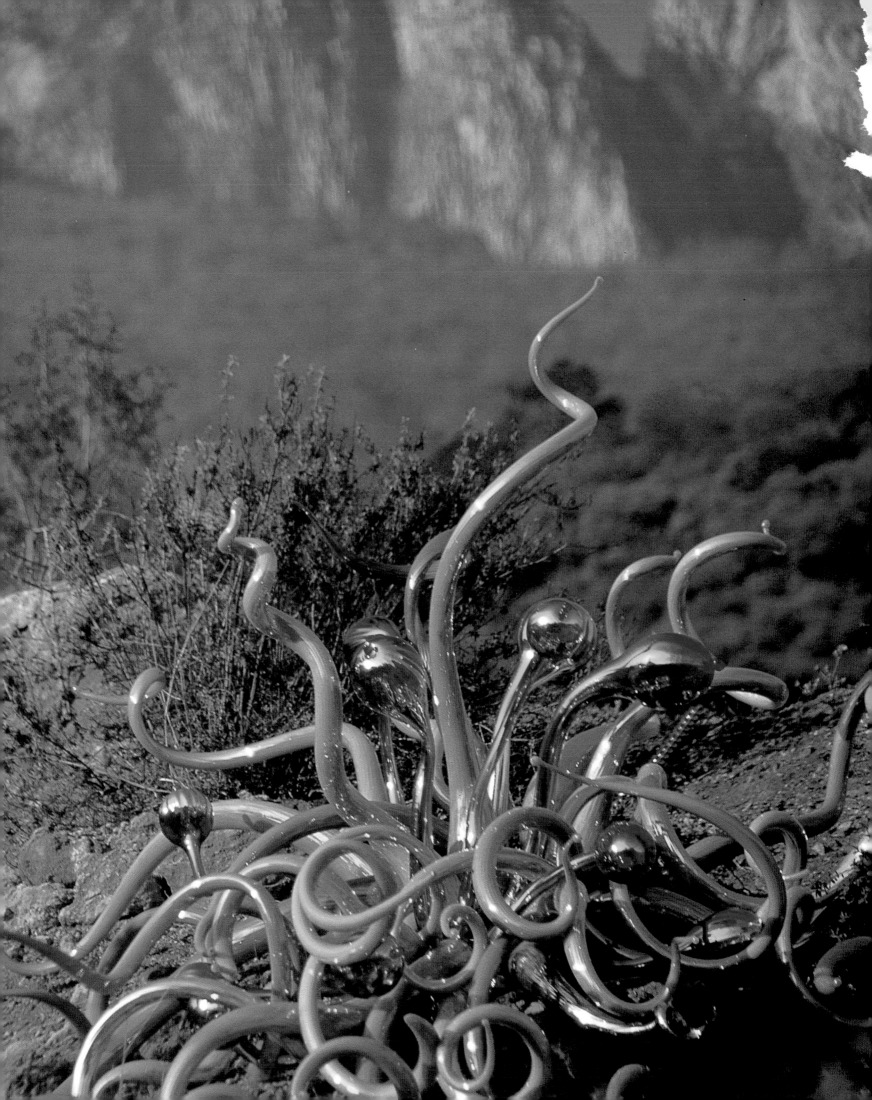

*Opposite and Below
Desert Installation, 1996, Sierra
Madre Mountains, Mexico*

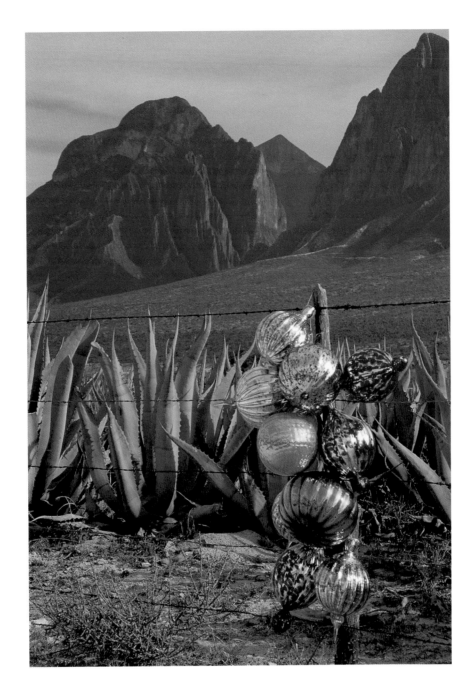

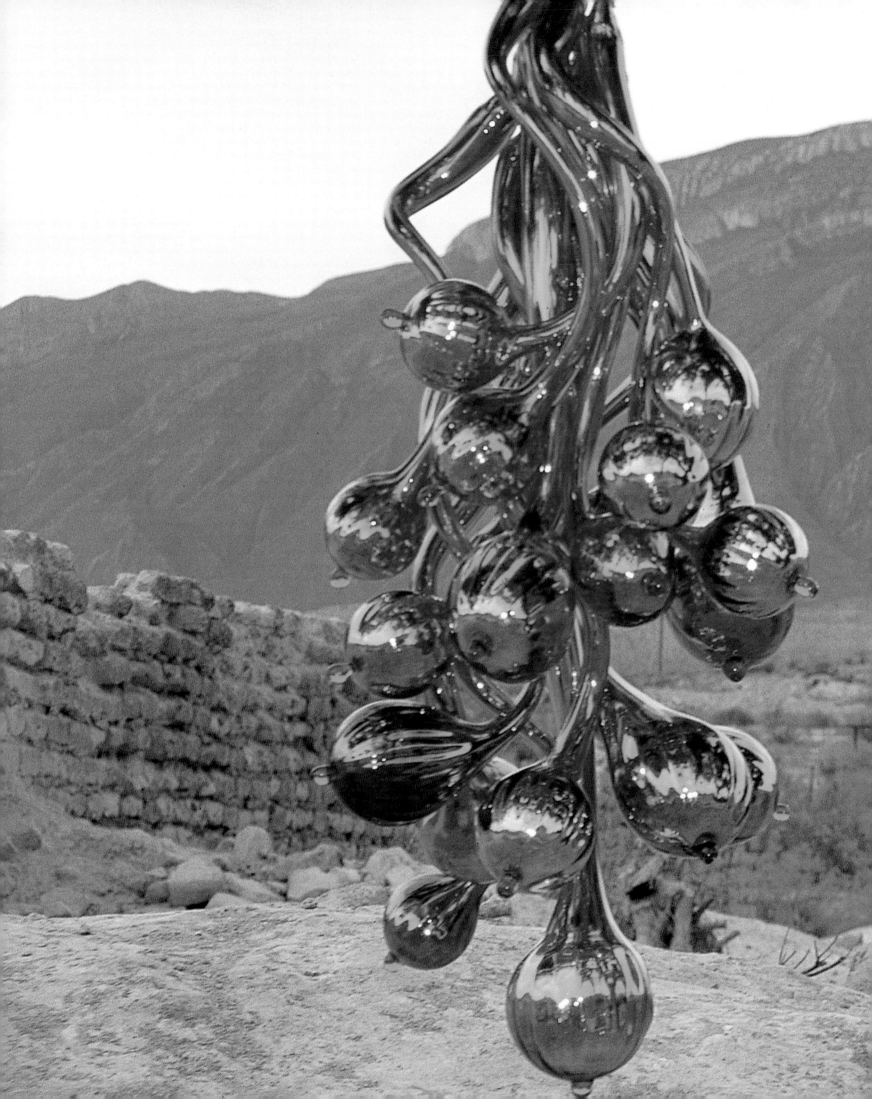

Previous
Mirrored Blue Chandelier, 1996,
7' x 4', Sierra Madre Mountains,
Mexico

Below
Desert Installation, 1996, Sierra
Madre Mountains, Mexico

Opposite
Citron Green Chandelier, 1996,
8' x 5', Vitro Crisa factory,
Monterrey, Mexico

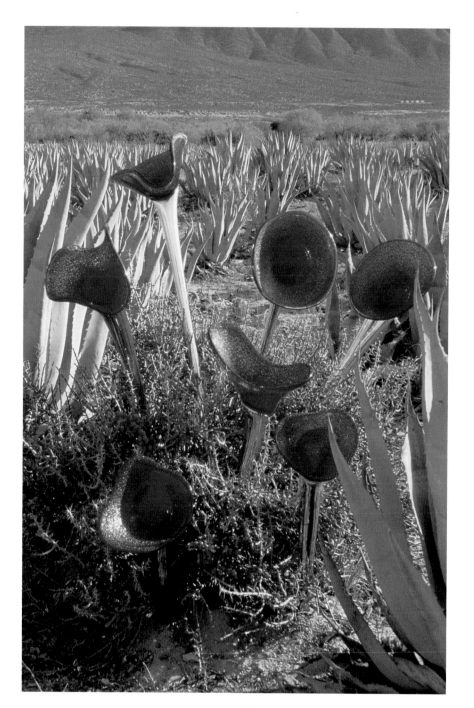

Overleaf
Court Jester Chandelier, 1996, 4' x 3',
Vitro Crisa factory, Monterrey, Mexico

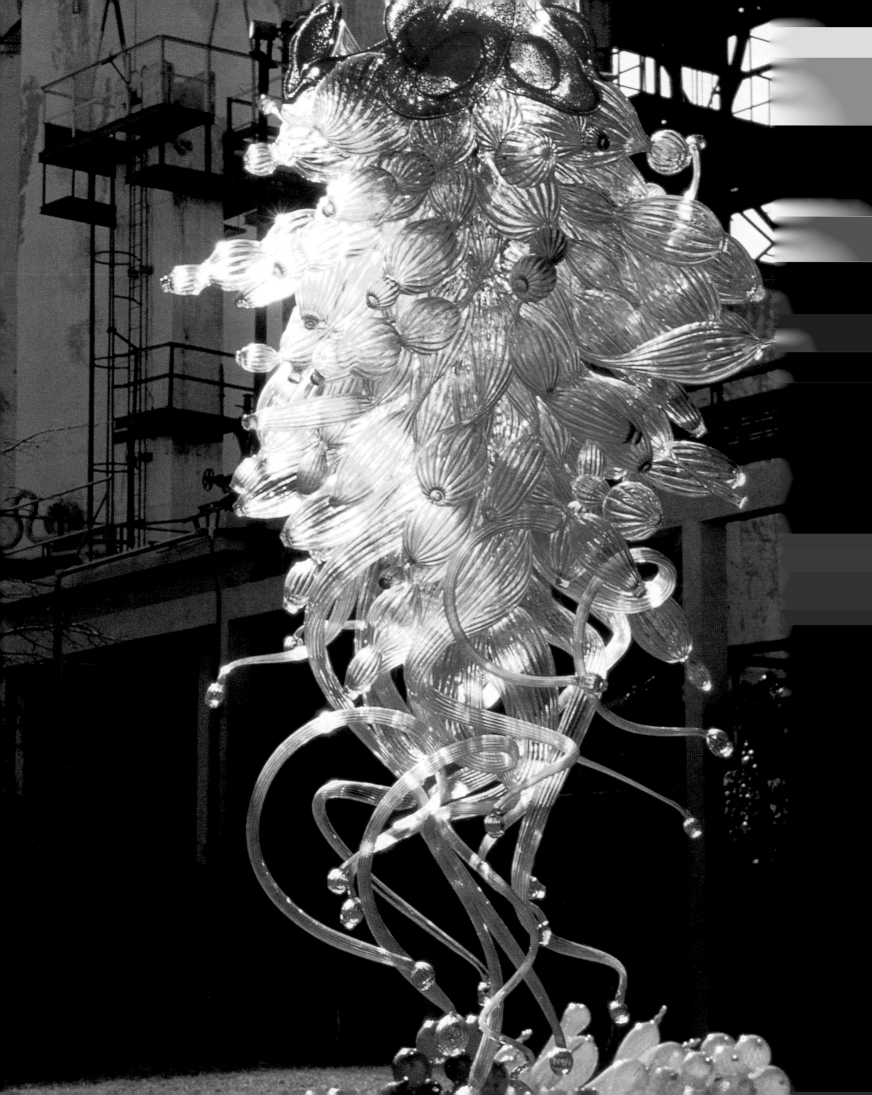

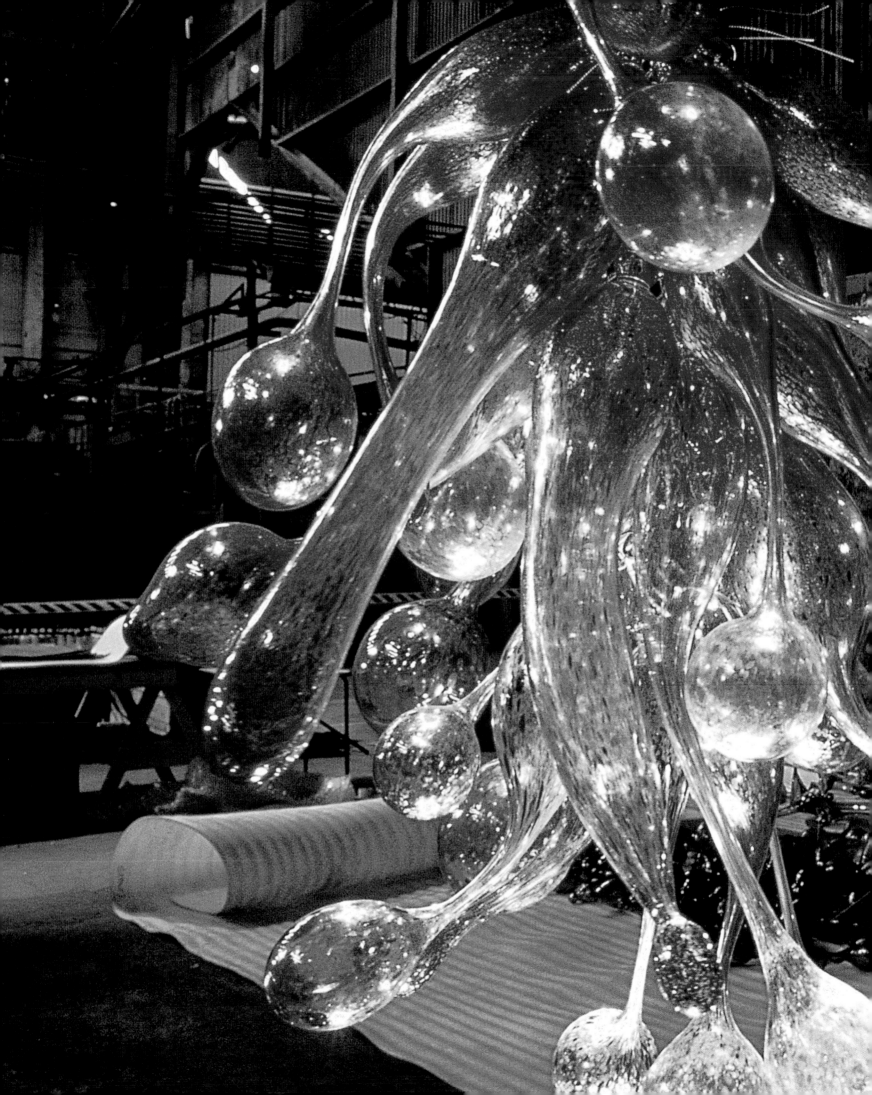

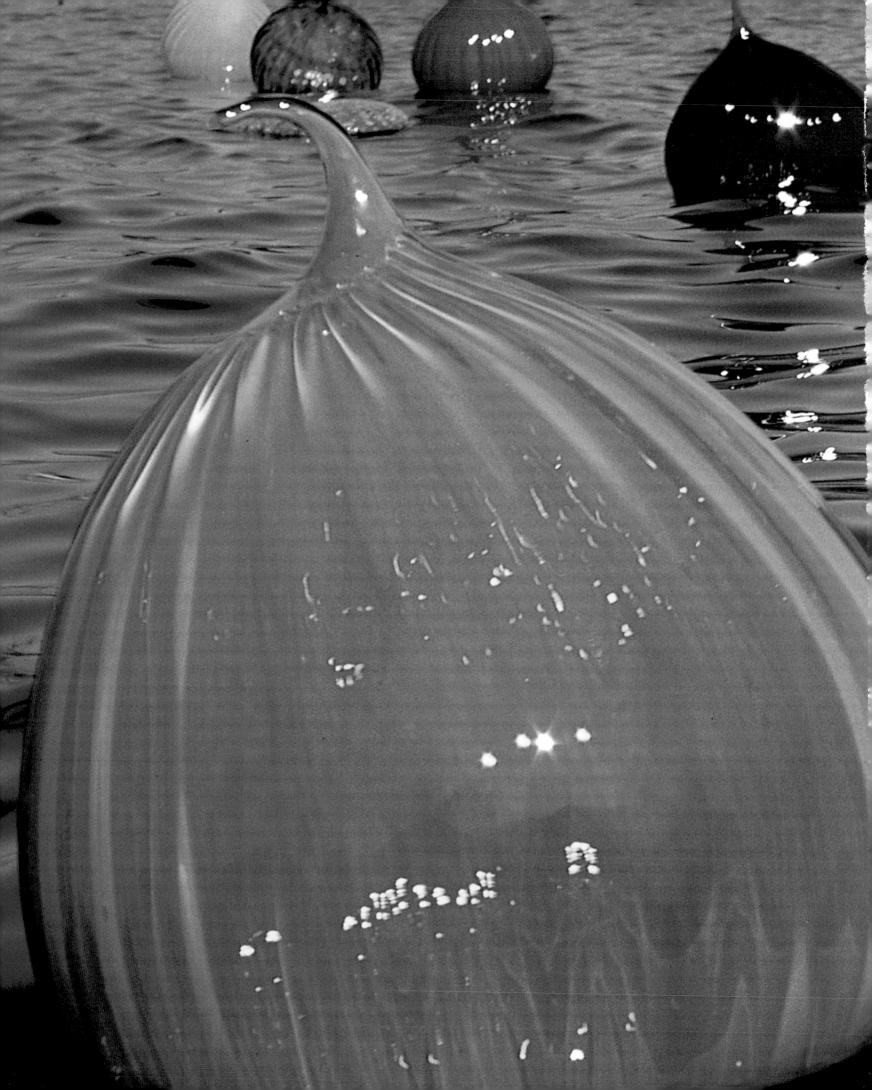

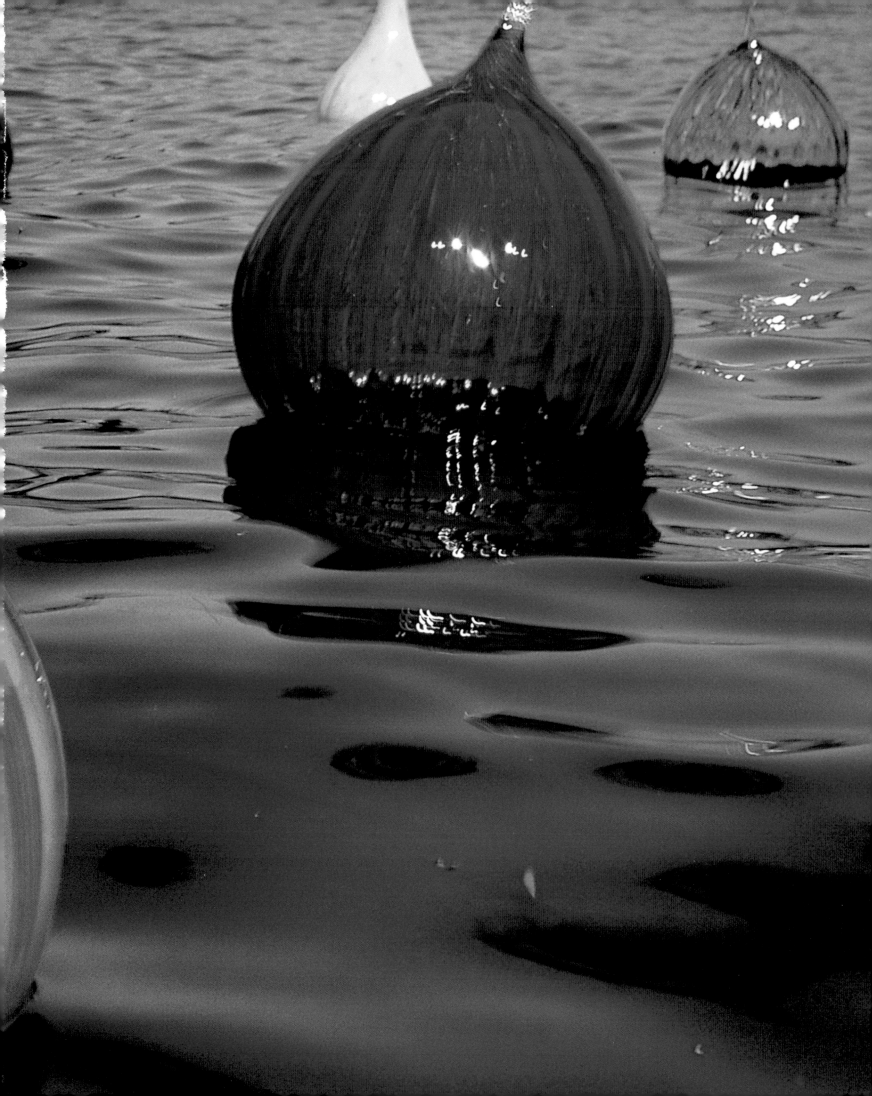

Previous
Walla Wallas, 1996, Lake Washington
Ship Canal, Seattle, Washington

Below
Fax for Chihuly Over Venice
installation, 1996

Opposite
Campo della Salute Chandelier, 1996,
14' x 6', Venice, Italy

Working with a team is good for me—
new people, new ideas, new places.
Chihuly Over Venice started out with
the end in sight—the chandeliers
hanging over canals. But the people
became more important—all the
glassblowers and artisans from
different countries working hand
in hand with all the Americans.
The hanging of the chandeliers
became secondary.
—Dale Chihuly, 1996

Overleaf
Mercato del Pesce di Rialto
Chandelier, 1996, 8' x 5', Venice, Italy

Campiello Remer Chandelier, 1996,
12' x 5', Venice, Italy

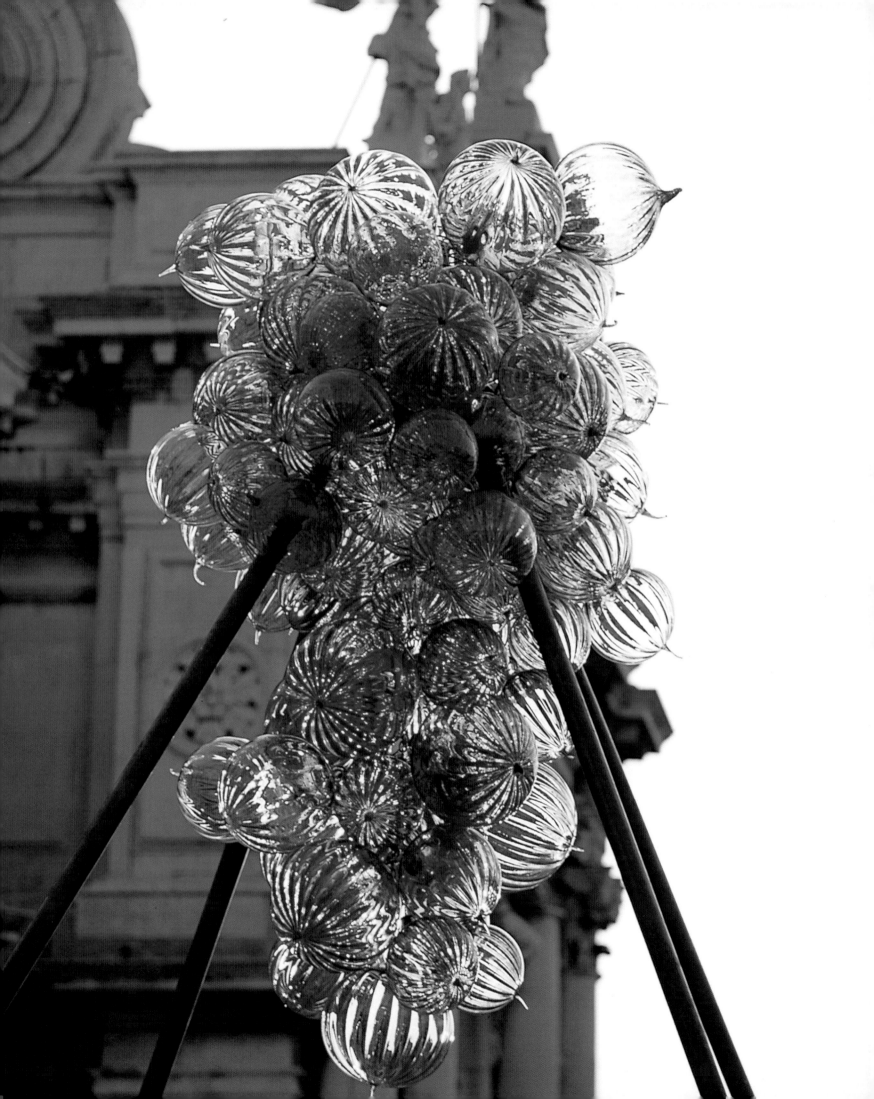

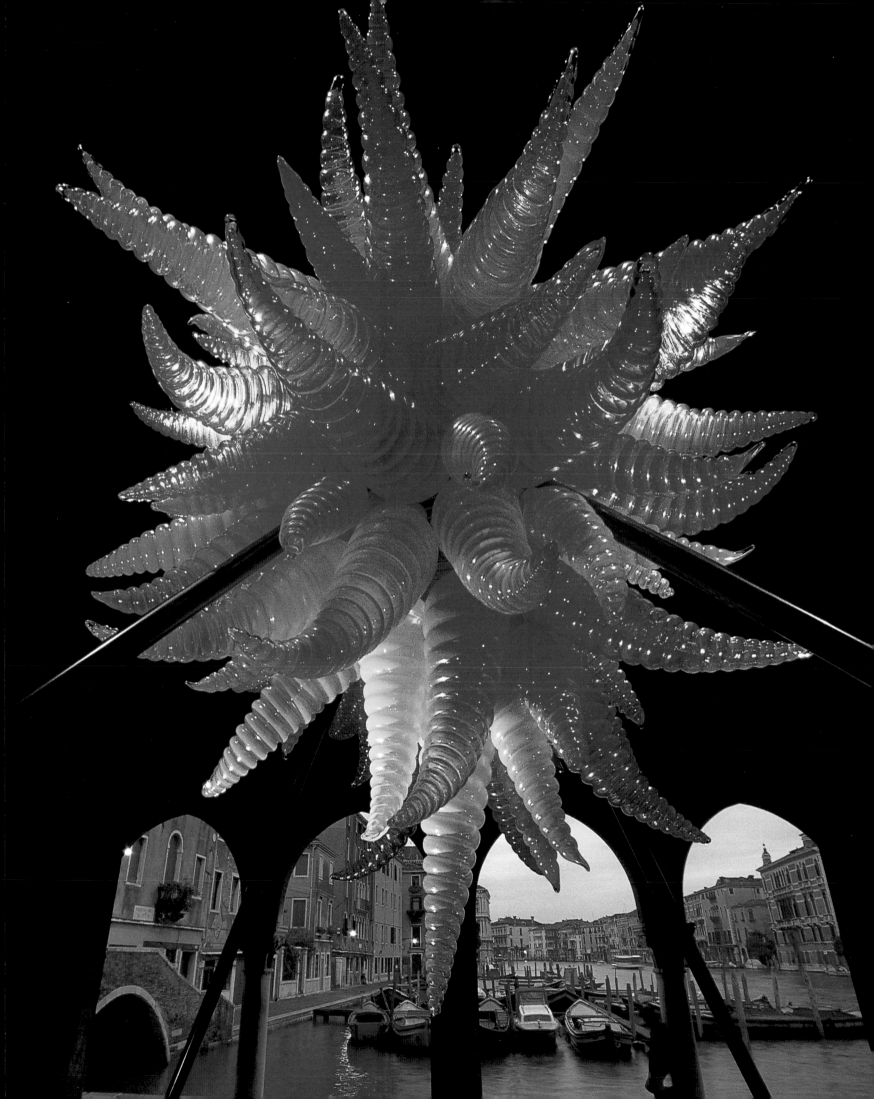

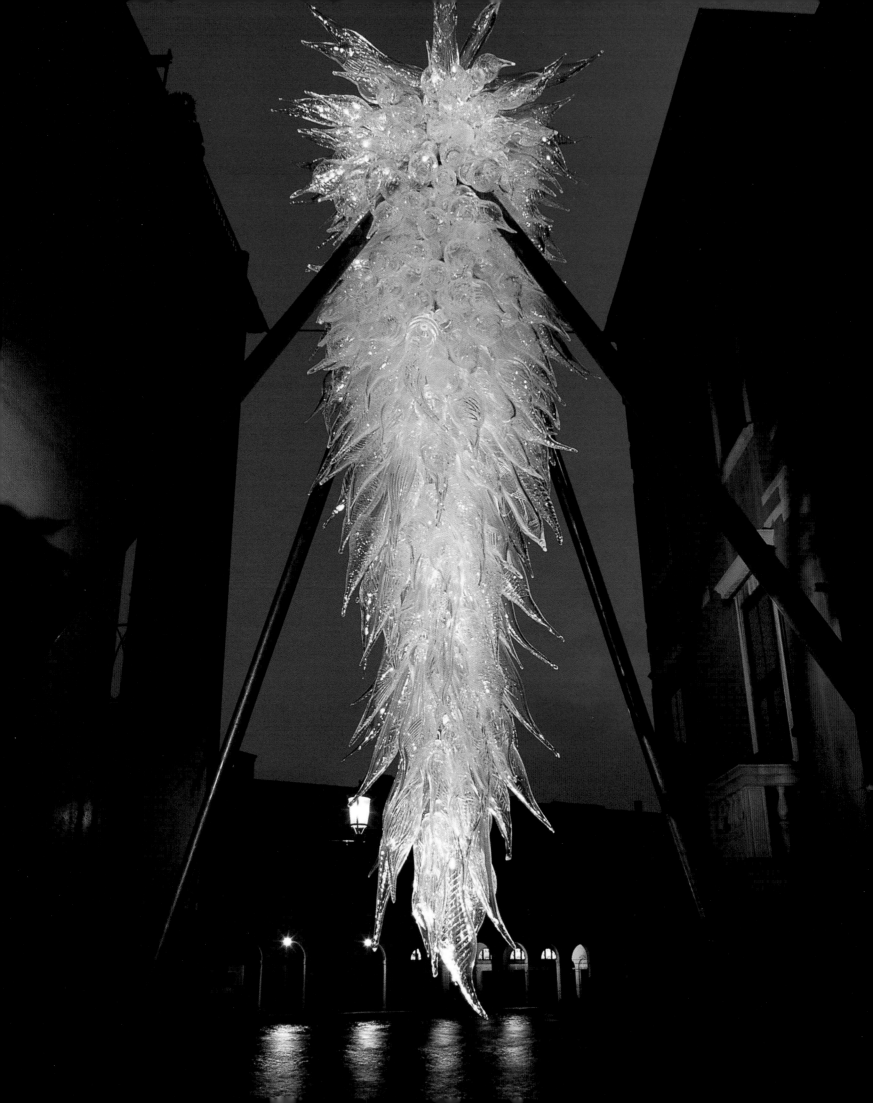

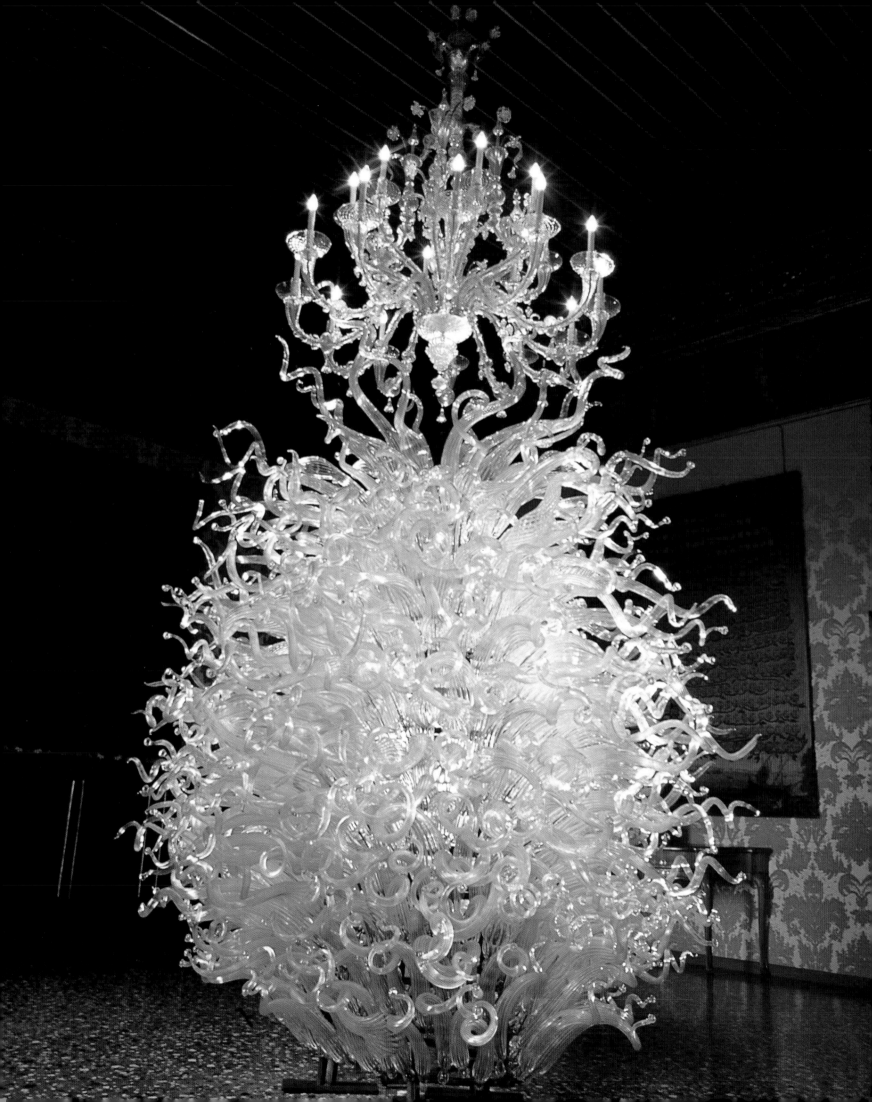

Opposite
Palazzo Ducale Chandelier, 1996,
9' x 8', Venice, Italy

Below
Chiostro di Sant' Apollonia
Chandelier, 1996, 5' x 7', Venice, Italy

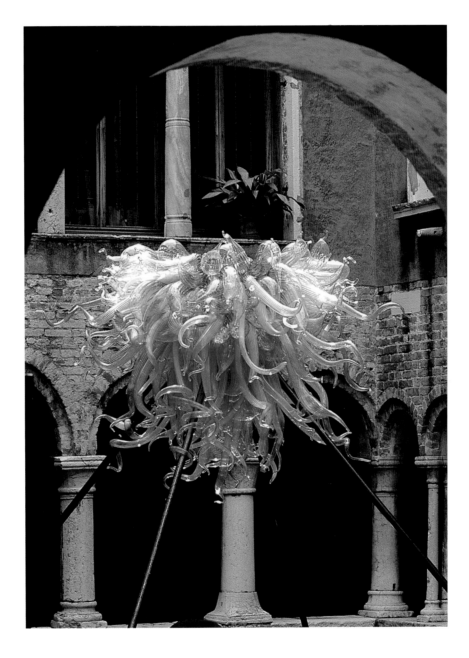

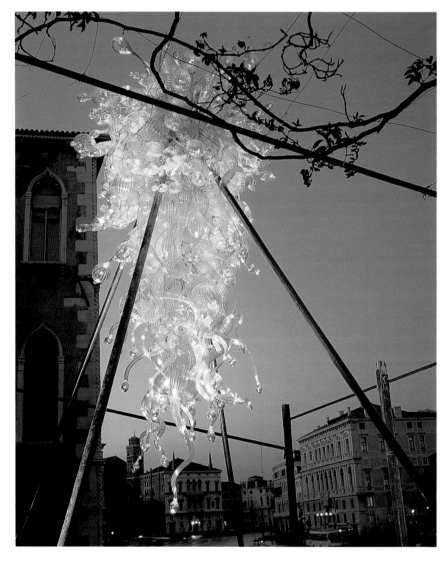

The Chandeliers have an ethereal, other-worldly quality, less like a living being than an astral presence. The primal aesthetic experience of Chihuly's childhood was the almost daily observation of the sunset with his mother. It is perhaps this ethereal, other-worldly sunset quality, which he seeks to capture in his glass.
—Henry Adams, "Dale Chihuly: Thirty Years in Glass: 1966–1996," *1996*

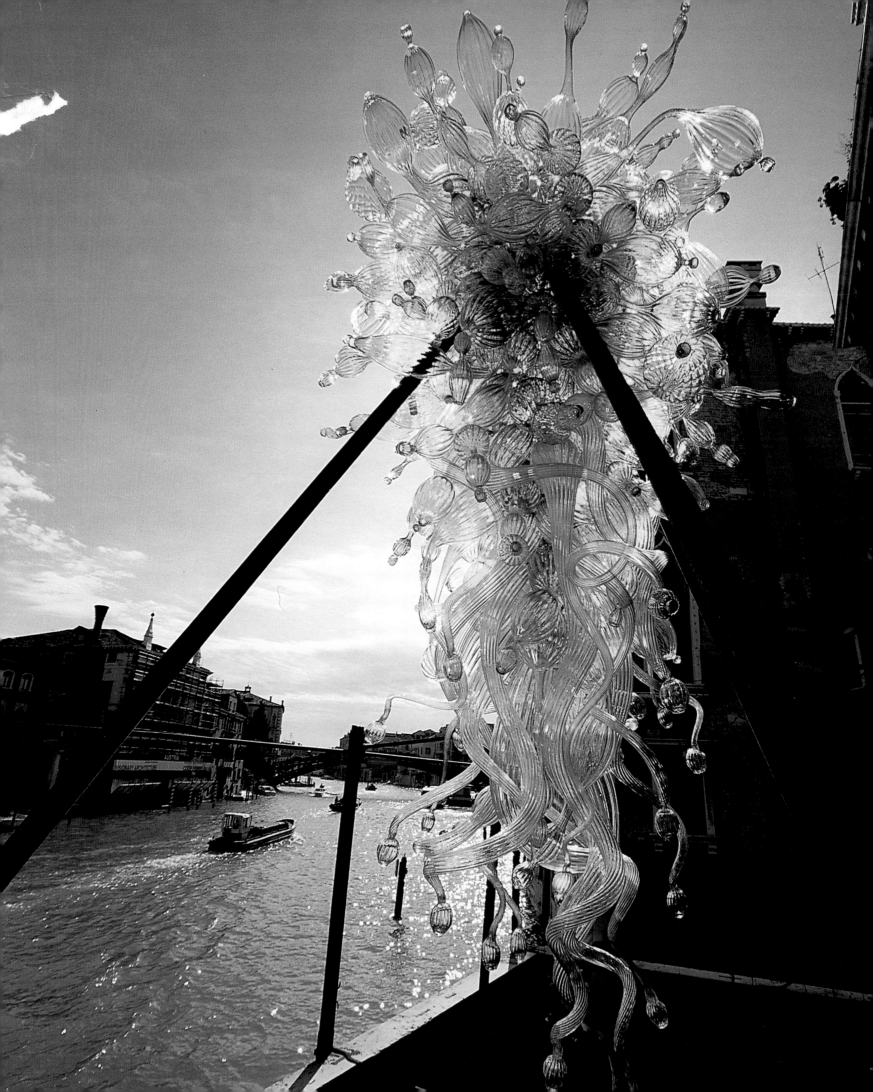

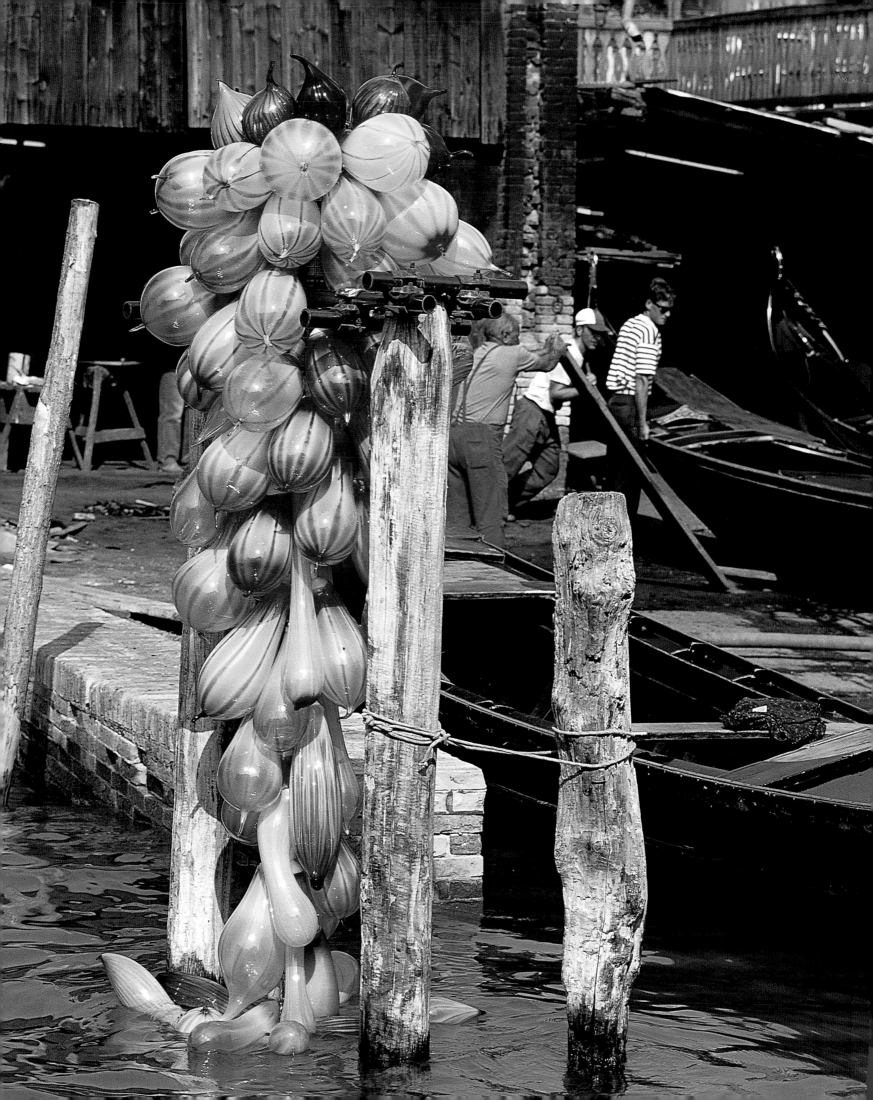

Opposite
Squero di San Trovaso Chandelier,
1996, 10' x 4', Venice, Italy

Below
Isola di San Giacomo in Palude
Chandelier, 1996, 9' x 7', Venice, Italy

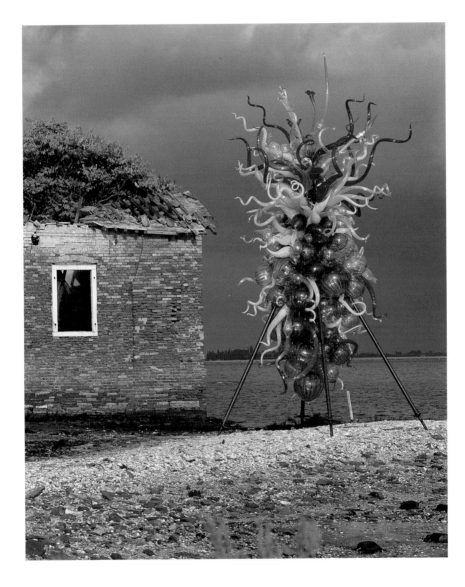

Below
Rio delle Torreselle Chandelier, 1996,
7' x 8', Venice, Italy

Opposite
Giardino Sammartini Chandelier,
1996, 13' x 4', Venice, Italy

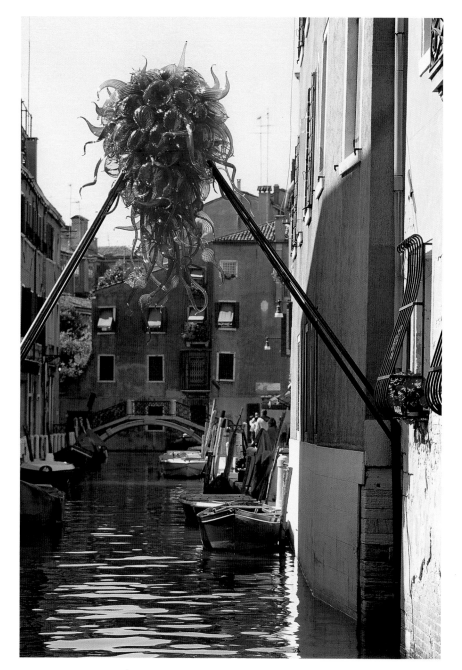

The centerpiece of the affair was a dramatically lit red chandelier rising like a fountain out of the middle of the formal, 17th-century garden. As lavender wafted through the evening air and boats passed back and forth along the canal, it was impossible not to admire the chandelier, which Chihuly's crew had assembled only hours before. . . . At night especially, lit by theatrical lighting designed by his team, many of the chandeliers were extraordinary. Like much of Chihuly's work, they were extravagant, flamboyant and beautiful.
—Robin Updike, *"Venice Under Glass,"* The Seattle Times, *16 September 1996*

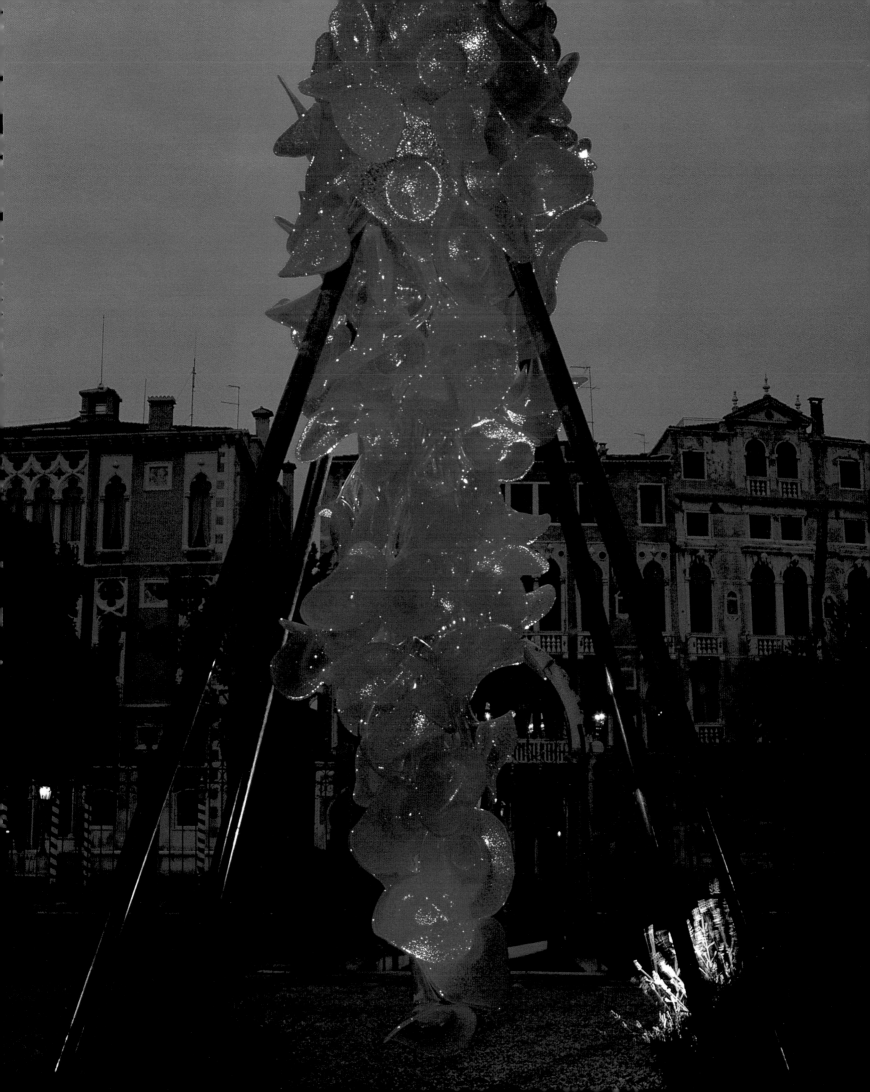

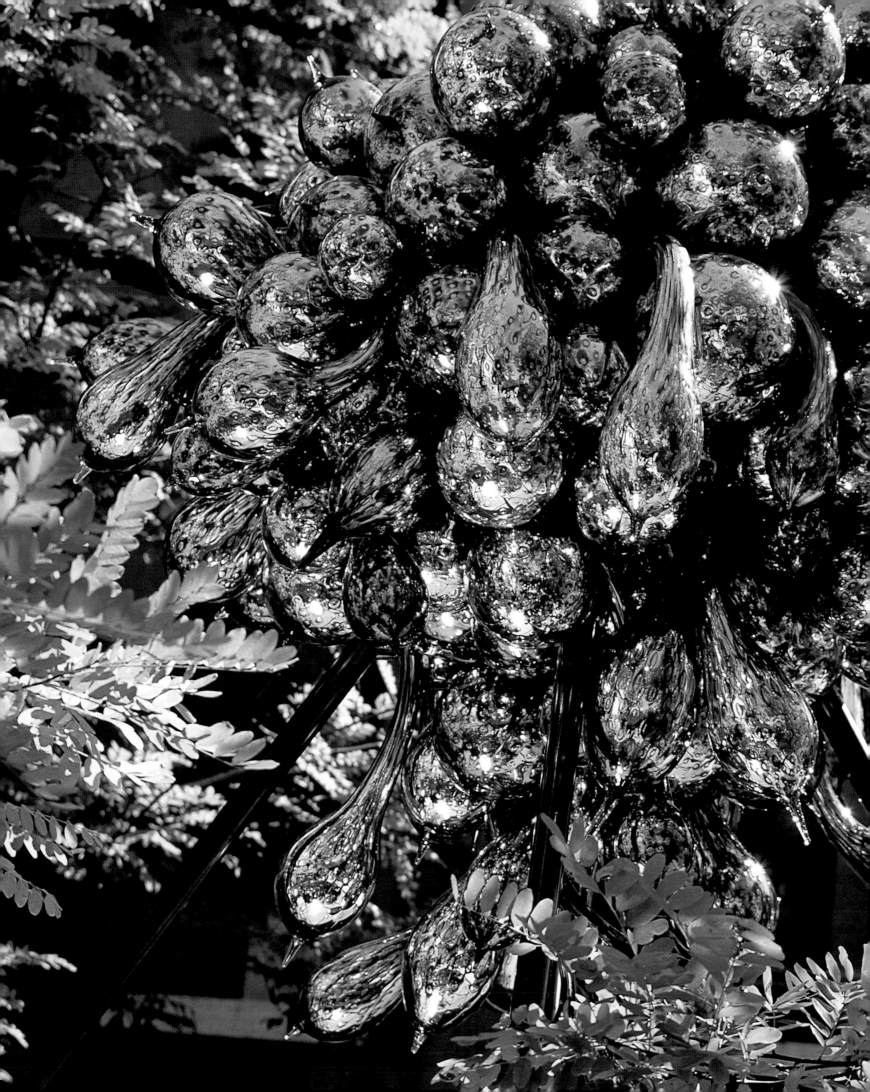

Opposite
Campiello Barbaro Chandelier (detail),
1996, 7' x 6', Venice, Italy

Below
Ponti Duodo e Barbarigo Chandelier,
1996, 11' x 4', Venice, Italy

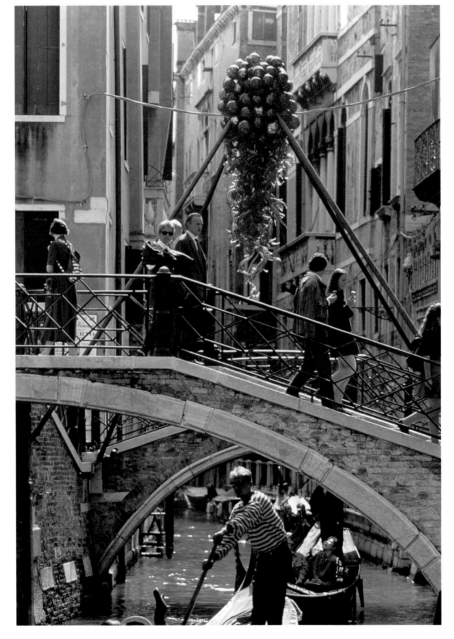

The chandeliers, some weighing as
much as a ton, appear to be galactic
globules of light, flowers from the
heart of a volcano—so gravity-free
one expects them to lift the room in
which they are hung.
—Mary Daniels, "Blown Away,"
Chicago Tribune, *12 January 1997*

Below
Thin Cranberry Chandelier, 1997,
20' x 3', Minneapolis, Minnesota

Opposite
Thin Cobalt and Neodymium
Chandelier, 1995, 15' x 4', Nuutajärvi,
Finland

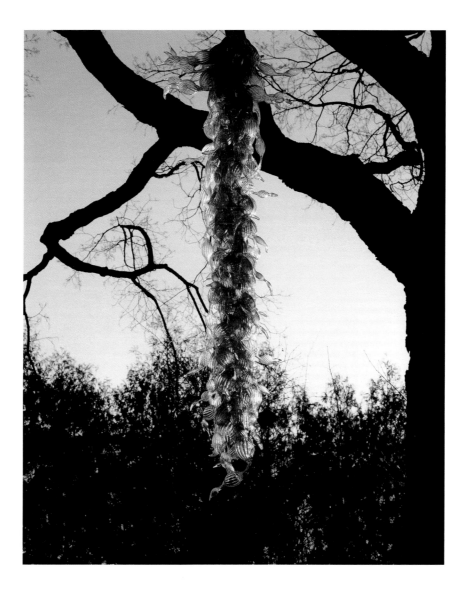

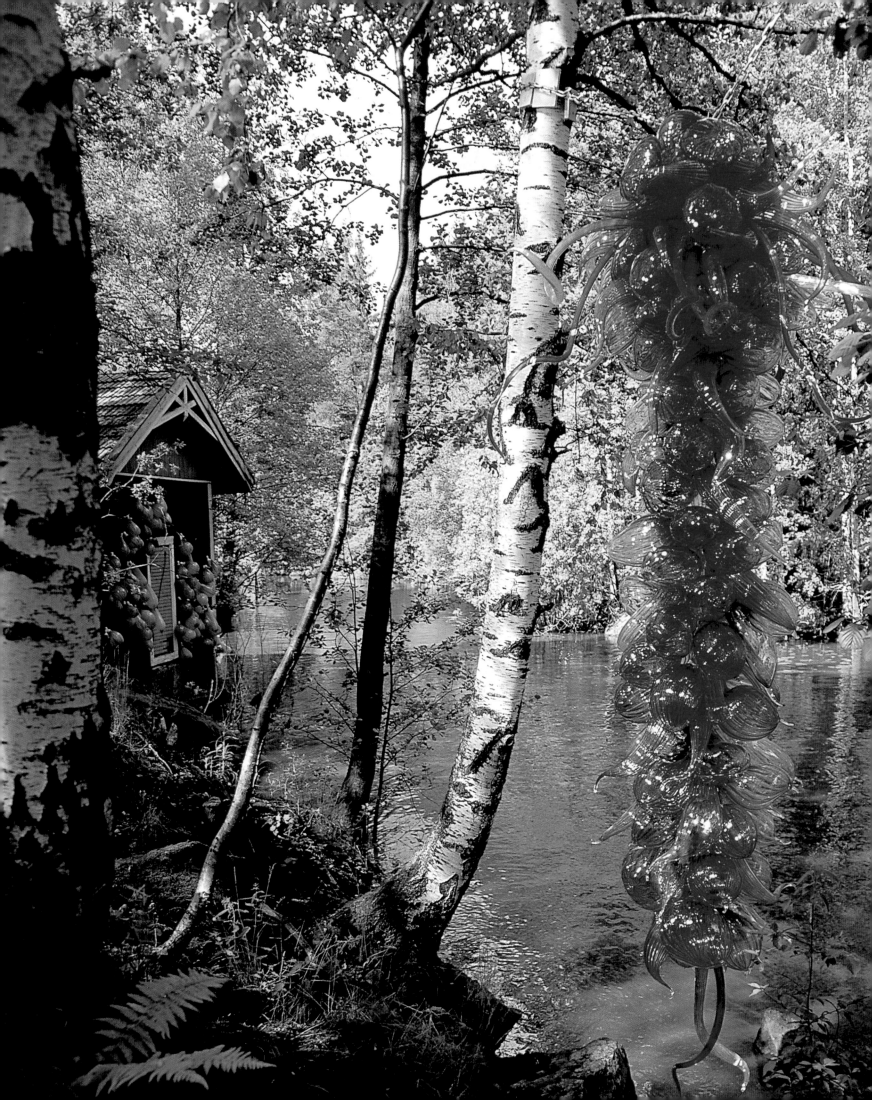

Below
Reed Drawing, 1997, acrylic on paper,
60" x 40", Vianne, France

Opposite
Red Spear Installation, 1997,
Vianne, France

322

Overleaf
Teal Green and Gilded Clear
Chandelier with Sconces, 1997,
New York, New York

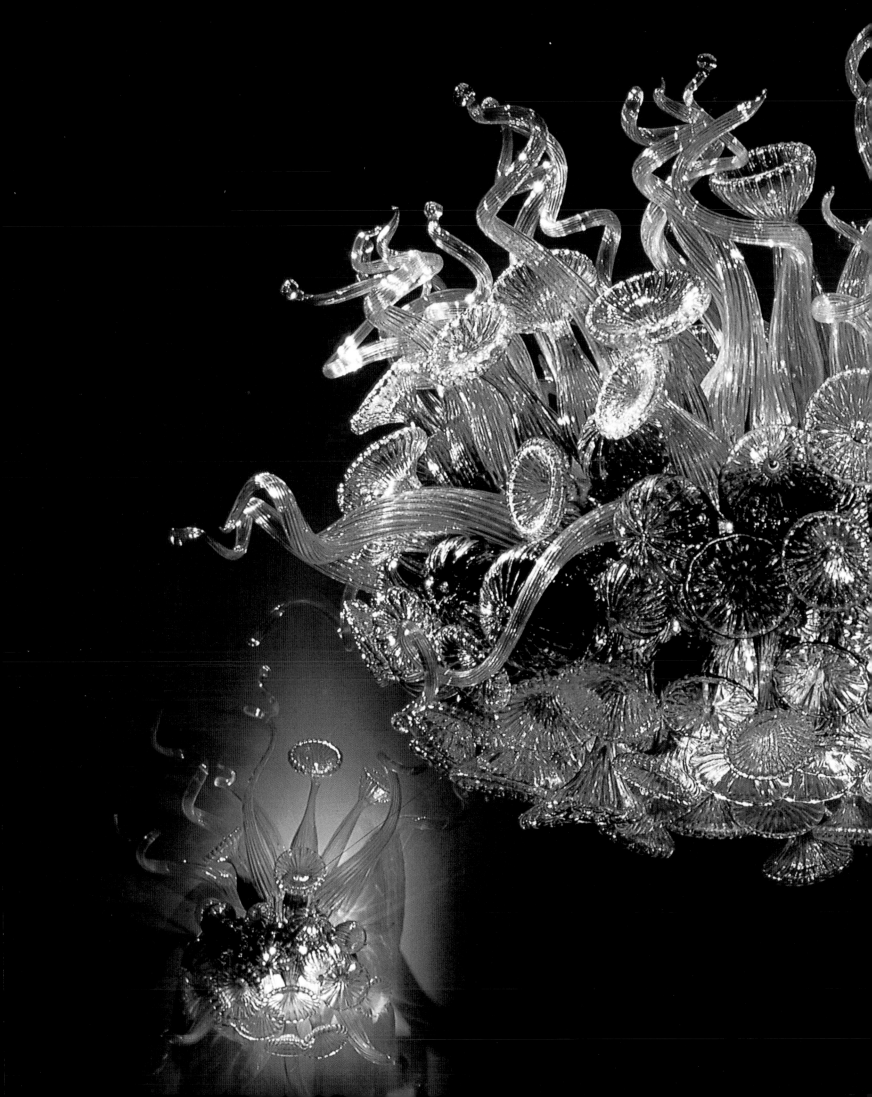

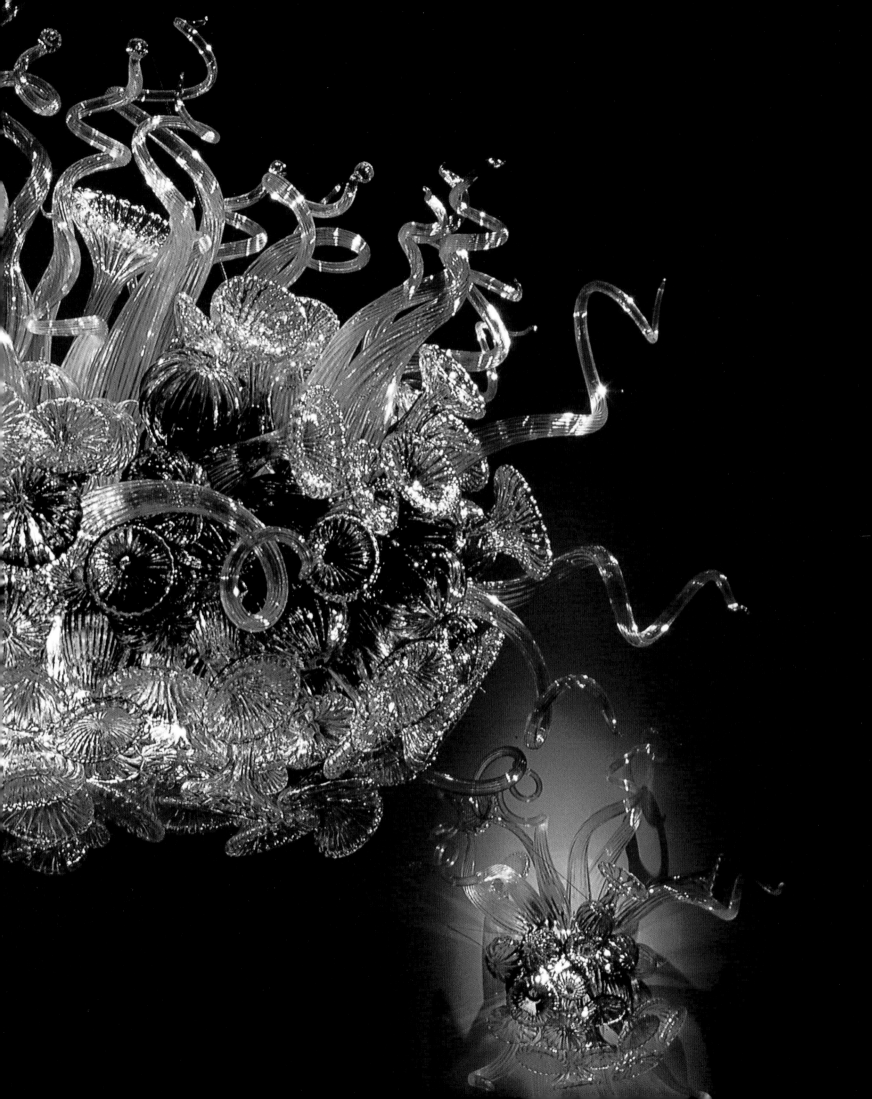

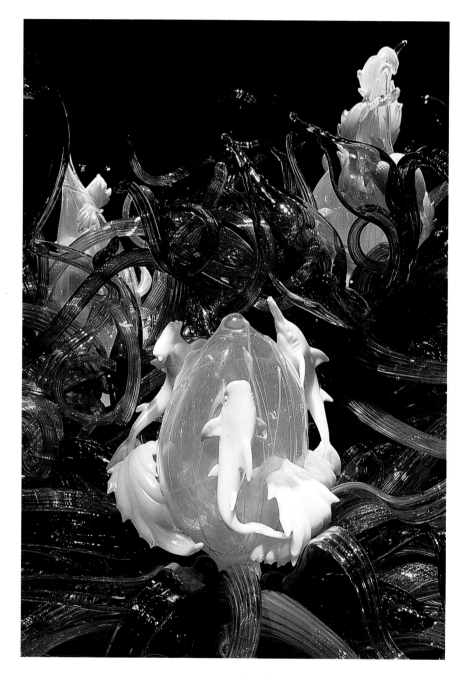

Overleaf
Palazzo Ducale Chandelier, 1996,
Kemper Museum of Contemporary Art
& Design, Kansas City, Missouri

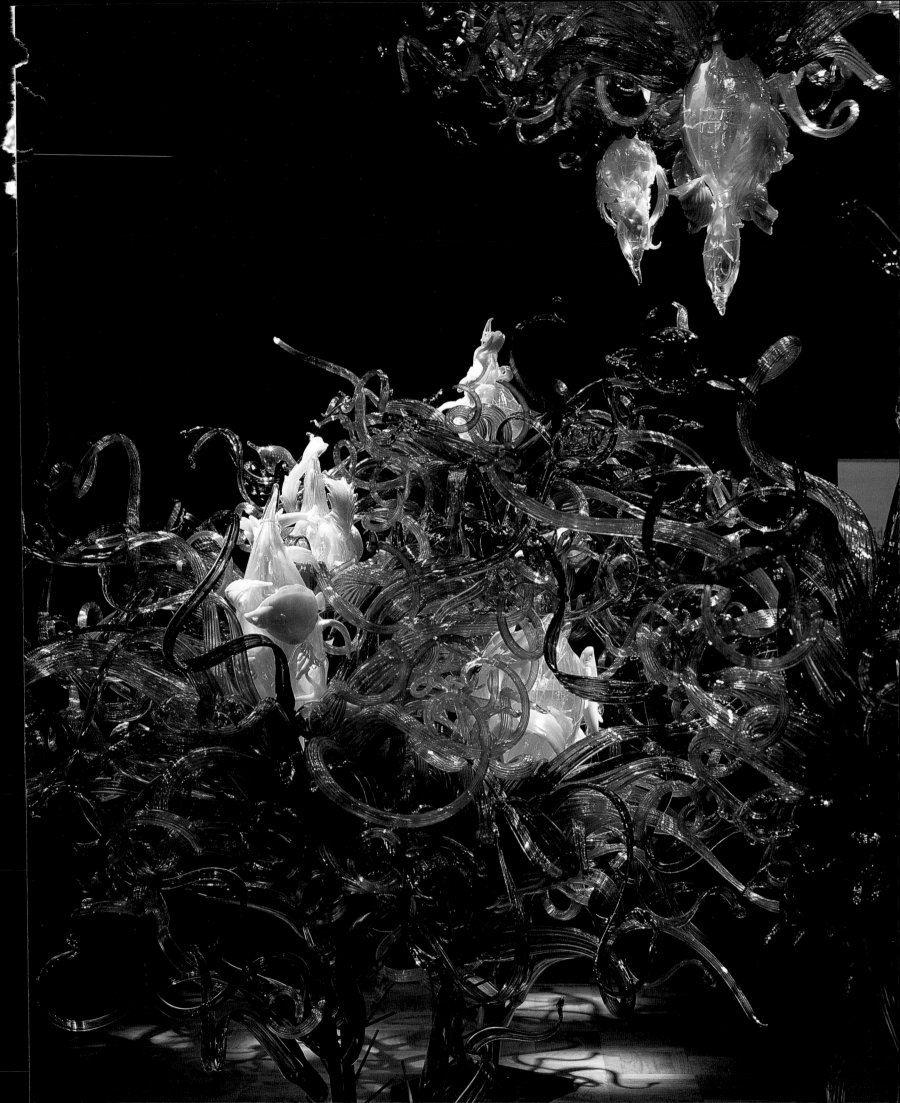

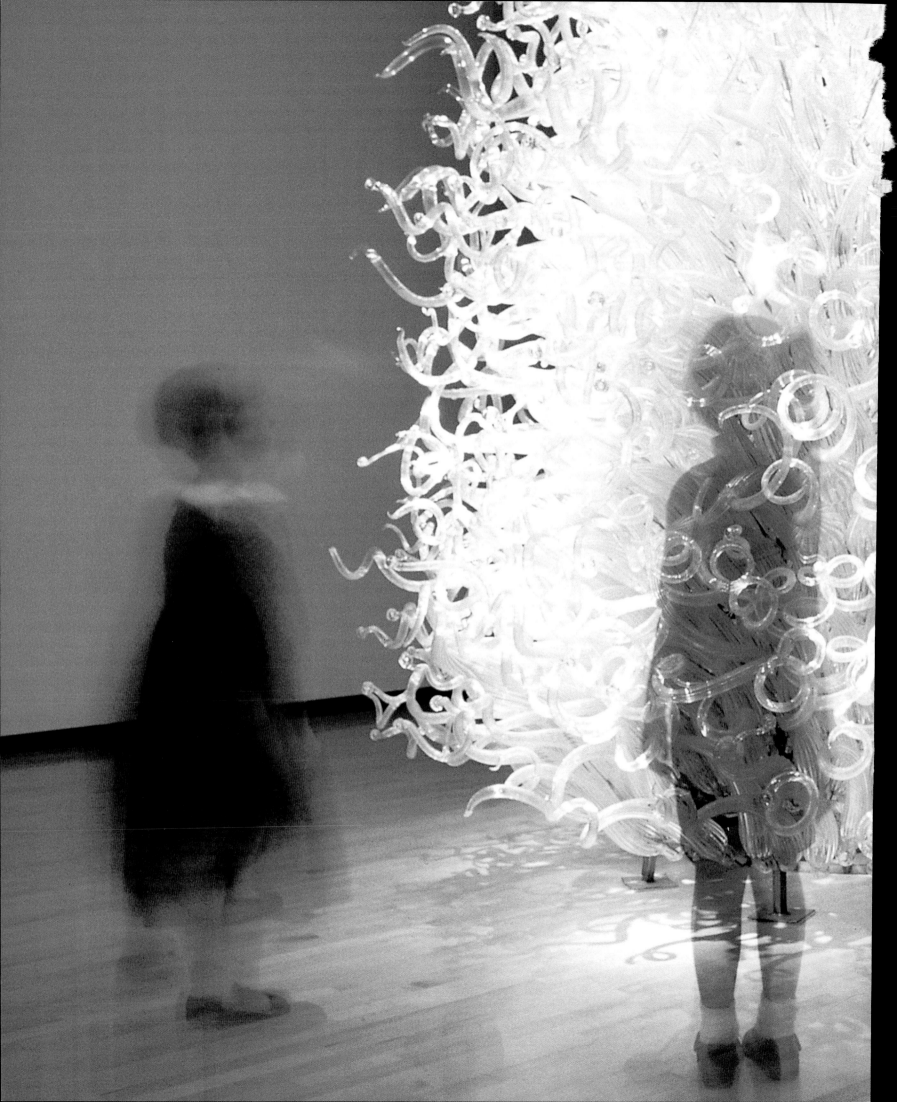

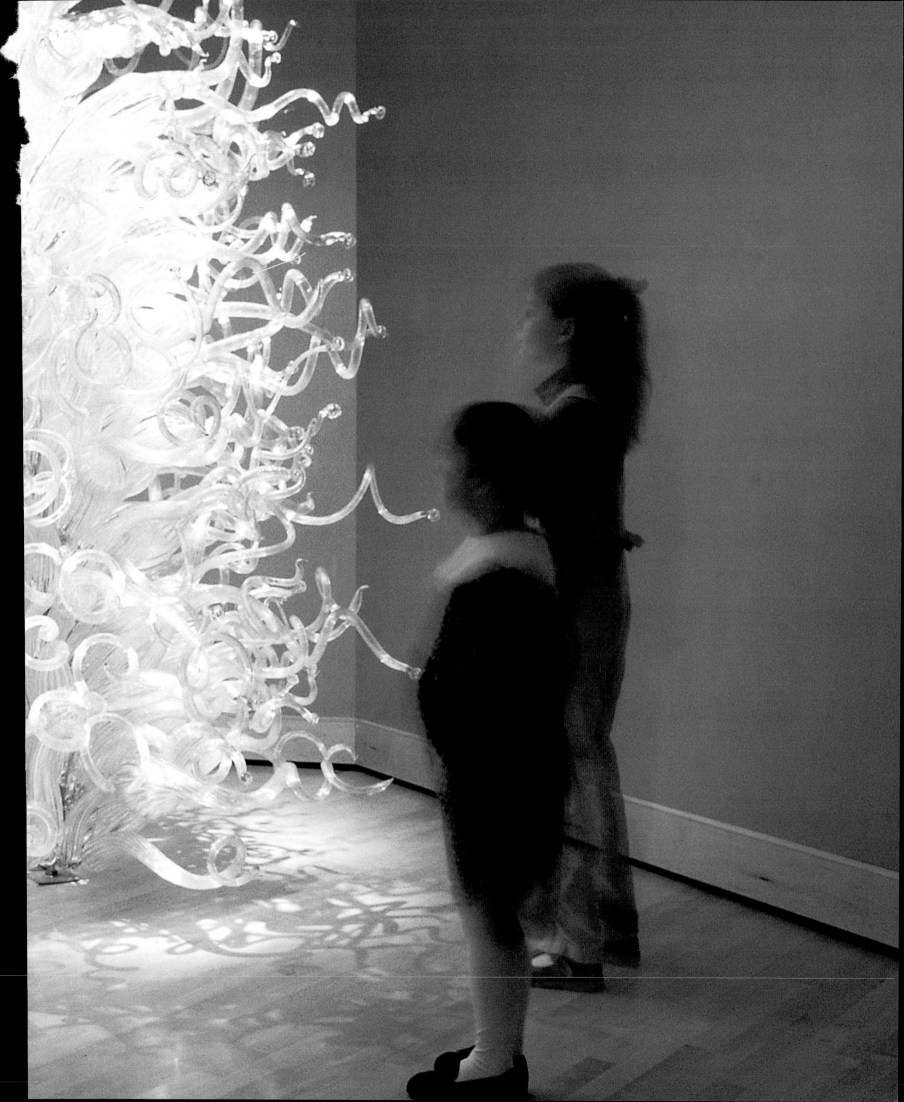

Palazzo Ducale Chandelier, 1997, Hakone Glass Forest, Ukai Museum, Hakone, Japan

Icicle Creek Chandelier, 1996,
12' x 9' x 6', Sleeping Lady Retreat,
Leavenworth, Washington

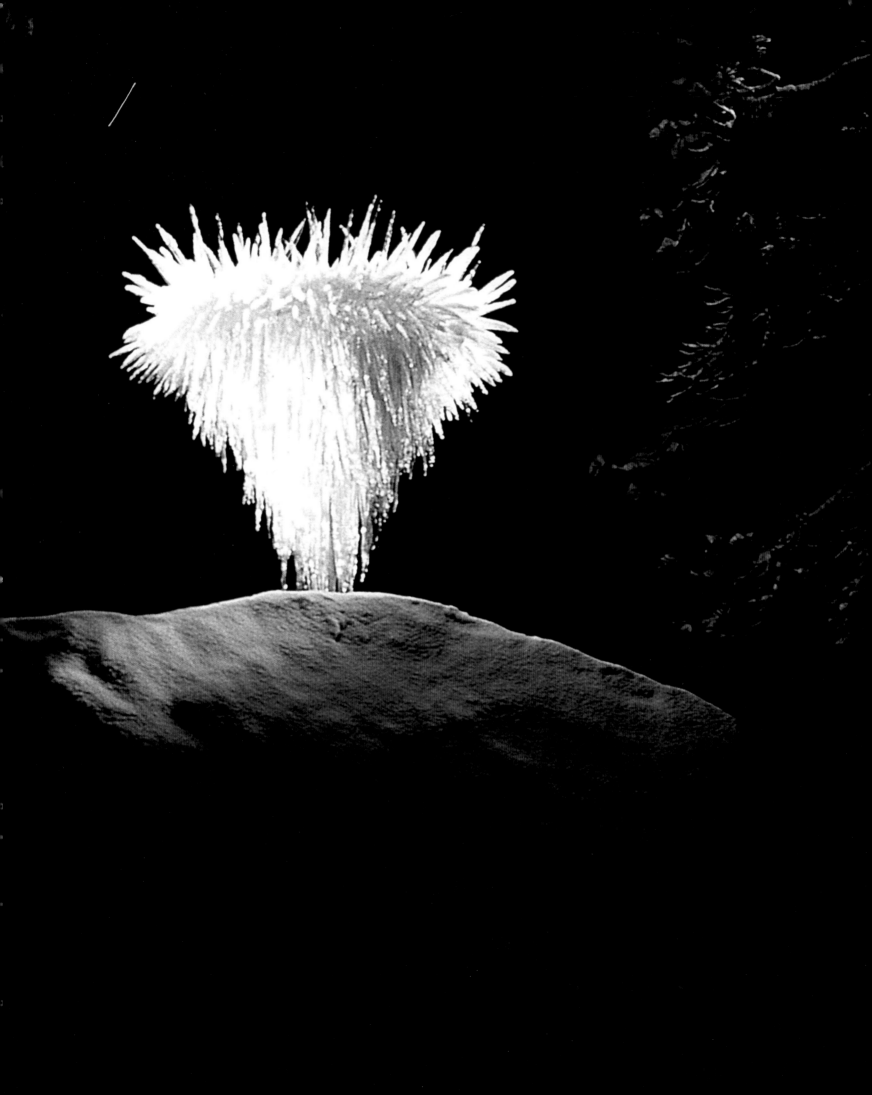

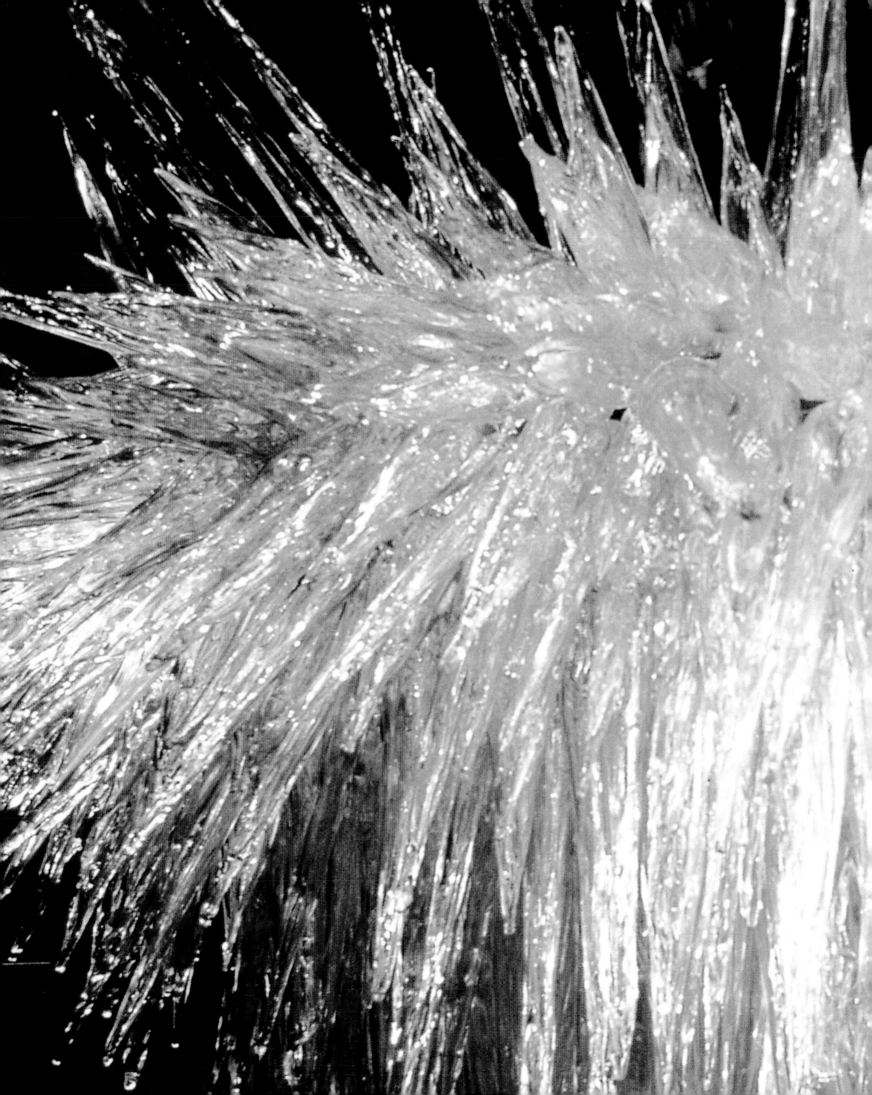

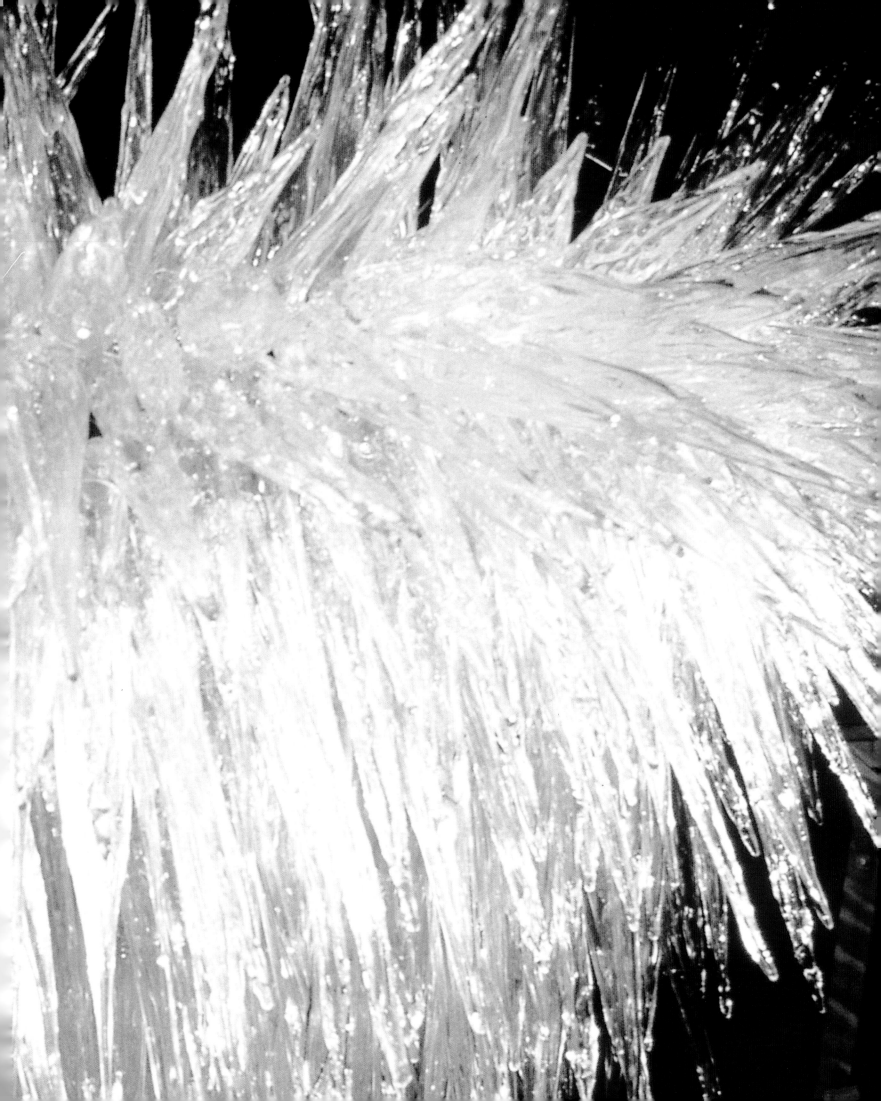

1941	**1957**	**1958**	**1959**

Born September 20 in Tacoma, Washington, to George Chihuly and Viola Magnuson Chihuly. George Chihuly is a butcher by trade and a union organizer. Viola Chihuly is a homemaker and avid gardener. The family's ancestry is predominantly Hungarian, Czech, and Slavic on the Chihuly side and Swedish and Norwegian on the Magnuson side.

Older brother and only sibling, George, is killed in a Navy Air Force training accident in Pensacola, Florida.

His father suffers a fatal heart attack at age 51. His mother goes to work to support herself and Dale.

Graduates from high school in Tacoma. Although he has no interest in pursuing a formal education, his mother persuades him to enroll in the College of Puget Sound (now the University of Puget Sound) in his hometown. Two accomplishments the following year—a term paper on Van Gogh and the remodeling of the recreation room in his mother's home—motivate him to transfer to the University of Washington in Seattle to study interior design and architecture.

Tacoma, 1942

Dale's first known sculpture, "Pig," 1948

Grandfather Chihuly, Dale, and his brother, George, 1948

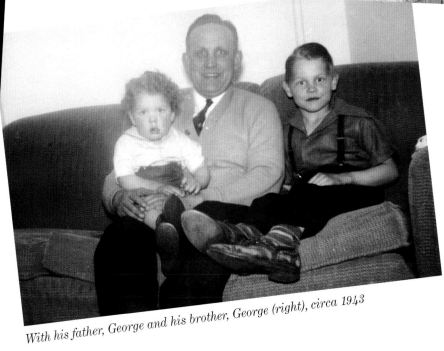

With his father, George and his brother, George (right), circa 1943

Joins Delta Kappa Epsilon fraternity and becomes rush chairman. Learns to melt and fuse glass.

Disillusioned with his studies, he leaves school and travels to Florence to study art. Discouraged by not being able to speak Italian, he travels to the Middle East.

Works on a kibbutz in the Negev Desert. Meets architect Robert Landsman in Jericho, Jordan, and they visit the site of ancient Petra together. Redirected after meeting Landsman and spending a year abroad, he returns to the University of Washington in the College of Arts and Sciences and studies under Hope Foote and Warren Hill. In a weaving class with Doris Brockway, he incorporates glass shards into woven tapestries.

While still a student, receives the Seattle Weavers Guild Award for his innovative use of glass and fiber. Returns to Europe, visits Leningrad, and makes the first of many trips to Ireland.

Viola and George Chihuly, circa 1949

With his mother, Viola, circa 1951

In the Austin Healey inherited from his brother, George, 1957

His father with Bud Klepstein and Toke Semba, 1941

1965	**1966**	**1967**	**1968**

Receives B.A. in Interior Design from the University of Washington and works as a designer for John Graham Architects in Seattle. Introduced to textile designer Jack Lenor Larsen, who becomes a mentor and friend. Experimenting on his own in his basement studio, Chihuly blows his first glass bubble by melting stained glass and using a metal pipe. Awarded Highest Honors from the American Institute of Interior Designers (now ASID).

Works as a commercial fisherman in Alaska to earn money for graduate school. Enters the University of Wisconsin at Madison, on a full scholarship, where he studies glassblowing under Harvey Littleton. It was the first glass program in the United States.

Receives M.S. in Sculpture from the University of Wisconsin. Enrolls at the Rhode Island School of Design (RISD) in Providence, where he begins his exploration of environmental works using neon, argon, and blown glass. Visits the Montreal World Exposition '67 and is inspired by the architectural glass works of Stanislav Libenský and Jaroslava Brychtová at the Czechoslovak pavilion. Awarded a Louis Comfort Tiffany Foundation Grant for work in glass. Italo Scanga, then on the faculty at Pennsylvania State University's Art Department, lectures at RISD, and the two begin a lifelong friendship. They consider themselves brothers.

Receives M.F.A. in Ceramics from RISD. Awarded a Fulbright Fellowship, which enables him to travel and work in Europe. Invited by architect Ludovico de Santillana, son-in-law of Paolo Venini, Chihuly becomes the first American glassblower to work in the Venini factory on the island of Murano. Returns to the United States and spends the first of four consecutive summers teaching at Haystack Mountain School of Crafts in Deer Isle, Maine. There he meets Director Fran Merritt, who becomes a friend and lifetime mentor. Visits "The Block" (Block Island) for the first time, his favorite retreat in the United States.

At the Venini factory on the island of Murano, 1969

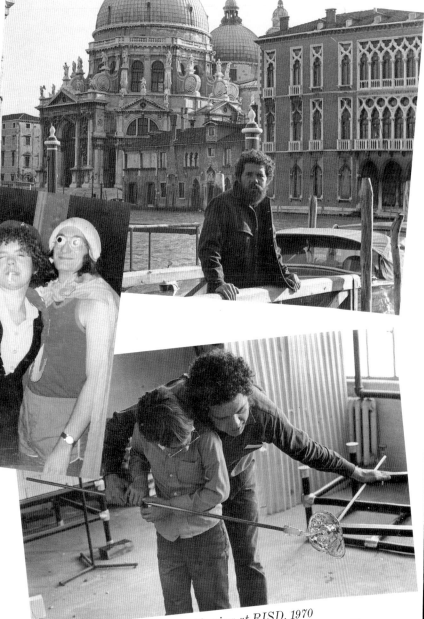

Venice, 1968

At a shooting range with Frannie Hamilton, Italy, 1969

Teaching Art Wood's son glassblowing at RISD, 1970
Middle: With Paul Inveen and Louis Mueller, Providence, 1970

1969	1970	1971	1972

Travels again, this time with his mother, throughout Europe, visiting relatives in Sweden and making pilgrimages to meet glass masters Erwin Eisch in Germany and Jaroslava Brychtová and Stanislav Libenský in Czechoslovakia. Returning to the United States, Chihuly establishes the glass program at RISD, where he teaches full time for the next eleven years. Students include Hank Adams, Howard Ben Tré, James Carpenter, Dan Dailey, Michael Glancy, Roni Horn, Flora Mace, Mark McDonnell, Benjamin Moore, Pike Powers, Michael Scheiner, Paul Seide, Therman Statom, Steve Weinberg, and Toots Zynsky.

Chihuly and friends shut down RISD in protests over the Cambodian offensive. During the strike, Chihuly and student John Landon develop ideas for an alternative school in the Pacific Northwest, inspired by Haystack Mountain School of Crafts. Meets artist Buster Simpson, who later works with Chihuly and Landon at the school. Meets James Carpenter, a student in the illustration department, and they begin a four-year collaboration.

On the site of a tree farm donated by Seattle art patrons Anne Gould Hauberg and John Hauberg, the Pilchuck Glass School is created. A $2,000 grant to Chihuly and Ruth Tamura from the Union of Independent Colleges of Art and additional funding from the Haubergs provide seed money for this innovative new school. From this modest beginning, Pilchuck Glass School becomes an institution that will have a profound impact on artists working in glass worldwide. Chihuly's first environmental installation at Pilchuck is created that summer. In the fall he resumes teaching at RISD and creates "20,000 Pounds of Ice and Neon," "Glass Forest #1," and "Glass Forest #2" with James Carpenter, installations that prefigure later environmental works by Chihuly.

While he is at Pilchuck, his studio on Hobart Street in Providence burns down. Returns to Venice with Carpenter to blow glass for the "Glas heute" exhibition at the Museum Bellerive, Zurich, Switzerland. He and Carpenter continue to collaborate on large-scale architectural projects, and, confining themselves to the use of static architectural structures, they create "Rondel Door" and "Cast Glass Door" at Pilchuck. Back in Providence, they create "Dry Ice, Bent Glass and Neon," a conceptual breakthrough.

With James Carpenter, Venice, 1972

With Buster Simpson and Italo Scanga, 1971

With Erwin Eisch, Pilchuck Glass School, 1972

Barbara Vaessen and James Carpenter, Venice, 1972

1974	**1975**	**1976**	**1977**
Returns to Europe, this time on a tour of European glass centers with Thomas Buechner of the Corning Museum of Glass and Paul Schulze, head of the Design Department at Steuben Glass. Makes his first significant purchase of art, "La Donna Perfecta," an art-deco glass mosaic. Upon returning to the United States, he builds a glass shop for the Institute of American Indian Arts in Santa Fe, New Mexico. Supported by a National Endowment for the Arts grant at Pilchuck, James Carpenter, a group of students, and he develop a technique for picking up glass thread drawings. In December at RISD, he completes his last collaborative project with Carpenter, "Corning Wall."	At RISD, begins series of "Navajo Blanket Cylinders." Kate Elliott and, later, Flora Mace fabricate the complex thread drawings. He receives the first of two National Endowment for the Arts Individual Artist grants. Artist-in-residence with Seaver Leslie at Artpark, on the Niagara Gorge, in New York State. Begins "Irish" and "Ulysses" cylinders with Leslie and Mace.	Travels with Seaver Leslie to the British Isles and Ireland. An automobile accident in England leaves him, after weeks in the hospital and 256 stitches in his face, without sight in his left eye and with permanent damage to his right ankle and foot. After recuperating at the home of painter Peter Blake, he returns to Providence to serve as head of the Department of Sculpture and the Program in Glass at RISD. He invites Robert Grosvenor, Dennis Oppenheim, Fairfield Porter, Alan Seret, and John Torreano to RISD as visiting artists. Henry Geldzahler, curator of contemporary art at the Metropolitan Museum of Art in New York, acquires three "Navajo Blanket Cylinders" for the museum's collection. This is a turning point in Chihuly's career, and a friendship between artist and curator commences.	Inspired by Northwest Coast Indian baskets he sees at the Washington Historical Society in Tacoma, begins the "Basket" series at Pilchuck over the summer, with Benjamin Moore as his assistant gaffer. Continues his bicoastal teaching assignments, dividing his time between Rhode Island and the Pacific Northwest. Charles Cowles curates a three-person show of the work of Chihuly, Italo Scanga, and James Carpenter at the Seattle Art Museum.

With Italo Scanga, Pilchuck Glass School, 1974

Seattle, circa 1973

Corning Wall, 1974

With Dennis Oppenheim and his son, 1974

Michael Murphy, Ireland, 1976

"La Donna Perfecta," purchased in 1974

With William Morris, tours one thousand miles of Brittany by bicycle in the spring. First major catalog is published: "Chihuly Glass," designed by an RISD colleague and friend, Malcolm Grear.

Sells the Boathouse in Rhode Island and returns to the Pacific Northwest after sixteen years on the East Coast. Works at Pilchuck in the fall and winter, further developing the "Macchia" series with William Morris as chief gaffer.

Begins work on the "Soft Cylinder" series, with Flora Mace and Joey Kirkpatrick executing the glass drawings. He is honored as RISD President's Fellow at the Whitney Museum in New York and receives the Visual Artists Award from the American Council for the Arts, as well as the first of three state Governor's Arts Awards.

Returns to Baden, Austria, this time to teach with William Morris, Flora Mace, and Joey Kirkpatrick. Travels to Malta and the Channel Islands. Purchases the Buffalo Shoe Company building on the east side of Lake Union in Seattle and begins restoring it for use as a primary studio and residence.

Viola Chihuly and Italo Scanga, circa 1976

Toots Zynsky, Flora Mace, Joey Kirkpatrick, and Claydine Eugenia, Malta, 1985

Dan Dailey, Alan Seret, Italo Scanga, Seaver Leslie, Dale Chihuly, Viola Chihuly, and James Carpenter, Tacoma, 1976

With Thomas Buechner and Stanislav Libenský, Corning, 1980

344

Meets William Morris, a student at Pilchuck Glass School, and the two begin a close, eight-year working relationship. A solo show curated by Michael W. Monroe at the Renwick Gallery, Smithsonian Institution, in Washington, D.C., is another milestone in Chihuly's career.

Dislocates his shoulder in a bodysurfing accident and relinquishes the gaffer position for good. William Morris becomes his chief gaffer for the next several years. Chihuly begins to make drawings as a way to communicate his designs. Together with Morris, Benjamin Moore, and student assistants Michael Scheiner and Richard Royal, he blows glass in Baden, Austria.

Resigns his teaching position at RISD. He returns there periodically during the 1980s as artist-in-residence. Begins "Seaform" series at Pilchuck in the summer and later, back in Providence, returns to architectural installations with the creation of windows for the Shaare Emeth Synagogue in St. Louis, Missouri. Purchases his first building, the Boathouse, in Pawtuxet Cove, Rhode Island, for his residence and studio.

Begins "Macchia" series, using up to three hundred colors of glass. These wildly spotted, brightly colored forms are dubbed "the uglies" by his mother, but they are eventually christened "Macchia," Italian for "spotted," by his friend Italo Scanga.

With Laurence Madrelle, London, 1976

An automobile accident leaves him without sight in his left eye, 1976

With Fairfield Porter, Providence, 1976

With Joanie Wolcott, Providence, 1976
Above right: Recovering at the home of Peter Blake, 1976

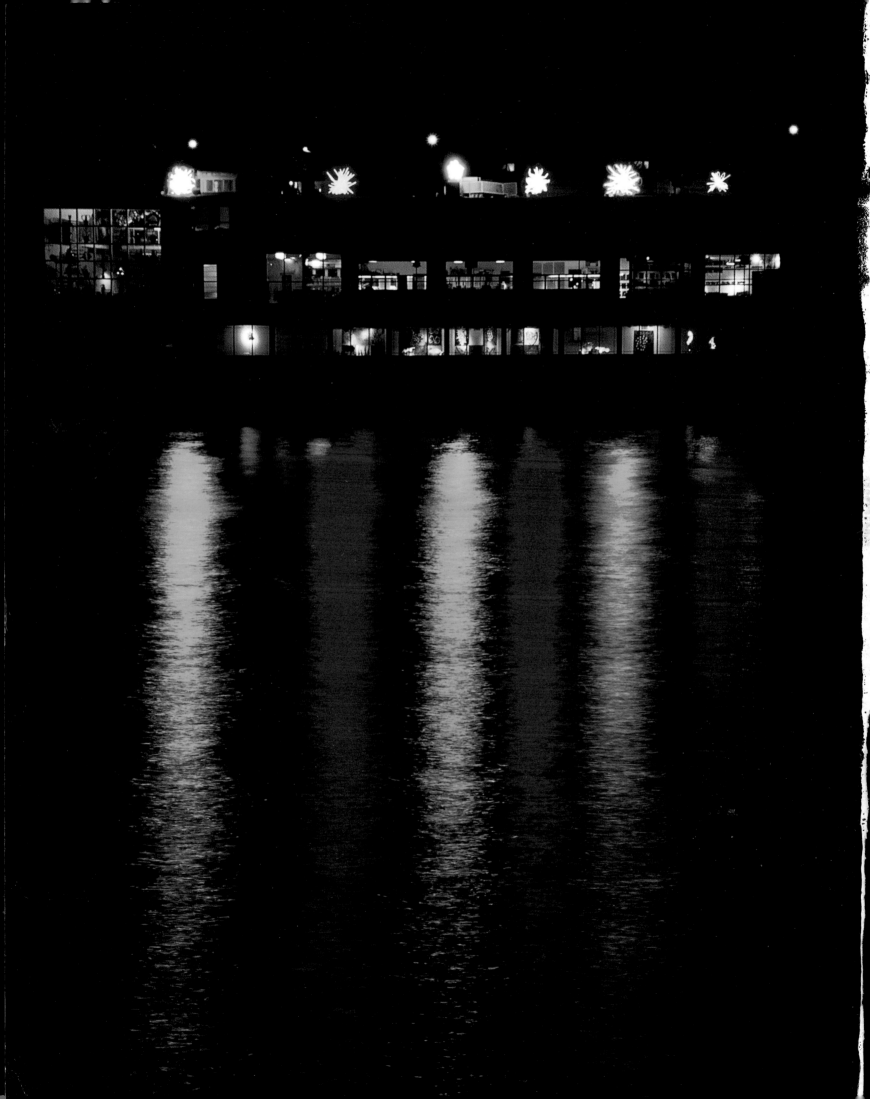

Colophon

*Book design by Massimo Vignelli, New York.
Graphic production and project coordination by
Shelly Langton, Portland Press, Seattle. Copyediting
by Richard Slovak, New Jersey.*

Text is set in Century ATFBQ. Printed in China

369

1993

Bannard, Walter Darby, and Henry Geldzahler. *Chihuly: Form from Fire*. Daytona Beach, Fla.: Museum of Arts and Sciences; [Seattle]: University of Washington Press.

Chihuly: A Night at the Opera. Aspen, Colo.: Susan Duval Gallery.

Dale Chihuly: Virtuose Spiele in Glas. Zurich: Sanske Galerie; Sarnen, Switzerland: Sarner Cristal.

Edwards, Geoffrey. *Chihuly in Australia: Glass and Works on Paper*. [Seattle]: Portland Press.

Geldzahler, Henry. *Dale Chihuly*. Hong Kong: Plum Blossoms.

Hobbs, Robert. *Chihuly alla Macchia: From the George R. Stroemple Collection*. Beaumont, Tex.: Art Museum of Southeast Texas.

Jenkins, Speight, and Dale Chihuly. *Pelléas + Mélisande + Chihuly*. [Seattle]: Seattle Opera in association with University of Washington Press.

1994

Bremser, Sarah. *Chihuly: Glass in Architecture*. Kaohsiung, Taiwan: Kaohsiung Museum of Fine Arts.

Duval, Susan. *Angels & Saints: Dale Chihuly & Italo Scanga*. Aspen, Colo.: Susan Duval Gallery.

Norden, Linda, and Murray Morgan. *Chihuly Baskets*. Seattle: Portland Press.

1995

Chihuly over Venice: Nuutajärvi, Finland, Part 1, June 1995. Seattle: Portland Press.

Earle, Sylvia, and Joan Seeman Robinson. *Chihuly Seaforms*. Seattle: Portland Press.

Geldzahler, Henry. *Dale Chihuly: Chosun Art Gallery*. Seoul, South Korea: Chosun Art Gallery.

1996

Adams, Henry. *Dale Chihuly: Thirty Years in Glass, 1966-1996*. Kansas City, Mo.: UMB Financial Corp.

Oldknow, Tina. *Chihuly Persians*. Seattle: Portland Press.

Self, Dana, and William Warmus. *Chihuly over Venice*. [Seattle]: Portland Press.

1997

Ichihara, Shigeru. *Dale Chihuly*. Nagoya, Japan: Daiichi Museum.

Kuspit, Donald B., and Jack Cowart. *Chihuly*. New York: Harry N. Abrams, Inc.; Seattle: Portland Press.

Kuspit, Donald B., and Kathryn Kanjo. *Chihuly: The George R. Stroemple Collection*. Portland, Ore.: Portland Art Museum.

Yasumasa, Oka, Tsuchida Ruriko, and Patterson Sims. *Magic of Chihuly Glass*. [Osaka, Japan]: Yomiuri Shimbun.

1998

Chihuly, Dale. *Icicles: The Icicle Creek Chandelier*. Seattle: Portland Press.

Kuspit, Donald B., and Jack Cowart. *Chihuly*. 2nd ed., rev. and expanded. New York: Harry N. Abrams, Inc.; Seattle: Portland Press.

1999

Chihuly Atlantis. Seattle: Portland Press.

Chihuly Bellagio. Seattle: Portland Press.

Chihuly—Glass Master. Hsinchu, Taiwan: Hsinchu Municipal Cultural Center.

Chihuly Jerusalem Cylinders. Seattle: Portland Press.

New, Lloyd Kiva. *Chihuly Taos Pueblo*. Seattle: Portland Press.

Warmus, William. *Chihuly in the Light of Jerusalem 2000*. Seattle: Portland Press.

2000

Chihuly, Dale, Barbara Rose, and Dale Lanzone. *Chihuly Projects*. Seattle: Portland Press; New York: Harry N. Abrams, Inc. [distributor].

Chihuly Jerusalem 2000. Seattle: Portland Press.

Lohrmann, Charles, and Dale Chihuly. *Chihuly's Pendletons: And Their Influence on His Work*. Seattle: Portland Press; [Tucson]: University of Arizona Press [distributor].

Warmus, William. *The Essential Dale Chihuly*. New York: Harry N. Abrams, Inc.

2001

Opie, Jennifer Hawkins. *Chihuly at the V&A*. London: V&A Publications; Seattle: Portland Press.

Tuchman, Phyllis. *Chihuly Marlborough*. New York: Marlborough Gallery.

Index

Publications about the Artist

1982
Cowart, Jack. *Currents: Dale Chihuly.* St. Louis: Saint Louis Art Museum.

Norden, Linda. *Chihuly Glass.* [Pawtuxet Cove, R.I.: Dale Chihuly].

1984
Cowart, Jack, and Karen Chambers. *Chihuly: A Decade of Glass.* Bellevue, Wash.: Bellevue Art Museum.

1986
Chihuly, Dale. *Chihuly: Color, Glass and Form.* Tokyo and New York: Kodansha International.

Geldzahler, Henry, and Robert Hobbs. *Dale Chihuly: Objets de verre, Musée des Arts Décoratifs, Palais du Louvre, 5 décembre 1986-18 janvier 1987.* [Paris]: Musée des Arts Décoratifs, Palais du Louvre.

1988
Hobbs, Robert. *Chihuly: Persians.* Bridgehampton, N.Y.: Dia Art Foundation.

1989
Glowen, Ron, and Dale Chihuly. *Venetians: Dale Chihuly.* Altadena, Calif.: Twin Palms Publishers.

1990
Dale Chihuly: Glass Artist. [Tokyo]: Mitsukoshi.

Geldzahler, Henry. *Dale Chihuly: Japan 1990.* [Tokyo: Japan Institute of Arts and Crafts].

1991
Chambers, Karen S. *Dale Chihuly/Klaus Moje: Exhibition, May 19-September 15, 1991.* Ebeltoft, Denmark: Glasmuseum.

Dale Chihuly: Tutti Putti, April 13 through May 25, 1991. Santa Monica, Calif.: Pence Gallery.

1992
Bremser, Sarah E. *Chihuly Courtyards.* Honolulu: Honolulu Academy of Arts.

Dale Chihuly: Glass. Taipei: Taipei Fine Arts Museum.

Dale Chihuly: October 10-October 30, 1992. Farmington Hills, Mich.: Habatat Galleries.

Dale Chihuly Niijima Floats: American Craft Museum, January 30, 1992-August 2, 1992. [New York]: American Craft Museum.

Geldzahler, Henry. *Dale Chihuly: November 26 to December 31, 1992.* Vancouver, B.C.: Doheny.

Sims, Patterson. *Dale Chihuly: Installations, 1964-1992.* [Seattle]: Seattle Art Museum.

Ocean Drive, Norwalk, Connecticut, 2000
Pacific First Center, Seattle, Washington, 1989
Pacific Lutheran University, Tacoma, Washington, 1995
Phoenix Park Hotel, Seoul, South Korea, 1996
Postrio, San Francisco, California, 1996
Ritz-Carlton Millennia Hotel, Singapore, Republic of Singapore,
1995
Rockefeller Center, New York, New York, 1987
Rubicon, San Francisco, California, 1997
Saint Peter's Church, New York, New York, 1994
San Jose Museum of Art, San Jose, California, 1996
Seattle Aquarium, Seattle, Washington, 1987
Seay Biomedical Building, Dallas, Texas, 1999
Security Pacific Bank, Los Angeles, California, 1989
Shaare Emeth Synagogue, St. Louis, Missouri, 1980
Sheraton Seattle Hotel and Towers, Seattle, Washington, 1986
Singapore Art Museum, Singapore, Republic of Singapore, 1995
Sleeping Lady Conference Retreat, Leavenworth, Washington, 1996
Sound Mind and Body, Seattle, Washington, 2000
Southwest Bank of St. Louis, St. Louis, Missouri, 2001
Spencer Museum of Art, University of Kansas, Lawrence,
Kansas, 1996
Spencer Theater for the Performing Arts, Ruidoso, New Mexico,
1997, 2000
Steelcase Inc., Grand Rapids, Michigan, 2000
Tacoma Financial Center, Tacoma, Washington, 1984
Toledo Public Library, Toledo, Ohio, 2001
Tropicana Products Inc., Bradenton, Florida, 1990
Ukai Museum, Hakone, Japan, 1997
UMB Bank Colorado: Denver Banking Center, Denver, Colorado,
1995
Union Station Federal Courthouse, Tacoma, Washington, 1994
United States Border Station, Blaine, Washington, 1979
University of Michigan Business School, Ann Arbor, Michigan, 2001
University of Minnesota at Duluth, Duluth, Minnesota, 2000
University of Nebraska, Omaha, Nebraska, 2000
University of Puget Sound, Tacoma, Washington, 2000
University of Texas Business Building, San Antonio, Texas, 1997
University of Washington, Meany Hall, Seattle, Washington, 1996
University of Washington, Tacoma Campus Library, Tacoma,
Washington, 1999
Victoria and Albert Museum, London, England, 1999
Washington Athletic Club, Seattle, Washington, 1999
Washington State Convention Center, Seattle, Washington, 1992,
1993
World Trade Center, Schiphol Airport, Amsterdam,
The Netherlands, 1996
Yasui Konpira-gu Shinto Shrine, Kyoto, Japan, 1991

Architectural Installations

ALZA Corporation, Mountain View, California, 2000
Atlantis, Paradise Island, Bahamas, 1998
Beach Museum of Art, Kansas State University, Manhattan, Kansas, 1996
Bellagio, Las Vegas, Nevada, 1998
Benaroya Hall, Seattle, Washington, 1998
Birmingham Museum of Art, Birmingham, Alabama, 1996
Celebrity Cruises, Inc., Miami, Florida, 2000, 2001
Chancellor Park, La Jolla, California, 1988
Cincinnati Art Museum, Cincinnati, Ohio, 2001
Claridge's Hotel, London, 2000
Cold Spring Harbor Laboratory, Cold Spring Harbor, New York, 1999
Columbus Visitors' Center, Columbus, Indiana, 1995
Contemporary Art Center of Virginia, Virginia Beach, Virginia, 2001
Corning Country Club, Corning, New York, 2000
Corning Museum of Glass, Corning, New York, 2000
Corning World Headquarters, Corning, New York, 1994
DaimlerChrysler Corporation, Auburn Hills, Michigan, 1999
Daum Museum of Contemporary Art, Sedalia, Missouri, 2001
Delaware Art Museum, Wilmington, Delaware, 1999
Desert Willow Golf Resort, Palm Desert, California, 2000
Disney Cruise Lines, Cape Canaveral, Florida, 1998, 1999
F. Hoffmann–La Roche AG, Basel, Switzerland, 1994
Fleet National Bank, Providence, Rhode Island, 1985
Frank Russell Company, Tacoma, Washington, 1988
Getty Educational Center, Los Angeles, California, 1997
Glendale Foothills Library, Glendale, Arizona, 1999
Global Aviation Inc., Hillsboro, Oregon, 2000
GTE World Headquarters, Irving, Texas, 1991
Guardian Industries Corporation, Auburn Hills, Michigan, 1996
Hyatt Hotel, Adelaide, Australia, 1988
Jewish Federation of Philadelphia, Philadelphia, Pennsylvania, 2000
Joe Serna Jr. California Environmental Protection Agency Headquarters Building, Sacramento, California, 2001
Joslyn Art Museum, Omaha, Nebraska, 2000
Jundt Art Museum, Gonzaga University, Spokane, Washington, 1996
Kalamazoo Institute of Arts, Kalamazoo, Michigan, 1998
Kemper Museum of Contemporary Art, Kansas City, Missouri, 1997
Kohl Center, University of Wisconsin, Madison, Wisconsin, 1997
Krasl Art Center, St. Joseph, Michigan, 2000
Little Caesar Enterprises Inc., Detroit, Michigan, 1993
Liz Claiborne Inc., New York, New York, 1999
Mattel Corporation, El Segundo, California, 1999
Mayo Clinic, Gonda Building, Rochester, Minnesota, 2001
McCormick Place South, Chicago, Illinois, 1999
Microsoft Corporation, Redmond, Washington, 1995
Milwaukee Art Museum, Milwaukee, Wisconsin, 1999
Minneapolis Institute of Arts, Minneapolis, Minnesota, 1999
Mint Museum of Craft + Design, Charlotte, North Carolina, 1998
Naples Museum of Art, Naples, Florida, 2000
National Liberty Museum, Philadelphia, Pennsylvania, 1999
Neiman Marcus, Paramus, New Jersey, 1996
News Tribune, Tacoma, Washington, 1997
Northwest Building Corporation, Seattle, Washington, 2000

Samuel P. Harn Museum of Art, University of Florida,
Gainesville, Florida
San Francisco Museum of Modern Art, San Francisco, California
San Jose Museum of Art, San Jose, California
Scitech Discovery Centre, Perth, Australia
Scottsdale Center for the Arts, Scottsdale, Arizona
Seattle Art Museum, Seattle, Washington
Shimonoseki City Art Museum, Shimonoseki, Japan
Singapore Art Museum, Singapore
Smith College Museum of Art, Northampton, Massachusetts
Smithsonian American Art Museum, Washington, D.C.
Sogetsu Art Museum, Tokyo, Japan
Speed Art Museum, Louisville, Kentucky
Spencer Museum of Art, University of Kansas, Lawrence, Kansas
Springfield Museum of Fine Arts, Springfield, Massachusetts
Suntory Museum of Art, Tokyo, Japan
Suomen Lasimuseo, Riihimäki, Finland
Suwa Garasu no Sato Museum, Nagano, Japan
Tacoma Art Museum, Tacoma, Washington
Taipei Fine Arts Museum, Taipei, Taiwan
Tochigi Prefectural Museum of Fine Arts, Tochigi, Japan
Toledo Museum of Art, Toledo, Ohio
Uměleckoprůmsylové muzeum, Prague, Czech Republic
Utah Museum of Fine Arts, University of Utah, Salt Lake City,
Utah
Victoria and Albert Museum, London, England
Wadsworth Atheneum, Hartford, Connecticut
Waikato Museum of Art and History, Hamilton, New Zealand
Walker Hill Art Center, Seoul, South Korea
Whatcom Museum of History and Art, Bellingham, Washington
White House Collection of American Crafts, Washington, D.C.
Whitney Museum of American Art, New York, New York
Württembergisches Landesmuseum Stuttgart, Stuttgart,
Germany
Yale University Art Gallery, New Haven, Connecticut
Yokohama Museum of Art, Yokohama, Japan

Elvehjem Museum of Art, University of Wisconsin, Madison, Wisconsin
Eretz Israel Museum, Tel Aviv, Israel
Everson Museum of Art, Syracuse, New York
Experience Music Project, Seattle, Washington
Fine Arts Institute, Edmond, Oklahoma
Flint Institute of Arts, Flint, Michigan
Glasmuseum, Ebeltoft, Denmark
Glasmuseum, Frauenau, Germany
Glasmuseum alter Hof Herding, Glascollection, Ernsting, Germany
Glasmuseum Wertheim, Wertheim, Germany
Grand Rapids Art Museum, Grand Rapids, Michigan
Hakone Glass Forest, Ukai Museum, Hakone, Japan
Hawke's Bay Exhibition Centre, Hastings, New Zealand
High Museum of Art, Atlanta, Georgia
Hiroshima City Museum of Contemporary Art, Hiroshima, Japan
Hokkaido Museum of Modern Art, Hokkaido, Japan
Honolulu Academy of Arts, Honolulu, Hawaii
Hunter Museum of American Art, Chattanooga, Tennessee
Indianapolis Museum of Art, Indianapolis, Indiana
Israel Museum, Jerusalem, Israel
Japan Institute of Arts and Crafts, Tokyo, Japan
Jesse Besser Museum, Alpena, Michigan
Jesuit Dallas Museum, Dallas, Texas
Joslyn Art Museum, Omaha, Nebraska
Jundt Art Museum, Gonzaga University, Spokane, Washington
Kalamazoo Institute of Arts, Kalamazoo, Michigan
Kaohsiung Museum of Fine Arts, Kaohsiung, Taiwan
Kemper Museum of Contemporary Art, Kansas City, Missouri
Kestner-Gesellschaft, Hannover, Germany
Kobe City Museum, Kobe, Japan
Krannert Art Museum, University of Illinois, Champaign, Illinois
Krasl Art Center, St. Joseph, Michigan
Kunstmuseum Düsseldorf, Düsseldorf, Germany
Kunstsammlungen der Veste Coburg, Coburg, Germany
Kurita Museum, Tochigi, Japan
Leigh Yawkey Woodson Art Museum, Wausau, Wisconsin
Lobmeyr Museum, Vienna, Austria
Los Angeles County Museum of Art, Los Angeles, California
Lowe Art Museum, University of Miami, Coral Gables, Florida
Lyman Allyn Art Museum, New London, Connecticut
M.H. de Young Memorial Museum, San Francisco, California
Madison Art Center, Madison, Wisconsin
Manawatu Museum, Palmerston North, New Zealand
Matsushita Art Museum, Kagoshima, Japan
Meguro Museum of Art, Tokyo, Japan
Memorial Art Gallery, University of Rochester, Rochester, New York
Metropolitan Museum of Art, New York, New York
Milwaukee Art Museum, Milwaukee, Wisconsin
Minneapolis Institute of Arts, Minneapolis, Minnesota
Mint Museum of Craft + Design, Charlotte, North Carolina
Mobile Museum of Art, Mobile, Alabama
Modern Art Museum of Fort Worth, Fort Worth, Texas
Montreal Museum of Fine Arts, Montreal, Quebec, Canada
Morris Museum, Morristown, New Jersey
Musée d'Art Moderne et d'Art Contemporain, Nice, France
Musée des Arts Décoratifs, Lausanne, Switzerland

Musée des Arts Décoratifs, Palais du Louvre, Paris, France
Musée des Beaux-Arts et de la Céramique, Rouen, France
Musée Provincial Sterckshof, Antwerp, Belgium
Museo del Vidrio, Monterrey, Mexico
Museum Bellerive, Zurich, Switzerland
Museum Boijmans Van Beuningen, Rotterdam, The Netherlands
Museum für Kunst und Gewerbe Hamburg, Hamburg, Germany
Museum für Kunsthandwerk, Frankfurt am Main, Germany
Museum of American Glass at Wheaton Village, Millville, New Jersey
Museum of Art, Fort Lauderdale, Florida
Museum of Art, Rhode Island School of Design, Providence, Rhode Island
Museum of Art and Archaeology, Columbia, Missouri
Museum of Arts and Sciences, Daytona Beach, Florida
Museum of Contemporary Art, Chicago, Illinois
Museum of Contemporary Art at San Diego, La Jolla, California
Museum of Fine Arts, Boston, Massachusetts
Museum of Fine Arts, St. Petersburg, Florida
Museum of Modern Art, New York, New York
Museum of Northwest Art, La Conner, Washington
Museum voor Sierkunst en Vormgeving, Ghent, Belgium
Muskegon Museum of Art, Muskegon, Michigan
Muzeum mesta Brna, Brno, Czech Republic
Muzeum skla a bižuterie, Jablonec nad Nisou, Czech Republic
Naples Museum of Art, Naples, Florida
National Gallery of Australia, Canberra, Australia
National Gallery of Victoria, Melbourne, Australia
National Liberty Museum, Philadelphia, Pennsylvania
National Museum Kyoto, Kyoto, Japan
National Museum of American History, Smithsonian Institution, Washington, D.C.
National Museum of Modern Art Kyoto, Kyoto, Japan
National Museum of Modern Art Tokyo, Tokyo, Japan
Nationalmuseum, Stockholm, Sweden
New Orleans Museum of Art, New Orleans, Louisiana
Newport Harbor Art Museum, Newport Beach, California
Niijima Contemporary Art Museum, Niijima, Japan
North Central Washington Museum, Wenatchee, Washington
Notojima Glass Art Museum, Ishikawa, Japan
O Art Museum, Tokyo, Japan
Otago Museum, Dunedin, New Zealand
Palm Beach Community College Museum of Art, Lake Worth, Florida
Palm Springs Desert Museum, Palm Springs, California
Palmer Museum of Art, Pennsylvania State University, University Park, Pennsylvania
Parrish Art Museum, Southampton, New York
Philadelphia Museum of Art, Philadelphia, Pennsylvania
Phoenix Art Museum, Phoenix, Arizona
Plains Art Museum, Fargo, North Dakota
Portland Art Museum, Portland, Oregon
Powerhouse Museum, Sydney, Australia
Princeton University Art Museum, Princeton, New Jersey
Queensland Art Gallery, South Brisbane, Australia
Robert McDougall Art Gallery, Christchurch, New Zealand
Royal Ontario Museum, Toronto, Ontario, Canada
Saint Louis Art Museum, St. Louis, Missouri

Museum Collections

Akita Senshu Museum of Art, Akita, Japan
Akron Art Museum, Akron, Ohio
Albany Museum of Art, Albany, Georgia
Albright-Knox Art Gallery, Buffalo, New York
Allied Arts Association, Richland, Washington
American Craft Museum, New York, New York
Amon Carter Museum, Fort Worth, Texas
Anchorage Museum of History and Art, Anchorage, Alaska
Arizona State University Art Museum, Tempe, Arizona
Arkansas Arts Center, Little Rock, Arkansas
Art Gallery of Greater Victoria, Victoria, British Columbia, Canada
Art Gallery of Western Australia, Perth, Australia
Art Museum of Missoula, Missoula, Montana
Art Museum of Southeast Texas, Beaumont, Texas
Asheville Art Museum, Asheville, North Carolina
Auckland War Memorial Museum, Auckland, New Zealand
Azabu Museum of Arts and Crafts, Tokyo, Japan
Ball State University Museum of Art, Muncie, Indiana
Beach Museum of Art, Kansas State University, Manhattan, Kansas
Bellevue Art Museum, Bellevue, Washington
Berkeley Art Museum, University of California, Berkeley, California
Birmingham Museum of Art, Birmingham, Alabama
Boarman Arts Center, Martinsburg, West Virginia
Boca Raton Museum of Art, Boca Raton, Florida
Brooklyn Museum, Brooklyn, New York
Canadian Clay & Glass Gallery, Waterloo, Ontario, Canada
Canadian Craft Museum, Vancouver, British Columbia, Canada
Carnegie Museum of Art, Pittsburgh, Pennsylvania
Charles A. Wustum Museum of Fine Arts, Racine, Wisconsin
Chrysler Museum of Art, Norfolk, Virginia
Cincinnati Art Museum, Cincinnati, Ohio
Cleveland Center for Contemporary Art, Cleveland, Ohio
Cleveland Museum of Art, Cleveland, Ohio
Columbus Cultural Arts Center, Columbus, Ohio
Columbus Museum of Art, Columbus, Ohio
Contemporary Arts Center, Cincinnati, Ohio
Contemporary Crafts Association and Gallery, Portland, Oregon
Contemporary Museum, Honolulu, Hawaii
Cooper-Hewitt, National Design Museum, Smithsonian Institution, New York, New York
Corcoran Gallery of Art, Washington, D.C.
Corning Museum of Glass, Corning, New York
Crocker Art Museum, Sacramento, California
Currier Gallery of Art, Manchester, New Hampshire
Daiichi Museum, Nagoya, Japan
Dallas Museum of Art, Dallas, Texas
Danske Kunstindustrimuseum, Copenhagen, Denmark
David Winton Bell Gallery, Brown University, Providence, Rhode Island
Dayton Art Institute, Dayton, Ohio
DeCordova Museum and Sculpture Park, Lincoln, Massachusetts
Delaware Art Museum, Wilmington, Delaware
Denver Art Museum, Denver, Colorado
Detroit Institute of Arts, Detroit, Michigan
Dowse Art Museum, Lower Hutt, New Zealand

2001

Chihuly at the V&A
Victoria and Albert Museum, London, England

Chihuly Baskets
Crocker Art Museum, Sacramento, California
Loveland Museum of Art, Loveland, Colorado
Lauren Rogers Museum of Art, Laurel, Mississippi
Tyler Museum of Art, Tyler, Texas

Chihuly Over Venice
Milwaukee Art Museum, Milwaukee, Wisconsin

Chihuly: Seaforms
Bowers Museum of Cultural Art, Santa Ana, California
Springfield Museum of Fine Arts, Springfield, Massachusetts
Southern Vermont Arts Center, Manchester, Vermont

Chihuly: The George R. Stroemple Collection
Las Vegas Art Museum, Las Vegas, Nevada
Boise Art Museum, Boise, Idaho

Form from Fire: Glass Works by Dale Chihuly
Dayton Art Institute, Dayton, Ohio

The Magic of Chihuly Glass
Kobe City Museum, Kobe, Japan
Suntory Museum of Art, Tokyo, Japan

1998
Alaska Baskets
Skagway Museum and Archives, Skagway, Alaska

Chihuly Baskets
West Sound Arts Council, Bremerton, Washington
Alaska State Museum, Juneau, Alaska

Chihuly Over Venice
Columbus Museum of Art, Columbus, Ohio

Chihuly: Seaforms
Memorial Art Gallery, University of Rochester, Rochester, New York
New Britain Museum of American Art, New Britain, Connecticut
Ball State University Museum of Art, Muncie, Indiana

Chihuly: The George R. Stroemple Collection
Akron Art Museum, Akron, Ohio

Dale Chihuly
University Art Gallery, University of California–San Diego, La Jolla, California

Dale Chihuly: Installations
Norton Museum of Art, West Palm Beach, Florida

Dale Chihuly: On Site
Albuquerque Museum of Art and History, Albuquerque, New Mexico

Dale Chihuly: Venetians
Providence Athenaeum, Providence, Rhode Island

The Magic of Chihuly Glass
Fukuoka Art Museum, Fukuoka, Japan

Montana Macchia
Holter Museum of Art, Helena, Montana
Paris Gibson Square Museum of Art, Great Falls, Montana
Hockaday Center for the Arts, Kalispell, Montana
Custer County Art Center, Miles City, Montana

1999
Chihuly Baskets
Delaware Art Museum, Wilmington, Delaware
Plains Art Museum, Fargo, North Dakota

Chihuly: Glass Master
Hsinchu Municipal Cultural Center, Hsinchu, Taiwan

Chihuly in the Light of Jerusalem 2000
Tower of David Museum of the History of Jerusalem, Jerusalem, Israel

Chihuly: Macchia
Northwest Art Center, Minot State University, Minot, North Dakota
North Dakota Museum of Art, Grand Forks, North Dakota
Rourke Art Gallery, Moorhead, Minnesota

Chihuly Over Venice
Columbus Museum of Art, Columbus, Ohio

Chihuly: Seaforms
Palmer Museum of Art, Pennsylvania State University, University Park, Pennsylvania
Indianapolis Museum of Art, Columbus Gallery, Columbus, Indiana

Chihuly: The George R. Stroemple Collection
California Center for the Arts, Escondido, California

Dale Chihuly: Installations
Hiroshima City Museum of Contemporary Art, Hiroshima, Japan
Contemporary Art Center of Virginia, Virginia Beach, Virginia
Mint Museum of Craft + Design, Charlotte, North Carolina

Dale Chihuly: Masterworks in Glass
National Gallery of Australia, Canberra, Australia

2000
Chihuly Baskets
Braithwaite Fine Arts Gallery, Southern Utah University, Cedar City, Utah
Brigham Young University Museum of Art, Provo, Utah

Chihuly in Iceland: Form from Fire
Listasafn Reykjavíkur, Reykjavík, Iceland

Chihuly: Inside and Out
Joslyn Art Museum, Omaha, Nebraska

Chihuly: Masterworks in Glass
JamFactory Contemporary Craft and Design, Adelaide, Australia

Chihuly: Seaforms
Fuller Museum of Art, Brockton, Massachusetts
Fayetteville Museum of Art, Fayetteville, North Carolina

Chihuly: The George R. Stroemple Collection
San Jose Museum of Art, San Jose, California

Dale Chihuly: Installations
Knoxville Museum of Art, Knoxville, Tennessee
Arkansas Arts Center, Little Rock, Arkansas

Dale Chihuly: On Site
Nevada Museum of Art, Reno, Nevada

Reflections of Chihuly: A Naples Museum of Art Inaugural Exhibition
Naples Museum of Art, Naples, Florida

Chihuly: Form from Fire
Philharmonic Center for the Arts, Naples, Florida
Samuel P. Harn Museum of Art, University of Florida,
Gainesville, Florida
Museum of Fine Arts, Florida State University, Tallahassee,
Florida
Center for the Arts, Vero Beach, Florida

Chihuly: Glass in Architecture
Kaohsiung Museum of Fine Arts, Kaohsiung, Taiwan

Chihuly in New Zealand: Glass and Works on Paper
Dowse Art Museum, Lower Hutt, New Zealand
Waikato Museum of Art and History, Hamilton, New Zealand
Otago Museum, Dunedin, New Zealand
Robert McDougall Art Gallery, Christchurch, New Zealand
Manawatu Museum, Palmerston North, New Zealand

Dale Chihuly: Installations
Dallas Museum of Art, Dallas, Texas
Santa Barbara Museum of Art, Santa Barbara, California

Dale Chihuly: Pelléas and Mélisande
Renwick Gallery, National Museum of American Art, Smithsonian
Institution, Washington, D.C.

1995
Chihuly: alla Macchia
Polk Museum of Art, Lakeland, Florida
Grace Museum, Abilene, Texas

Chihuly Baskets
Washington State Historical Society Museum, Tacoma, Washington
Maryhill Museum of Art, Goldendale, Washington
Sheehan Gallery, Whitman College, Walla Walla, Washington

Chihuly: Form from Fire
Saint John's Museum of Art, Wilmington, North Carolina

Chihuly in New Zealand: Glass and Works on Paper
Hawke's Bay Exhibition Centre, Hastings, New Zealand
Auckland Museum, Auckland, New Zealand

Dale Chihuly
Jundt Art Museum, Gonzaga University, Spokane, Washington

Dale Chihuly: Installations
Anchorage Museum of History and Art, Anchorage, Alaska
San Jose Museum of Art, San Jose, California

Dale Chihuly: On Site
Jacksonville Museum of Contemporary Art, Jacksonville, Florida

1996
Alaska Baskets
Alutiiq Museum and Archaeological Repository, Kodiak, Alaska
Sheldon Jackson Museum, Sitka, Alaska
Sheldon Museum and Cultural Center, Haines, Alaska

Chihuly: alla Macchia
Brevard Museum of Art and Science, Melbourne, Florida
Leigh Yawkey Woodson Art Museum, Wausau, Wisconsin

Chihuly Baskets
Art Museum of Missoula, Missoula, Montana
Schneider Museum of Art, Southern Oregon State College,
Ashland, Oregon
University of Wyoming Art Museum, Laramie, Wyoming
Scottsdale Center for the Arts, Scottsdale, Arizona

Chihuly Over Venice
Kemper Museum of Contemporary Art & Design, Kansas City,
Missouri

Chihuly: Seaforms
Corcoran Gallery of Art, Washington, D.C.
Museum of Art, Williams College, Williamstown, Massachusetts
Portland Museum of Art, Portland, Maine

Crystal Gardens
LongHouse Foundation, East Hampton, New York

Dale Chihuly: Installations
Contemporary Arts Center, New Orleans, Louisiana
Baltimore Museum of Art, Baltimore, Maryland
Saint Louis Art Museum, St. Louis, Missouri

Dale Chihuly: On Site
Palm Springs Desert Museum, Palm Springs, California

1997
Alaska Baskets
Carrie M. McLain Memorial Museum, Nome, Alaska
Pratt Museum, Homer, Alaska
Valdez Museum and Historical Archive, Valdez, Alaska
Tongass Historical Museum, Ketchikan, Alaska

Chihuly Baskets
Allied Arts Association, Richland, Washington
Prichard Art Gallery, University of Idaho, Moscow, Idaho

Chihuly Over Venice
Corcoran Gallery of Art, Washington, D.C.
Portland Art Museum, Portland, Oregon

Chihuly: Seaforms
Middlebury College Museum of Art, Middlebury, Vermont
Everson Museum of Art, Syracuse, New York
Heckscher Museum of Art, Huntington, New York

Chihuly: The George R. Stroemple Collection
Portland Art Museum, Portland, Oregon

Dale Chihuly: Installations
Minneapolis Institute of Arts, Minneapolis, Minnesota
Dixon Gallery and Gardens, Memphis, Tennessee
Albright-Knox Art Gallery, Buffalo, New York

1984
Chihuly: A Decade of Glass
Bellevue Art Museum, Bellevue, Washington
Modern Art Museum of Fort Worth, Fort Worth, Texas

Dale Chihuly: Recent Works in Glass
Crocker Art Museum, Sacramento, California

1985
Chihuly: A Decade of Glass
Arkansas Arts Center, Little Rock, Arkansas
Madison Art Center, Madison, Wisconsin
Palmer Museum of Art, Pennsylvania State University, University Park, Pennsylvania
University Galleries, Illinois State University, Normal, Illinois

1986
Chihuly: A Decade of Glass
Brunnier Art Museum, Iowa State University, Ames, Iowa
Chicago Cultural Center, Chicago, Illinois
Mint Museum of Art, Charlotte, North Carolina
Muskegon Museum of Art, Muskegon, Michigan
Musée des Arts Décoratifs de Montréal, Montreal, Quebec, Canada

Dale Chihuly: Objets de Verre
Musée des Arts Décoratifs, Palais du Louvre, Paris, France

1987
Chihuly: A Decade of Glass
Fred Jones Jr. Museum of Art, University of Oklahoma, Norman, Oklahoma
Art Museum of Western Virginia, Roanoke, Virginia

Dale Chihuly: Objets de Verre
Musée Matisse, Le Cateau-Cambrésis, France

1988
Chihuly: Persians
DIA Art Foundation, Bridgehampton, New York

Dale Chihuly: Objets de Verre
Fundação Calouste Gulbenkian, Lisbon, Portugal
Musée d'Unterlinden, Colmar, France

1989
Chihuly: Persians
Society for Contemporary Craft, Pittsburgh, Pennsylvania

20ª Bienal Internacional de São Paulo
São Paulo, Brazil

1990
Chihuly: Glass Master
Museo Nacional de Bellas Artes, Santiago, Chile

Chihuly: Persians
Hudson River Museum of Westchester, Yonkers, New York

Dale Chihuly: Japan 1990
Azabu Museum of Arts and Crafts, Tokyo, Japan

1991
Chihuly: Venetians
Uměleckoprůmyslové muzeum, Prague, Czech Republic
Röhsska Konstslöjdmuseet, Göteborg, Sweden

1992
Chihuly Courtyards
Honolulu Academy of Arts, Honolulu, Hawaii

Dale Chihuly
Toledo Museum of Art, Toledo, Ohio

Dale Chihuly: Glass
Taipei Fine Arts Museum, Taipei, Taiwan

Dale Chihuly: Installations
Seattle Art Museum, Seattle, Washington
Contemporary Arts Center, Cincinnati, Ohio

Dale Chihuly: Venetians
Museum für Kunst und Gewerbe Hamburg, Hamburg, Germany
Nationaal Glasmuseum, Leerdam, The Netherlands
Museum voor modern kunst, Oostende, Belgium

1993
Chihuly: alla Macchia
Art Museum of Southeast Texas, Beaumont, Texas

Chihuly: Form from Fire
Lowe Art Museum, University of Miami, Coral Gables, Florida
Tampa Museum of Art, Tampa, Florida
Museum of Arts and Sciences, Daytona Beach, Florida

Chihuly in Australia: Glass and Works on Paper
Powerhouse Museum, Sydney, Australia
National Gallery of Victoria, Melbourne, Australia
Scitech Discovery Centre, Perth, Australia

Dale Chihuly: Installations
Detroit Institute of Arts, Detroit, Michigan

Dale Chihuly: Virtuose Spiele in Glas
Altes Zeughaus Landenberg, Sarnen, Switzerland
Historiches Museum, Sarnen, Switzerland

1994
Chihuly: alla Macchia
Austin Museum of Art-Laguna Gloria, Austin, Texas

Chihuly Baskets
North Central Washington Museum, Wenatchee, Washington
Port Angeles Fine Arts Center, Port Angeles, Washington

Begins "Persian" series with Martin Blank, a former RISD student and assistant, as gaffer. With the opening of "Objets de Verre" at the Musée des Arts Décoratifs, Palais du Louvre, in Paris, he becomes one of only four American artists to have had a one-person exhibition at the Louvre. Receives honorary doctorates from both the University of Puget Sound, Tacoma, and RISD, Providence.

Establishes his first hotshop in the Van de Kamp building near Lake Union. Begins working hot glass on a larger scale and creates several site-specific installations, including "Puget Sound Forms" for the Seattle Aquarium. Donates permanent retrospective collection to the Tacoma Art Museum in memory of his brother and father. Begins association with artist Parks Anderson, commencing with the "Rainbow Room Frieze," an installation at Rockefeller Center in New York City. Marries playwright Sylvia Peto.

Inspired by a private collection of Italian art-deco glass, primarily designed by Martinuzzi and Scarpa, Chihuly begins "Venetian" series. Working from Chihuly's drawings, Lino Tagliapietra serves as gaffer. Receives an honorary doctorate from the California College of Arts and Crafts, Oakland.

With Italian glass masters Lino Tagliapietra and Pino Signoretto, and a team of glassblowers at Pilchuck Glass School, begins "Putti Venetian" series. Working with Tagliapietra, Chihuly creates "Ikebana" series, inspired by his travels to Japan and exposure to ikebana masters.

In his first Aston Martin, Volunteer Park, Seattle, 1986

With Sylvia Peto and Italo Scanga, circa 1988

With Henry Geldzahler, Southampton, New York, 1988

With Viola Chihuly, Sylvia Peto, and Aunt Naomi, circa 1989

Purchases the historic Pocock Building located on Lake Union, realizing his dream of being on the water in Seattle. Renovates the building and names it The Boathouse, for use as a studio, hotshop, archives, and residence. Travels to Japan.

Begins "Niijima Float" series with Richard Royal as gaffer, creating some of the largest pieces of glass ever blown by hand. Completes a number of large-scale architectural installations, including those for GTE World Headquarters in Irving, Texas, and the Yasui Konpira-gu Shinto Shrine in Kyoto, Japan. He and Sylvia Peto divorce.

Begins "Chandelier" series with a large-scale hanging sculpture for the exhibition "Dale Chihuly: Installations 1964–1992," curated by Patterson Sims at the Seattle Art Museum. Honored as the first National Living Treasure by the Institute for Human Potential, University of North Carolina, Wilmington. Designs sets for Seattle Opera production of Debussy's "Pelléas et Mélisande," which premieres in 1993. The "Pilchuck Stumps" are created during this project but are not widely exhibited.

Begins "Piccolo Venetian" series with Lino Tagliapietra. Alumni Association of the University of Washington names him Alumnus Summa Laude Dignatus, its most prestigious honor. Creates "100,000 Pounds of Ice and Neon," a temporary installation in the Tacoma Dome, Tacoma, Washington, attended by 35,000 visitors in four days.

With Viola Chihuly, The Boathouse, Seattle, 1991

With Petra Franklin, Seattle, 1992

With Paul Parkman and George Stroemple, Venice, 1996

With David Hockney, circa 1989

"Chihuly at Union Station," five large-scale installations for Tacoma's Union Station Federal Courthouse, is sponsored by the Executive Council for a Greater Tacoma and organized by the Tacoma Art Museum. Hilltop Artists in Residence, a glassblowing program for at-risk youths in Tacoma, is created by friend Kathy Kaperick; Chihuly assists with instruction of youths and is a major contributor. Discussions begin on a project to build the Museum of Glass on the Thea Foss Waterway in Tacoma and to design the "Chihuly Bridge," which will connect the museum to Tacoma's university district.

"Cerulean Blue Macchia with Chartreuse Lip Wrap" is added to the White House Collection of American Crafts. "Chihuly Over Venice" begins with a glassblowing session in Nuutajärvi, Finland, and a subsequent blow at the Waterford Crystal factory, Ireland. Creates "Chihuly e Spoleto," an installation for the 38th Spoleto Festival of the Two Worlds, in Spoleto, Italy. Receives an honorary doctorate from Pratt Institute, New York.

"Chihuly Over Venice" continues with a blow in Monterrey, Mexico, and culminates with the installation of fourteen "Chandeliers" at various sites in Venice. The exhibition "Chihuly Over Venice" begins its national tour at the Kemper Museum in Kansas City, Missouri. Chihuly purchases the Ballard Building in Seattle for use as mock-up and studio space. Creates a major installation for the Academy of Motion Picture Arts and Sciences Governor's Ball following the Academy Awards ceremony in Hollywood, California. Creates his first permanent outdoor installation, "Icicle Creek Chandelier," for the Sleeping Lady Conference Retreat in Leavenworth, Washington. Receives an honorary doctorate from Gonzaga University, Spokane, Washington.

Continues and expands series of experimental plastics he calls "polyvitro" in his newly renovated Ballard studio. "Chihuly" is designed by Massimo Vignelli and copublished by Harry N. Abrams, Inc., New York, and Portland Press, Seattle. A permanent installation of Chihuly's work opens at the Hakone Glass Forest, Ukai Museum, in Hakone, Japan. Chihuly and his team invite local high school students to photograph a blow and installation at the Vianne factory in France. Viola Chihuly is 90.

President Clinton at the Asia Pacific Economic Cooperation (APEC) Summit, Seattle, 1993

With Leslie Jackson and Jackson Viola Chihuly, 1998

With Robin Williams, in Malibu, California, at the American Academy of Achievement Awards, where both were honored in 1994

With Teddy Kollek, Jerusalem, 1999

Participates in the Sydney Arts Festival, Australia. A son, Jackson Viola Chihuly, is born February 12 to Dale Chihuly and Leslie Jackson. Hilltop Artists in Residence program expands to Taos, New Mexico, to work with Taos Pueblo Native Americans. Two large "Chandeliers" are created for Benaroya Hall, the home of the Seattle Symphony. Chihuly's largest sculpture to date, the "Fiori di Como," is installed in the Bellagio lobby in Las Vegas. Creates a major permanent installation for Atlantis on Paradise Island, Bahamas. PBS stations air "Chihuly Over Venice," the nation's first high-definition television (HDTV) broadcast.

Begins "Jerusalem Cylinder" series with gaffer James Mongrain, in concert with Flora Mace and Joey Kirkpatrick. In celebration of the millennium, Chihuly mounts his most ambitious exhibition to date: "Chihuly in the Light of Jerusalem 2000," for which he creates seventeen installations within the stone walls of an ancient military fortress, currently known as the Tower of David Museum of the History of Jerusalem. Creates an eighteen-foot "Chandelier" for the Victoria and Albert Museum in London. Returns to Jerusalem to create a sixty-foot wall from twenty-four massive blocks of ice shipped from Alaska.

Designs an installation for the White House Millennium Celebration. Creates "La Tour de Lumière" sculpture for the exhibition "Contemporary American Sculpture in Monte Carlo." Marlborough Gallery represents Chihuly. More than a million people visit "Chihuly in the Light of Jerusalem 2000." Receives an honorary doctorate from Brandeis University, Waltham, Massachusetts. "Chihuly Projects" is published by Portland Press and distributed by Harry N. Abrams, Inc.

"Chihuly at the V&A" opens at the Victoria and Albert Museum in London. Chihuly exhibits at Marlborough Gallery, New York and London. Creates a series of intertwining "Chandeliers" for the Gonda Building at the Mayo Clinic in Rochester, Minnesota. Begins a major commission for the Universal Oceanographic Park in Valencia, Spain, and exhibits artwork throughout the city.

With Jane Goodall, Seattle, 2000

With Colin Powell in the Boathouse hotshop, Seattle, 2000

Jackson, Christmas Day, Sun Valley, 1999

With Jackson, Seattle, 2000

Awards

1964
Seattle Weavers Guild Award, Seattle, Washington

1965
Highest Honors, American Institute of Interior Designers
(now ASID)

1967
Louis Comfort Tiffany Foundation Grant, New York, New York

1968
Fulbright Fellowship to Murano, Italy

1975
National Endowment for the Arts Individual Artist grant

Artist-in-Residence, Artpark, Lewiston, New York

1983
Achievement in the Arts Award, Tacoma Arts Commission,
Tacoma, Washington

1984
President's Fellow, Rhode Island School of Design, Providence,
Rhode Island

Visual Artists Award, American Council for the Arts, New York,
New York

Governor's Arts Award, Washington State (with Pilchuck
Glass School)

1985
Governor's Arts Award, Washington State

1986
Honorary Doctorate, University of Puget Sound, Tacoma,
Washington

Honorary Doctorate, Rhode Island School of Design, Providence,
Rhode Island

Governor's Arts Award, Rhode Island

Named Fellow of the American Craft Council

1987
Governor's Writers Award, University of Washington, Seattle,
Washington

Alumni Legend, Seattle, Washington

1988
Honorary Doctorate, California College of Arts and Crafts,
Oakland, California

1992
Honored as the first National Living Treasure, Institute for
Human Potential, University of North Carolina, Wilmington,
North Carolina

1993
Alumnus Summa Laude Dignatus, Alumni Association,
University of Washington, Seattle, Washington

1994
Golden Plate Award, American Academy of Achievement, Malibu,
California

Community Service Award, National Panhellenic Council,
Western Region

1995
Honorary Doctorate, Pratt Institute, New York, New York

1996
Honorary Doctorate, Gonzaga University, Spokane, Washington

Distinguished Achievement Award, University of Washington,
College of Arts & Sciences, Seattle, Washington

Globe Award, World Trade Center, Tacoma, Washington

Urban Glass Award for Outstanding Achievement in Glass,
New York Contemporary Glass Center, New York, New York

1998
Jerusalem Prize for Arts and Letters, Friends of Bezalel, Israel's
National Academy of Arts and Design, New York, New York

2000
Honorary Doctorate of Humane Letters, Brandeis University,
Waltham, Massachusetts

Distinguished Artist Gold Medal Award, University of the Arts,
Philadelphia, Pennsylvania

2001
Lifetime Achievement in the Arts Award, Corporate Council for
the Arts/ArtsFund, Seattle, Washington

Museum Exhibitions

1967
Dale Chihuly
University of Wisconsin, Madison, Wisconsin

1971
Glass Environment: Dale Chihuly & James Carpenter
American Craft Museum, New York, New York

1975
Dale Chihuly: Indian Blanket Cylinders
Utah Museum of Fine Arts, Salt Lake City, Utah
Institute of American Indian Arts Museum, Santa Fe,
New Mexico

1976
Dale Chihuly: Glass Cylinders
Wadsworth Atheneum, Hartford, Connecticut

Dale Chihuly: Indian Blanket Cylinders
David Winton Bell Gallery, Brown University, Providence,
Rhode Island
Leigh Yawkey Woodson Art Museum, Wausau, Wisconsin

1978
Baskets and Cylinders: Recent Glass by Dale Chihuly
Renwick Gallery, National Museum of American Art,
Smithsonian Institution, Washington, D.C.

1979
Dale Chihuly/VIDRO
Museu de Arte de São Paulo, São Paulo, Brazil

1980
Dale Chihuly: An American Glass Artist
Eretz Israel Museum, Tel Aviv, Israel

Dale Chihuly: Recent Works
Fine Arts Center Galleries, University of Rhode Island, Kingston,
Rhode Island

1981
Dale Chihuly: Glass
Tacoma Art Museum, Tacoma, Washington

1982
Dale Chihuly: Glass
Phoenix Art Museum, Phoenix, Arizona

Dale Chihuly: Recent Works in Glass
Tucson Museum of Art, Tucson, Arizona
San Diego Museum of Art, San Diego, California

1983
Dale Chihuly: Recent Works in Glass
Saint Louis Art Museum, St. Louis, Missouri
Palm Springs Desert Museum, Palm Springs, California